# MICHEL ANGELO

## THE FRESCOES OF THE SISTINE CHAPEL

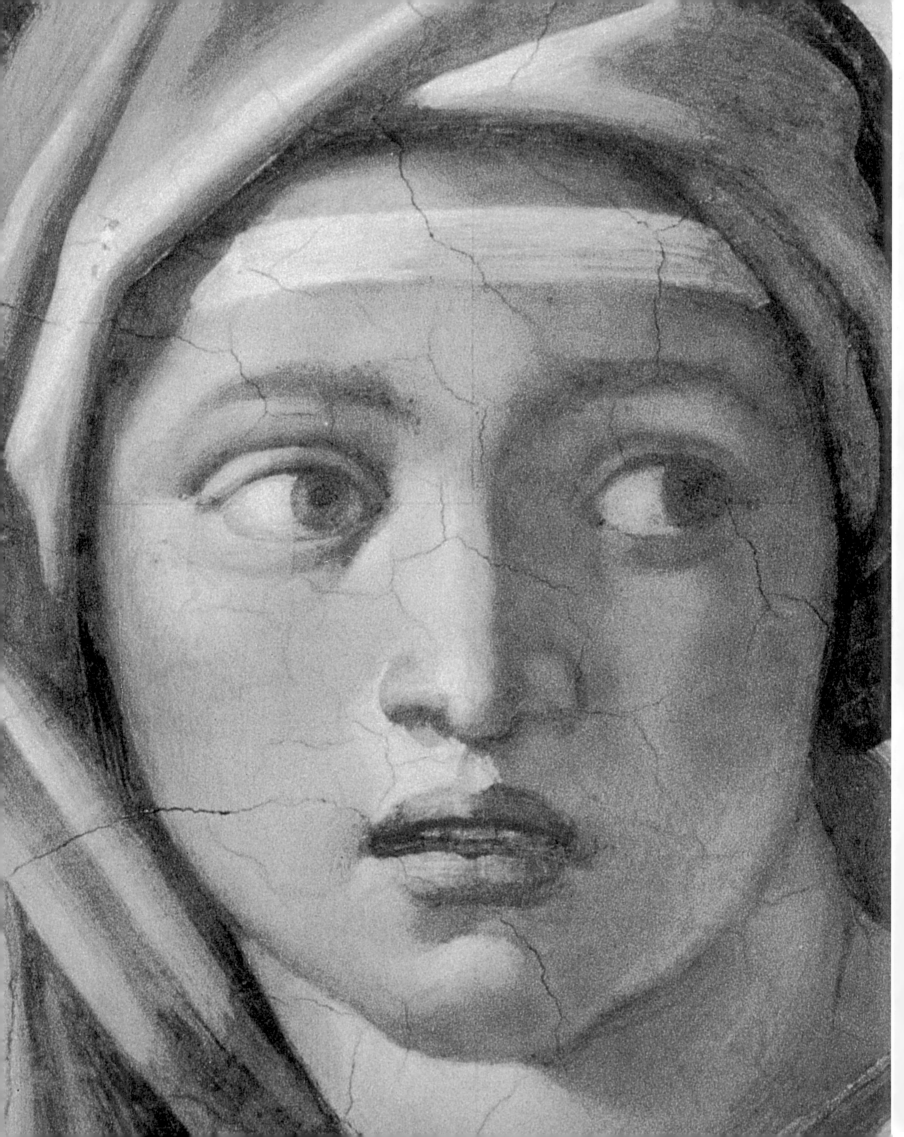

# MICHEL ANGELO
## THE FRESCOES OF THE SISTINE CHAPEL

Commentary by
Marcia Hall
Photographs by
Takashi Okamura

Harry N. Abrams Inc., Publishers

*The author thanks Dana Prescott and William Wallace for helpful readings of the manuscript.*

Michelangelo

Art Direction and Editorial Coordination:
    Massimo Giacometti
Design Consultant: Pino Milas
Editor, English-language edition: Barbara Burn
Editorial Assistant, English-language edition:
    Josh Faught
Color separations: Eurocrom 4, Villorba
    and Eurografica, Marano Vicentino
Produced by Ultreya/Edizioni, Milan

Printed and bound in Italy by Eurografica,
Marano Vicentino
10 9 8 7 6 5 4 3 2 1

All photographs of Michelangelo's frescoes
are by Takashi Okamura except:
Alinari, Florence, p. 8
Scala, Florence, pp. 16, 22, 23, 137, 152, 158
Courtauld Institute, London, p. 155a
Rhode Island School of Design, p. 161
Ultreya archive, pp. 19, 21, 155b, 156, 157, 230, 233

Harry N. Abrams, Inc.
100 Fifth Avenue
New York, N.Y. 10011
www.abramsbooks.com

Abrams is a subsidiary of

# TABLE OF CONTENTS

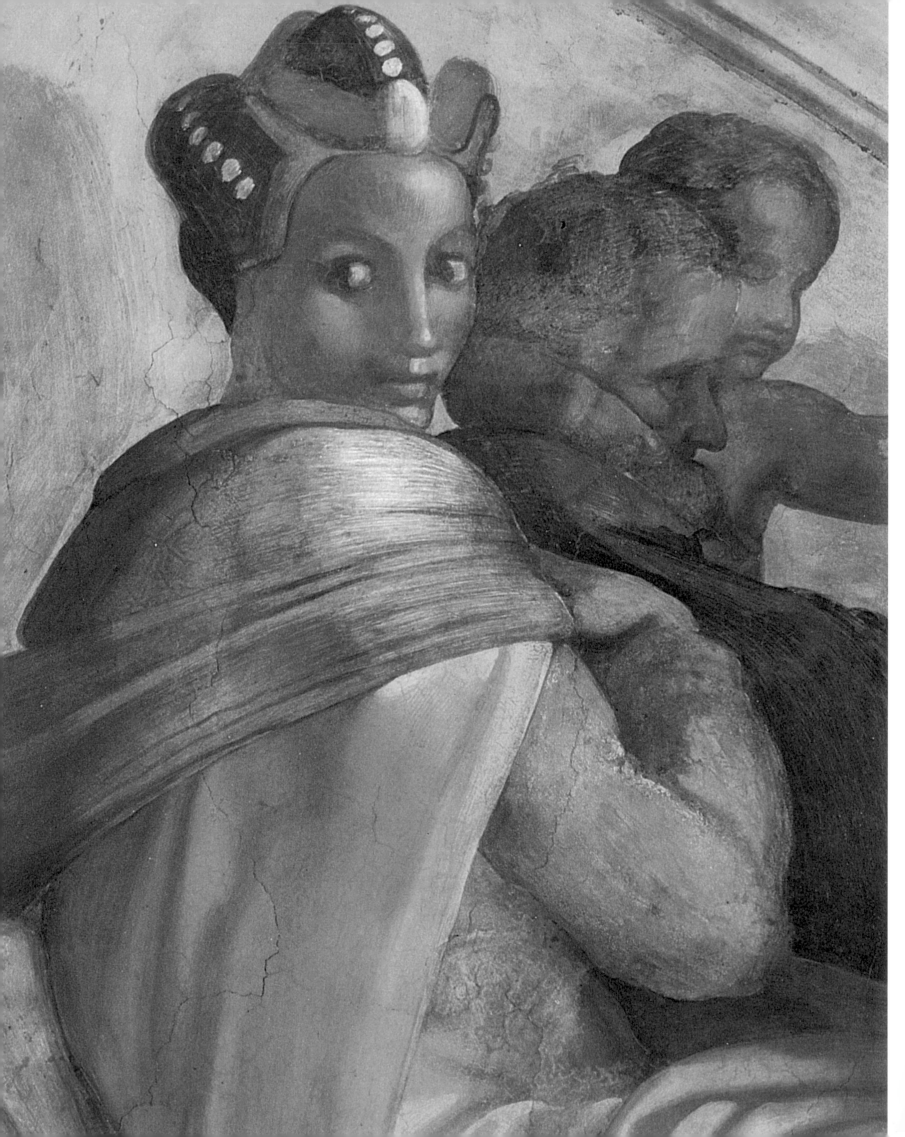

# THE VAULT

Pope Sixtus IV built the chapel named after him to replace the *cappella magna*, which was dilapidated, with one of the walls leaning precariously, like St. Peter's itself. The last ceremony held in the old chapel was in February 1477. By summer 1481, however, the fresco decorations were under way, to be completed by 1483.

Previously it was thought that Sixtus had the existing structure demolished, but new evidence has shown that the peripheral walls were preserved. The earlier structure was consolidated, reinforced, and refaced with a layer of brick, which explains how the work could have proceeded so rapidly. It may also, however, help to explain why problems of instability were not solved and why the chapel continued to suffer damage from its shifting foundations.

The chapel served several functions. It was the Papal Chapel and in that sense a palace chapel, built to host the conclave to elect a new pope, a function it still serves today. In addition, it was where all the ceremonies of the corporate body of the Papal Chapel were held. This group included the College of Cardinals, the generals of the monastic and mendicant orders, visiting bishops and archbishops, and certain qualified laity. Space for approximately two hundred was needed in Sixtus's time in the presbyterium on the altar side of the chancel screen, which separated these dignitaries from those who were admitted only to the area outside the screen. The chapel was a busy place, for some forty-two celebrations took place in the chapel every year during Sixtus's time, many more than were designated for Old St. Peter's, and more might be added, according to the wishes of the pope.

Sixtus had a new vault constructed and then a floor, which revived the kind of mosaic known as Cosmati work that had been popular in the churches of Rome in the Middle Ages. Its splendid patterns laid out the zones and locations for the performance of the liturgy, designating where people were to stand, process, sit, and perform other functions in the ceremonies.

The papal throne was located to the left of the altar. A *cantoria* was placed about halfway down the right side wall. The chancel screen that we see today originally divided the space roughly in half, but it was moved in the 1550s to make room for the enlarged College of Cardinals behind the screen. A step in the floor, symbolically indicating the distinction of status, marks the place where the screen originally stood. The floor design was also disrupted by the move.

The chapel was clearly designed to accommodate the frescoes that would cover the walls. A regular pattern of windows circled the walls, dividing them into six convenient fields on each side wall and two on each end wall. Around the bottom, fictive tapestries were painted, richly ornamented with gold and silver pigment and bearing the coat of arms of the patron's family, della Rovere, whose name means "of the oak." In a tier between the tapestry frescoes and the clerestory windows was a band for the narratives. It is separated from the tapestry zone by a minor entablature. A major entablature runs around the chapel separating the narrative zone from the window zone, strongly accentuating the horizontal axis. Between the windows there is space for what would become the gallery of sainted popes, two in painted niches between each window.

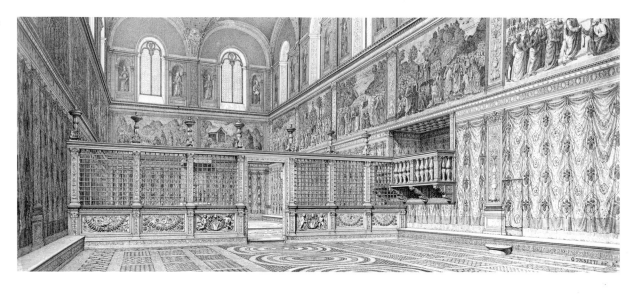

Above the windows were lunettes and above them, making a transition to the vault, were triangular areas, called severies. The design continued on the altar wall, although today what we see reflects the changes made in the 1530s to accommodate Michelangelo's *Last Judgment*.

When it came time to have the walls frescoed, Sixtus solved the problem of having no local Roman school of painters by having artists imported from Florence and its surrounding area. The pope appears to have called upon Lorenzo de'Medici to advise him and to intervene with the artists, and perhaps also their patrons. Sixtus and Lorenzo had only recently made peace following the war that began with Sixtus's participation in the Pazzi conspiracy, which had succeeded in murdering Lorenzo's younger brother Giuliano but failed to overthrow Medici control in Florence. It was perhaps a symbol of the new peace that Perugino, Botticelli, Domenico Ghirlandaio, and Cosimo Rosselli came to Rome for this important project.

Perugino, who had worked previously for this pope, came first and executed the altar wall. The chapel was dedicated to the Virgin Mary, so the altar fresco he painted appropriately represented the Assumption of the Virgin, in the presence of a kneeling Pope Sixtus. Perugino painted the first two of the biblical narratives flanking it on either side. The theme of the iconography chosen for the cycle was the Old Testament era of law as an antetype of the New Testament era of grace. Scenes from the life of Moses and the life of Christ were arranged in pairs across the chapel to emphasize typological relationships. Inscriptions above the frescoes made the parallels unmistakable. Thus, Perugino painted two Nativity scenes, *Pharaoh's Daughter Finding Moses* opposite the *Adoration of the Shepherds* on the altar wall. When the other painters arrived, there would have been a model they could follow so that the series would be stylistically coherent. As befits a palace chapel, an extraordinary amount of gold was used throughout the chapel, not only in the tapestry frescoes, the *cantoria*, and the chancel screen. The narratives are unusual for their date in having gilding scattered in the landscape as well as on the borders of robes. One must suppose that this was done on the explicit instructions of the pope.

We know from Vasari that the lunettes above the windows were decorated, but we have no record of how. The vault was apparently painted in the way that vaults were treated at the time, like the starred blue vault of heaven. The chapel, therefore, was fully decorated by Sixtus's painters, and there was no reason to think of redoing it—no reason, that is, until 1504, when a huge crack opened in the ceiling and the chapel had to be closed for six months while repairs were made. The pope at this time was Julius II, the nephew, as it happened, of Sixtus. Julius had structural work done, including inserting tie-rods in the area above the vault. He was perhaps less reluctant than another pope might have been to make changes in the della Rovere chapel. Obviously the ceiling would have to be repainted, and a kind of ceiling decoration, inspired by the newly discovered ancient Roman "grottoes," had made its stunning appearance in Rome in the years since Sixtus. The possibility of embellishing still further the work of his uncle must have been irresistible to Julius.

In the early Quattrocento (fifteenth century), before his grandfather lost a lot of money, Michelangelo's family had been relatively wealthy. Not surprisingly, Michelangelo was expected to get a good education and restore the family position. The story goes, however, that he refused to study and ran off to draw instead (a familiar topos one hears about almost every outstanding artist).

Only after much battling did he convince his father to allow him to follow his calling. The boy was apprenticed in 1488 at the age of thirteen to Domenico Ghirlandaio, whose large workshop attested to the success that he had increasingly enjoyed since returning to Florence from frescoing in Sixtus's chapel earlier in the decade.

It is often said that Michelangelo had no experience of fresco when he mounted the Sistine scaffolding, but this is not the case. Ghirlandaio was working on the chapel of Giovanni Tornabuoni, father-in-law of Lorenzo de'Medici, in Santa Maria Novella when Michelangelo entered the workshop, and that commission was not finished until the artist left the shop after only two years. During that time he would have had ample exposure to the practice of fresco.

The boy caught the eye of Lorenzo and was invited to become a member of the Medici household. There he could study antiquities in the family collection and garden, and he could hear discussions among the humanists Lorenzo had gathered around him, such men as Marsilio Ficino and Angelo Poliziano, who was tutor to Lorenzo's children. Although Lorenzo died just two years later, he had a lasting influence on Michelangelo, who would become one of the most learned and literate artists of the Cinquecento.

The unrest in Florence that followed Lorenzo's death and his son Piero's mismanagement of negotiations with the invading French army contributed to the rise of the Dominican priest Savonarola to political power, and the expulsion of the Medici from Florence. Michelangelo, who had been closely associated with the Medici and their circle, judged it expedient to get out of town, so he fled to Bologna. There he was befriended by Gianfrancesco Aldobrandini, who had himself lived in Florence, and who gave the young artist shelter and work. Michelangelo executed three small figures, an angel and two saints, for the tomb of Saint Dominic, which had been left incomplete when Niccolò dell'Arca died in 1492. After little more than a year, Michelangelo returned briefly to Florence before removing himself to Rome. The city must have delighted the young sculptor, especially the collections of antique statues that had been amassed by such collectors as Cardinal Giuliano della Rovere (later Pope Julius II), who possessed the Apollo Belvedere among other treasures. Cardinal Riario, who was building the enormous palace known today as the Cancelleria, had bought the Cupid that Michelangelo had made in Florence and then "aged" to give the appearance of antiquity. When the collector learned that it was modern, however, he demanded his money back and thereby lost an early Michelangelo. But Riario helped the young artist find a commission to make another statue in the manner of the antique, and this a life-sized one. The Bacchus that Michelangelo carved stood in the garden of Jacopo Galli and was drawn there in the 1530s by Martin van Heemskerck, surrounded by antique marble fragments.

Galli was instrumental in getting Michelangelo another commission, a Pietà for a French cardinal. The piece we see now in St. Peter's was made for the cardinal's tomb in that church. After its completion, Michelangelo decided to return to Florence, despite the fact that economic conditions there, in the wake of Savonarola's burning at the stake, were depressed and there was not much hope of work. Once again his good fortune exceeded expectation, for he was given the commission by the Opera del Duomo to make a colossal figure from an existing but botched block, which if he succeeded was to be installed high up on the cathedral. The David that emerged in 1504 was judged too good to be placed in so inconspicuous a site, and it was proudly installed in front of the Palazzo Vecchio. From this point onward, Michelangelo would never lack for commissions; in fact, patrons would compete for his services.

Leonardo da Vinci had returned home to Florence after the collapse of the Sforza regime in Milan, where he had been court artist for almost eighteen years. He brought with him a cartoon for an altarpiece of the Virgin and Child with Saint

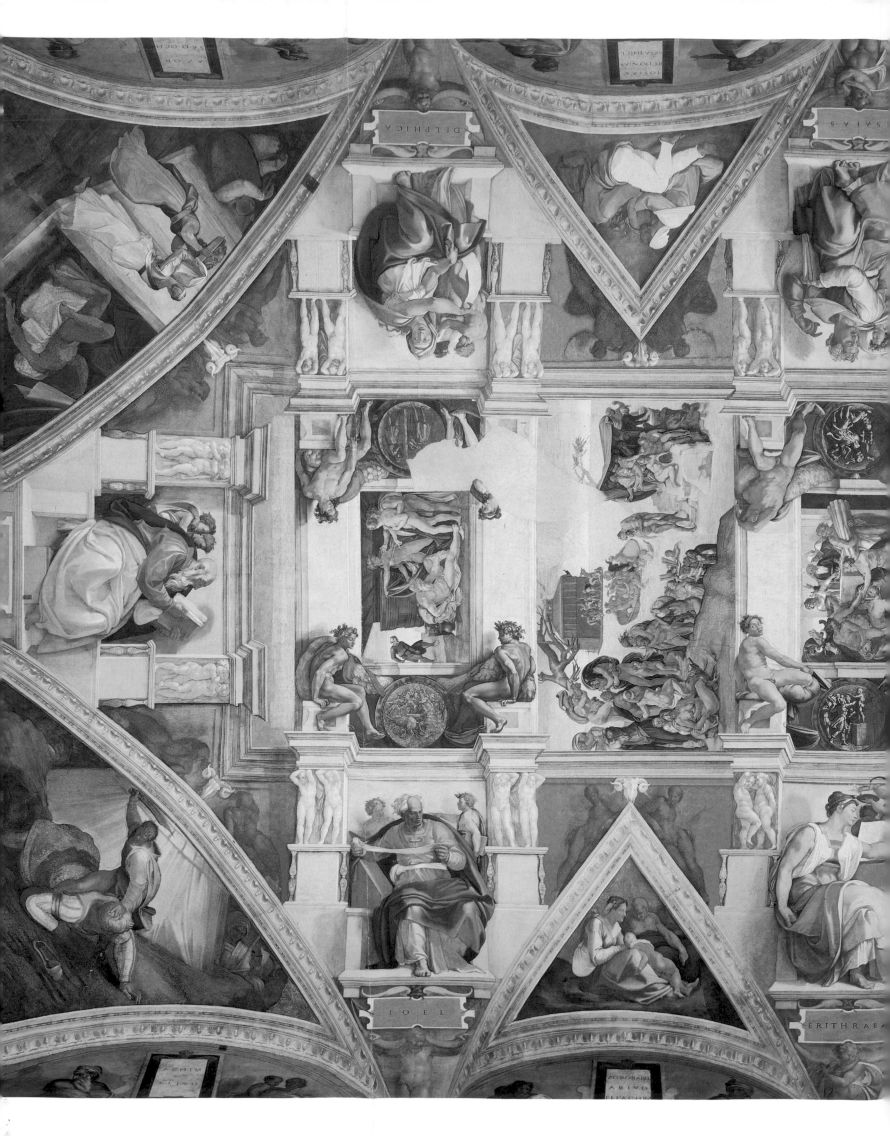

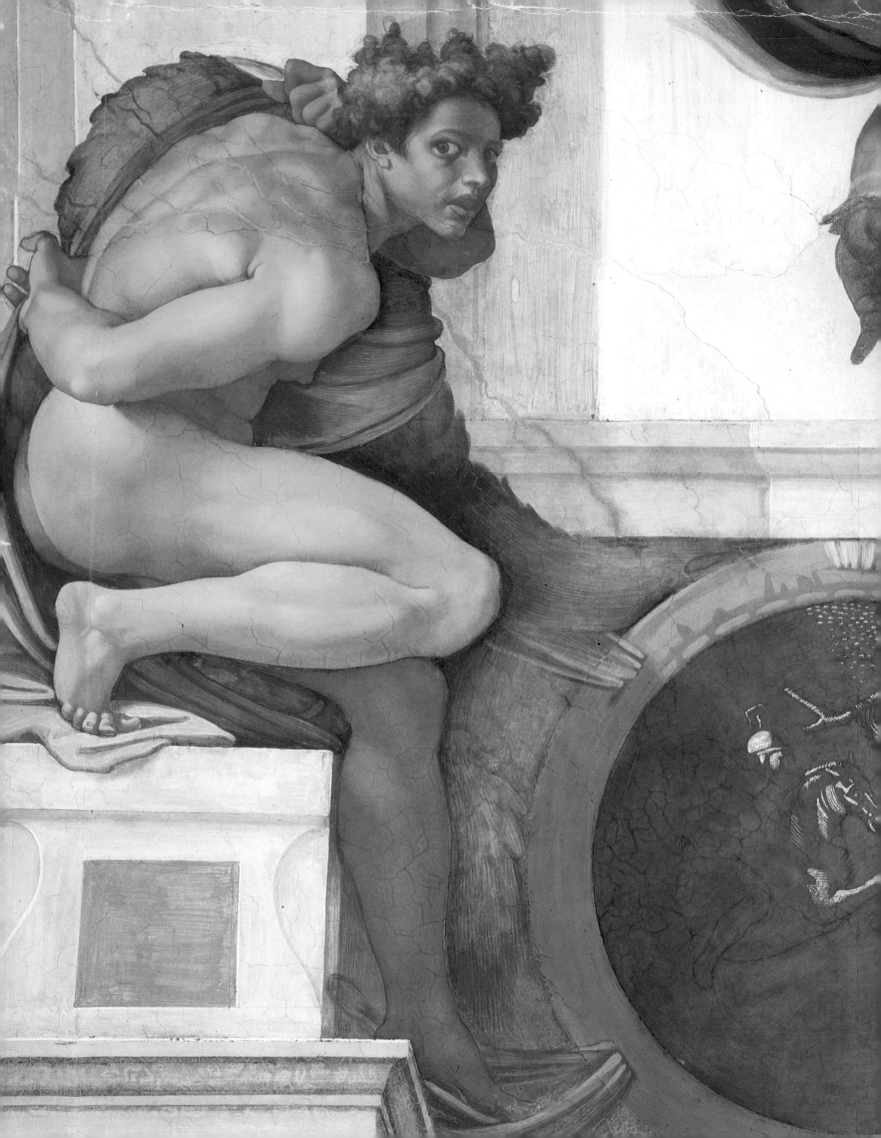

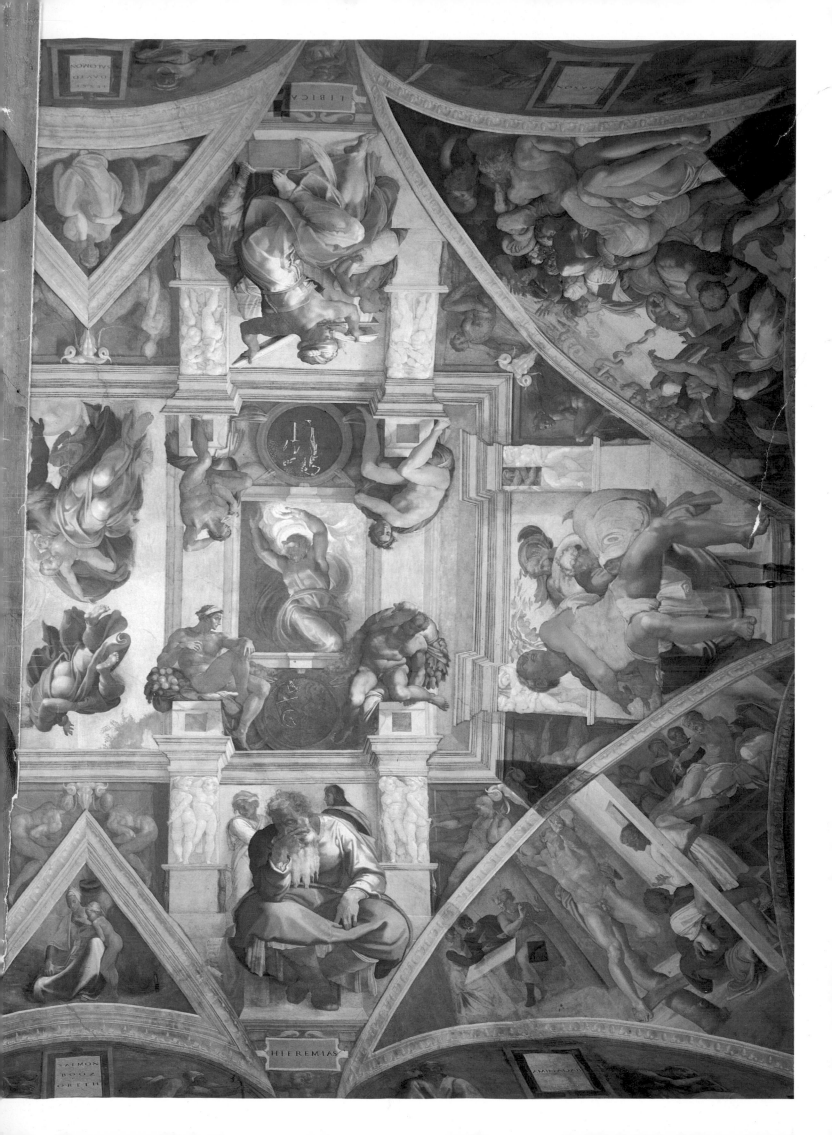

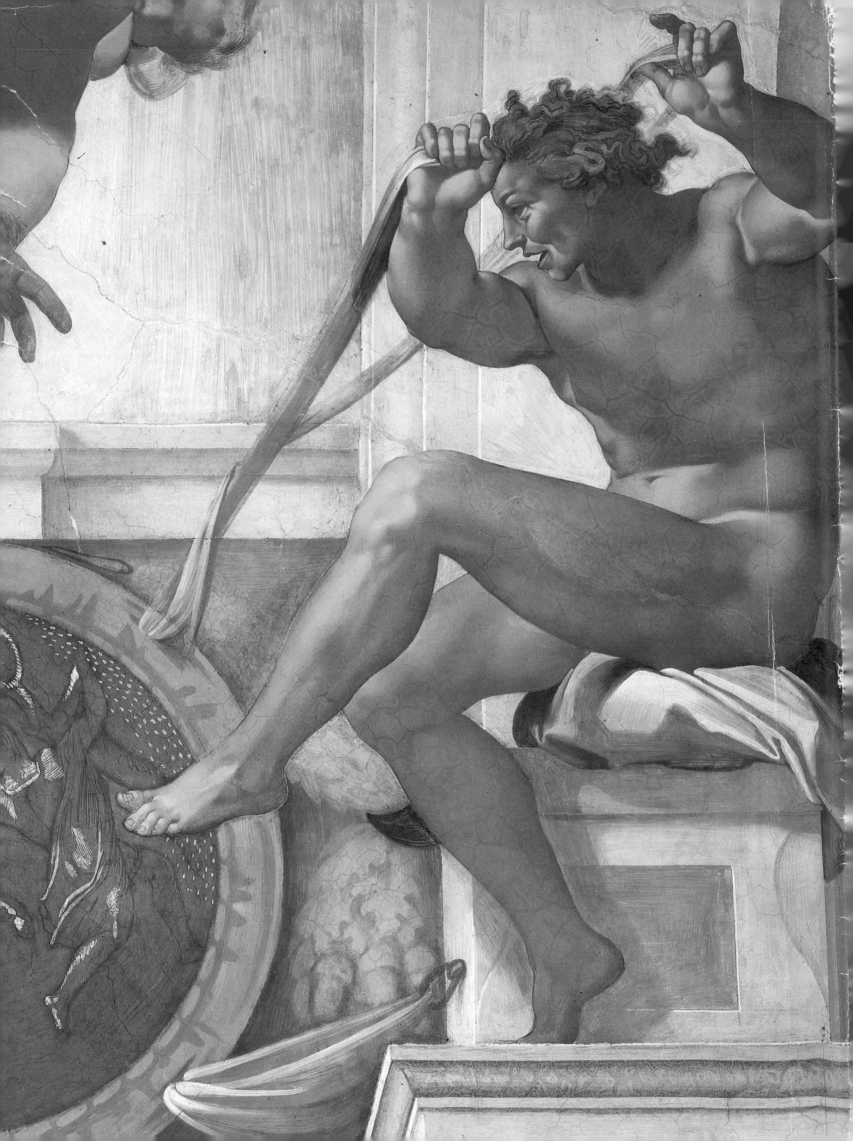

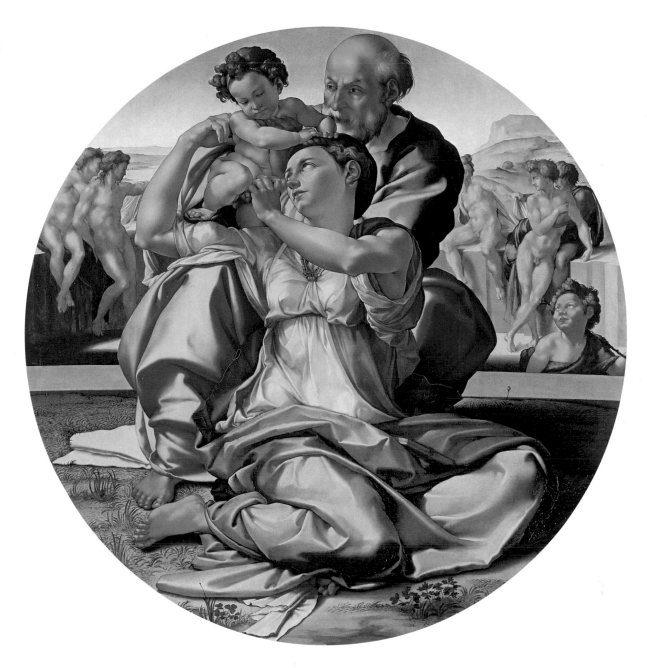

Michelangelo's brilliant and contrasted colors in the Doni Tondo are a kind of response to Leonardo's subdued and unified colors.

Anne. When he displayed it and his new misty sfumato, it created a sensation, according to Vasari. Drawings show that Michelangelo studied Leonardo's cartoon. It is evident from them that, as much as Michelangelo admired the compact and unified composition, he rejected the soft and blurred contours. The sculptor in him came to the fore when he painted his Doni *Holy Family*, a kind of response to Leonardo. His colors are brilliant and contrasted, where Leonardo's are subdued and unified; his contours are crisp and set off against a contrasting background, whereas Leonardo's blend and avoid silhouette. Despite their different approaches, the two artists

were commissioned to fresco battle scenes commemorating great moments in the Florentine past, side by side in the Palazzo Vecchio. The huge Sala del Gran Concilio was the core space of the new republic, which had replaced Savonarola's theocracy. *The Battle of Anghiari* by Leonardo and *The Battle of Cascina* by Michelangelo, had they been executed, would have offered a concentration of artistic talent rarely seen in history. However, it was not to be. Leonardo's experimental technique ran down the wall in great drips, and in March 1505 Michelangelo's presence was commanded in Rome, where Pope Julius had plans.

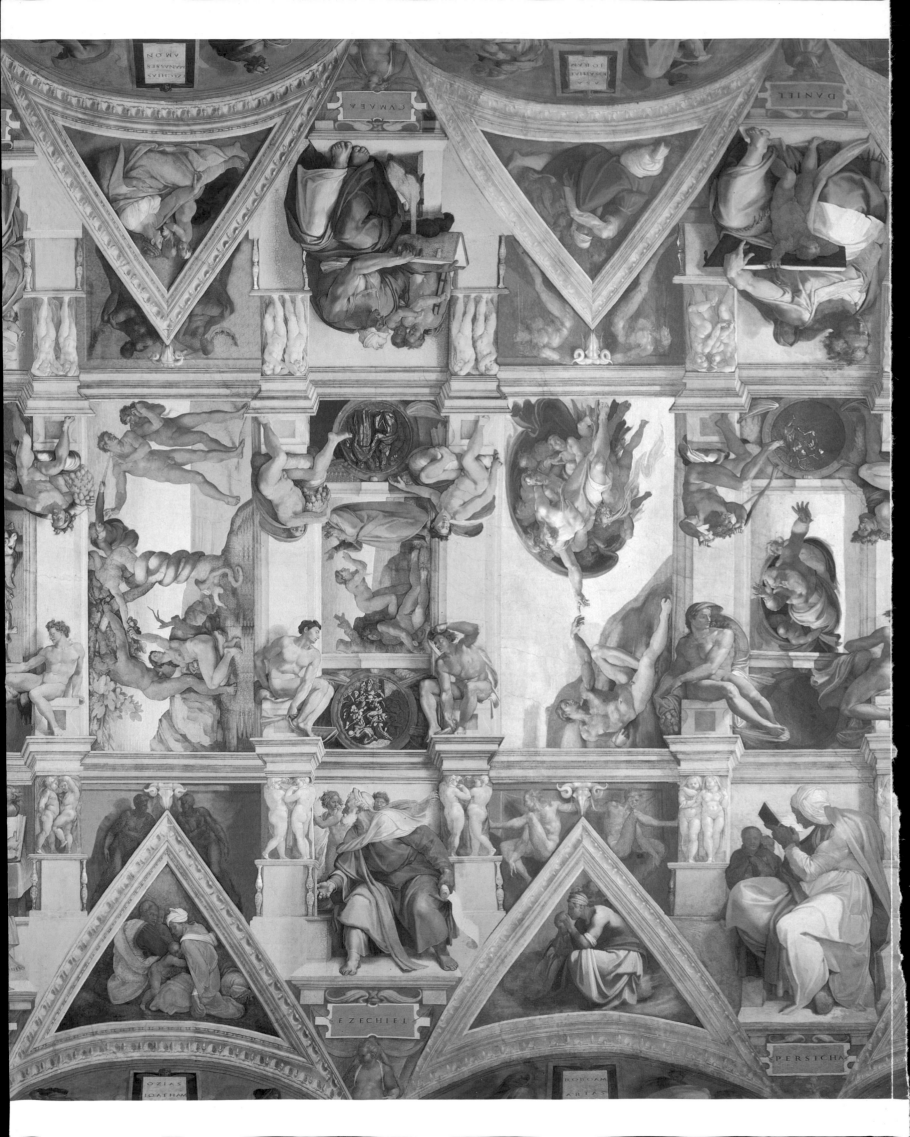

When Cardinal Giuliano della Rovere was elected pope late in 1503, he wasted no time in launching a campaign to rebuild the Vatican and restore Rome as the capital of a great empire, this time a Christian empire. The pope's choice of name may have been intended to signal his imperial ambitions.

He put in charge his chosen architect, Donato Bramante, who had recently completed a miniature Doric gem, the Tempietto, for their Majesties Ferdinand and Isabella of Spain on the Janiculum, the hill adjoining the Vatican. Bramante was ordered to tame the woods running between the Villa Belvedere and the palace to create a three-stage garden, enclosed on each long side by a loggia and a covered passage. This new Cortile del Belvedere was recollective of the gardens of antique imperial villas and, in its kilometer-long extension, rivaled them. Julius had in mind for Michelangelo a tomb for himself of equally imperial scale. It was to be installed in St. Peter's as a freestanding monument, with about forty figures on three levels; it would cost 10,000 ducats, and take five years to complete.

Michelangelo submitted several plans, and when one had been selected, he set off in April 1505 for Carrara to oversee the quarrying of the marble blocks. While he was away, Julius decided that, rather than repair St. Peter's, he would tear it down and rebuild it. He had in Bramante just the architect for such an audacious plan. When Michelangelo returned to Rome, he found that Julius had transferred his enthusiasm, and his financial resources, to his new project. In April 1506, a few days before the cornerstone of the new church was to be laid, Michelangelo tried to see the pope but was refused entry. In a fury of humiliation he fled to Florence. Despite commands from the pope to return, he refused. Julius must have recognized that he had met his match, for he promised there would no punishment if Michelangelo returned. The artist responded that he would be glad to carry on, but that he wanted to do it from Florence, where life was both cheaper and more convenient. The pope sent three separate briefs to Florence ordering him to return. Finally Piero Soderini, the Florentine head of state, intervened, telling the artist that he did not want to go to war on his account. But by this time Julius had taken himself and his army off to reconquer lost provinces of the Papal States.

When Michelangelo finally caught up with the pope in Bologna, it was November 1506. He was pardoned, but the reward he received was not a welcome one. Pope Julius ordered him to cast an over-life-sized statue of himself in bronze, which was, Michelangelo complained, not his material, nor was he much interested in portraiture. The statue was to be installed on the facade of San Petronio as a reminder to the Bolognese of who their master was. Four years later, when they successfully rebelled, Michelangelo's statue was thrown down and melted into a cannon nicknamed La Giulia, which was then turned against the papal army.

In March 1508 Michelangelo returned to Florence, bought a house on the Via Ghibellina (later to become the Casa Buonarroti), and evidently hoped to return to Florentine projects, such as the unfinished Saint Matthew and the other Apostles that had been commissioned in 1503 to decorate the cathedral. Once again the pope summoned him to Rome, but not, as Michelangelo hoped, to continue work on the tomb. As early as May 1506 Julius had it in mind to have Michelangelo paint the Sistine ceiling. Although his reluctance is well recorded, by May 1508 he had signed a contract to do it for 3,000 ducats.

The original commission was not for the ceiling as we see it today, but for a much less ambitious project. What Julius intended was to modernize the decor of the chapel by introducing the fashionable compartments with *grotteschi*, which were all the rage in Rome after the discovery of the ancient Roman "grottoes" on the Esquiline. Sometime around 1480, some sinkholes opened on the top of the hill, and when they were explored, it was discovered that they were the vaults and upper walls of a Roman imperial structure covered with fresco and stucco decorations. The Renaissance explorers believed it was the Baths of Titus, which were nearby. In fact, it was the infamous Golden House of Nero (*Domus Aurea*), which was so lavish and ostentatious that Trajan had filled it with rubble and built his baths on top, a gift to the people to compensate for

the excesses of his decadent predecessor. It became the chief attraction for local and visiting artists to climb down into these "caves" and sketch the decorations. Pinturicchio, who left his autograph carved in the wall, became the principal practitioner of the new grotesque ornaments. They appear in the frames of his chapel decorations, on the walls of Pope Alexander VI's apartment in the Vatican, on the vault and pilasters of the Piccolomini Library in Siena, and on the vault in the chancel chapel at Santa Maria del Popolo. Julius II had commissioned the last about the same time he was making his contract with Michelangelo for the Sistine vault.

A couple of Michelangelo's sketches give an idea of the original plan. Where the Prophets and Sibyls are found there were to be the twelve Apostles. The rest was to be filled with Domus Aurea–style compartments and the usual ornaments. It is easy to understand Michelangelo's resistance to this project.

No one had ever painted anything serious on a vault, and it must have seemed a frivolous undertaking to the artist who had conceived, and then been prevented from executing, a work of such profundity and monumentality as the Julius tomb. Perhaps it rankled that, on the one hand, Bramante was rebuilding the most important church in Christendom, and on the other hand, his other rival, Raphael, was painting the walls of the papal apartment, the Stanza della Segnatura.

Michelangelo wrote in a letter of 1523 how the plan was converted—an implausible version, written enough later so that there was no one alive to refute it. According to Michelangelo, when the pope inquired how the work was progressing, Michelangelo replied that it would be "a poor thing." When asked why, Michelangelo retorted: "because the Apostles were poor," at which point the pope told Michelangelo to do whatever he wanted.

## THE CAMPAIGNS, THE SCAFFOLDING, THE TECHNIQUE

Michelangelo began work immediately after signing the contract in May and was already painting by August, beginning at the entrance wall with the Noah scenes. The curvature of the vault (which is, incidentally, very uneven) creates its own foreshortenings, so it was difficult to project foreshortened figures, even with cartoons.

Bramante remarked in a letter that he did not think Michelangelo would be able to handle the foreshortening, presumably thinking of his limited experience as a painter. Michelangelo appears to have thought that the work of the first six months had gone slowly, for he wrote his father in Florence in January 1509: "I do not ask anything [of the pope] because my work does not seem to me to go ahead in a way to merit it. This is due to the difficulty of the work and also because it is not my profession. In consequence I lose my time fruitlessly. May God help me."

During this first phase, mold had appeared on the frescoed ceiling, and Michelangelo had decided to fire some of the workshop assistants whom he had brought down from Florence and proceed with the painting himself. This could not have pleased the pope, for it would certainly mean that the work would be protracted. The complaints we hear about

the impatience of Julius to see it completed surely are related to this issue. Normal workshop practice would have assigned to assistants all but the designing of the cartoons and the painting of the most important figures. With such a division of labor, frescoing could proceed with surprising speed. Vasari tells us that one morning Michelangelo arrived early and locked the assistants out of the chapel. As dramatic as this story is, it seems not to be entirely accurate. The restorers found evidence of the participation of assistants throughout the opening Noah triad. In any case, we should not imagine that Michelangelo did not use assistants for such menial tasks as preparing the plaster, transferring the cartoons, and inscribing the lettering for identifying plaques. He apparently retained some half dozen of the less skilled painters, who executed the fictive architecture, the putti flanking the Seers' thrones, and other repetitive tasks.

Throughout the period of this first campaign Michelangelo's letters are a litany of complaints. In June 1509 he wrote again to his father: "I am living ill-content and not in too good health staying here, faced with an enormous task, without anyone to manage for me and without money. But I have good hope that God will help me."

In October he told his brother Buonarroto: "I live here in great state of anxiety and great weariness of body, and have no friends of any kind and don't want any. I haven't even time to eat as I should."

The physical strain of standing on the scaffolding and reaching over his head to paint took its toll, which Michelangelo recorded in a sonnet written in 1510. His head was continually splattered with dripping paint, he complains, and he describes how his body had been distorted: "I've already grown a goiter . . . Which sticks my stomach by force beneath my chin. With my beard toward heaven, I feel my memory-box atop my hump. . . . My loins have entered my belly and I make my ass a crupper as a counterweight. . . . In front of me my hide is stretching out and, to wrinkle up behind, it forms a knot."

Despite these difficulties, he finished the first part of the ceiling by July or August 1510, two years after he had begun. This first campaign comprised the first five bays up to the top of the *Creation of Adam*, and certainly included everything down to the spandrels of those bays. Whether the lunettes were painted at the same time or in a separate campaign has still not been resolved, although the former seems likely.

Condivi reported (presumably as Michelangelo dictated) that while the work was proceeding, the pope came and visited it many times. The painter would give the elderly pontiff a hand up from the ladder to the platform of the scaffolding. When it was half completed, Julius demanded that the scaffolding be removed and the vault uncovered, even though some of the finishing touches had not been applied.

The opportunity to view the work from the floor seems to have been advantageous for the painter, despite his evident reluctance, for he made certain changes in the second half. The figures become larger and the painting bolder. The second half makes the first half look tentative. The modeling becomes more forceful, and application of paint is more fluent, imparting a new movement and energy. We will note that the Ignudi (nudes) and Seers are enlarged in the second half, and that the figure of the Creator, who dominates the last bays, has an unprecedented majesty.

Until the recent cleaning it was mistakenly believed that Michelangelo had worked lying on his back, but one of his sketches shows him standing.

Michelangelo must have prepared the cartoons for the second campaign at this time, but when he was ready to install the new scaffolding Julius had gone off to war and there was no money. The artist pursued him to Bologna twice, once in September and then again in December. He was finally able to resume work in February 1511. He continued for another twenty-one months, until the end of October 1512. The vault was unveiled on All Saints' Day, just over four years after it had been begun. Not only did Michelangelo's style become more fluid in the second half, but he also worked faster. In the first campaign, he transferred his cartoons, for the most part, using the tedious method of pouncing, that is, dusting pinholes that mark the outlines with charcoal. In the second half we find him often incising the outlines into the damp plaster. In a raking light on their scaffolding, the restorers could see the indentations, just as they could occasionally make out the little black pounced dots. When he came to paint, Michelangelo would sometimes exceed the incised contour, enlarging the figure still more. Studying details, one can sense his energy, his confidence, and his chafing to be done with it. Sometimes the paint is applied with his fingers rather than a brush. One of the mysteries about the lunettes of the Ancestors is that they show no evidence of transfer of cartoons, either by pouncing or by incision. Apparently they were painted freehand, with only small sketches as guides and an outline brushed in with the tip of the brush. One can imagine the relief he felt when he was able to stand on the scaffolding and paint in the normal way, without reaching over his head. He seems to have experienced it as a liberation, for these figures are painted with broad strokes and thinly applied paint, and with great speed. As a rule, each seated figure was executed on a single patch of

plaster. Given their size—more than six feet across—this was very rapid, sure-handed work, and it becomes even more bold and confident as the Ancestors approach the altar.

Until the recent cleaning, it was mistakenly believed that Michelangelo had worked lying on his back, but one of his sketches shows him standing. The construction of the scaffolding had posed problems. The pope originally ordered his architect, Bramante, to design it. His design suspended it with ropes from the ceiling. Michelangelo scoffingly rejected the design, asking how he would fill the holes after it was removed. The scaffolding he designed for himself spanned the width of the chapel with beams set into holes just above the entablature at the bottom of the lunettes. The projection of the entablature hid the holes and the unfinished plaster when viewed from the floor. These same holes were used when the scaffolding for the restoration was built in the 1980s, substituting steel beams for the wood that was used in the sixteenth century.

## THE ICONOGRAPHICAL PROGRAM OF THE VAULT

Michelangelo took credit for enlarging the program, but no one thinks he was responsible for the complex iconography we see. The problem that faced the designers was that it had to be fitted around the preexisting wall frescoes, which covered parts of both the Old and the New Testaments.

Helpful, however, was the clear typology that was the organizing principle there, in which Old Testament stories prefigured New Testament events. Whatever Old Testament stories might be chosen for the vault, the message—that they pointed to the coming of the Messiah—would be unmistakable. For example, each of the corner spandrels represents a deliverance of the Hebrew people: from hostile armies at the entrance wall in the beheadings of Goliath and Holofernes, from a plague of serpents and the treachery of Haman at the altar end. All together they foretell the redemption that would come with Christ's incarnation and death.

It was decided that three portions of the Old Testament would be deployed in the three major divisions of the vault and upper side walls. Down the spine of the ceiling would be chronological scenes from Genesis, preceding the Moses stories on the walls below. Then where the Apostles were originally to have been, there would be enthroned Seers, Old Testament Prophets, and pagan Sibyls, all of whom uttered cryptic announcements of the coming of the Messiah. Finally, in the triangular severies and the lunettes above the windows would be the Ancestors of Christ, making transition from the Old Testament to the New. On bronze shields beside the Genesis scenes, stories drawn from the books of the histories were depicted.

The Genesis scenes are nine in number and are divided into three triads, representing in order from the altar: the Creation of the World, the Creation and Fall of Humankind, and the Noah story—or God in the cosmos without man, God and man together in paradise, and man in the world separated from God. The iconography of the vault seems to have taken into account the placement of the chancel screen and to have been designed around it. Today the screen is below the division between the *Sacrifice of Noah* and the *Temptation and Fall of Adam and Eve*. It was originally closer to the altar, below the border between the *Temptation and Fall* and the *Creation of Eve*, so that it divided sacred scenes from profane, as the screen separated sacred from profane space. Inside the screen were scenes of God and man in harmony; outside it, sinning man without God.

At the very center of the vault was the *Creation of Eve*. Mary was understood to be the second Eve, who reversed her sin. Mary as the Bride of Christ represents also allegorically the Church. The Church then stands here at the center, and at the division between man with God and man without God, to provide the means to bring man back to God and to salvation. This convergence of Eve-Mary-Church was a key concept, relating to the dedication of the chapel to Mary, and connecting this scene to Perugino's altarpiece with its representation of the Assumption of Mary.

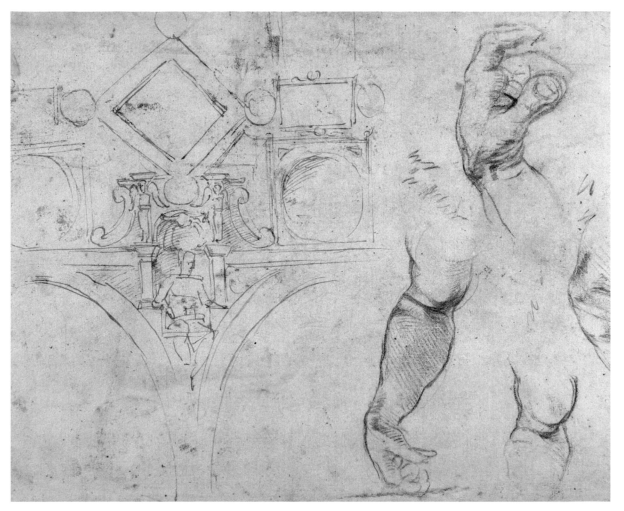

There are deviations from the textual order, which have been variously explained. Both the Flood and the Creation of the Sun, Moon, and Plants are depicted out of order. One explanation sees a structural relationship between panel 2 (the *Creation of the Sun, Moon, and Plants*) and panel 8 (the *Flood*). Both are large scenes at the center of their triads, symmetrically opposing the *Creation of the World* with the *Destruction of the World*.

Michelangelo's thoughts for the original plan are preserved in a sketch (in the British Museum), which he later recycled, using the sheet to make chalk studies for Adam's extended arm. In pen we see an enthroned Apostle where the Prophets and Sibyls would eventually be painted, and above, the ornamental compartments that would fill the rest of the vault. The much more ambitious final design resembles superficially both the Domus Aurea and this first project in that it utilized compartments and thrones, but it differs significantly from both. In the initial design the thrones were projected forward from the surface of the wall, but they then came into conflict with the flat compartments at the center of the vault. Michelangelo preserved the projecting thrones in the final design, but he rationalized their relationship to the other zones.

It is frequently said that the ceiling is not illusionistic, and this is true in the sense that it is not projected from a single point of view, like such seventeenth-century ceilings as the Gesù or Sant'Ignazio. But Michelangelo has created the illusion that the Seer's thrones and the bases on which the Ignudi sit are in front of the surface of the wall. Seers and Ignudi project forward, while the transverse ribs that frame the tops and bottoms of the Genesis scenes recede to the surface. The bronze medallions are attached to and flush with the wall. Together with the Genesis pictures, which are painted on the surface of the vault, they establish the location of the wall plane. The Ancestors in the severies are within coves that recede back into undefined darkness, as does the space above them where we see dimly lit bronze nudes. Light, which is consistently represented throughout the vault as entering from the altar wall windows, helps us differentiate the levels in space.

The Domus Aurea provided the impetus for the commission and Michelangelo's initial design, but the final design is fundamentally different from it and from other vaults designed around the same time and inspired by the Domus Aurea. What distinguishes Michelangelo's ceiling from the others is that it is the only one not shown as a flat surface. Pinturicchio's

What distinguishes
Michelangelo's ceiling from the
others is that it is the only one
not shown as a flat surface.
Pinturicchio's contemporary
vault on the chancel of Santa
Maria del Popolo shows
compartments in which figures
are framed.

contemporary vault on the chancel of Santa Maria del Popolo shows compartments in which figures are framed. These compartments are enclosed with richly ornamented borders on gilded backgrounds filled with *grotteschi*. The whole design must be read as in the same plane, and each part as having essentially the same importance. The gilded backgrounds of both the compartments and the frames help flatten and make ambiguous the space. All the contemporary or immediately preceding ceilings—Perugino's ceiling in the Cambio, Pinturicchio's in the Piccolomini library, Raphael's in the Stanza della Segnatura—adorn the surface of the vault, without attempting to create an illusion of space.

Michelangelo's ceiling was so much bigger than these that he must have recognized that it required a more dynamic treatment. To emphasize the differences in levels of projection, the painter used energetic poses and overlapping. Some of the Seers project beyond their thrones, but most important, the Ignudi in their constantly varied poses overlap the frames and vigorously guide the viewer down the ceiling. There is no

come. The syntax of large-scale mural decorations of Roman palaces depended upon and drew its inspiration from the Sistine vault. Reused first in Raphael's Sala di Costantino, fictive bronzes, faux marble relief, and simulated marble architecture all reappear not only in Rome, but are carried by Giulio Romano to Mantua, then raised to new heights at Fontainebleau by Rosso Fiorentino and Primaticcio.

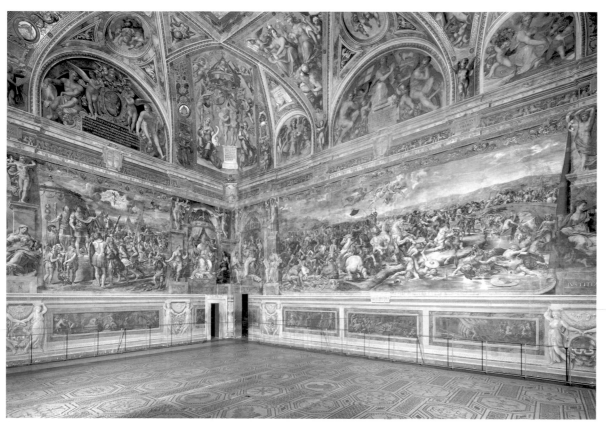

The syntax of large-scale mural decorations of Roman palaces depended upon and drew its inspiration from the Sistine vault. Reused first in Raphael's Sala di Costantino, fictive bronzes, faux marble relief, and simulated marble architecture all reappear not only in Rome, but are carried by Giulio Romano to Mantua, then raised to new heights at Fontainebleau by Rosso Fiorentino and Primaticcio.

gold to establish a uniform ground, as in some comparable ceilings.

Michelangelo's invention catapulted ceiling design a quantum leap beyond where it had ever been. Even more significant, Michelangelo's idea of simulating materials in paint introduced new ideas that would feed artists for some time to

The Seers create a new genre: statuelike figures that appear to be real presences. Raphael will imitate them in the enthroned popes in the Sala di Costantino. Perino del Vaga will reuse them in the Sala Paolina in the Castel Sant'Angelo. Salviati will evoke them in Palazzo Farnese frescoes of the Fasti Farnesiani in the 1550s. Their history continues for generations.

## STRUCTURE AND MEANING OF THE CEILING DECORATION

Although the choice of subjects is on the whole logical and easy to understand, the reason for the selection of individual scenes or persons and their placement is not always apparent. Why choose these particular moments from the Creation story? Why select these seven Prophets, and these five Sibyls? Why place the Sacrifice of Noah out of sequence?

What sources beyond the Bible guided the choices? Not all these questions can be fully answered. Scholars have offered various texts and interpretations. The Neoplatonic reading was popular around the middle of the twentieth century, but it was supplanted when it was correctly recognized that a theological reading was indispensable for the pope's chapel. The most convincing interpretation is that of Esther Dotson, based on Augustine's City of God, and augmented with insights into Renaissance theology drawn especially from the sermons preached in the papal court, which have been studied only in recent decades by John O'Malley.

The mystical concordance of the Old and New Testaments is no longer the commonplace it was in the Renaissance and may strike us as strange and implausible. But Saint Augustine's analogical interpretations would have been familiar to the audience to whom the Sistine decorations were addressed, which included learned theologians. Today we do not need to be professional theologians to appreciate the most important of the multiple meanings of Michelangelo's imagery. Understanding of some of the principal symbolic structures enhances our appreciation of Michelangelo's accomplishment and can help us penetrate the culture that produced it.

In part 2 of Augustine's City of God (chapters XI–XXII) the fifth-century Father of the Church tells the history of God's people as a binary opposition. On the one hand are people living in the spirit, making their pilgrimage through life toward the City of God, and on the other hand are those living in the flesh, in the unholy City of Man. In terms of the imagery of Michelangelo's ceiling, that division is seen between the sons of Noah, when Ham mocked his father and Shem and his brother reverently covered his nakedness. Ham's progeny became the founders of Babel, Nineveh, and Babylon—the cities of sin and corruption. Earlier, that same opposition had been created between the sons of Adam, Cain and Abel, and before them, between the good angels and the rebels, led by Lucifer.

Working our way from the entrance to the altar, we find the presence of the opposing forces for good and for evil always implied: the descendants of Cain are destroyed in the flood. Lucifer appears in the *Temptation of Adam and Eve*, in the form of the tempting serpent. It will be suggested that what God separates in the first scene of Creation are the good angels, the agents of light, from the demonic angels, the agents of dark.

In Augustine's reading of the Old Testament as prophesying the New, each event had a place in the divine plan for redemption. Thus even a calamitous judgment, such as God's decision to destroy the sin-ridden people with the waters of the Flood, was an intimation of future redemption, for it prefigured baptism, where water again, as in the Flood, washes away sin.

In addition to Augustine, antique culture provided inspiration to the Renaissance theologians. The prominently displayed Sibyls remind us that this is another way we should think about the ceiling. As representatives of the pagan world, they point us to the revival of the study of classical antiquity that animated so much of the artistic life of Julius's papal court, and they serve as "proof" of Christianity, Christ's arrival having been predicted by the Sibyls themselves. Julius's program for the renewal of Rome centered on reconciliation of the pagan and Christian cultures. The iconography of Raphael's Stanza della Segnatura shows ancient philosophers in the School of Athens engaging in the same kind of quest for truth that motivates the Early Church theologians in the Disputa on the wall opposite. Erasmus's startling injunction, "Saint Socrates, pray for us," powerfully suggests the regard with which the ancient world could be embraced.

Central to Renaissance theology is a fundamental optimism, expressed in the sermons preached in the papal chapel in the Renaissance. Study of ancient Roman rhetoric brought to the fore the kind of speech that had praise as its principal purpose. Increasingly we find the preachers focused on praising the

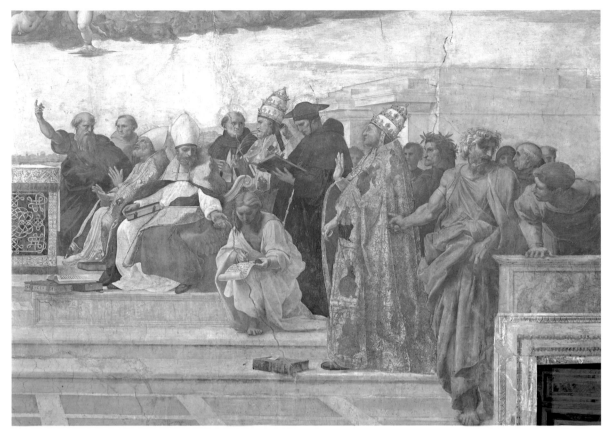

goodness of creation. To look just at the subjects of the Genesis scenes might lead us to a pessimistic view of humanity: disobedient sinners, thrust first from paradise, and then destroyed by flood. But the sequence of scenes ends not with the Flood but with the story of Noah's discovery of wine. Analogical reading immediately suggests the meaning of wine in the New Testament: as the central element of the Eucharist and therefore the means of our redemption.

The Messianic message is fundamental to the whole construct. God has redeemed sinful man by sending his son, whose sacrifice is reenacted by the Church each time the Mass is celebrated. According both to Augustine and to the Renaissance preachers, the apparently hopeless situation of humanity is only apparent. The illuminated viewer will see God's plan of forgiveness operating beneath the surface meaning.

Augustine was much read in the Renaissance, and he was the chief mentor of Egidio da Viterbo—not at all surprisingly, for Egidio was an Augustinian friar who became the head of the Order. Egidio was Pope Julius's favorite preacher and a member of the papal court. He is the most likely theological ad-

viser to Michelangelo, one who could readily have created an Augustinian program for the Sistine vault.

The way Michelangelo used color differs from one population to another. It seems that the coloring was as carefully structured as the iconography. The Genesis scenes are the most conventionally colored. Contrasts are not emphasized, and brilliant ornamental effects are avoided. The Ancestors employ the most *cangiantismo*, that is shifting to another hue in modeling, say, a drapery (for reasons that will be discussed). The Seers are much more brilliantly colored, with strong contrasts of large fields of color, than the Genesis panels. When one looks at the ceiling as a whole, the Genesis scenes, where the color is most conservative, are at the center of the field of vision. The Ancestors, at the edge, we see with our peripheral vision, which does not register color as vividly because the cones in that part of the eye are more sparsely distributed. His large fields of bright hues and high contrasts do not fade away into grays as readily as more muted and more closely woven tones would do. Michelangelo did not know about rods and cones, but like other painters, he knew this by observation.

# THE NINE CENTRAL PANELS
# THE NARRATIVE CYCLE

The Genesis scenes that form the spine of the vault are the largest fields and dominate the attention of viewers as they enter the chapel. The scenes alternate large and small panels, the small panels being framed at each corner by Ignudi holding garlands. This alternation impels a movement down the vault that has been compared to respiration.

The lively poses of the Ignudi and the way they sometimes overlap the frames of the histories help bind the vault imagery together, giving unity to the series. Nevertheless, the Genesis scenes are not presented illusionistically in the sense that they pretend to present a vision or even a view through the architecture to the sky above. The scenes are each projected individually, and the viewer must progress through the chapel to view them. They are oriented so that one must face the entrance to see them right side up. To view the Seers and lunettes, one must change orientation and face each side wall. Clearly then, the ceiling was meant to be experienced serially, one part at a time, as the viewer moved through the chapel.

The only one of these stories frequently represented in painting is the Temptation and Expulsion of Adam and Eve. For the other scenes, Michelangelo did not have much in the way of artistic precedent, especially in Renaissance painting (though certainly he had studied Uccello's frescoes in the cloister of Santa Maria Novella). Most previous decorations would have been in mosaic, like those of the Monreale cathedral in Sicily or the Genesis mosaic at San Marco in Venice. Thus, Michelangelo was faced with the problem of translating into fresco, and particularly into fresco colors. How was he to make these appearances of the Creator aptly grand without the precious gold tesserae that traditionally lent their splendor as background to these scenes? To make the problem worse, the conventional color for God's robe was blue, but ultramarine on this scale would have been prohibitively expensive— at least to the parsimonious Pope Julius—and the less elegant but still impressive blue pigment azurite had to be applied *secco*. Water damage to the vault of Giotto's Arena Chapel, where portions of the blue have turned into malachite green, shows us what would happen to azurite if the Sistine roof should leak. (All roofs leak at one time or another, as Michelangelo would have calculated.) Michelangelo scrupulously avoided painting in *secco*. His choice for God's robe fell on a purplish red (*morellone*), which by good fortune, or more likely by good planning, he had not used on any of the previously painted figures. This color would dominate the whole second half of the vault. The magisterial scale of the figures— though not the idea with which he began the Genesis scenes, but rather one he discovered as he worked—lends these scenes the monumental quality they deserve.

Appropriately it seems, the compositions grow in grandeur as we move down the chapel, from representations of the mundane activities of Noah toward the depictions of God in the first solitary acts of creation. It may be that during the enforced break of at least six months when the scaffolding was removed and Michelangelo had leisure to study his work so far, he determined that he should enlarge the scale. Or he may have wanted to be sure that viewers restricted to the zone outside the screen would be able to see these more distant scenes. It could also be that his impatience, and the pope's, urged him to simplify and aggrandize his images in the second campaign. Whatever the reason, we can note that much less detail is given in the figures of the last four bays compared to those in earlier bays, particularly those of the Noah story. However, the expressive power increases correspondingly. Concomitantly, the Seers and Ignudi increase in size as well as in energetic postures and contortions, as if to heighten the drama, or to compensate for the simplification in the Genesis scenes.

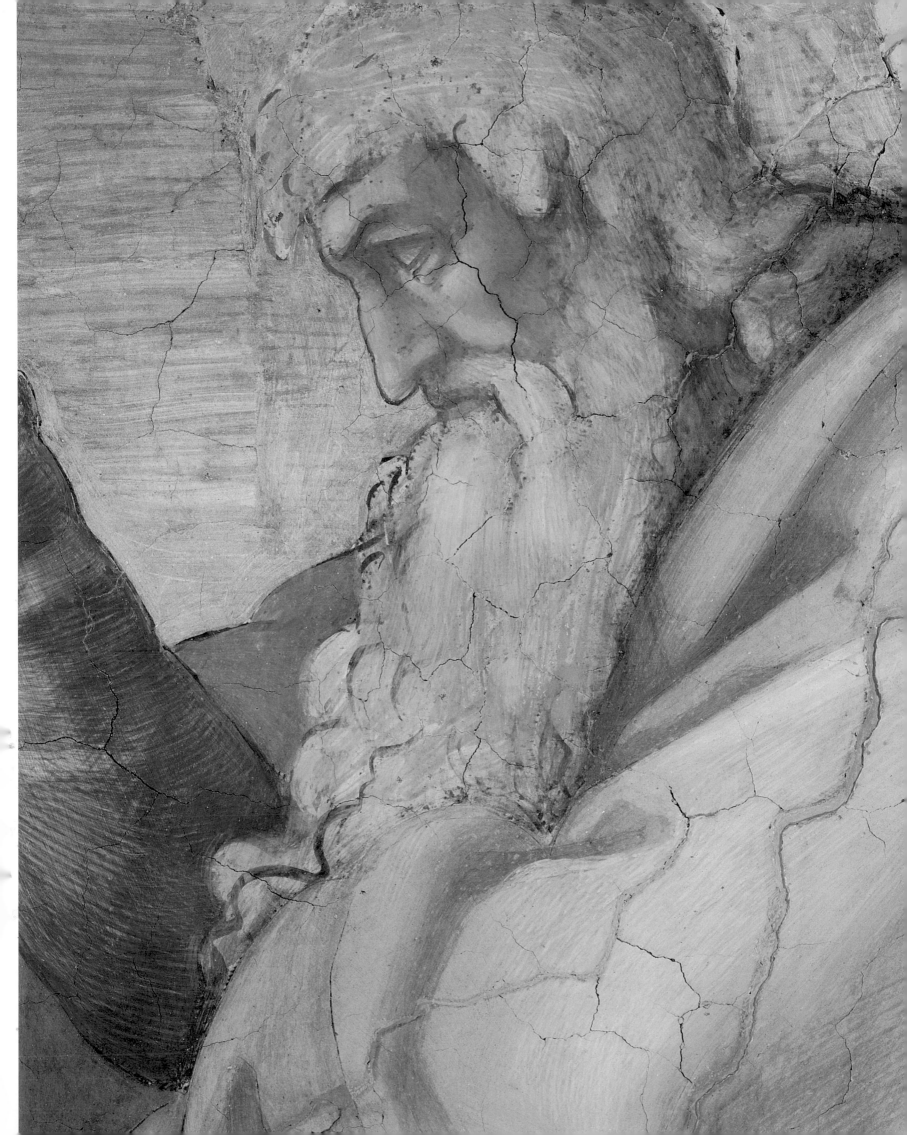

# THE DRUNKENNESS OF NOAH

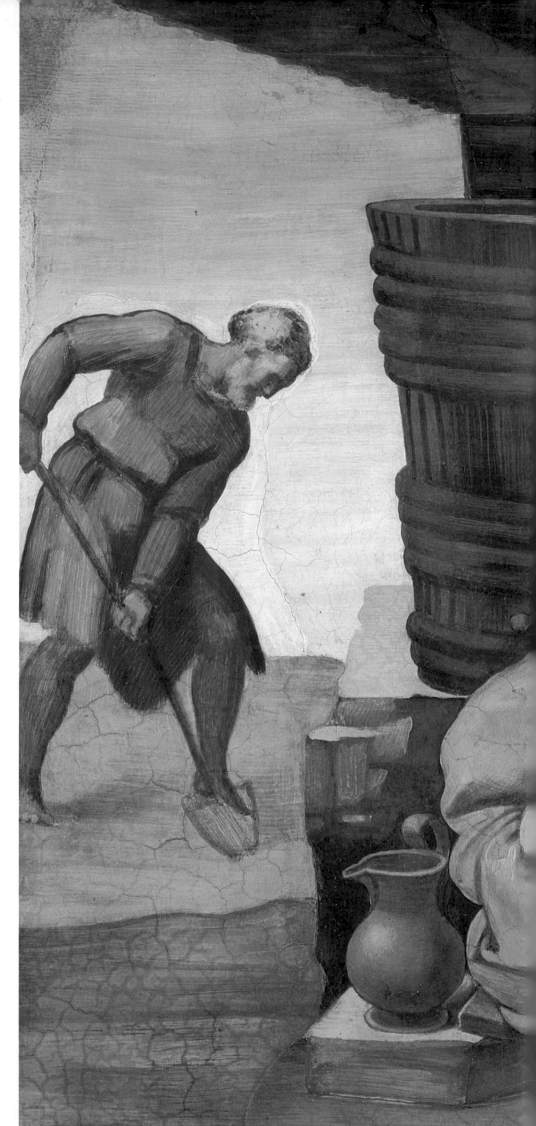

The Genesis scenes are arranged in reverse chronological order from the entrance to the altar, and this is the direction in which Michelangelo proceeded to paint. The *Drunkenness of Noah* is not, however, the first chronologically, but rather the last of the Noah triad. One explanation for the order is purely structural, depending upon the alternation in his design of small and large fields. If he felt it required a large field, he could not have begun with the Flood—the earliest and most important of this set— because the even-numbered scenes are the large ones. But there are iconographical reasons, having to do with the typology, that were probably even more important. At first glance and on the literal level, what is represented is the discovery of the effect of overindulging in wine. Noah planted a vineyard and then, in sampling his vintage, got drunk and fell asleep. When his son Ham found him naked, he mocked him and called in his two brothers who, with heads averted, reverently covered their father. At the far left we see Noah digging the earth with his spade. A huge vat with a spigot, a pitcher, and a drinking bowl surround the oblivious patriarch. The middle figure, Ham, pointing at his father, is restrained by one of his brothers.

The story brings us face-to-face with humanity's sinful nature and the need for redemption, even after God's destruction of all but righteous Noah and his family in the Flood. The significance, however, lies in the analogical meaning of wine and the Eucharist, as already suggested. The cycle of creation, sin, re-creation, and sin, recurs, setting the stage for the coming of the Messiah.

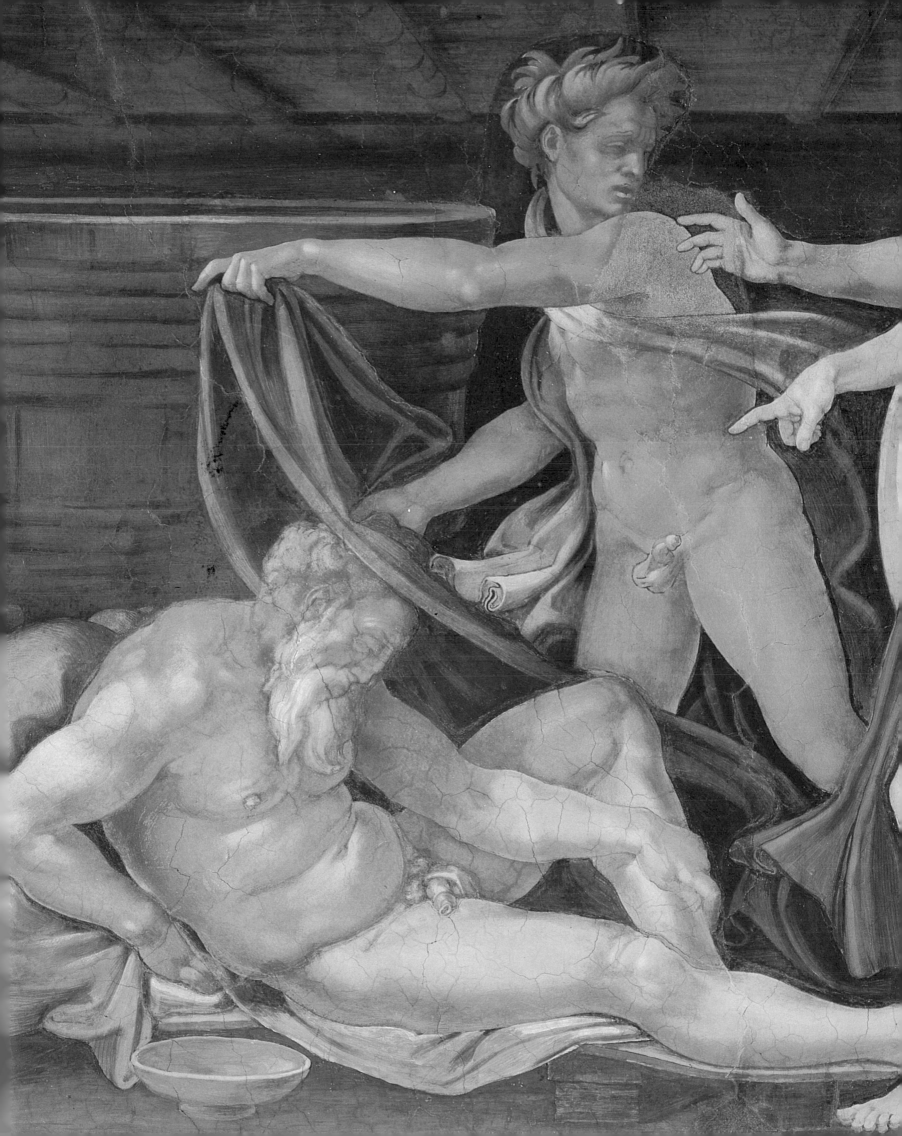

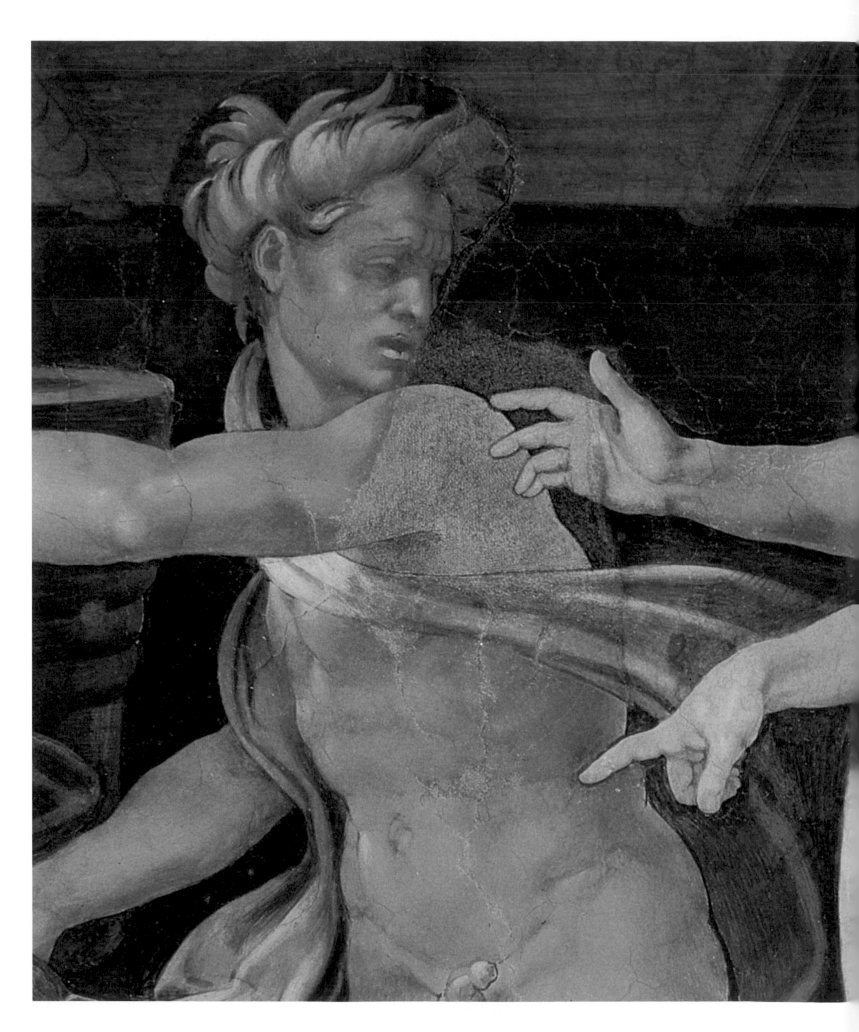

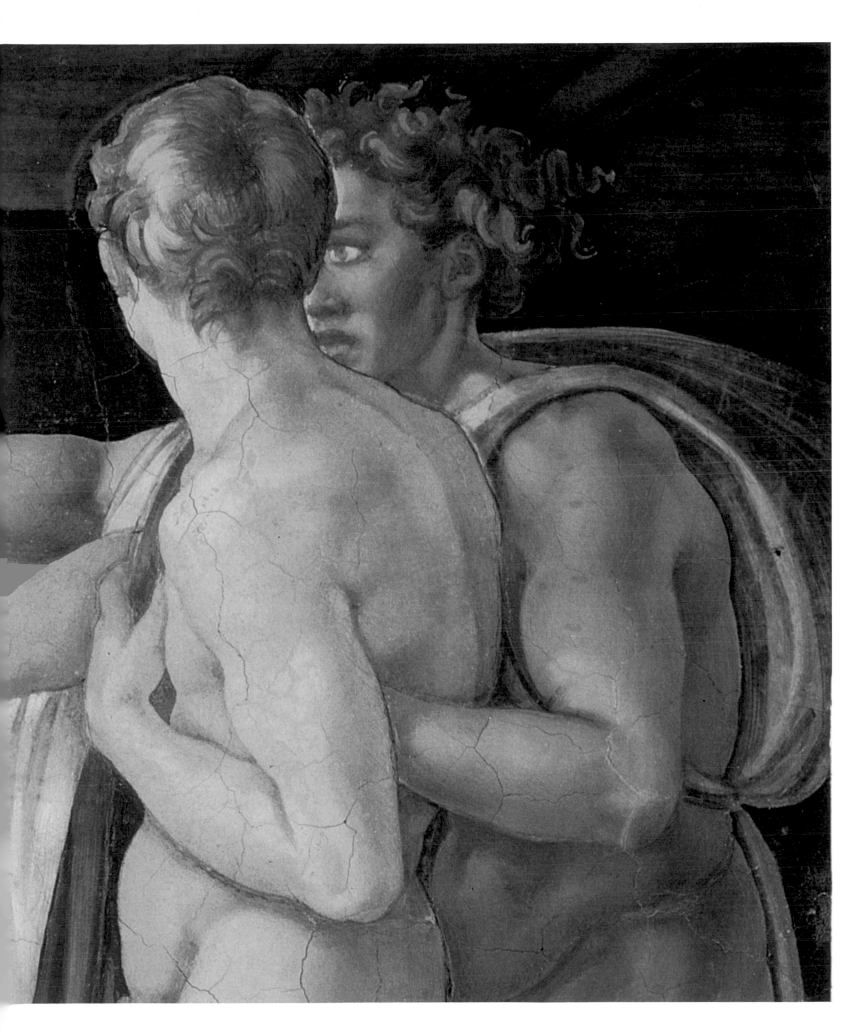

The Flood was the first of the Genesis scenes that Michelangelo executed. As the one large scene in the Noah group, it is the centerpiece of that story, chosen to represent God's judgment, on the one hand, and his merciful salvation of the Just, on the other. In the foreground men and women desperately toil up the hill to the highest ground in order to escape the rising water. The viewer can appreciate the irony of those already condemned to die who are hauling along the skillet and the kitchen table. This scene is full of poignant touches. A mother with empty breasts has collapsed, resigned and despondent, while her child wails for nourishment behind her. In the middle ground a father carries his dead son on his shoulders. Under an improvised tent another man curls protectively around his keg. A small boat lists ominously as frantic swimmers trying to board are assailed by their fellows. Although some show compassion for one another, none are shown addressing themselves to God. They are totally self-absorbed, even when that self extends to family. Their concerns are totally of this world. In Augustine's terms, they live in the flesh, in the unholy city. With the flood God tries to purge the world of all the unrighteous, only to see Ham, the son of Noah, return to sin. In the background, behind the windswept tree, the ark floats serenely, heedless of those clambering for admission. The ark is, of course, an allegory of the Church, in which the righteous will be saved. Noah leans from a window high on the right checking the sky.

The restorers ascertained that Michelangelo worked slowly and laboriously on this scene: there are twenty-nine *giornate* (patches of plaster), some apparently executed by assistants. He began work at the upper right. In the middle of the sky, there is a large patch that has been replaced, and the loss continues into the Ignudo above. This is one of the very few significant losses the cycle has sustained. The excellent condition of the frescoes today is a tribute to Michelangelo's technique, so it is interesting that this portion, the first he worked on, was the weakest. Vasari reported that shortly after the artist began to paint, he discovered mold growing on the plaster, indicating that it was not drying properly. An adviser was called in who told Michelangelo that for the Roman climate, he needed to add more sand to his plaster. Thereafter Michelangelo had no further difficulty, but in the late eighteenth century, when there was an explosion of gunpowder stored in the nearby Castel Sant'Angelo, this portion of the plaster fell.

Michelangelo composed this scene employing the usual Renaissance devices of perspective. Apparently when he observed it from the floor of the chapel, he recognized that the figures deep in space were so diminished in scale that they were scarcely legible. For the succeeding scenes in the Genesis cycle he invented a new relieflike mode of composition that would surmount this difficulty.

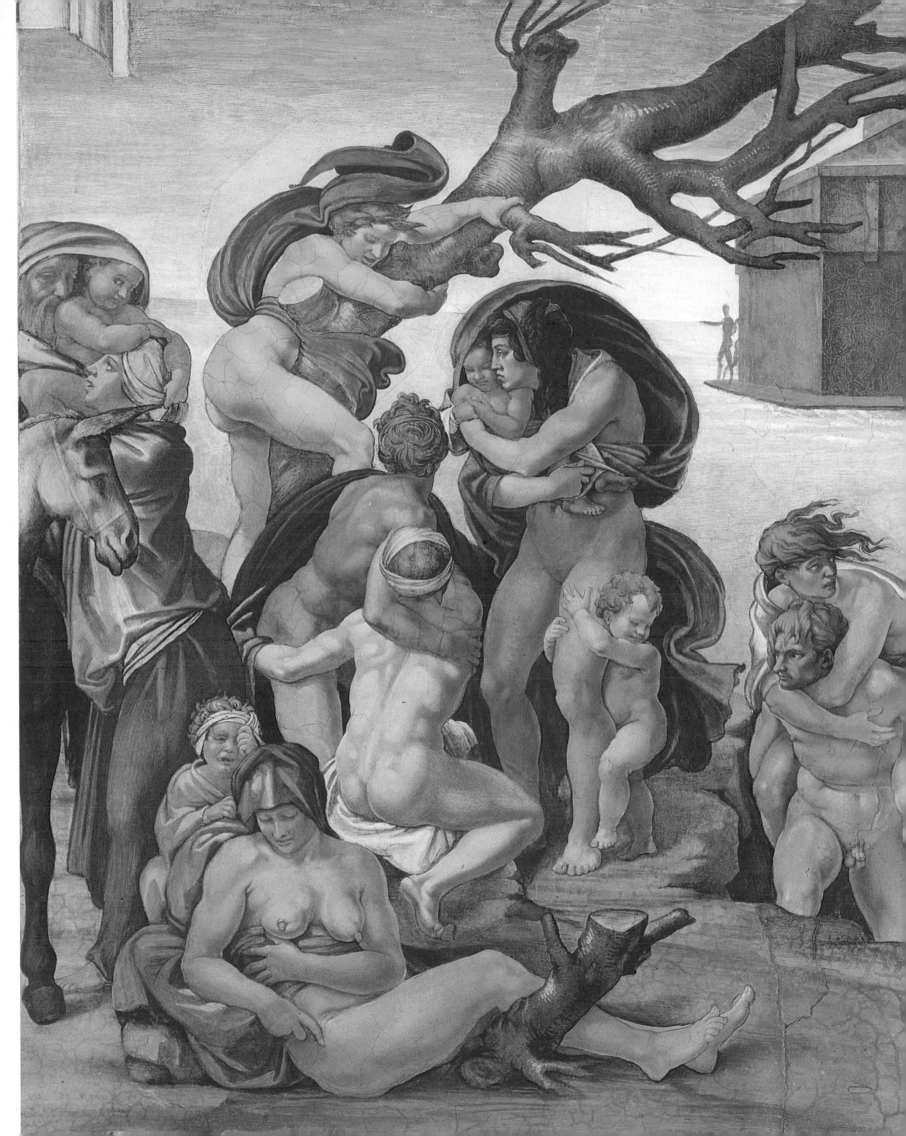

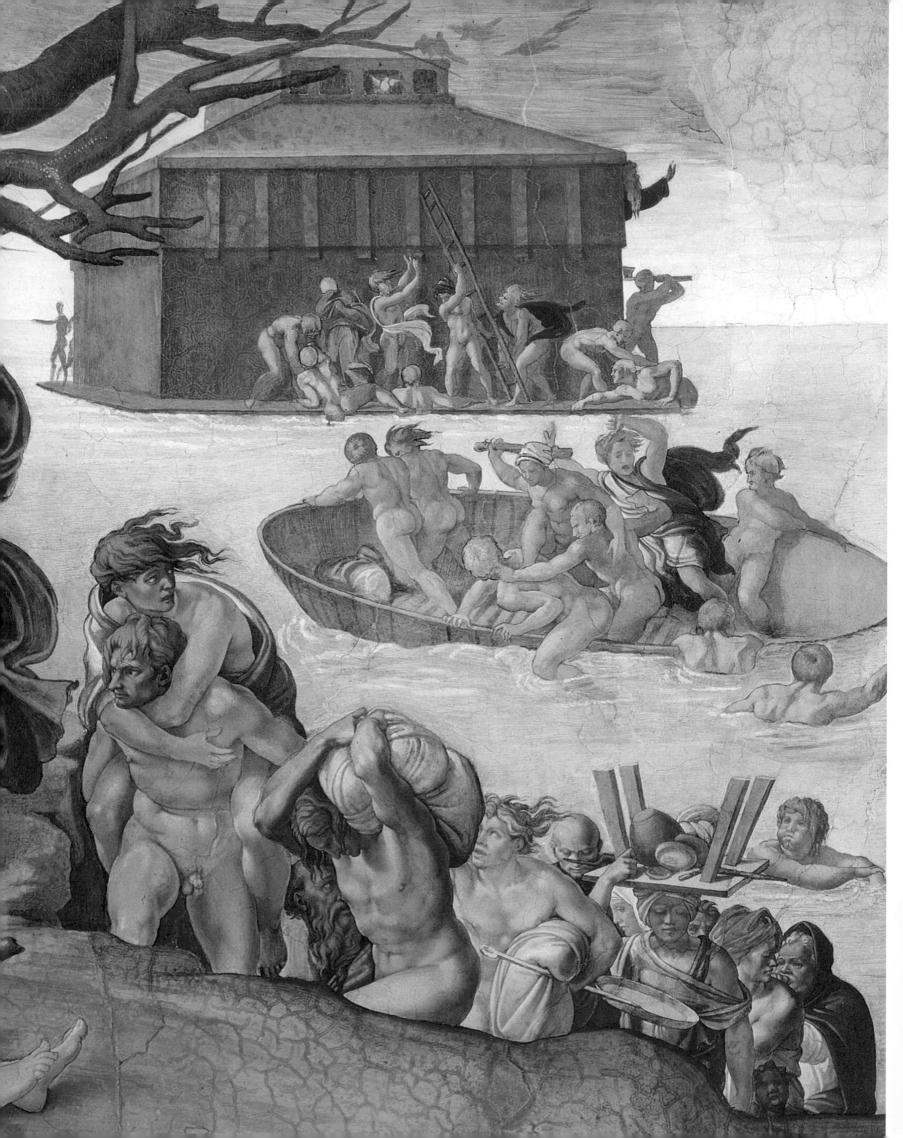

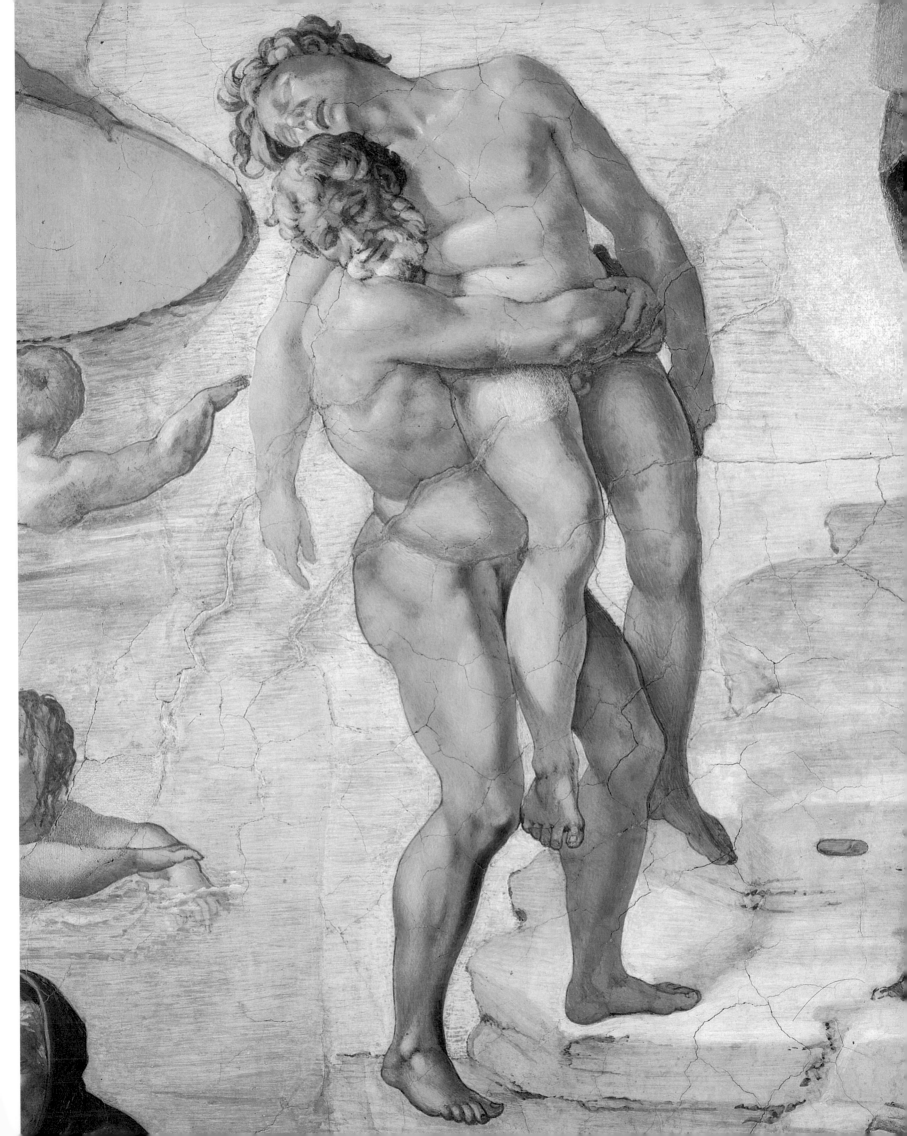

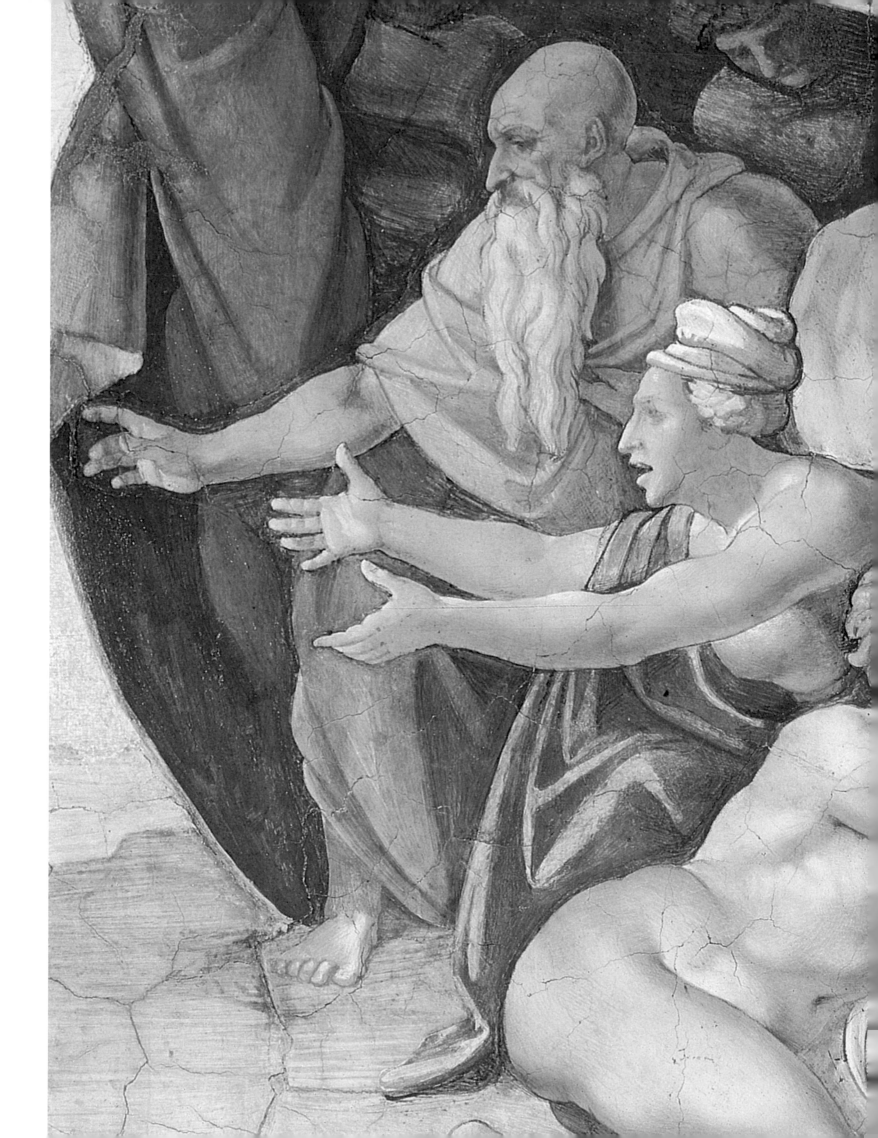

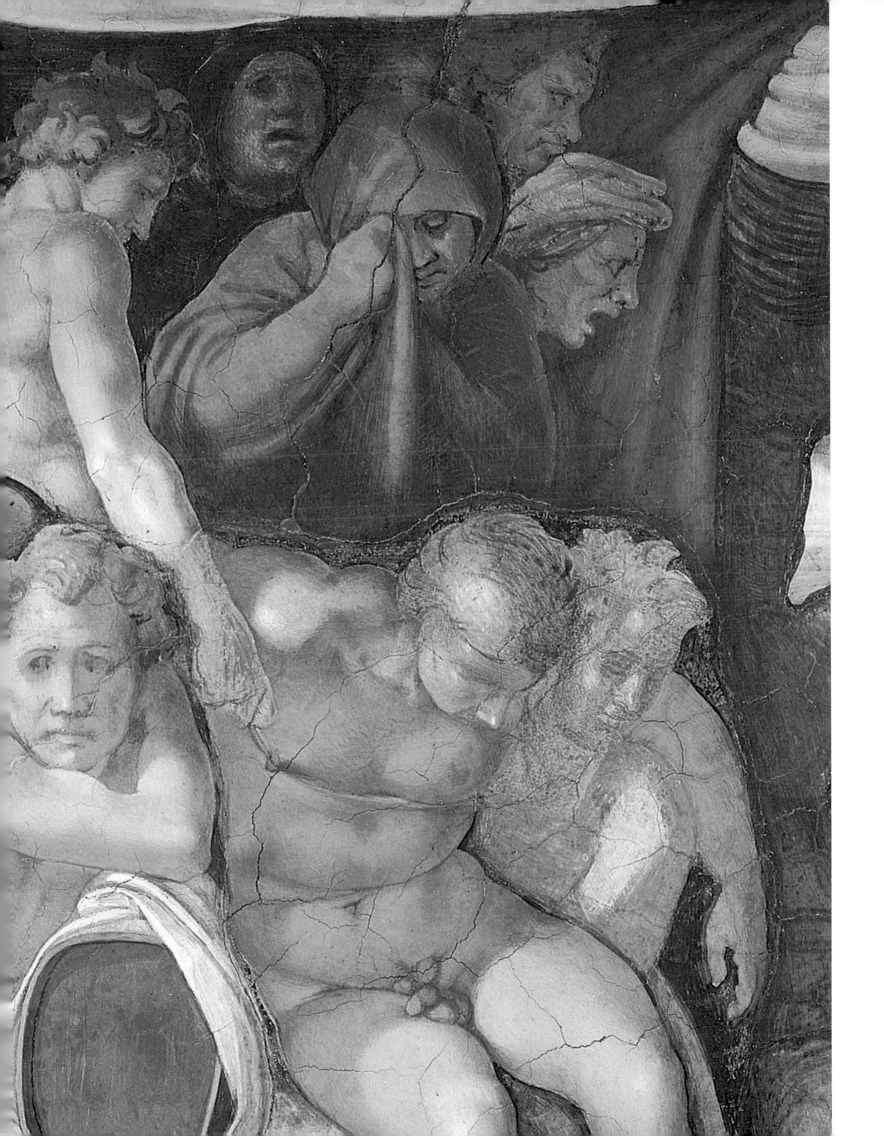

# THE SACRIFICE OF NOAH

Noah stands behind an altar making burnt offerings in thanks to God. Sacrificial rams and a bullock are being prepared. This event marks God's promise never again to destroy every living thing. The old woman in profile is Noah's wife; the three young men are their sons, who also appear in the *Drunkenness* panel; and the women are Noah's daughters-in-law.

This scene is out of order if it is understood to be Noah's thanksgiving for his salvation from the Flood. If it is taken as indication of Noah's habit of attention to the honor due the Lord, however—in contrast to those doomed in the Flood—it makes sense. Augustine provided the justification, saying that Noah must have sacrificed regularly. Some scholars have explained the apparent deviation from proper sequence by claiming that it represents instead the Sacrifice of Cain. Others object, saying that this then destroys the symmetry of the three triads, granting four scenes to Adam and Eve and only two to Noah. It can be argued that reference to Cain's sacrifice is implied and that it ambiguously encompasses both sacrifices. Aware now of the problem of the legibility of his paintings from more than sixty feet above the chapel floor, Michelangelo has moved all the figures close to the front and made them so tall that they nearly fill the height of the field. He has eliminated the middle ground and the background and organized his composition like a sculptural relief. As if to signal what he was doing, he has borrowed a figure from an ancient Roman relief that was well known in Rome at the time, the Death of Meleager. He has quoted in reverse the gesture and pose of Althaea casting the brand into the fire. He used the same compositional mode in the *Drunkenness of Noah* and all the subsequent narratives.

A section of the paint replaced in the Cinquecento can be seen at the left in the two standing figures. The conscientious artist Carnesecchi, who was an admirer of Michelangelo, made a cartoon of the section, then removed the plaster and repainted it in *buon fresco* (true fresco, using wet plaster). Although he carefully matched the colors, what we see today after the cleaning is noticeably darker than the surrounding area. This indicates how much the colors had already darkened with dirt from the candles and incense in the half century after Michelangelo executed the original painting.

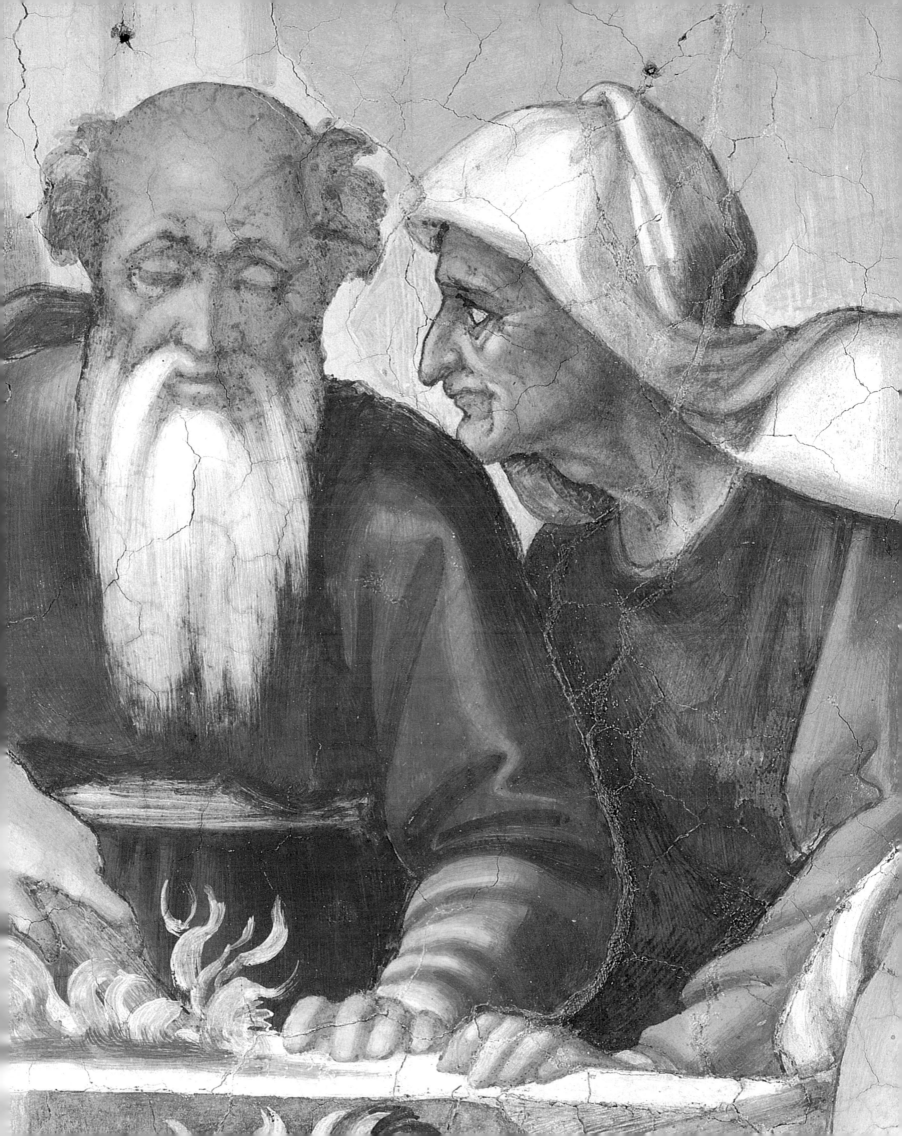

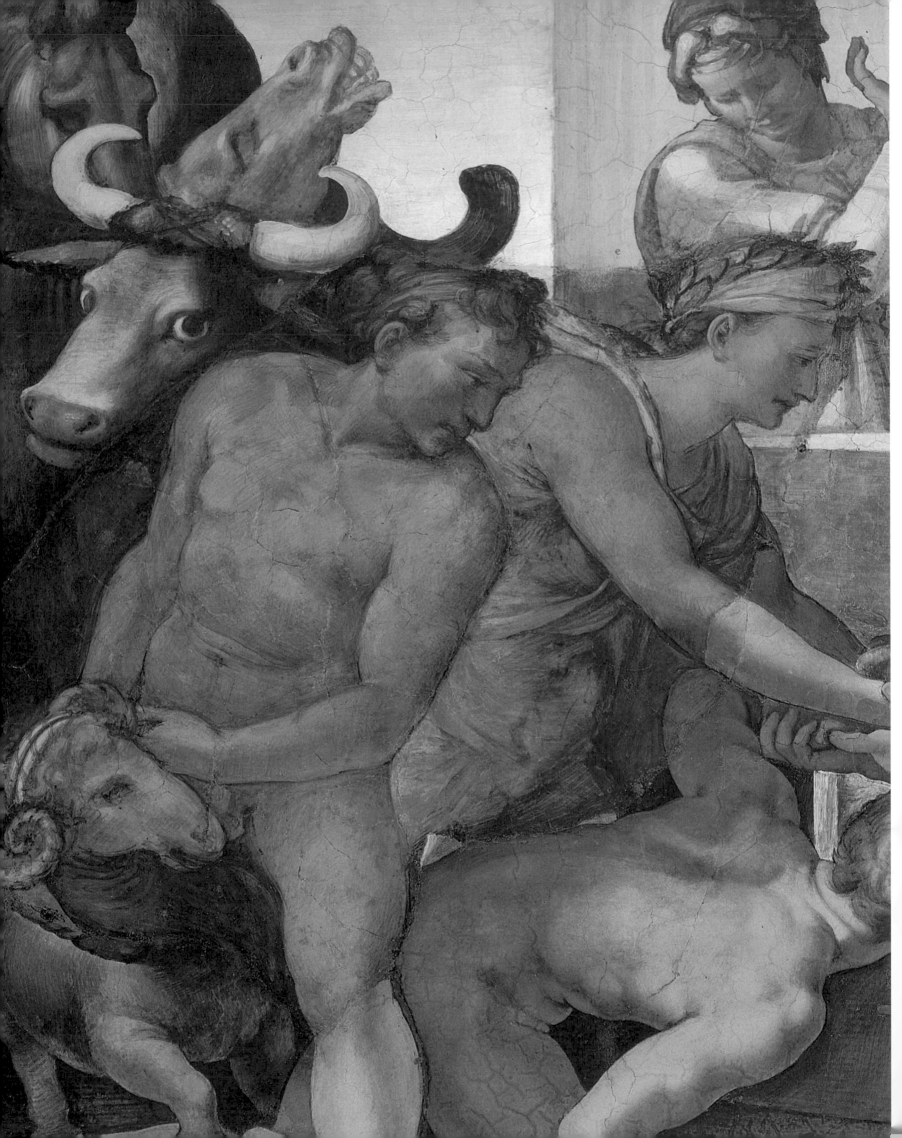

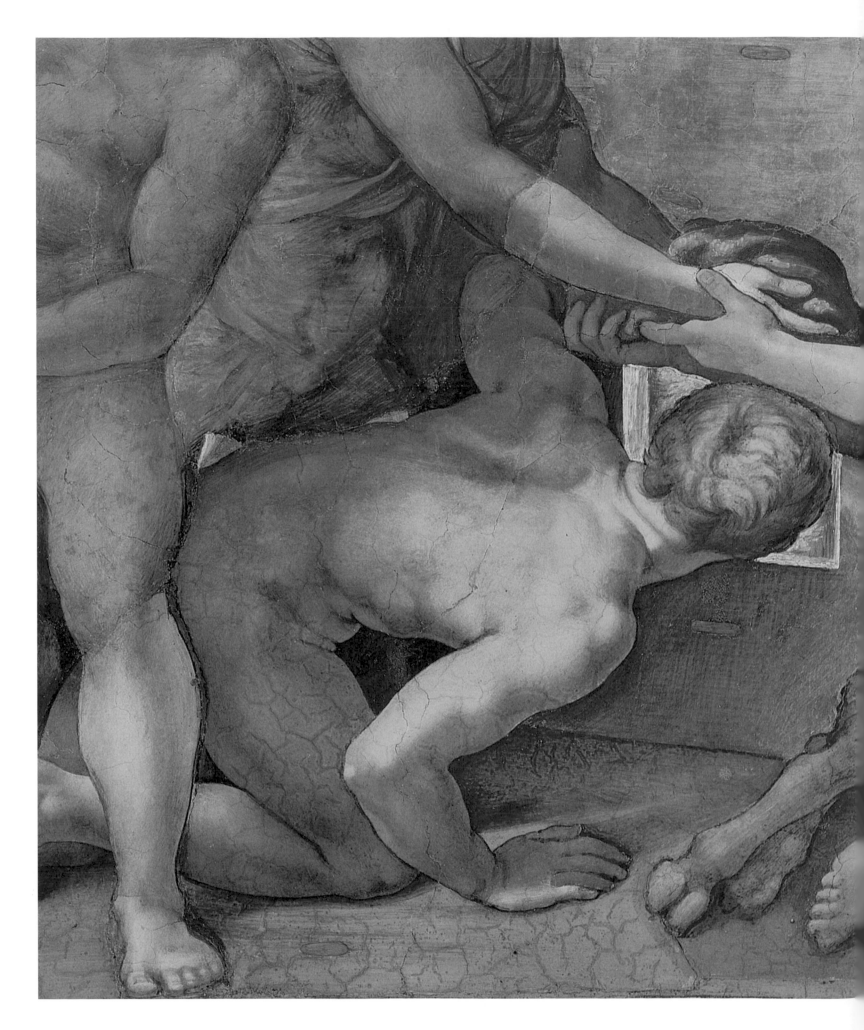

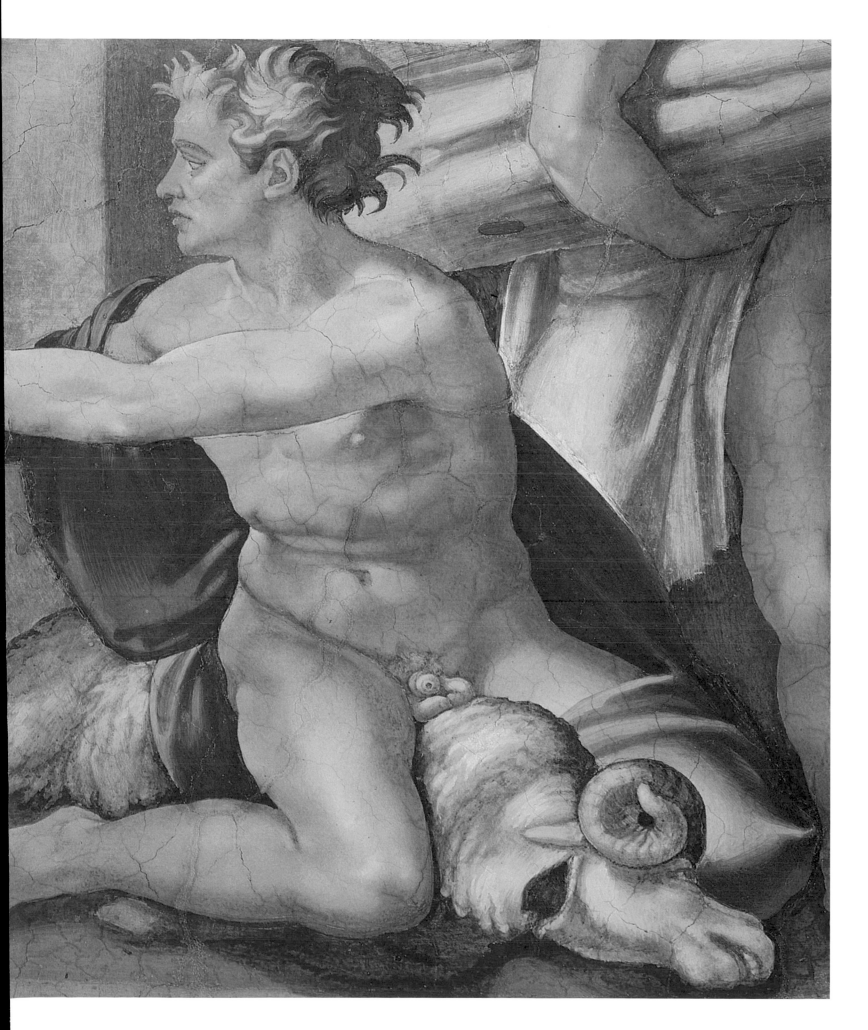

# THE TEMPTATION OF ADAM AND EVE AND THE EXPULSION

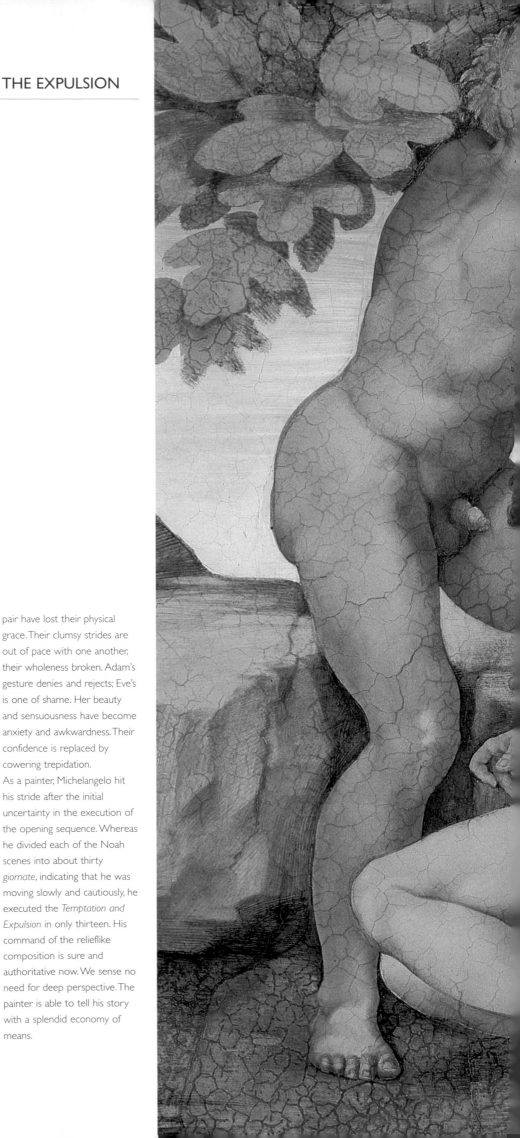

The triad of the creation and fall of humanity at the center of the vault is constituted uniquely of two large scenes and a small one. There is an august simplicity to Michelangelo's composition. Adam and Eve appear twice in continuous narrative, contrasted on either side of the field and connected by the central tree around which the serpent is entwined. The center is solidly held in our attention with the alluring coloring of the serpent's tail, which shifts from reddish orange to green to yellow, perhaps suggesting iridescent scales. Eve's figure is countered by the expelling angel; her gesture of reaching with the fruit becomes the angel's arm extended with the sword. It is as if the fallen angel has been rotated back-to-front to become the Angel of Judgment.

The interpretation in Augustine's *City of God* is that the Temptation prefigures the Crucifixion. The contrast between the Cross and the tree of man's fall had been stated by Augustine's precursor Ambrose in a terse antithesis: "Death through the tree, life through the Cross." Michelangelo has composed the tree so that it resembles the Cross, if the expelling angel is seen as the arm opposed to the branch to which Adam clings.

In the garden on the left the figures are fitted into one another, suggesting both intimacy and wholeness with sexual implications. Adam reaches eagerly for the forbidden fruit, as much implicated in the sin in Michelangelo's version as Eve. The sheltering shade gives way to barren earth at the right. Deprived of God's grace, the pair have lost their physical grace. Their clumsy strides are out of pace with one another, their wholeness broken. Adam's gesture denies and rejects; Eve's is one of shame. Her beauty and sensuousness have become anxiety and awkwardness. Their confidence is replaced by cowering trepidation.

As a painter, Michelangelo hit his stride after the initial uncertainty in the execution of the opening sequence. Whereas he divided each of the Noah scenes into about thirty *giornate*, indicating that he was moving slowly and cautiously, he executed the *Temptation and Expulsion* in only thirteen. His command of the relieflike composition is sure and authoritative now. We sense no need for deep perspective. The painter is able to tell his story with a splendid economy of means.

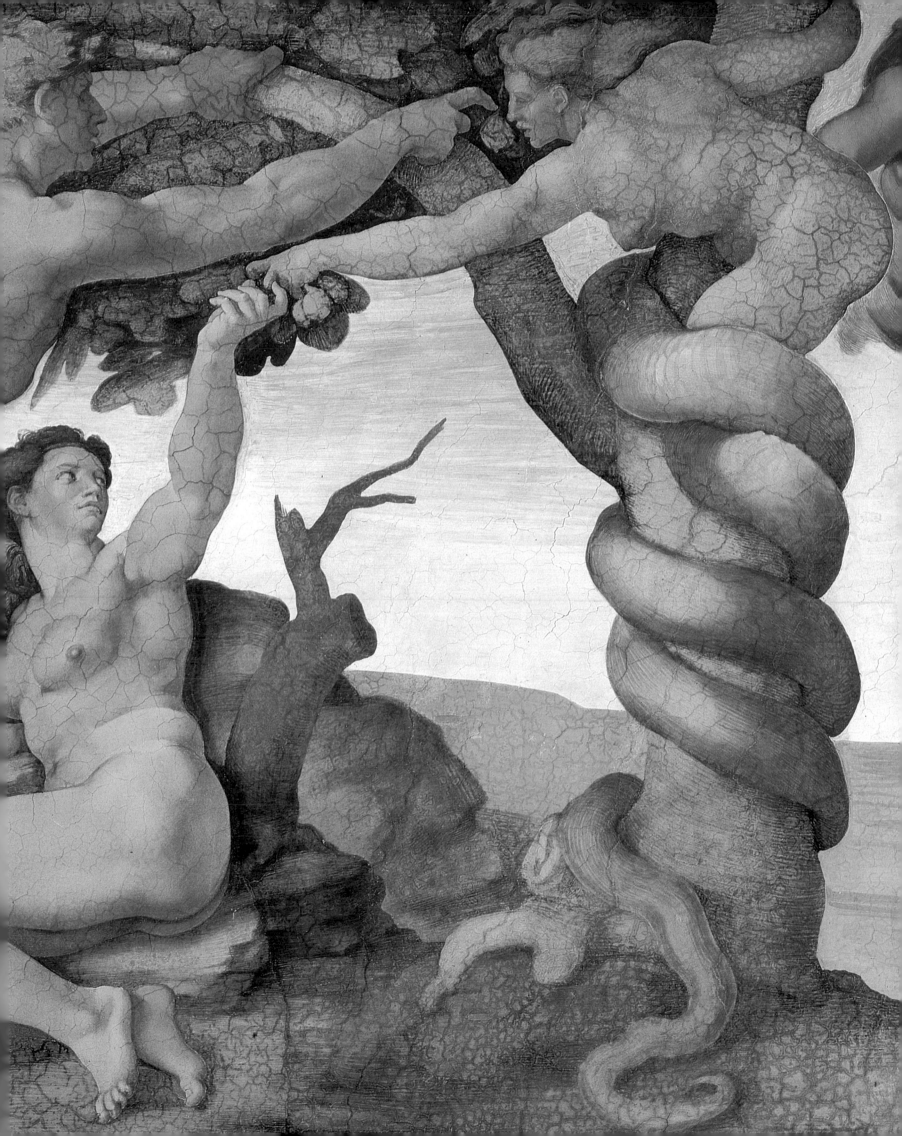

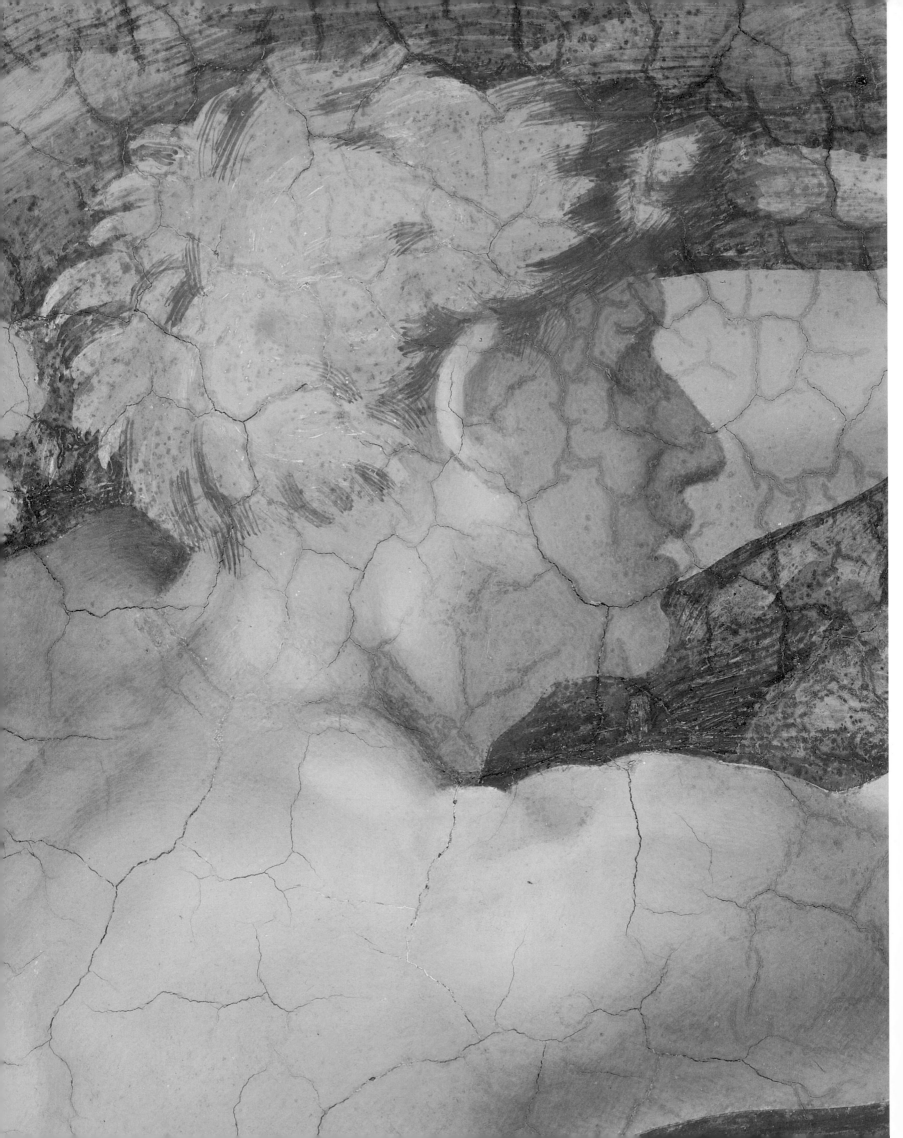

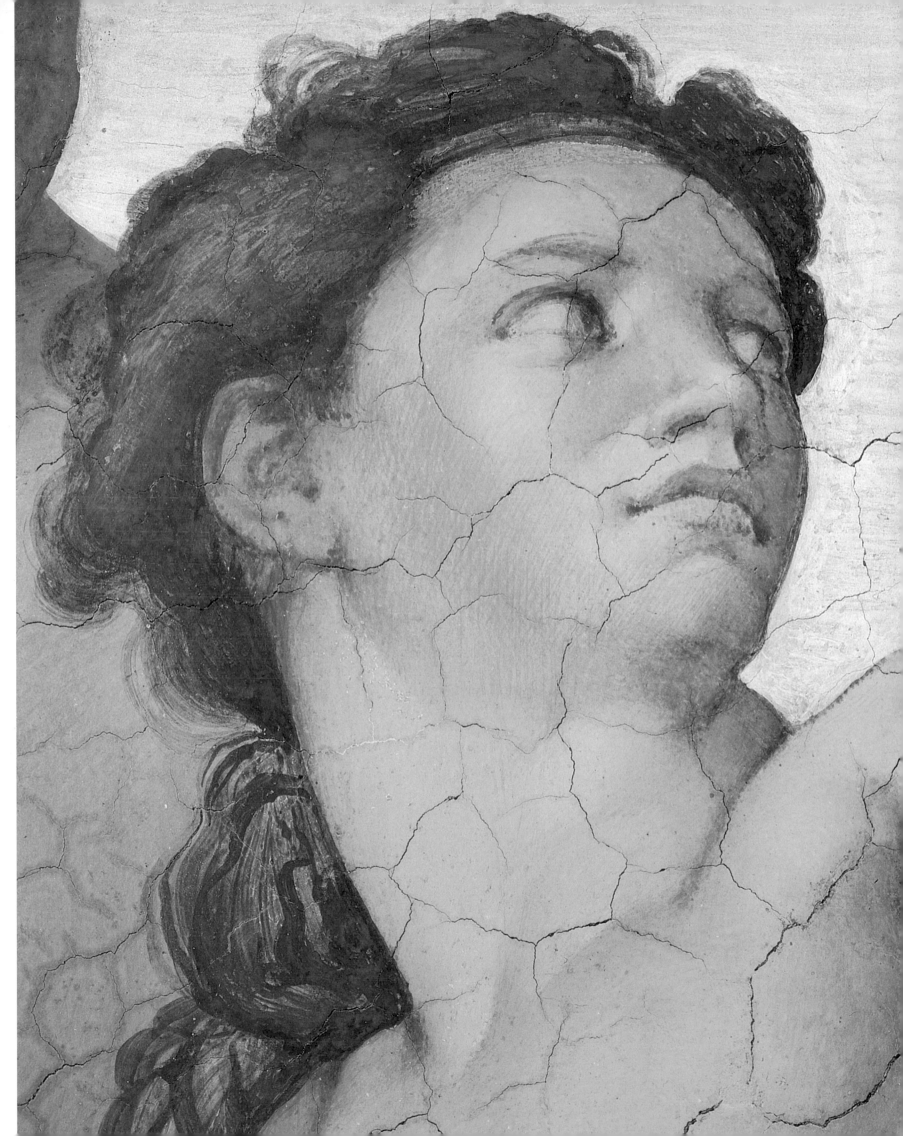

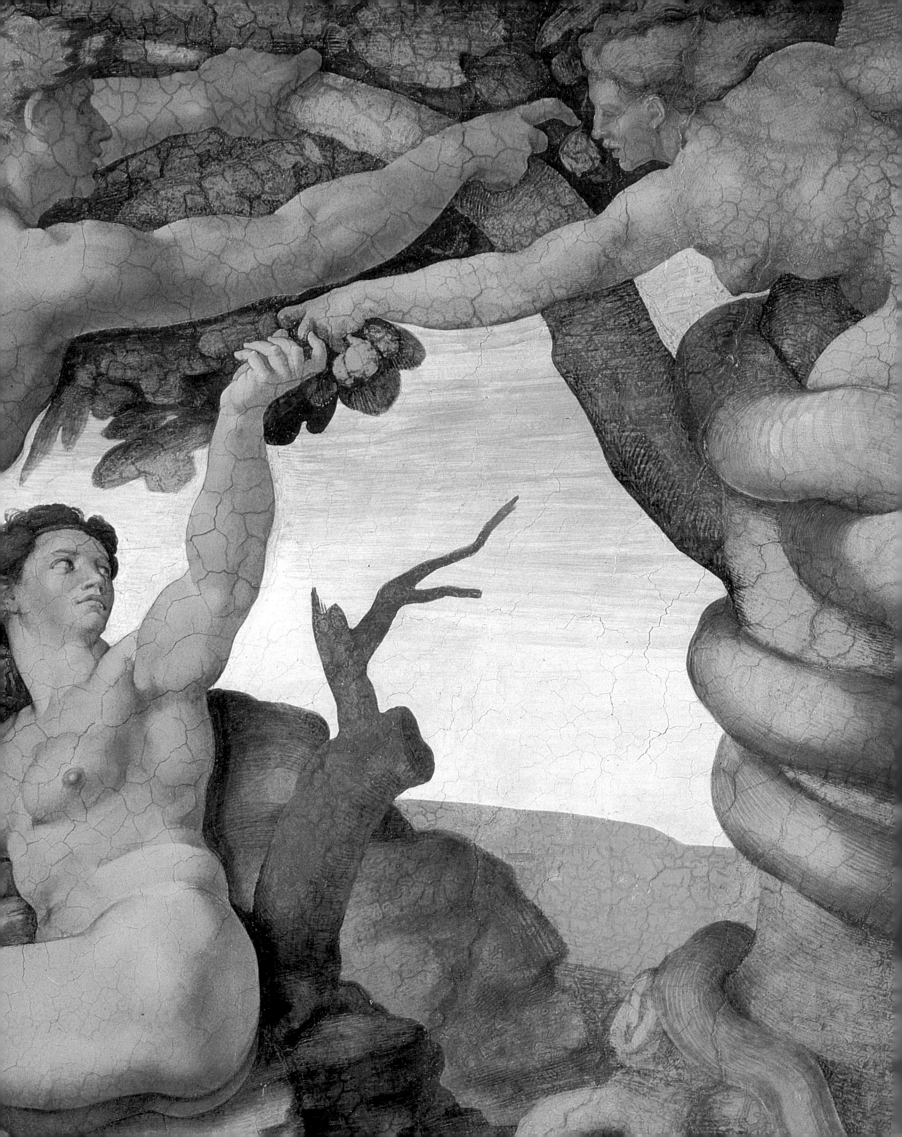

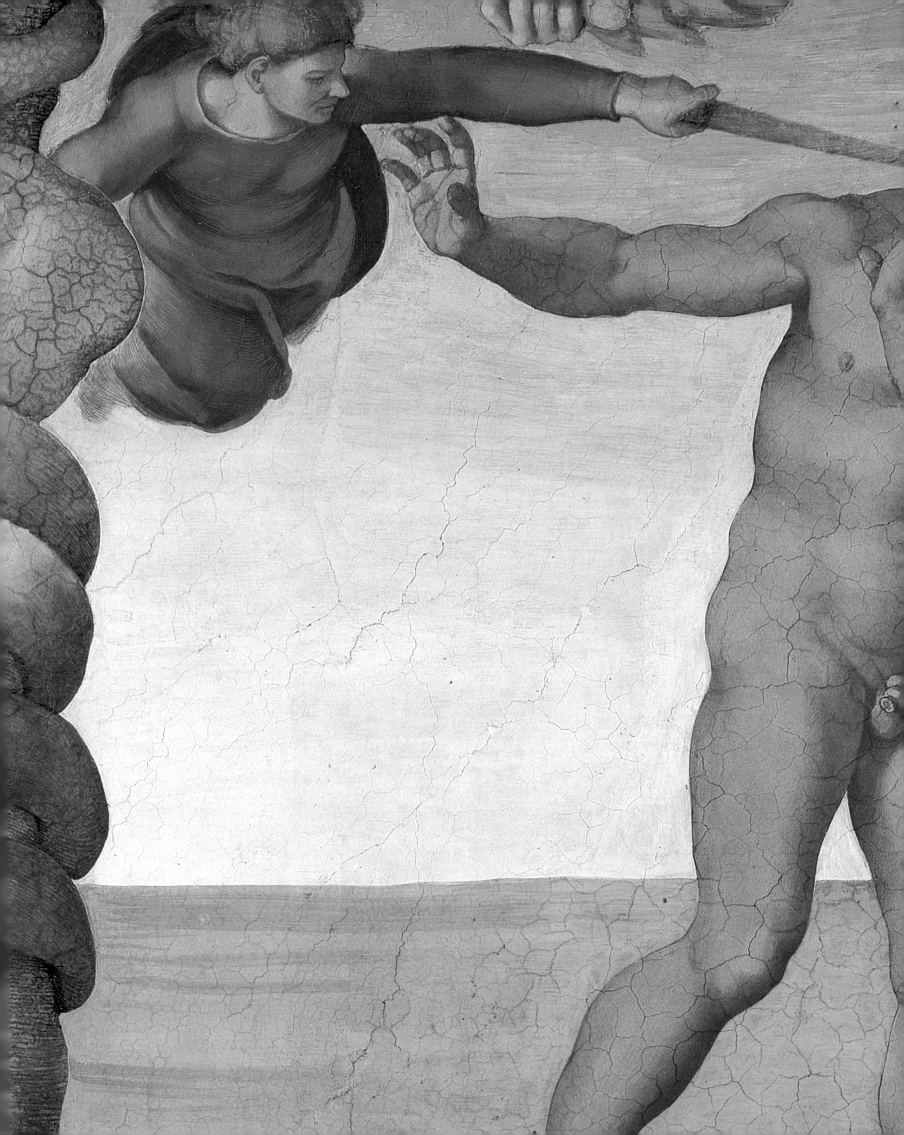

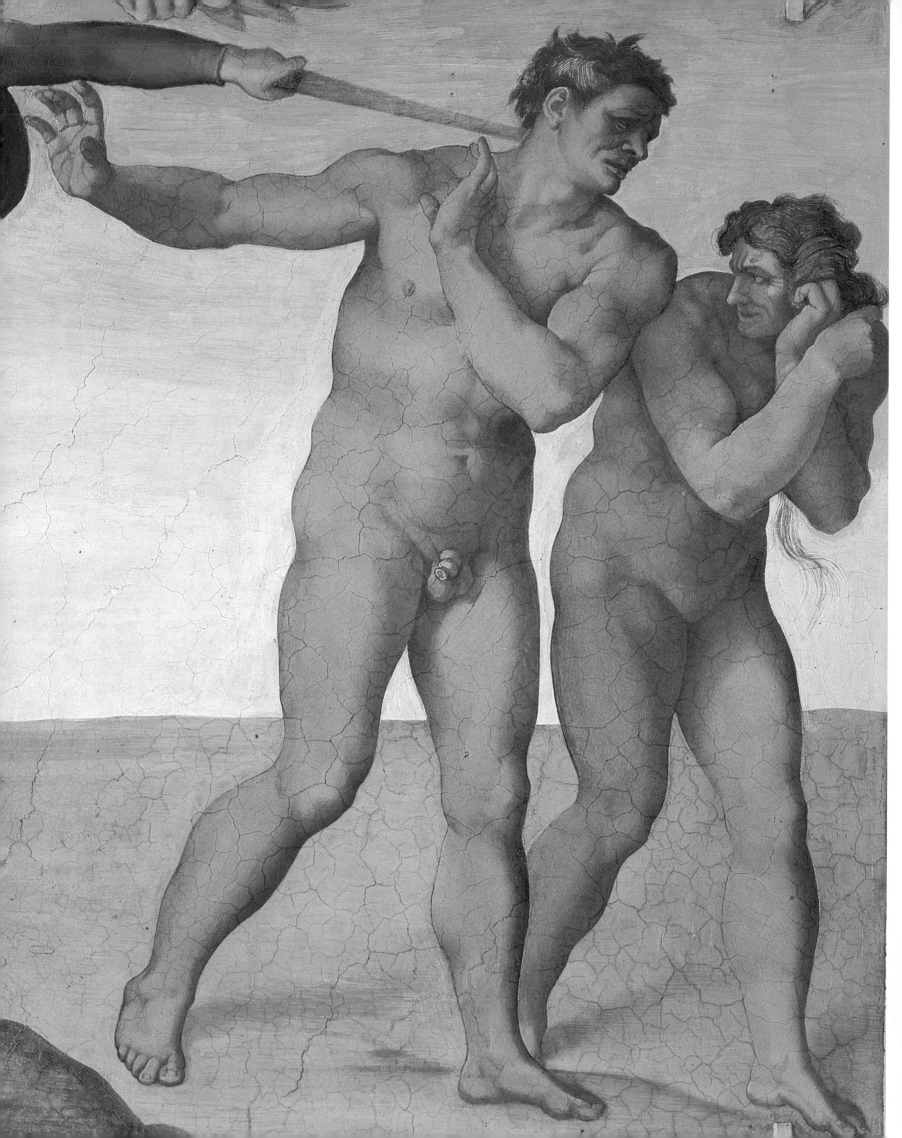

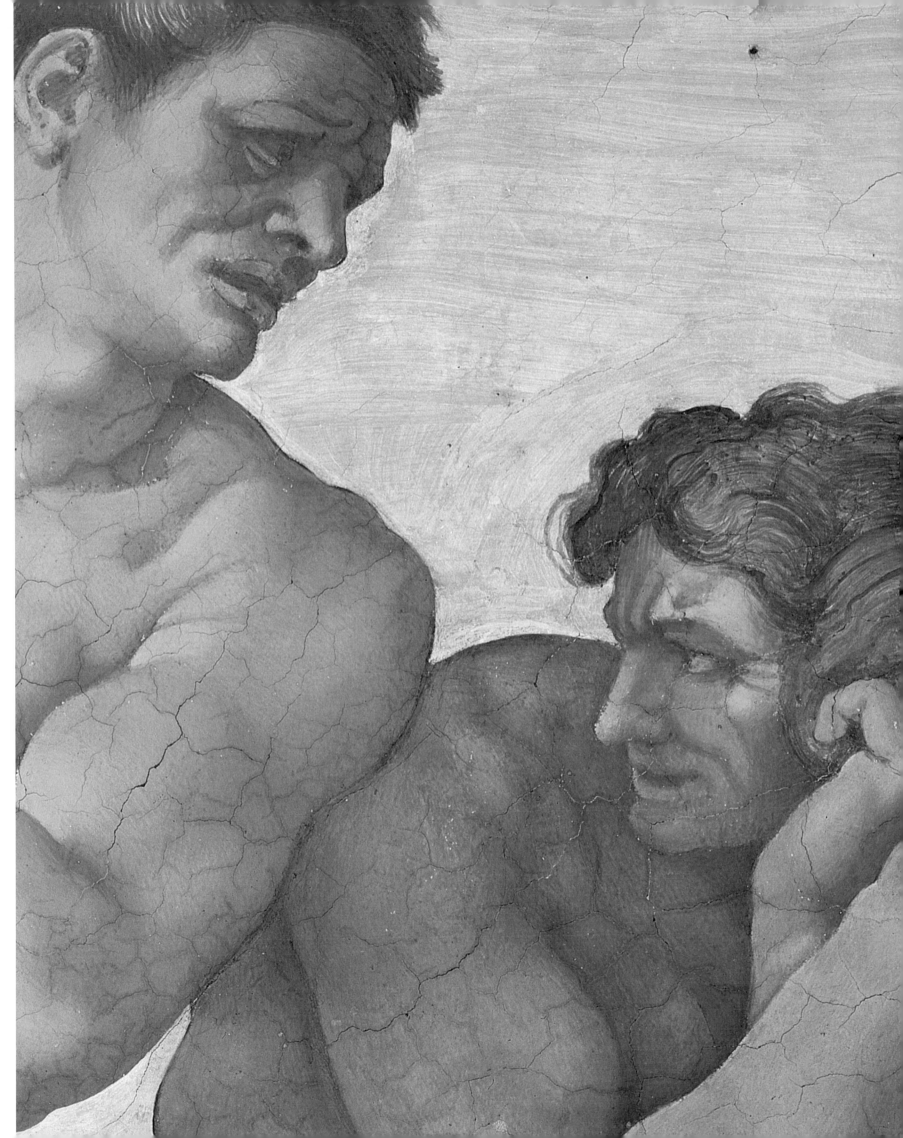

According to Gen. 2, Adam needed a companion, so God caused him to fall into a deep sleep. He took one of Adam's ribs and fashioned Eve out of it. Michelangelo depicts Adam slumped in sleep while Eve, in response to God's commanding gesture, emerges from his side.

The iconography here follows the tradition of showing God standing on the earth alongside his creatures, but the artist nicely exploits the format of the small field by showing God's head bumping up against the frame. The chapel, as it has been noted, was dedicated to the Virgin Mary. Mary is regarded as the second Eve, who erased the original sin of that first woman; thus it was logical that the scene representing Eve should be placed at the exact center of the ceiling. Mary, as the Bride of Christ, also represents the Church. The placement of this scene above the chancel screen that divided the outer church from the sanctuary made apparent the division of those alienated from God and in need of the Church's salvation from those in the inner circle. This was the last of the panels executed in the first campaign before the scaffolding was removed. Comparison with the dynamic treatment of the Creation of Adam in the next panel, executed after the break, makes clear the change of style that separates the two campaigns.

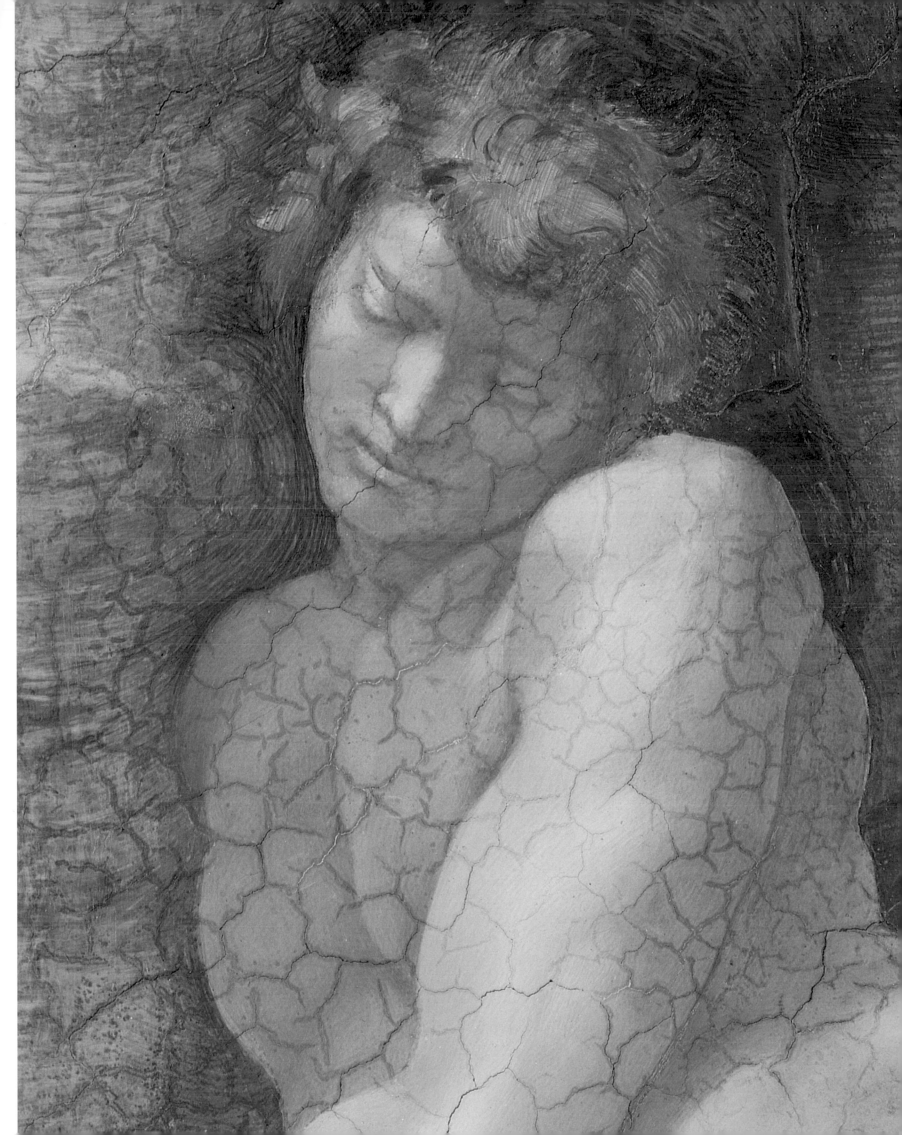

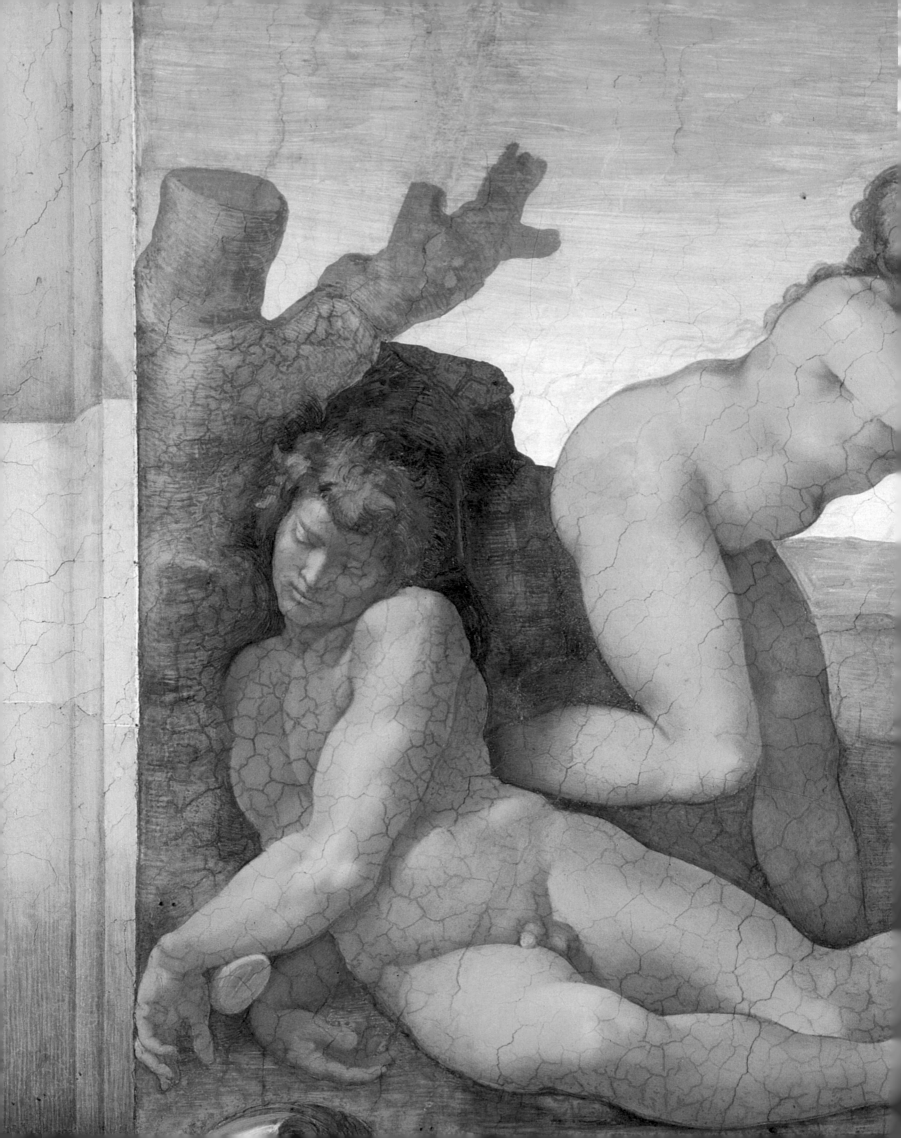

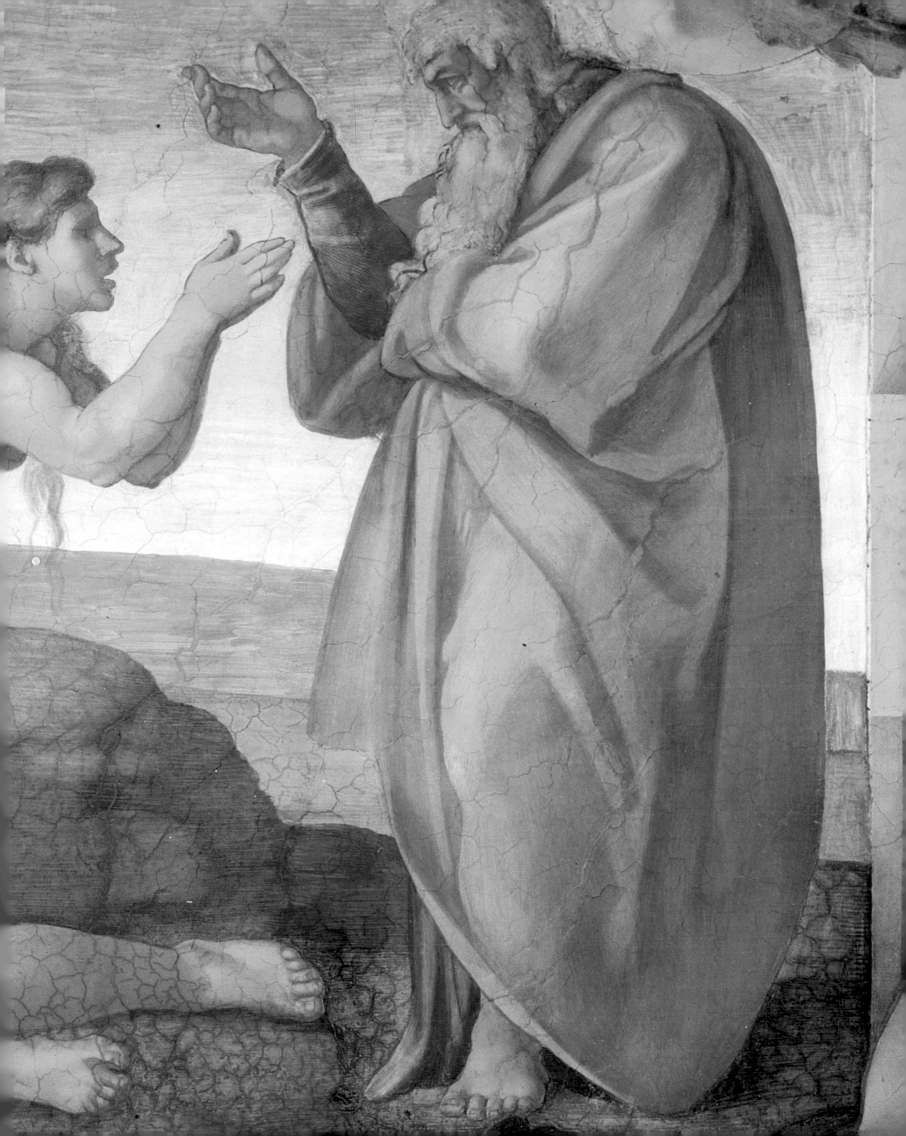

Michelangelo invented a new iconography for this scene. In previous representations, God had stood on the ground, as he does in the *Creation of Eve*. Here the forces of lethargic Adam and energizing Creator approach one another. The fresco centers on the meeting of hands, a gesture that no amount of abuse by advertisers can deprive of its expressive power. Adam, created in God's image, is the perfected human body, lacking only the spark of life. The fingers of Adam's outstretched arm drape languidly. God sweeps in, his hair and drapery swept back by the rush of wind, and gracefully extends his animating hand.

Adding to the dynamism of the image are the figures encompassed in his mantle. One of these, the woman under his arm whose prominence is underscored by the light, has implausibly been identified as Mary. Her curiosity and the liveliness of her glance as she eyes Adam have suggested to some that she is Eve, who exists already in the mind of God, according to this argument. A more convincing identification is that she represents Sophia, Wisdom, who in Proverbs was present at God's side at the time of Creation. Her impishness corresponds to her description of herself in Prov 8:23.27–31.

"The Lord created me first, long before the earth," she says: "When he established the heavens, I was there, when he drew a circle on the face of the deep, when he made firm the skies above, when he established the fountains of the deep, when he assigned to the sea its limit, so that the waters might not transgress his command, when he marked out the foundations of the earth, then I was beside him, like a master workman; and I was daily his delight, rejoicing before him always, rejoicing in his inhabited world and delighting in the sons of men."
Saint Augustine confirmed her role at the creation: "The

wisdom of God, by which all things were created, was there: and this wisdom also passes into human souls, making them friends of God and mouthpieces for him" (*City of God*, Book 11, iv). Indeed, Michelangelo depicts just that conferral of wisdom, for the current of energy runs from God's arm embracing her, through his shoulders and arm to connect with Adam. Here is the supreme statement of that Renaissance humanist faith in human intellect. It is reason, as Pico della Mirandola had declared in his *Oration on the Dignity of Man*, that distinguishes us from the animals and all other of God's creations. That is

what it means, in the view of the Italian Renaissance, that we are created in God's image. Leo Steinberg has argued that other members of God's entourage can be identified. In the darkness on the underside are two angels whom he describes as sulky and out of sorts. These envious malcontents are Lucifer and Beelzebub, whose fall will result from their refusal to adore Adam, God's supreme creation. Steinberg espouses the identification (made long ago, but not given credence) of the infant whom God fingers as the Christ Child. The two notches in God's mantle signal this opposition of Lucifer and Christ.

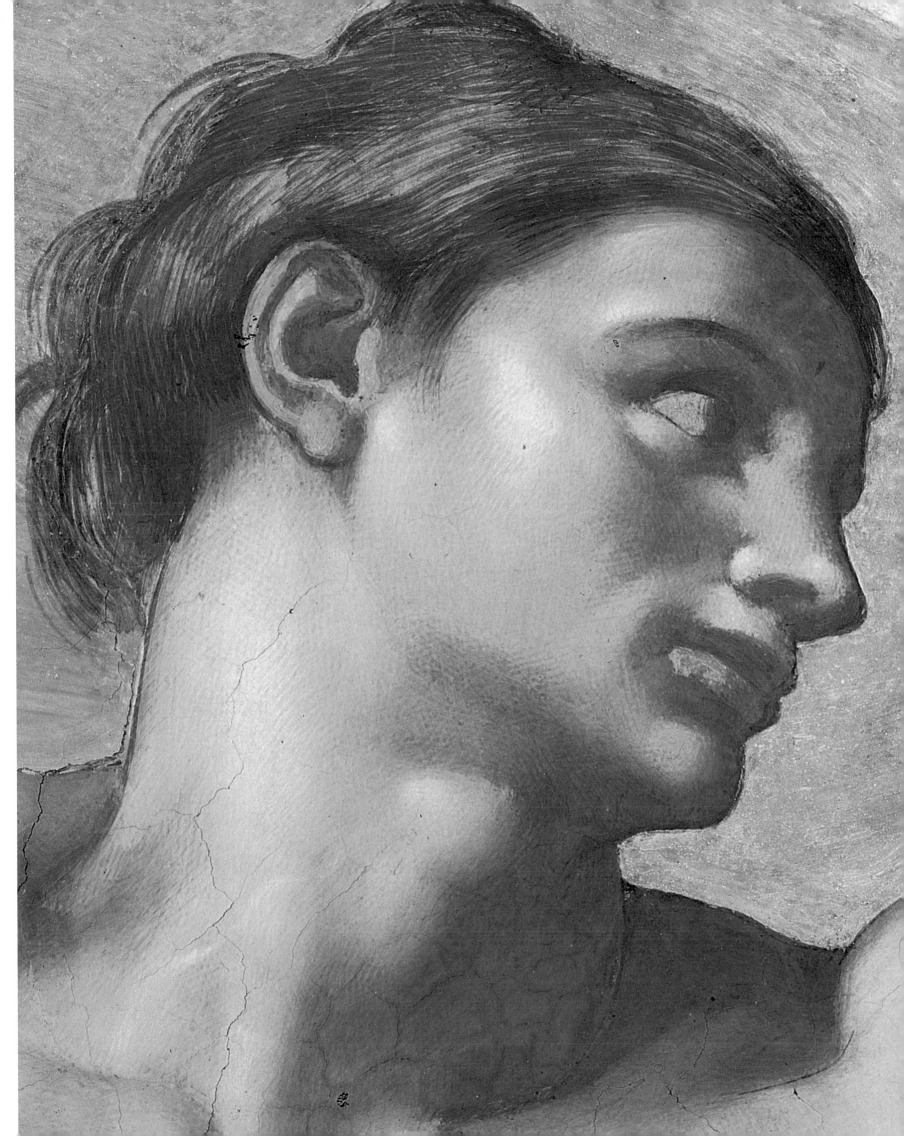

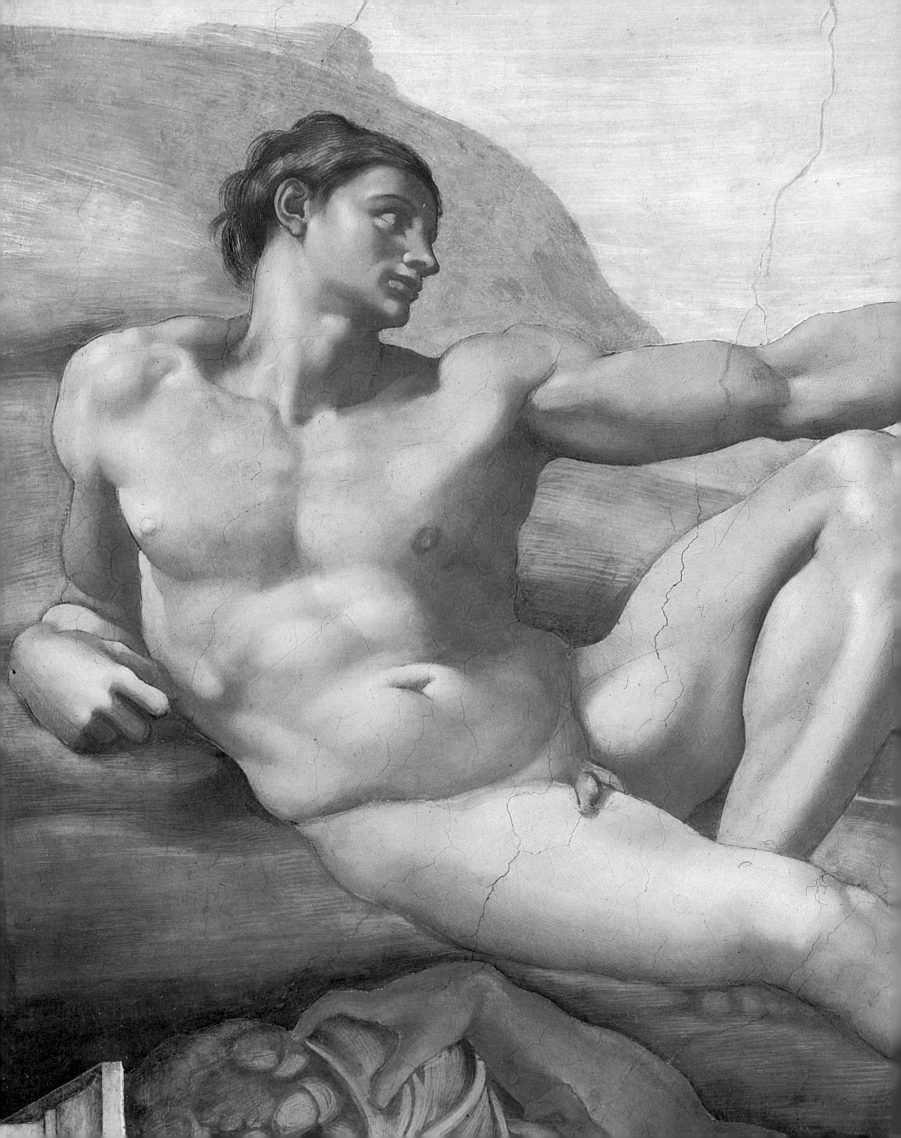

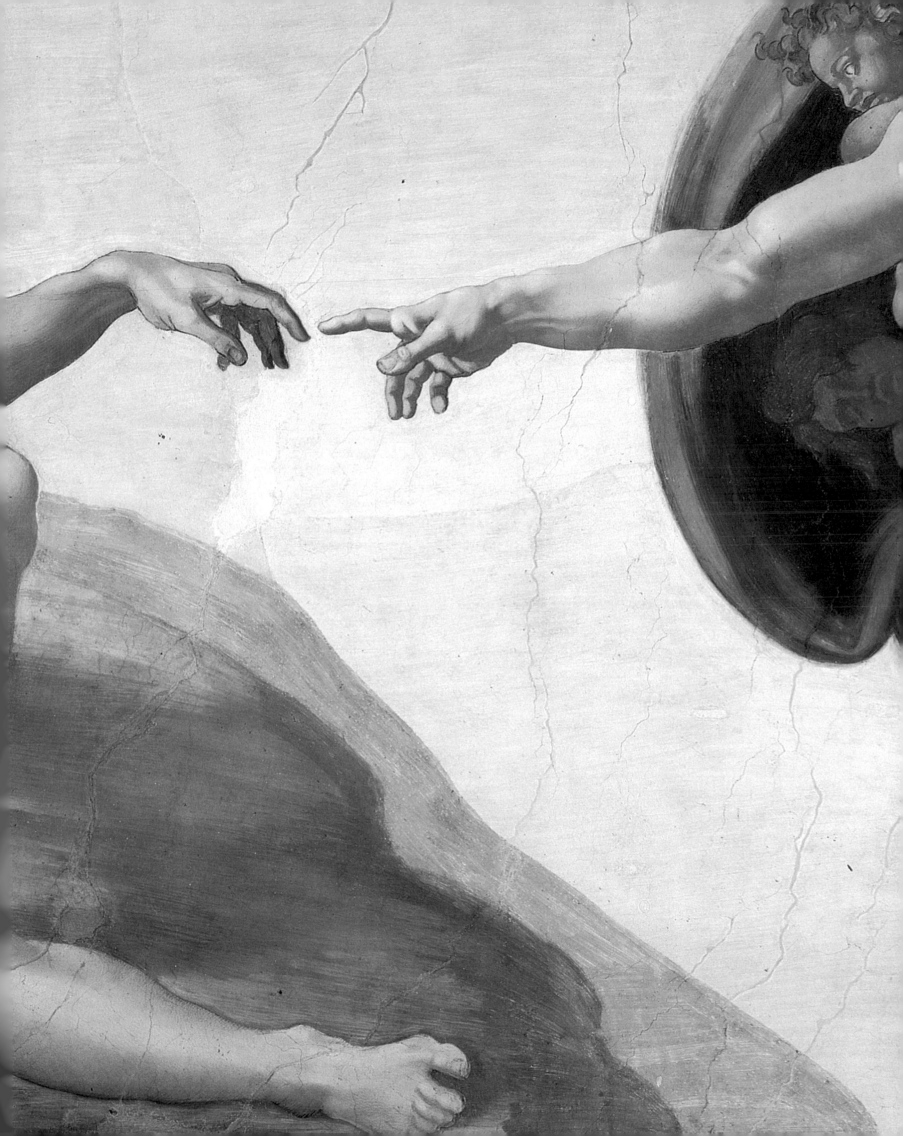

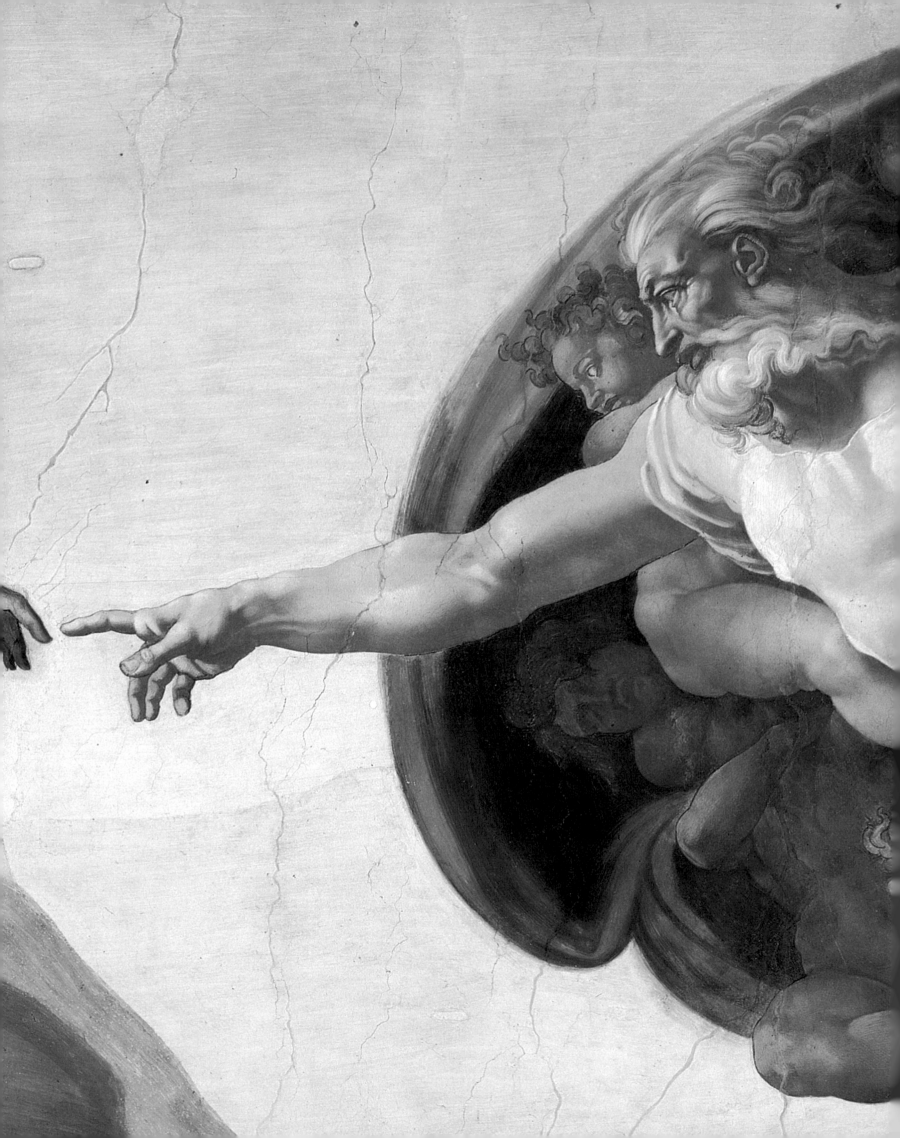

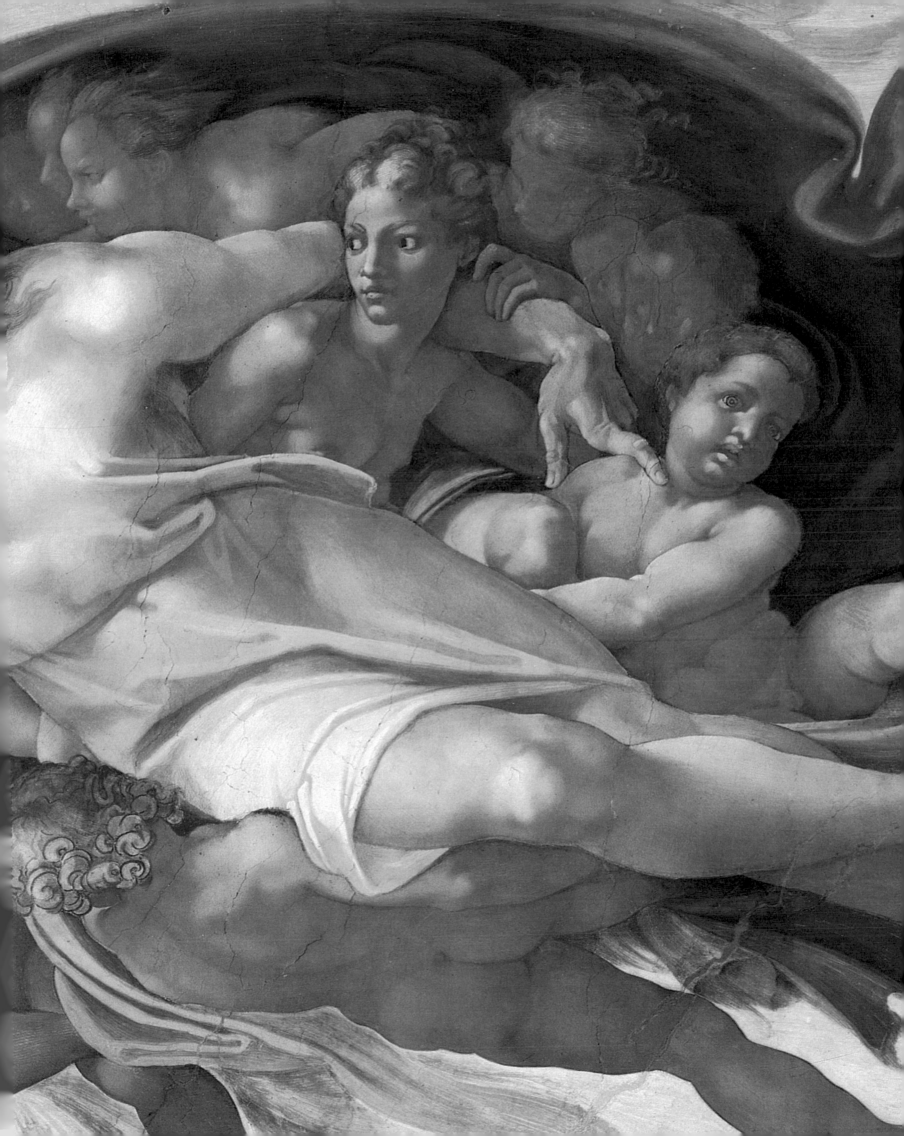

# GOD SEPARATING
# THE EARTH FROM THE WATERS

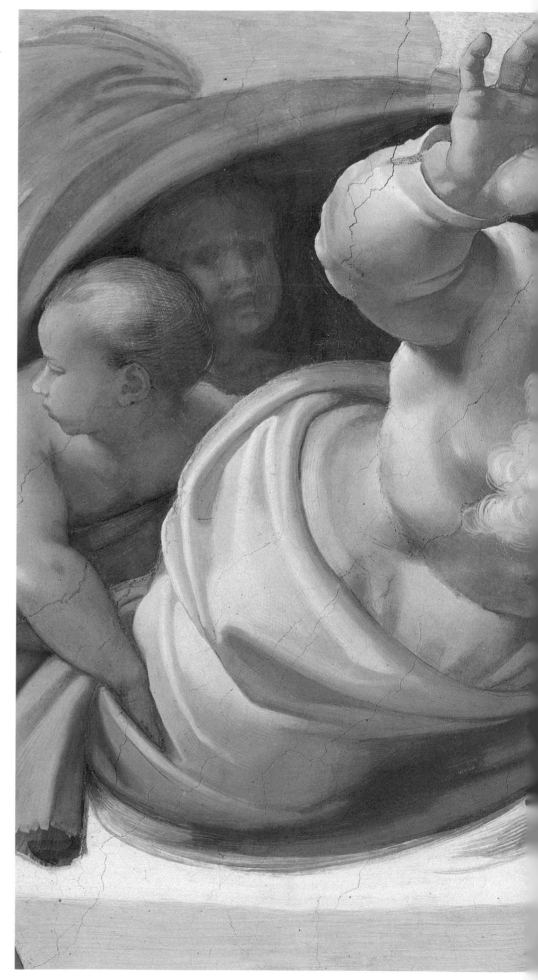

Although earlier periods had not often chosen to depict the Creation, the great importance it was given in the Sistine frescoes is wholly consonant with Renaissance theology. The preachers in the papal chapel frequently praised the wonder of the Creation and the splendor of the physical world. For the final triad representing the first acts of Creation, Michelangelo selected three days and, as in the Noah stories, rearranged their sequence. This scene comes closest to representing the second day of Creation, even though it lacks the fishes and other creatures that were part of that day's work. Both practical and theological explanations have been offered for the adjustment of sequence. Perhaps Michelangelo was guided by his wish to give the large field to the Creation of the Sun, Moon, and Plants. Some commentators have plausibly seen in this triad representations of each person of the Trinity, in which case God here, hovering over the waters, would symbolize the Holy Spirit. On the second day of Creation God is shown moving toward us, his vast gesture reaching across nearly the whole panel. As in the preceding *Creation of Adam*, he is enveloped in a swirling mantle and accompanied by angels, but it is as if that view has been rotated a quarter turn. Below, there is nothing but quiescent water. The Ignudi at the corners impinge, overlapping the frame at all four corners for the first time, making the scope of God's majestic gesture all the more titanic for being circumscribed. In these last scenes the challenge to the painter was to fill the space with only a single figure. Michelangelo used unexpected points of view and foreshortenings to awe the viewer. With this display of the power of art he succeeds in amazing, even as his possibilities for variety of color and pose or for pleasing ornamental effect are diminished by the subjects represented.

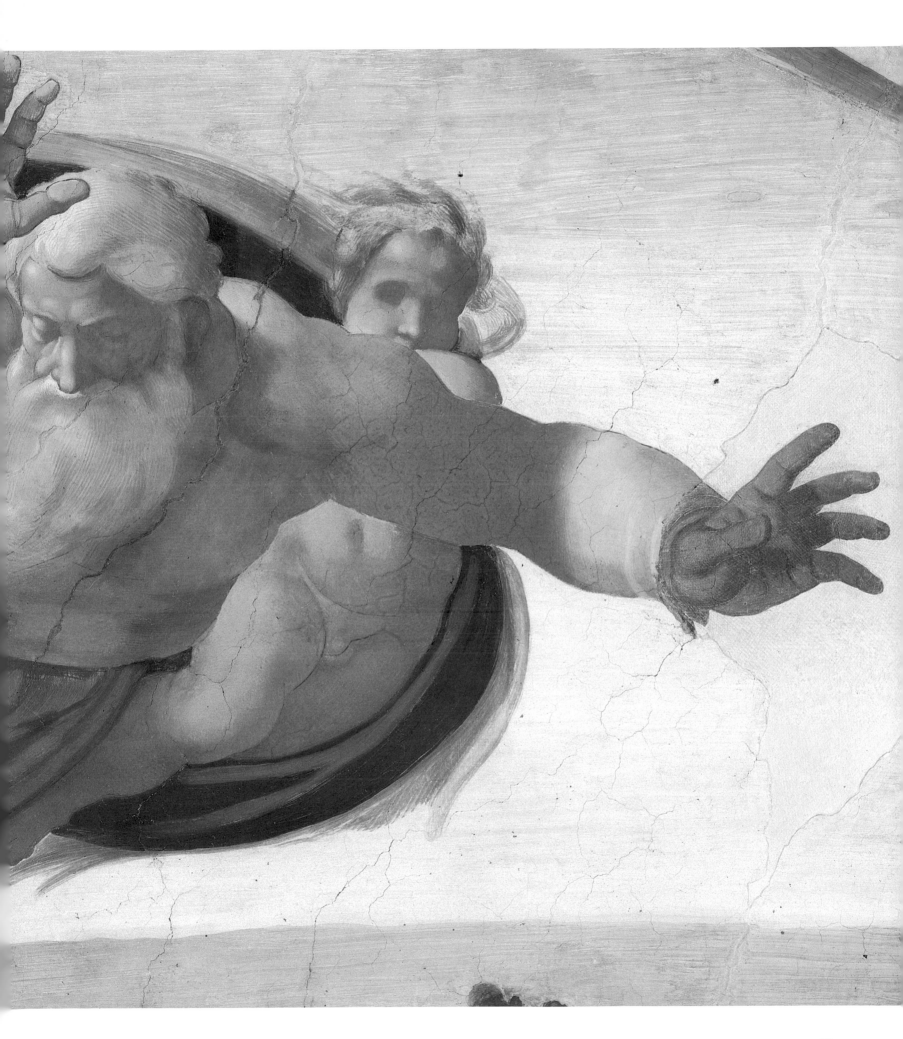

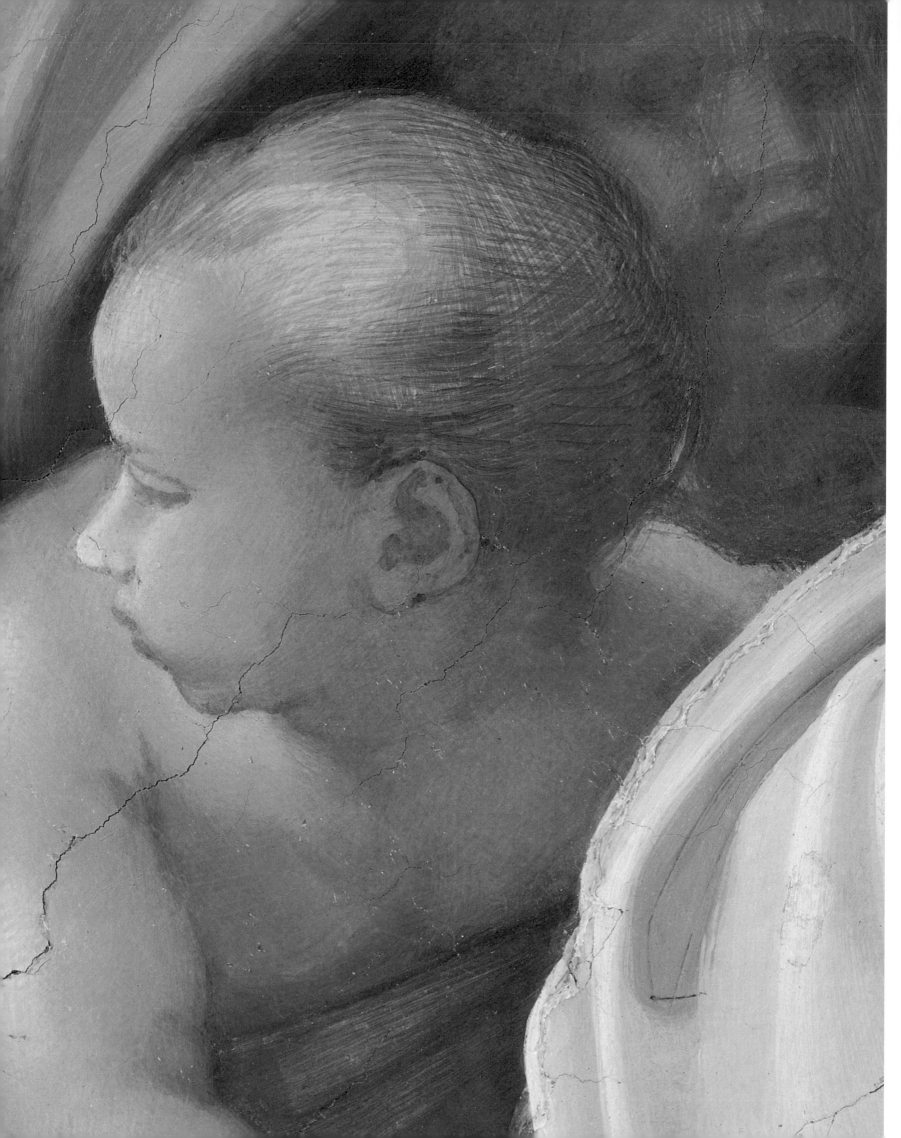

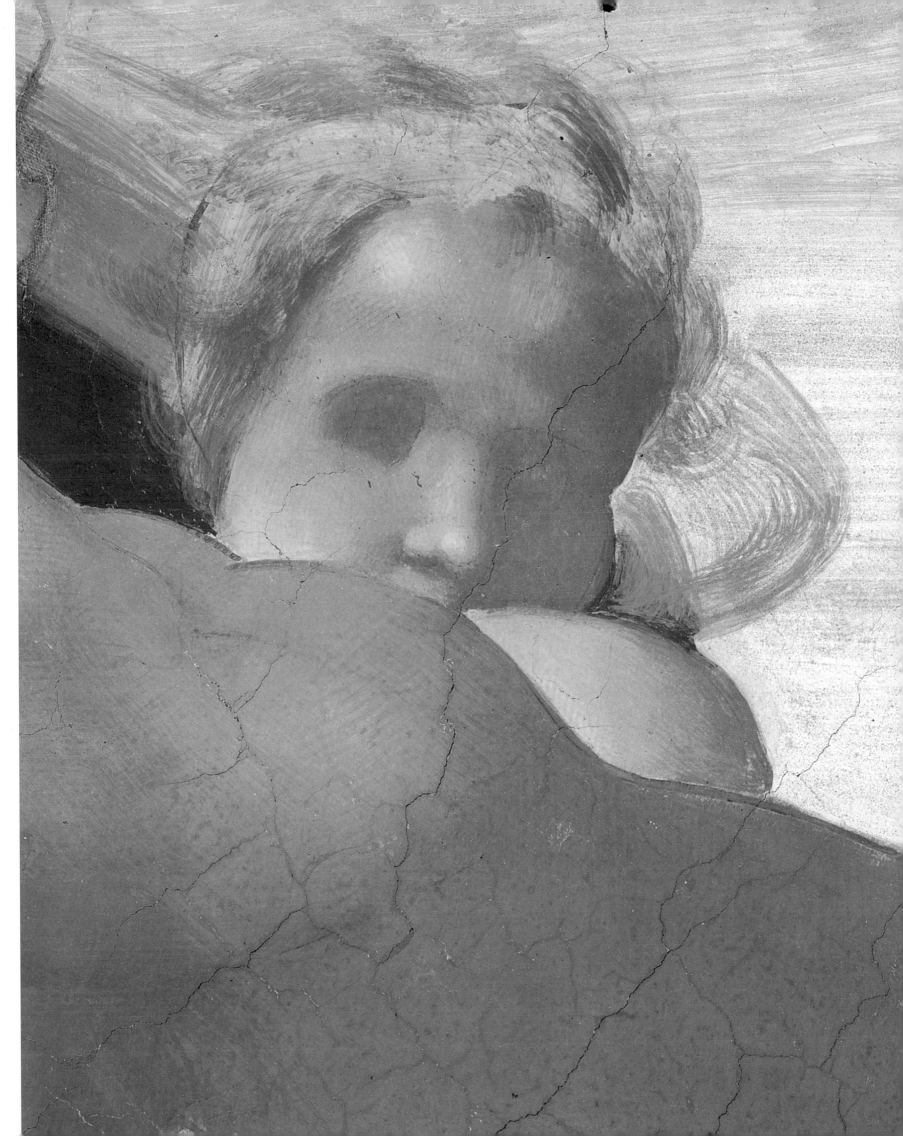

# THE CREATION OF THE SUN, MOON, AND PLANTS

As the preceding scene is calm, this scene is intense. A ferocious God is shown flying toward us, arms upraised, commanding the celestial bodies into being. With one arm he points to the sun, with the other to the moon, and then he sweeps past us in an orbital swing like the planets he is creating. Seen a second time from behind, his gesture brings the earth into being. As in the *Creation of Adam*, Michelangelo creates the impression of energetic speed. This most daring of inventions may remind us that Moses, when he visited God on the mountain, was only allowed to see his backside. In this scene, before anyone has been created to see him, he shows his face. As a representation of the second person of the Trinity, the scene makes the analogy between the sun and Christ as "the light of the world."

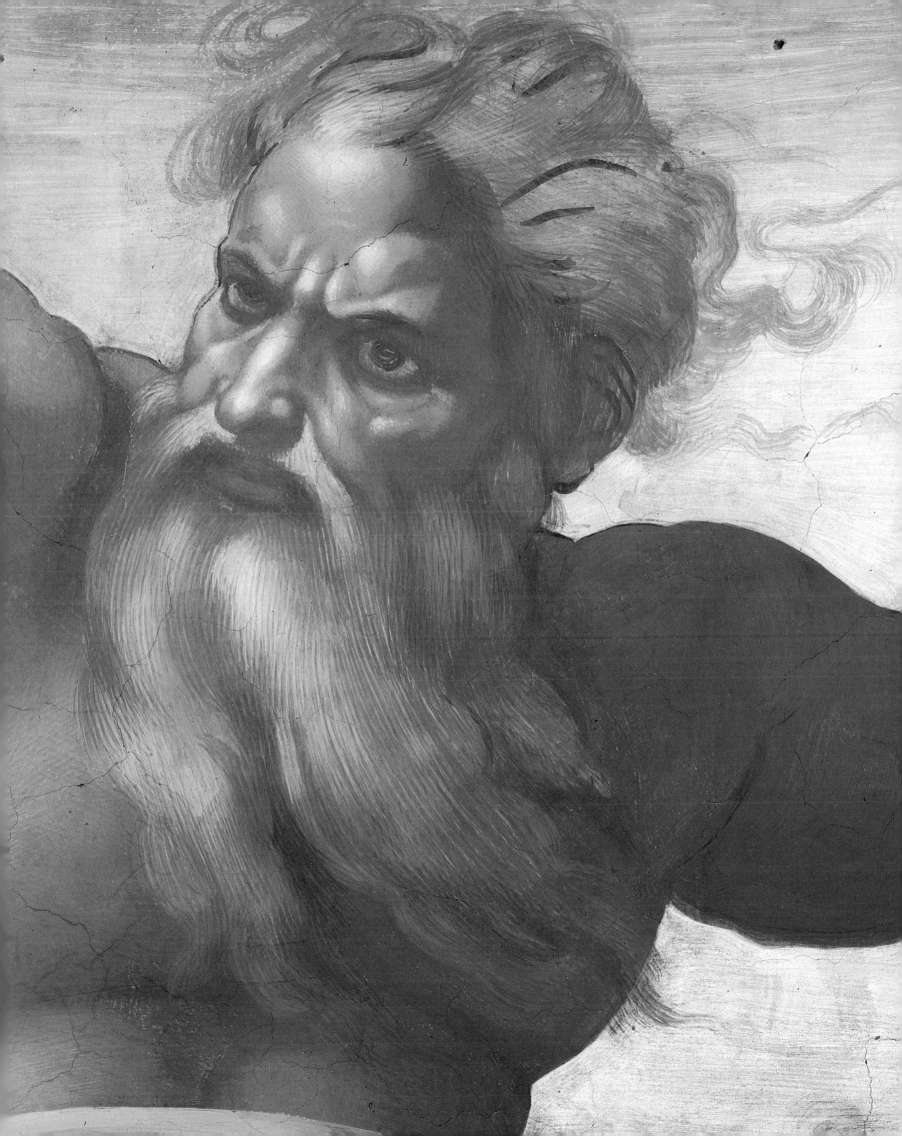

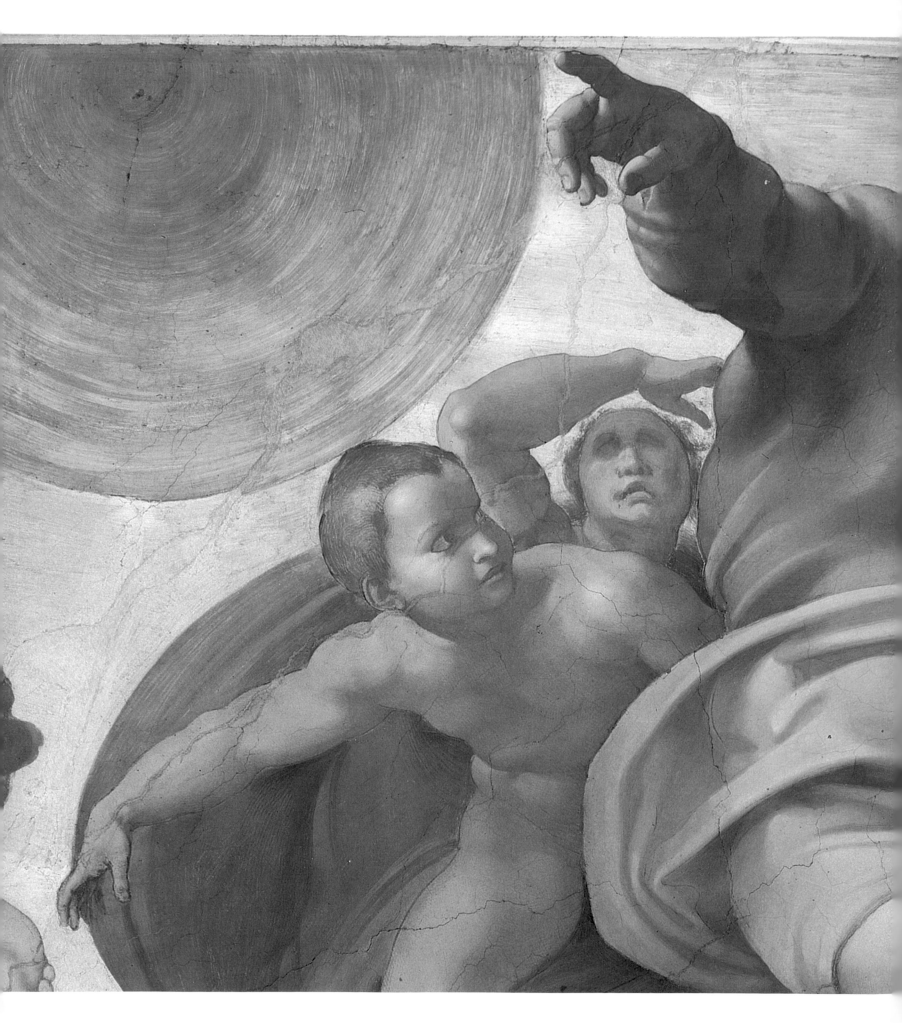

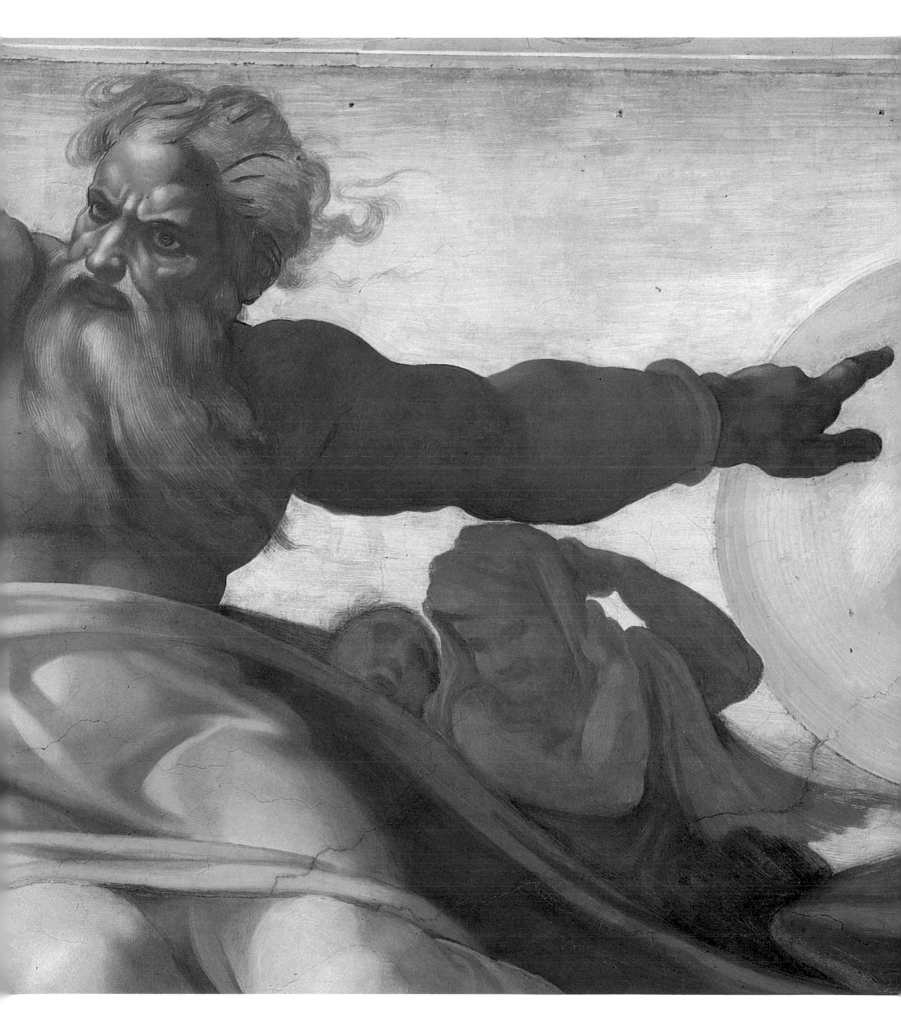

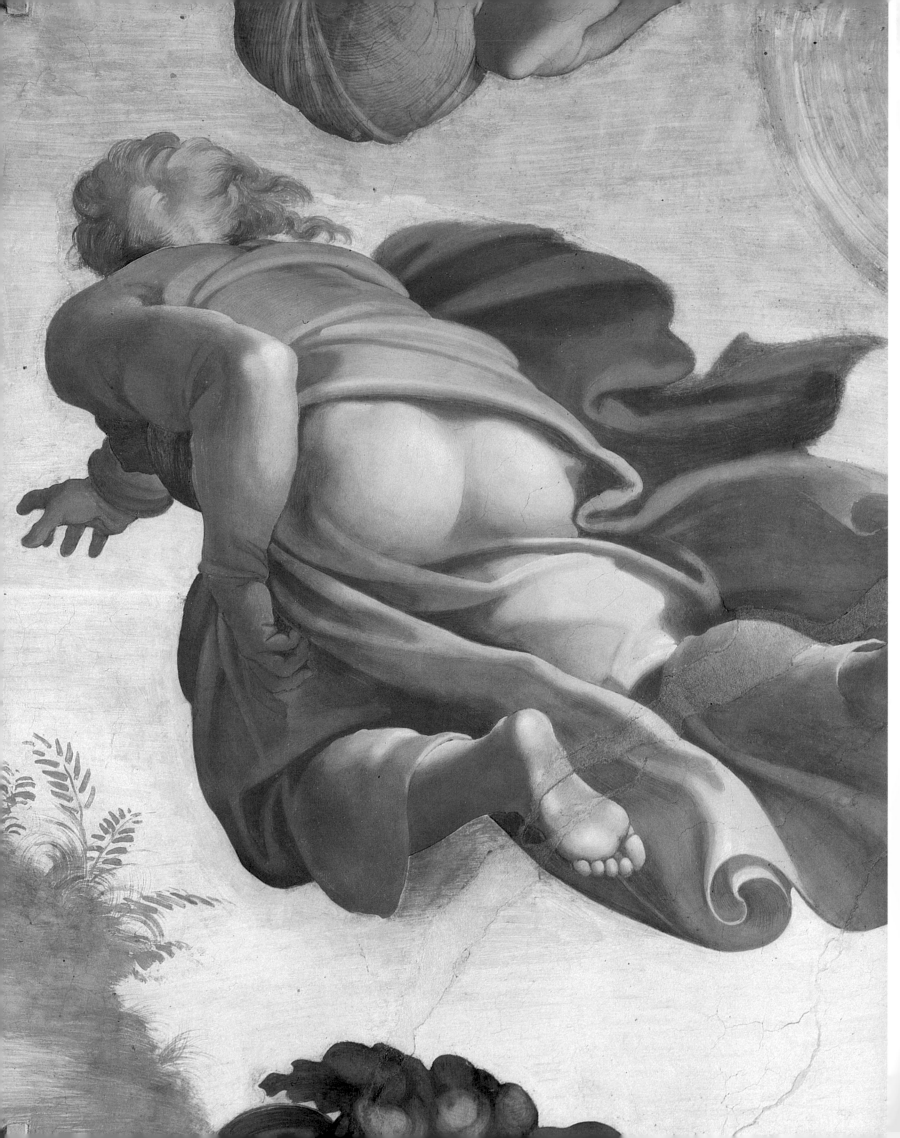

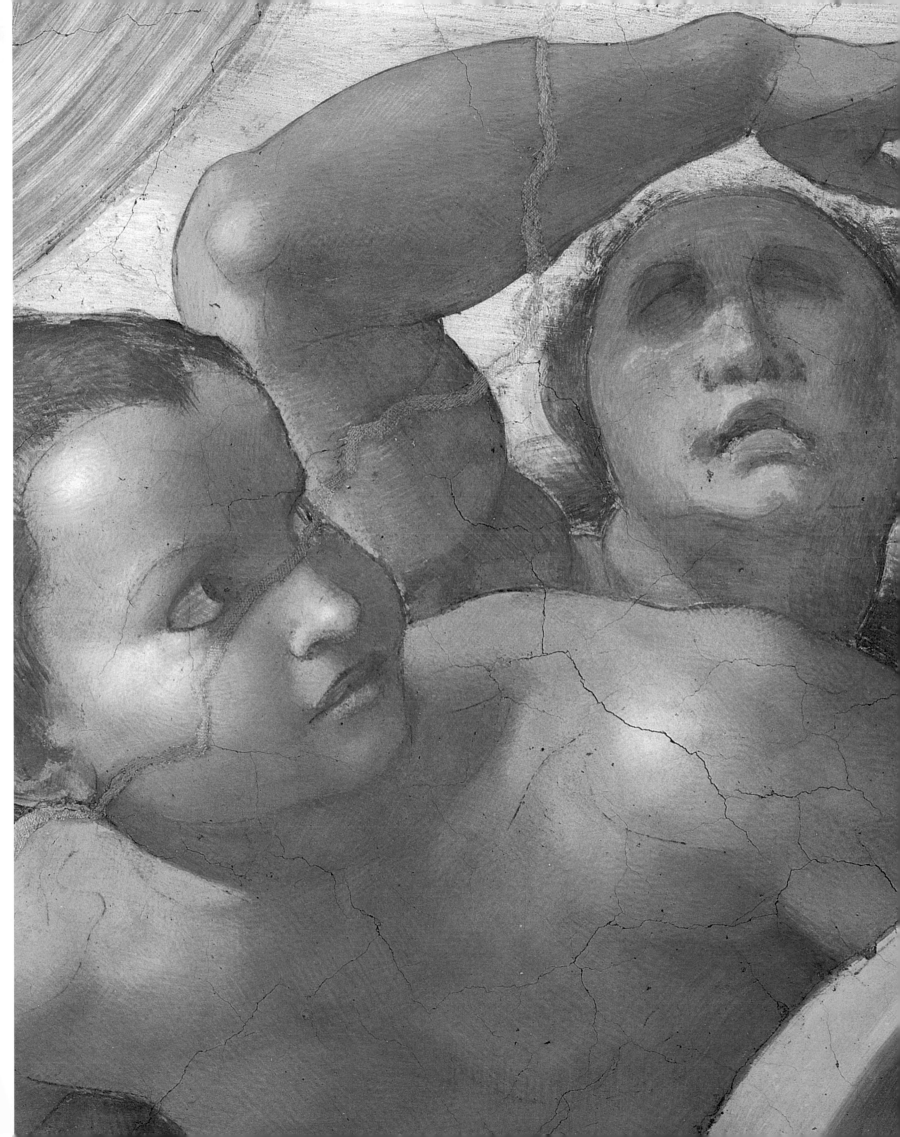

# THE SEPARATION OF LIGHT AND DARKNESS

In a masterful tour de force Michelangelo has invented an image of the very first act of Creation. God himself seems to be taking visible shape before us as light itself is created. It is only this one time that the painter shows us a view from below. His legs cut by the frame, it is as if the whole sky is filled with the Creator. With his arm he pushes back the darkness and the light rolls in like clouds. Here appropriately the first person of the Trinity shares the field with nothing.

According to Augustine, it was at this point that the populations of the City of God and the City of Man first divided: he understood the creation of light to be the creation of the good angels, and the creation of the dark to be the creation of the demonic angels.

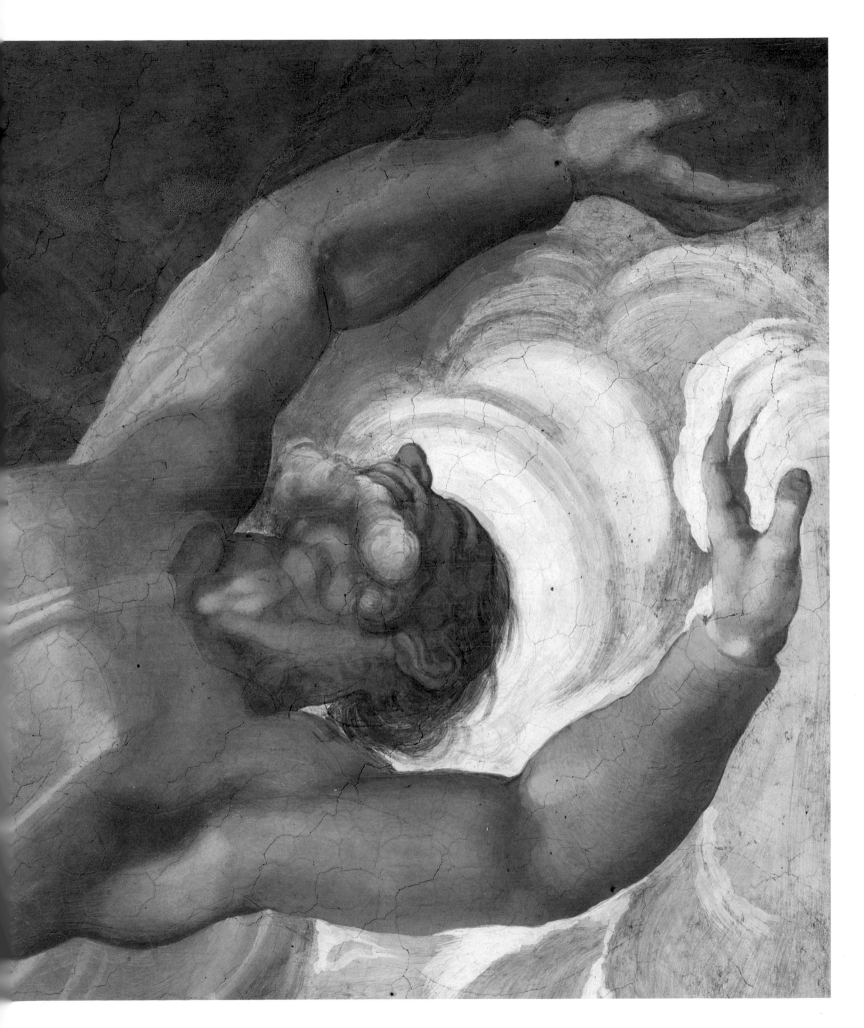

# THE HISTORIES OF THE LIBERATION OF THE ISRAELITES

At the four corners are large spherical triangles connecting the vault and the side walls. They are double normal size, and it is not clear whether the vault was built in this unusual way or whether Michelangelo cut back the groin to make a single unified field. The stories on the entrance wall represent two decapitations: David and Goliath, and Judith and Holofernes.

On the altar wall are two crucifixions (though here the point had to be stretched): the *Execution of Haman* and the *Brazen Serpent*. In each case a hero or a heroine delivers the Israelites from an enemy, making explicit the theme of the vault as the prefiguration of the redemption to come with the Messiah. Painted at opposite ends of the chapel and therefore at the beginning and end of Michelangelo's campaign, each pair of spandrels differs significantly in conception. A similar difference is to be seen in the two prophets who begin and end the series. Zechariah, on the entrance wall and the first to be painted, is compact and contained within his niche, the image of intellectual concentration. Jonah, considerably enlarged in scale on the altar wall, explodes with ecstatic emotion. Placed obliquely, he sits in front of his niche and the figure overlaps the framing pier.

Michelangelo had some difficulty with the triangular shape of the pendentive fields in the first pair. There are large empty spaces, particularly in the foreground of *Judith with the Head of Holofernes*, and in all three corners of *David and Goliath*, though one is filled somewhat unconvincingly with the heads of some barely visible soldiers. We see how much more adept the painter has become at dynamically using the whole space in the *Execution of Haman*, where he makes dramatic use of the full height of the triangle by placing Haman along its central vertical axis. It is in the *Brazen Serpent*, however, that Michelangelo demonstrates a new compositional compression, packing as much serpentine movement into the space as possible and making it seem too small. The figures are overlapped, and pressed up to the plane as in a sculptural relief. This composition will be studied by the painters of the next generation and will inspire them to abandon central point perspective, as Michelangelo had done here, in favor of the model of sculptural relief that protrudes into our space, rather than receding behind the picture plane.

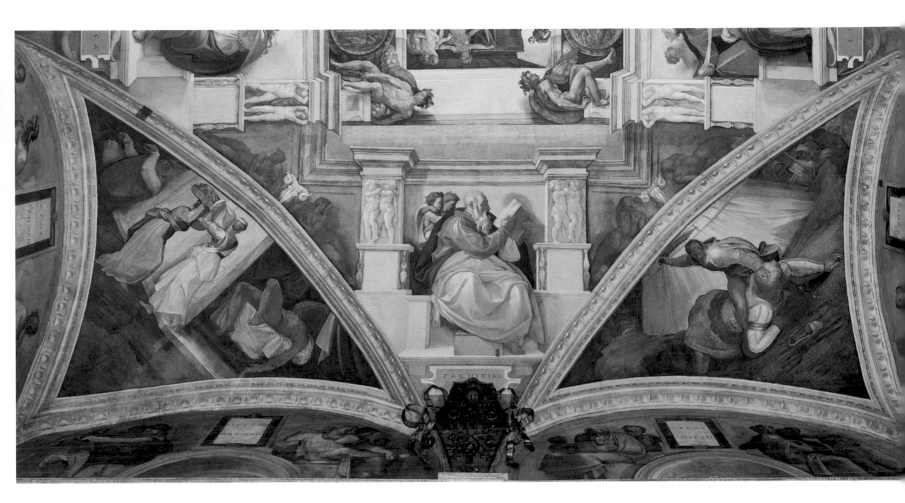

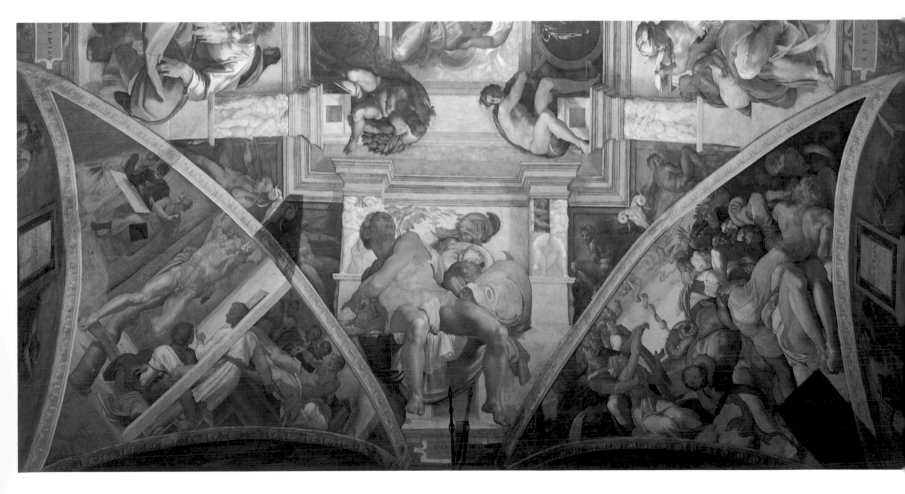

## DAVID AND GOLIATH

David is a recognized antetype of Christ. The shepherd boy who faces the Philistine giant and slays him resembles Christ in his humility. Michelangelo emphasizes the improbability of the deed by showing little David astride the colossal Goliath, who is not unconscious from the stone that had stunned him, but who rears up on his arms and struggles to regain his feet. By isolating the figures in the middle of the large field, surrounded by empty space, the artist makes David appear small and unprotected. The triangular composition reverses the shape of the field, so that there is no reinforcement of David's brave gesture offered by the formal structure.

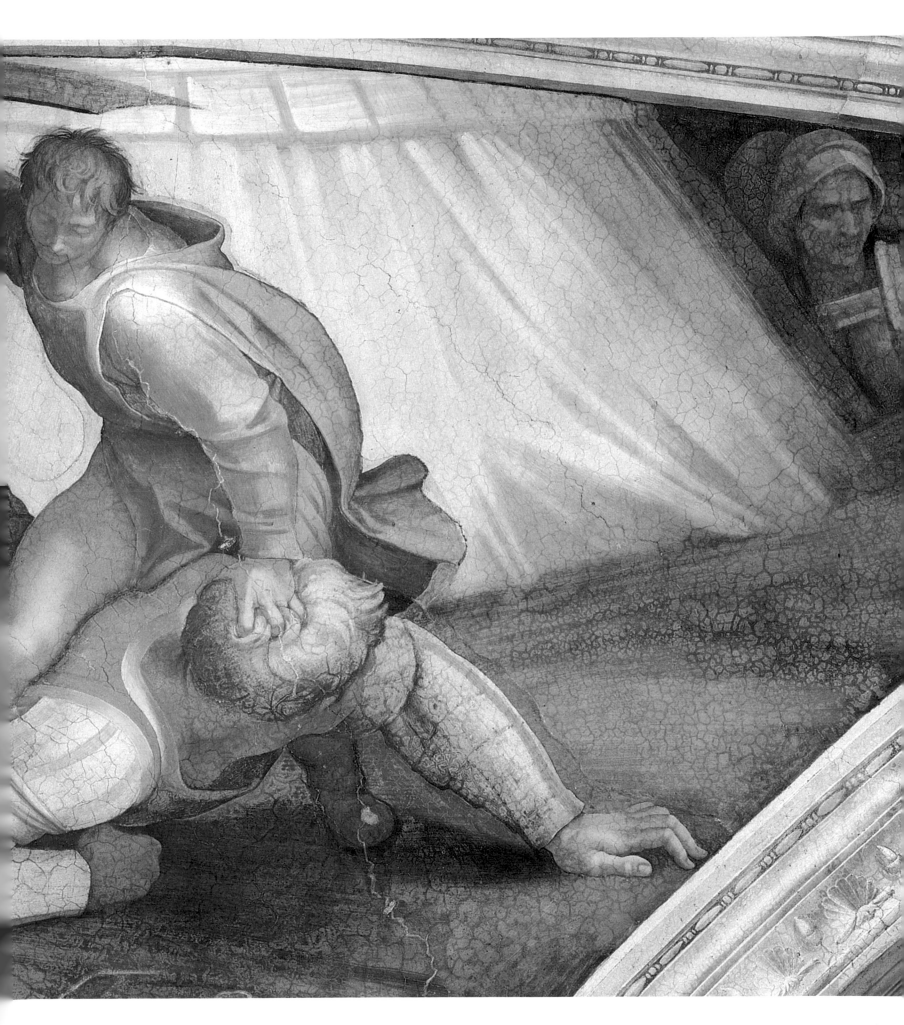

# JUDITH AND HOLOFERNES

In the opposite corner, the hero is matched by a heroine performing a similar deed. Judith, like David, volunteered to destroy the leader of an enemy army. Her method was as characteristically feminine as David's was masculine. Her beauty and charm disarmed Holofernes, and when he fell asleep Judith used his sword, as David used Goliath's, to cut off his head. She is shown as in the traditional iconography with her maid, carrying the head home as proof of her success. The boy and the woman resemble one another in their lack of power and social status in a patriarchal society. Like David, she can be understood to have overpowered pride with humility. Judith offers this prayer as she sets out for her task: "Bring to pass, O Lord, that his pride may be cut off with his sword . . . For this will be a glorious monument for thy name, when he shall fall by the hand of a woman . . . nor from the beginning have the proud been acceptable to thee, but the prayer of the humble and meek hath always pleased thee" (Jdt 9:13–16).

Augustine identified pride as the sin of Lucifer, of Adam, and of the citizens of the City of Man. The adjacent scene on the vault is the *Drunkenness of Noah*, where the heroic Noah is humbled by being seen naked by his sons. It prefigures Christ's reversal of that original sin of pride by humbling himself in the Incarnation.

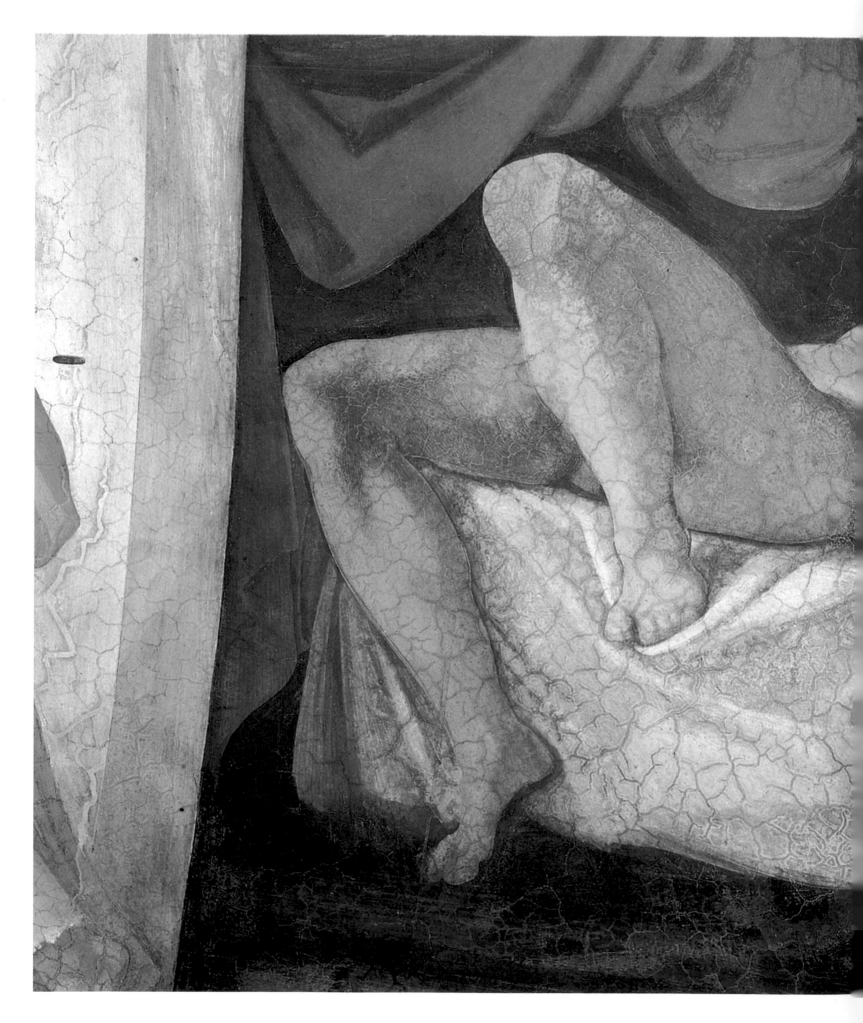

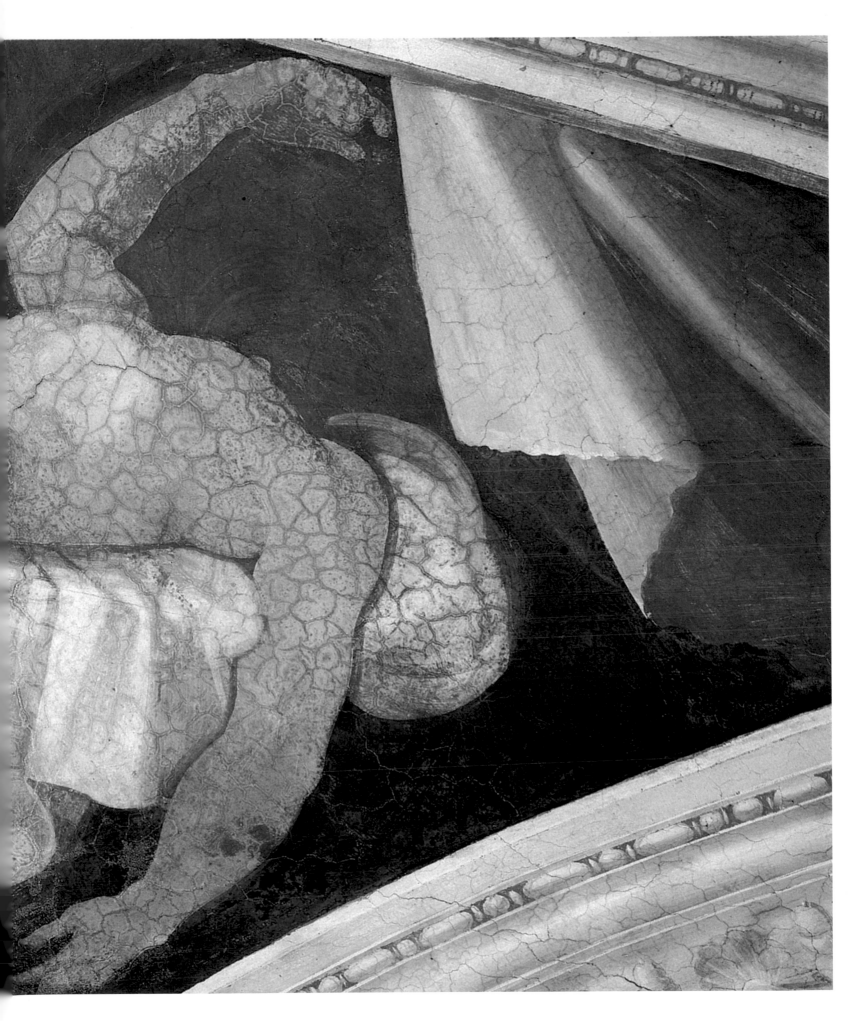

# THE BRAZEN SERPENT

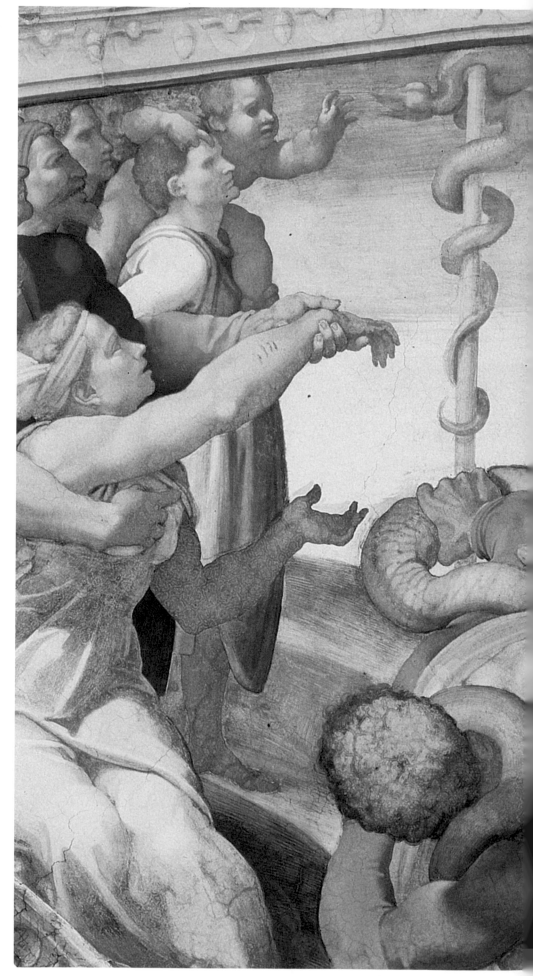

On the altar wall, the story of the Brazen Serpent is depicted. When the Israelites, wandering in the desert, complained to God, he punished them by sending a plague of serpents whose bite was lethal. Moses, when he appealed to God, was told to raise up an image of a serpent cast in bronze. Those who looked at it would be cured. The connection between this story and the Crucifixion is explicitly made in the New Testament: "And as Moses lifted up the serpent in the wilderness, so must the Son of man be lifted up, that whoever believes in him may have eternal life" (Jn 3:14–15). Michelangelo arranged the scene like a Last Judgment. The serpent in the shape of a cross is high, centralized, and isolated. On the viewer's left (God's right) are those who gaze on it and are saved. Opposite is the tangled mass of those writhing in the coils of the serpents, condemned to die. Michelangelo would return to his own images here of contorted faces when he represented the damned in his *Last Judgment*, painted adjacent to this scene more than a quarter century later.

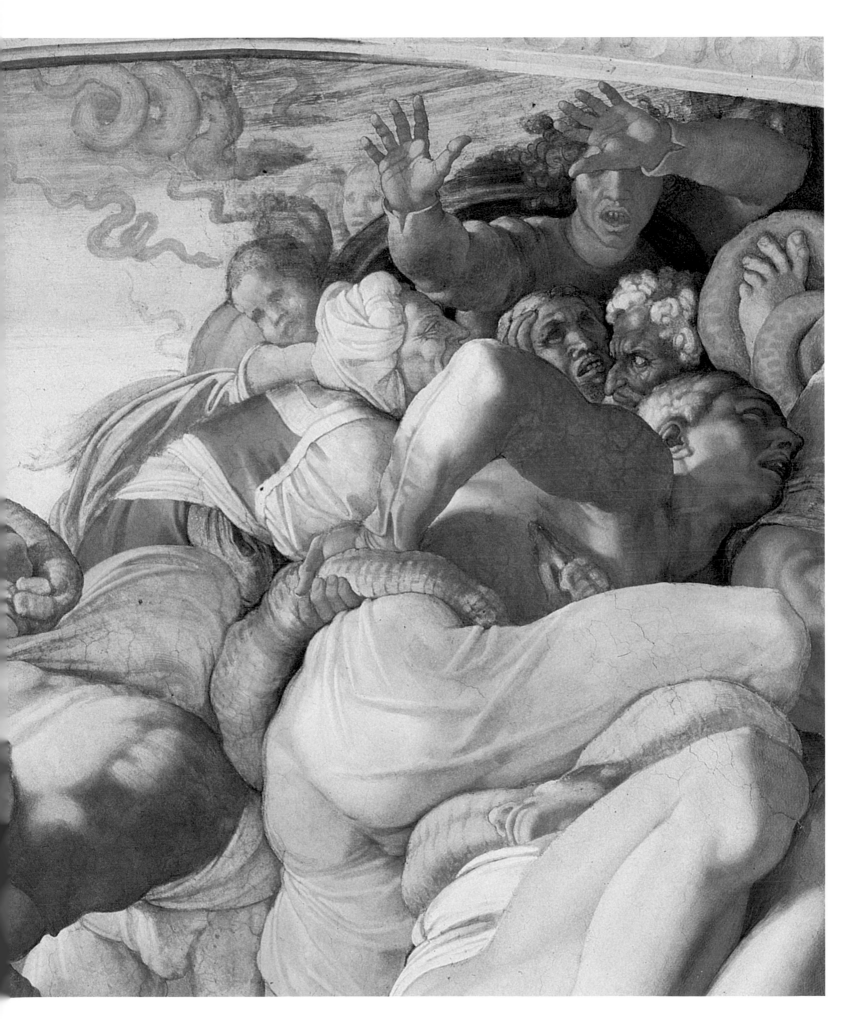

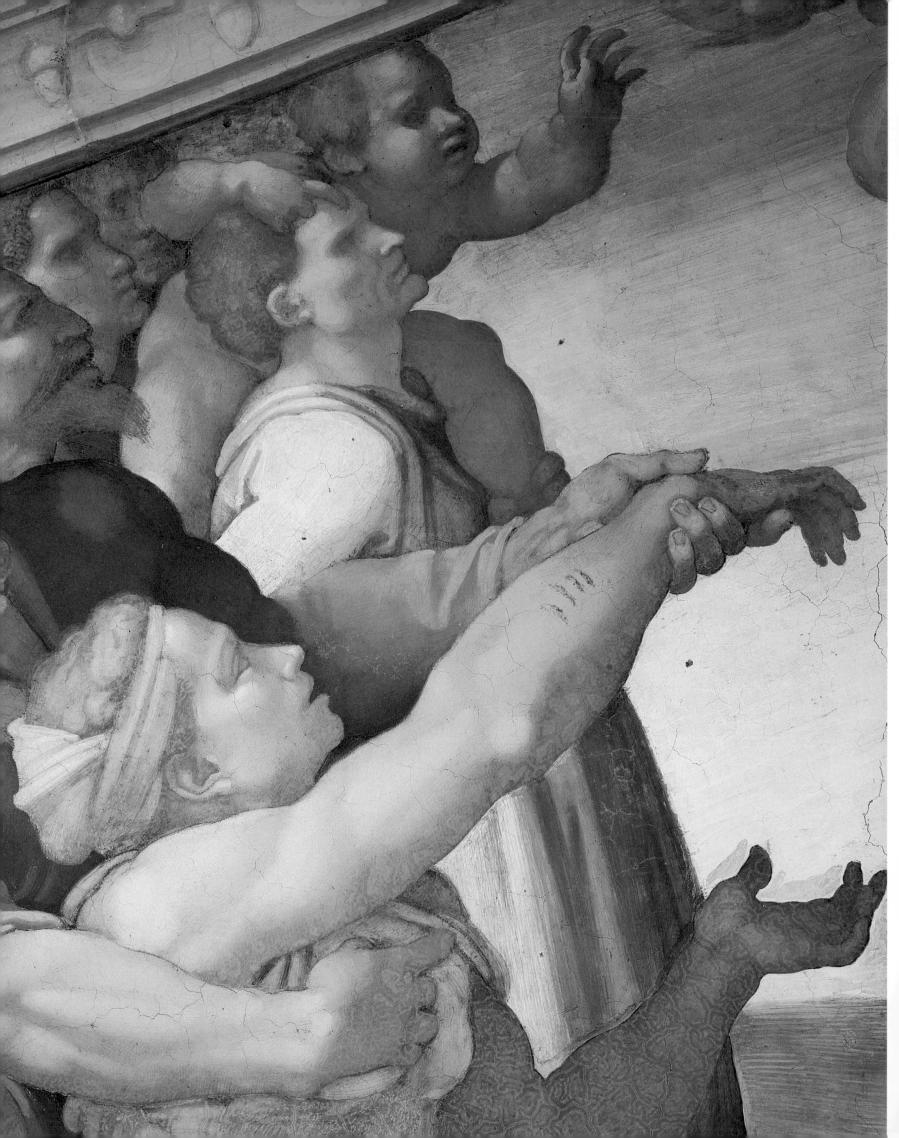

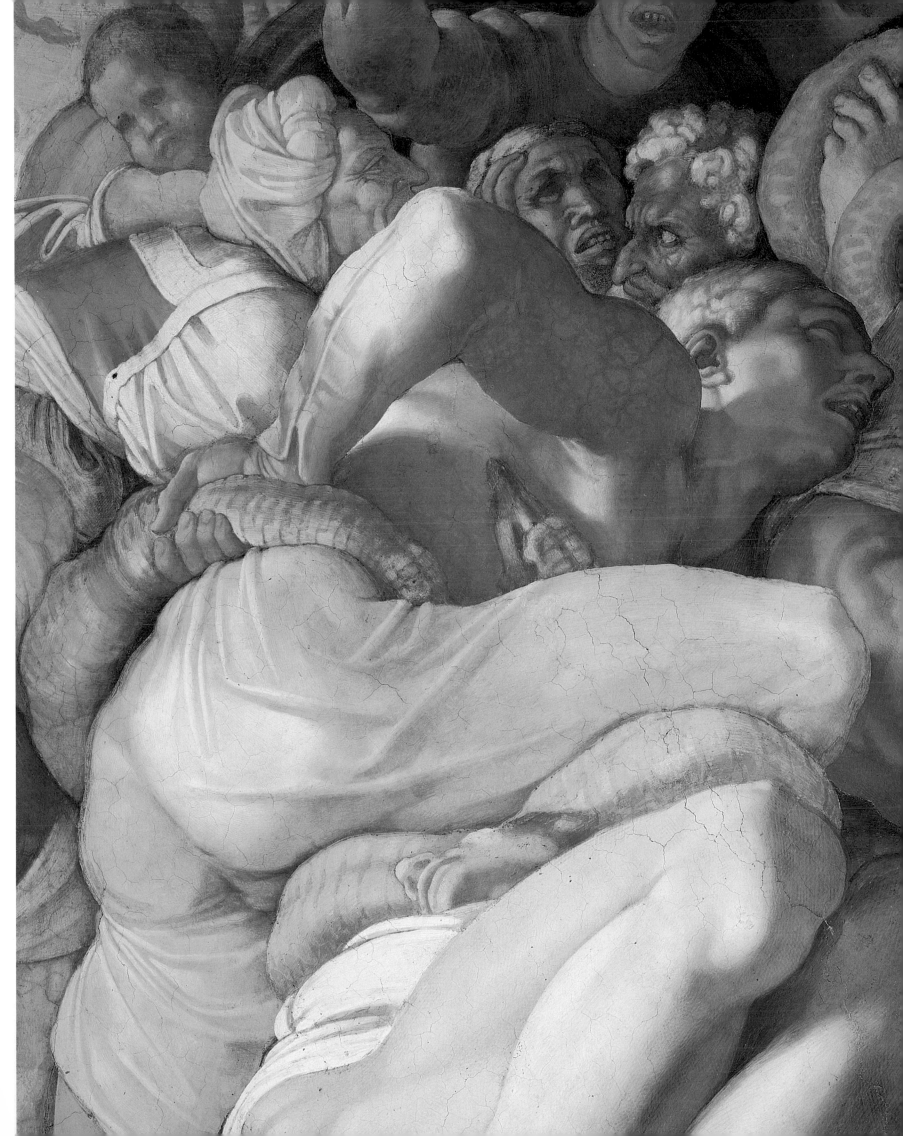

# THE EXECUTION OF HAMAN

The scene in the opposite corner is likewise related to the Crucifixion. The treachery of Haman was punished by his execution, described as hanging, but Michelangelo has transformed his gallows into a rough cross on which Haman hangs. This scene is the most difficult to interpret because Haman is not a hero and not a type of Christ. He is a wicked man punished for his crimes. He embodies iniquity. Elaborate interpretations have been offered. Haman embodies the sin of pride in medieval and Renaissance commentaries; he is even sometimes described as the Antichrist. It seems that only by interpreting Haman as the antithesis of Christ, and Christ's humility as the opposite of Haman's pride, can sense be made of this scene.

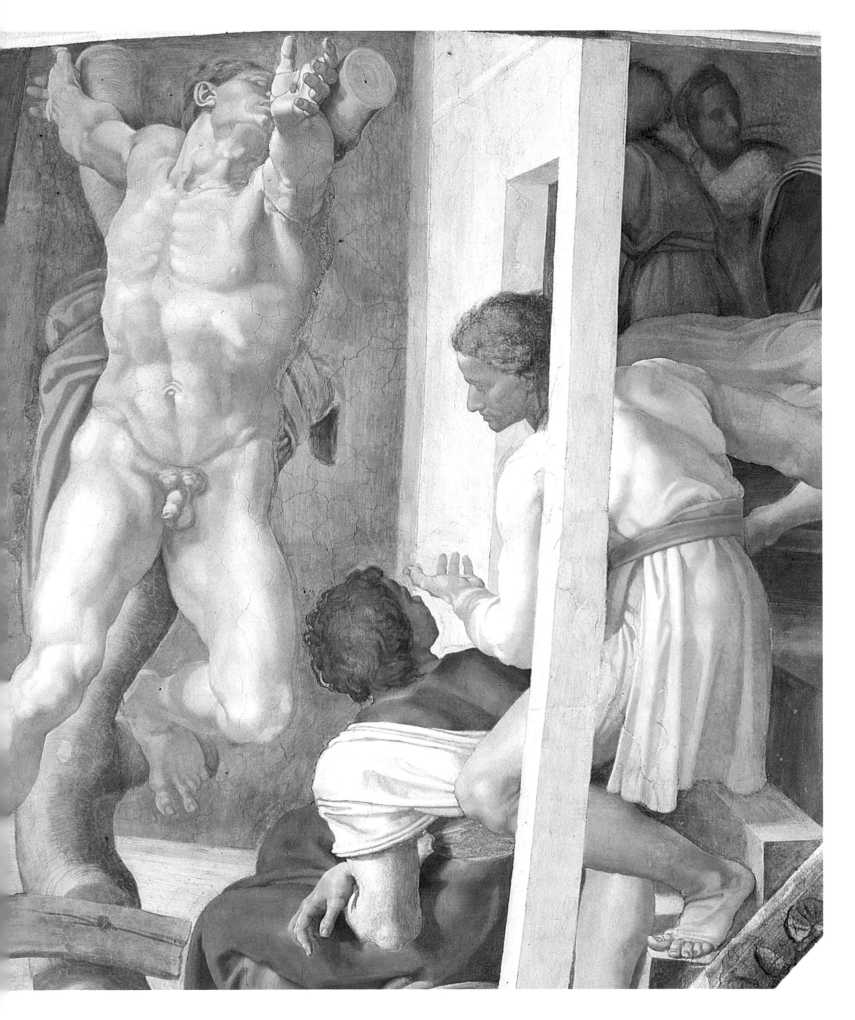

# THE SEERS:
# PROPHETS AND SIBYLS

In the position where the twelve Apostles were to be enthroned in the original project, Michelangelo arranged Old Testament Prophets, alternating them with Sibyls of the classical world, down and across the ceiling.

On the end walls he placed single prophets, bringing their number to seven and the Sibyls to five. How the particular Seers were chosen remains unclear, although some choices such as Jonah, Isaiah, and Cumae were obvious. These powerful figures are the largest on the ceiling, but conflict with the Genesis panels on the long axis is avoided because the Seers dominate the cross-axes, and must be viewed facing the side wall in each case. There was already a Renaissance tradition for including the Sibyls with the Prophets. Texts of Sibylline oracles, probably composed in the early Middle Ages, were widely known. There was also a booklet of the Sibyls and their prophecies by Filippo Barbieri—dedicated to Pope Sixtus IV, published in 1481, and reprinted several times in succeeding decades—that was used as a source of pictorial illustrations in Renaissance cycles. Most notable and nearest at hand were the frescoes in the Borgia Apartment on the level below the chapel, painted by Pinturicchio in the early 1490s. What made the Sibyls so popular was that their utterances were understood to have predicted the coming of a Messiah and thus reinforced the Renaissance humanist conviction that Christian truth was revealed in some measure to the Gentiles. With a generosity characteristic of the age, the Sibyls were included as part of the conciliation of pagan and Christian cultures. All antiquity was preparation for the Gospel, according to the Renaissance thinkers. The prominence of the Prophets and Sibyls rein-

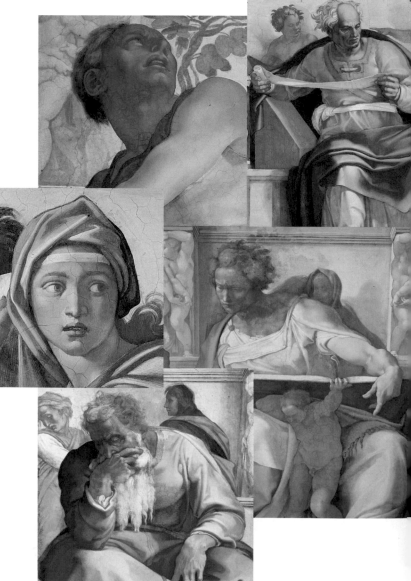

forces the message of the ceiling: it prefigures the divine plan of redemption.

The Old Testament prophets are viewed today as the social critics of their day, those men who looked around them, saw the faults and follies of their contemporaries, and spoke out courageously condemning them. But in the Renaissance they were understood to be visionaries foretelling the future. Michelangelo represents each in some stage of divine revelation. The Sibyls are also shown as visionaries, although the quality of their ecstasy is slightly less elevated and lofty than that of their Christian male counterparts.

Each Seer is placed alongside the smaller Genesis scenes, seated on a marble throne. They are fitted between the cornice atop which the Ignudi are seated and the triangular pendentives that run down beside the lunettes on the side walls. Beneath each throne a putto holds an identifying plaque.

Flanking each throne are paired marble putti, each different in attitude and mood, but giving the appearance of being sculpted. Within the space so defined, there are small figures understood to be genii who assist the visionary. When they are behind the throne, Michelangelo has painted their features indistinctly, as if out of focus. With this kind of exaggerated acuity perspective, he could diminish their significance to whatever degree he chose.

Color is one of the chief means Michelangelo used to bring the Seers to our attention. Because the figures are so large and he typically garbed them in only three hues, the size of the color fields is huge and therefore commanding. In places, the number of hues employed is in inverse ratio to the activity of the figure. For example, side by side we see the sedate Erythraean Sibyl in six distinct hues, while Ezechiel in the next bay, who gestures vehemently and seems about to rise to

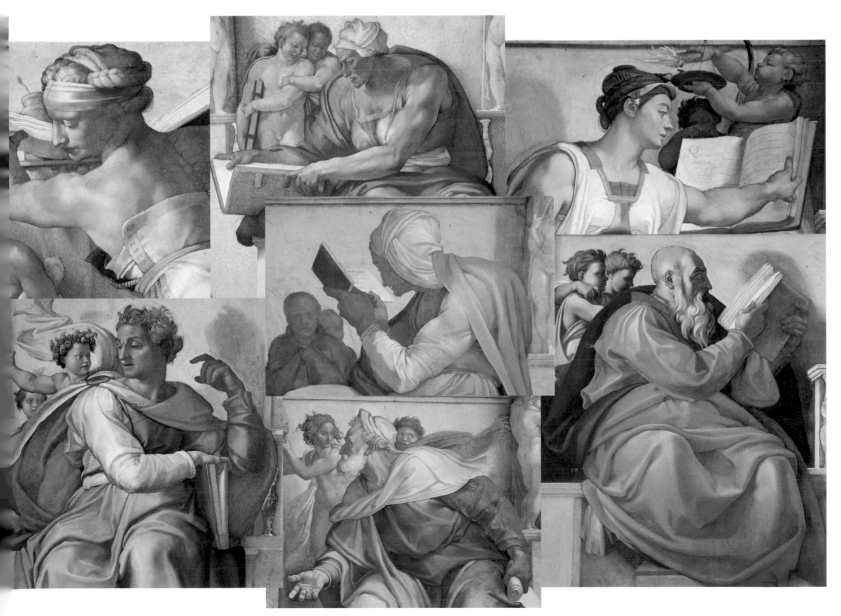

his feet, wears only three colors. There are some spectacular examples of *cangianti* draperies, but by no means every Seer is so ornamented.

Proceeding down the chapel the Seers increase in size. There is an abrupt shift to a larger scale on the south side: the base of the Persian Sibyl's throne is markedly lower than Ezechiel's. On the opposite side, however, the thrones gradually enlarge with each successive bay. The figures seem to be increasingly constrained within the architectural confines, so that the energy we perceive them to have increases steadily.

## ZECHARIAH

The Hebrew prophet over the entrance can be linked to several texts that make him a meaningful choice for this location. One of his prophecies went: "Here is a man named the Branch. He will shoot up from the ground where he is and will build the temple of the Lord" (Zech 6:12). This could be taken as a reference to the papal family that had built and decorated the chapel, the della Rovere, whose oak tree and acorns adorn various parts of the chapel. It can also refer to Christ, who is the topmost branch of the tree of Jesse, referred to in the chapel with the representation of the Ancestors of Christ. Zechariah also predicted Christ's entry into Jerusalem: "Rejoice greatly, O daughter of Zion! Shout aloud, O daughter of Jerusalem! Lo, your king comes to you; Triumphant and victorious is he, humble and riding on an ass . . . And he shall command peace

to the nations; his dominion shall be from sea to sea, and from the River to the ends of the earth" (Zech 9:9–10). Palm Sunday was one of the ceremonies that were celebrated in the Sistine Chapel, the pope leading the procession that entered directly beneath Zechariah.

Shown completely absorbed in his reading, the prophet is contained within the frame of his throne. His genii look on from behind in quiet patience. His head in profile, his upper body rotates, but the rounded shape given to his robe serves to draw attention away from his twisting pose and front-pointing knees. His poise and self-containment are conveyed by the echoing curves of arm and drapery hem. Whereas in figures executed later, Michelangelo will draw attention to the torsion of a pose to create tension and drama, here he de-emphasizes it.

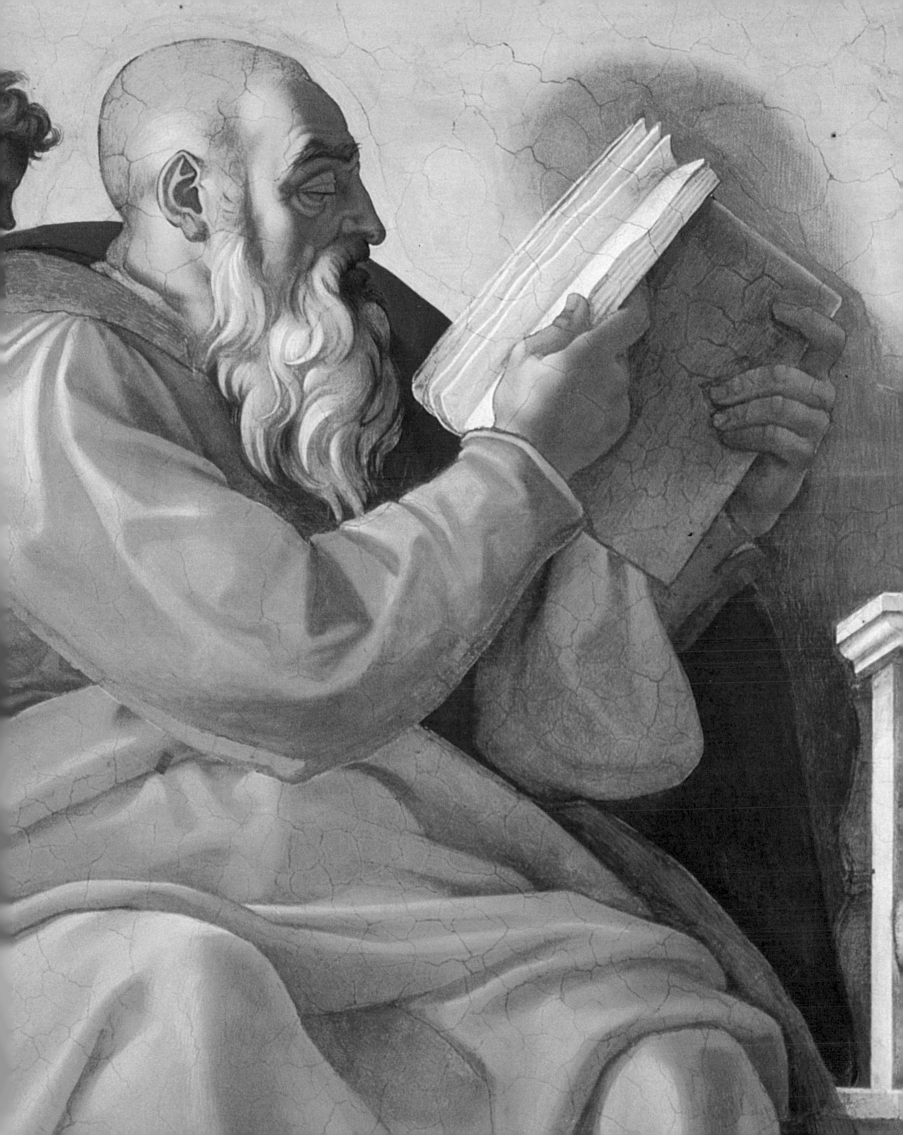

# THE DELPHIC SIBYL AND JOEL

Delphica and Joel flank the Drunkenness of Noah. The Delphic Sibyl is the most famous of the Sibyls because of her important situation as the oracle at the Temple of Apollo at Delphi. Over and over we read in Greek literature of heroes consulting her. It was from her that Oedipus learned that he would kill his father and marry his mother. Her prophecy that was taken in Christian texts to be messianic refers to the Virgin birth: "A prophet will be born without his mother's coition, from a virgin."

She is shown consulting a scroll, assisted by her genius who reads a book. Her extraordinary face captures the sense of her rapt state. Her lips are parted, about to give utterance, but her statement of innocence and perhaps fear carries the feeling that she is the vessel, but not a participant, in the message she will deliver.

The prophet Joel, her masculine counterpart, contrasts with her graceful pose and comely face. Balding, with gray hair flying, he sits facing forward as he excitedly consults a scroll. With his boldly foreshortened arms and the red mantle that circles his broad shoulders, Michelangelo confronts us with an image of power and conviction. His prophecy that connects him to the Drunkenness of Noah is expounded in Acts 2:13–20. Peter is responding to people who were mocking the Apostles, just as Noah was mocked. "Others mocking said, They are filled with new wine." But Peter said, listen to me: "For these men are not drunk, as you suppose ... but this is what was spoken by the prophet Joel: And in the last days it shall be, God declares, that I will pour out my Spirit upon all flesh. And your sons and your daughters shall prophesy, and your young men shall see visions, and your old men shall dream dreams; Yea, and on my menservants and maidservants in those days I will pour out my Spirit; and they shall prophesy, And I will show wonders in the heaven above and signs on the earth beneath, blood, and fire, and vapor of smoke; the sun shall be turned into darkness and the moon into blood, Before the day of the Lord comes, the great and manifest day" (Joel 2:28–31). We will see below that it connects also with the scene on the bronze medallion above his head.

94

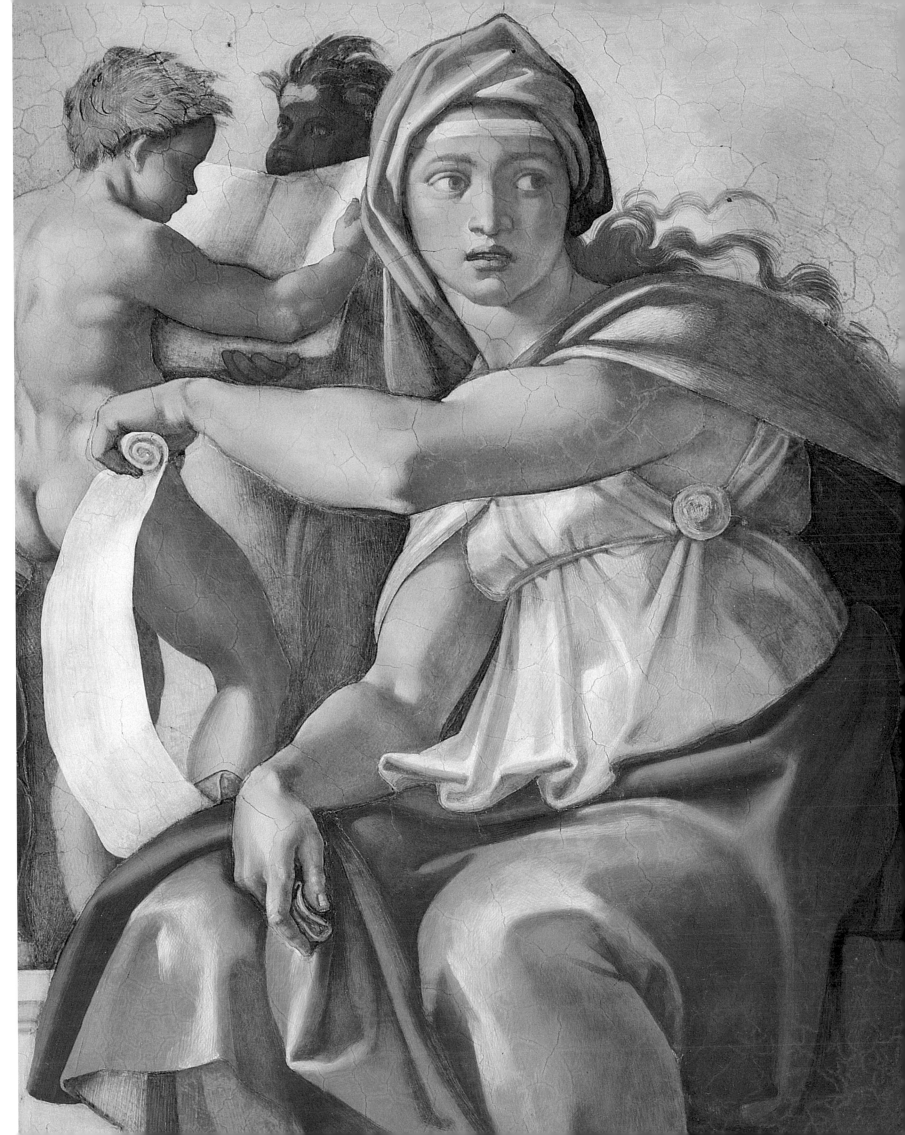

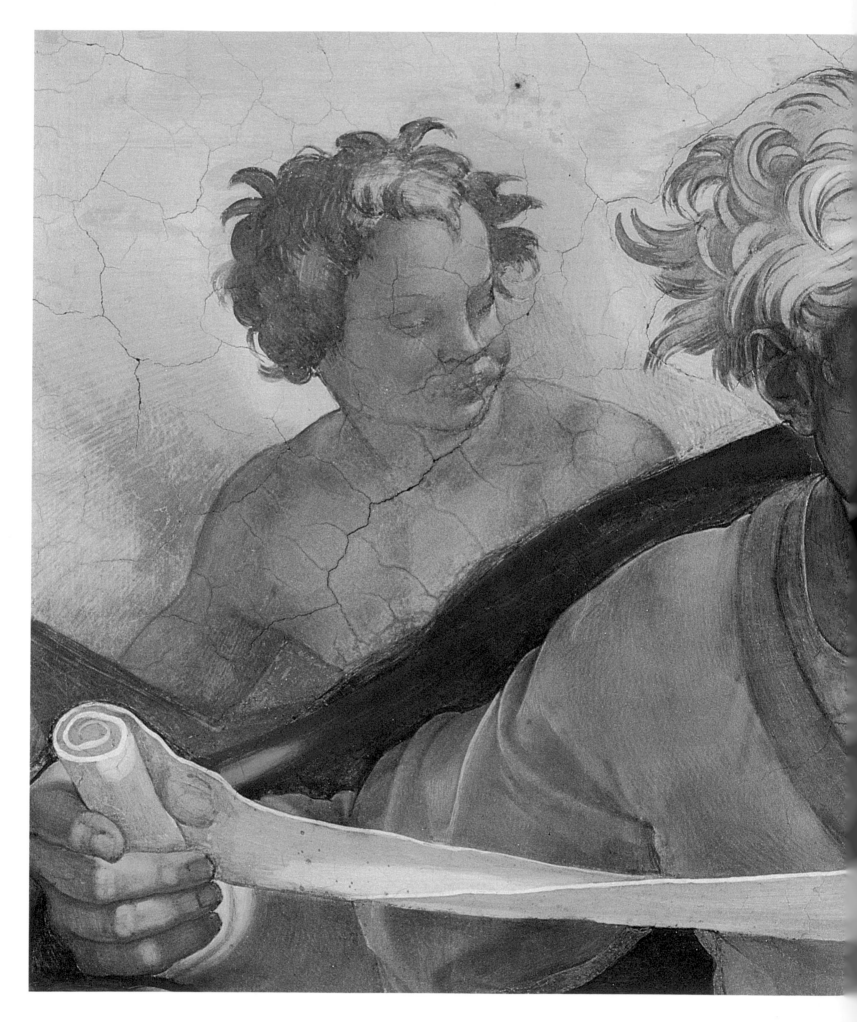

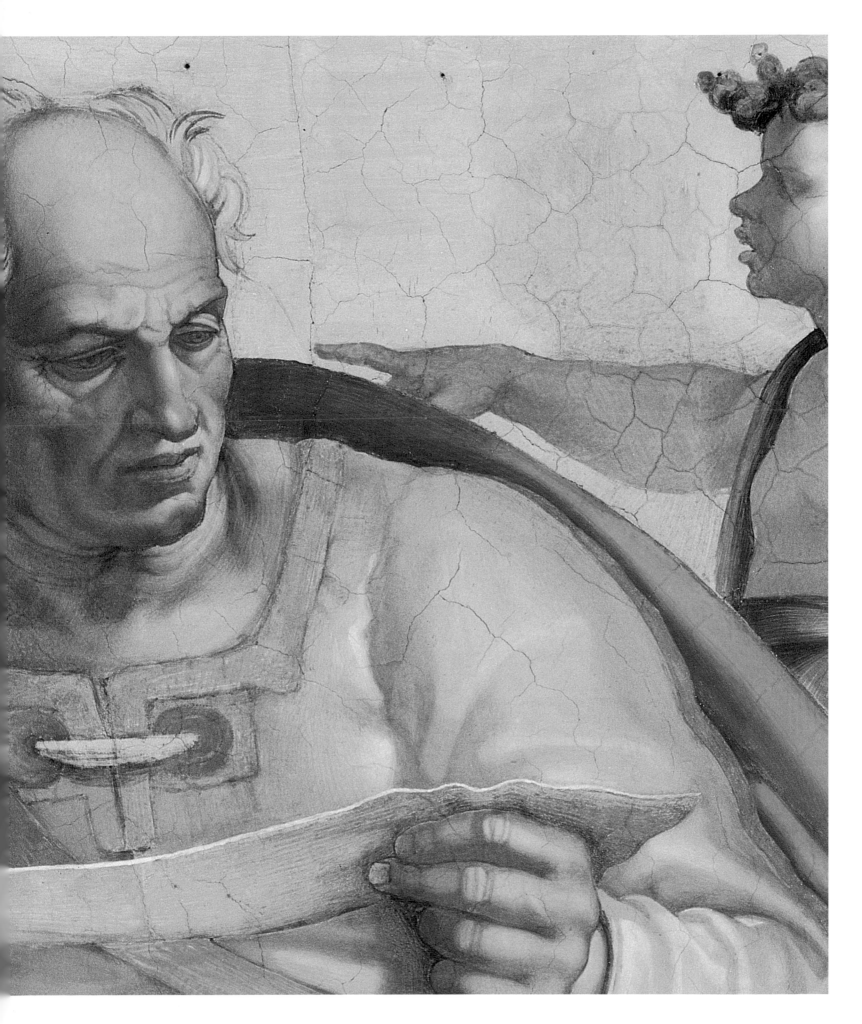

## THE ERYTHRAEAN SIBYL AND ISAIAH

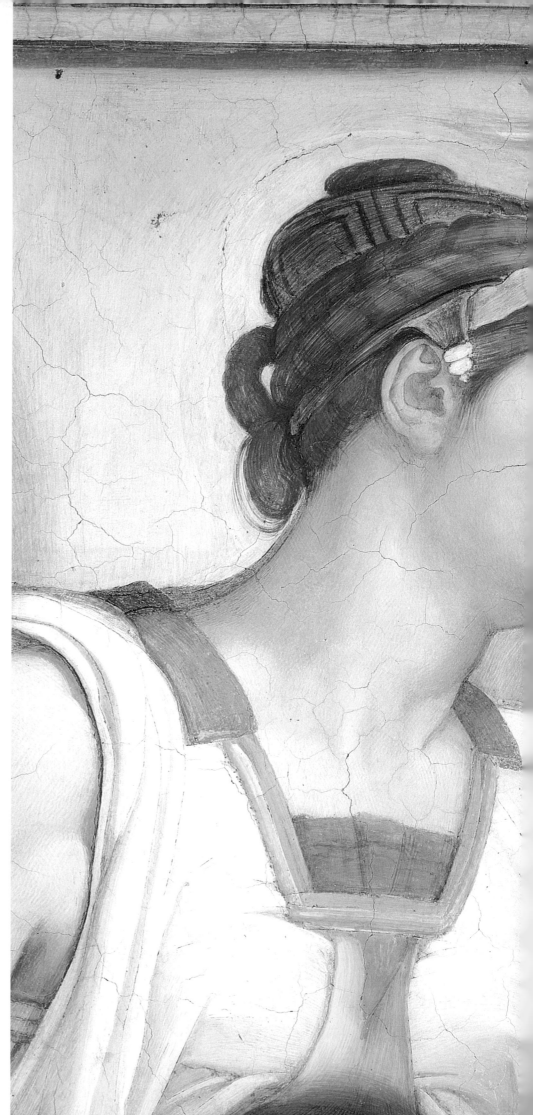

Erythraea and Isaiah flank the Sacrifice of Noah. It is difficult to find a specific oracle that would connect Erythraea, but she has a different kind of relationship that may explain her presence and her placement here. According to legend she had married one of the sons of Noah, who are depicted assisting their parents in preparing the sacrifice in the adjacent panel. She thus links the Sibyls and the Genesis scenes in a unique way. She is young and lovely, shown in a moment preparatory to revelation. She is studying her book while the genius above her lights the lamp that will enable her prophecy. Another genius in the dark rubs his eyes, as if he has just awakened for the important moment to come. In contrast to Erythraea, Isaiah is outside himself, caught in the very moment of ecstasy. He was the prophet most closely associated with messianic prophecies, so his presence here is inevitable. Exactly why he was placed in this bay is not known. He has been interrupted in his reading and still holds his place in the book beside him. A very animated genius with wild curls and scarf flying behind him gestures in the direction to which Isaiah has turned his head; it is as if this is where the revelation is coming from. His body is taut with concentration. He half closes his eyes and furrows his brow to bring the vision into focus.

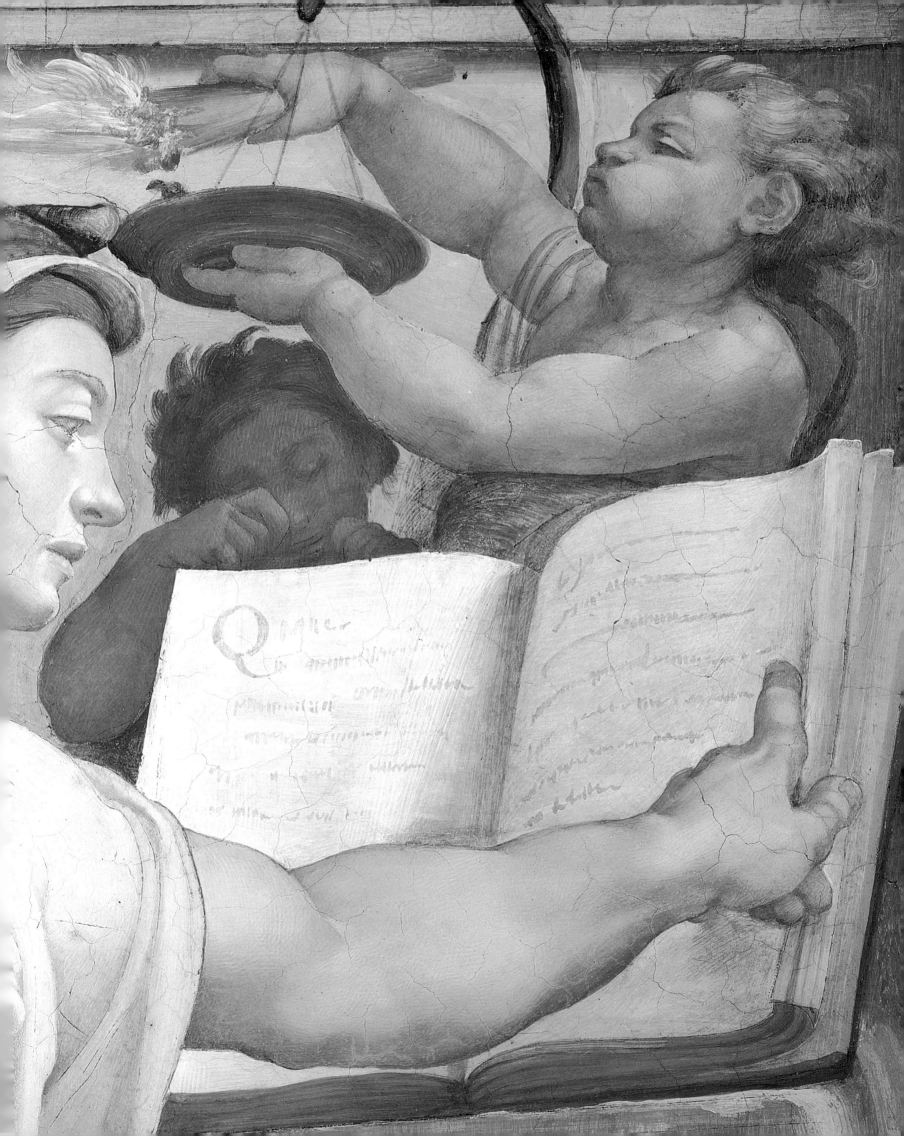

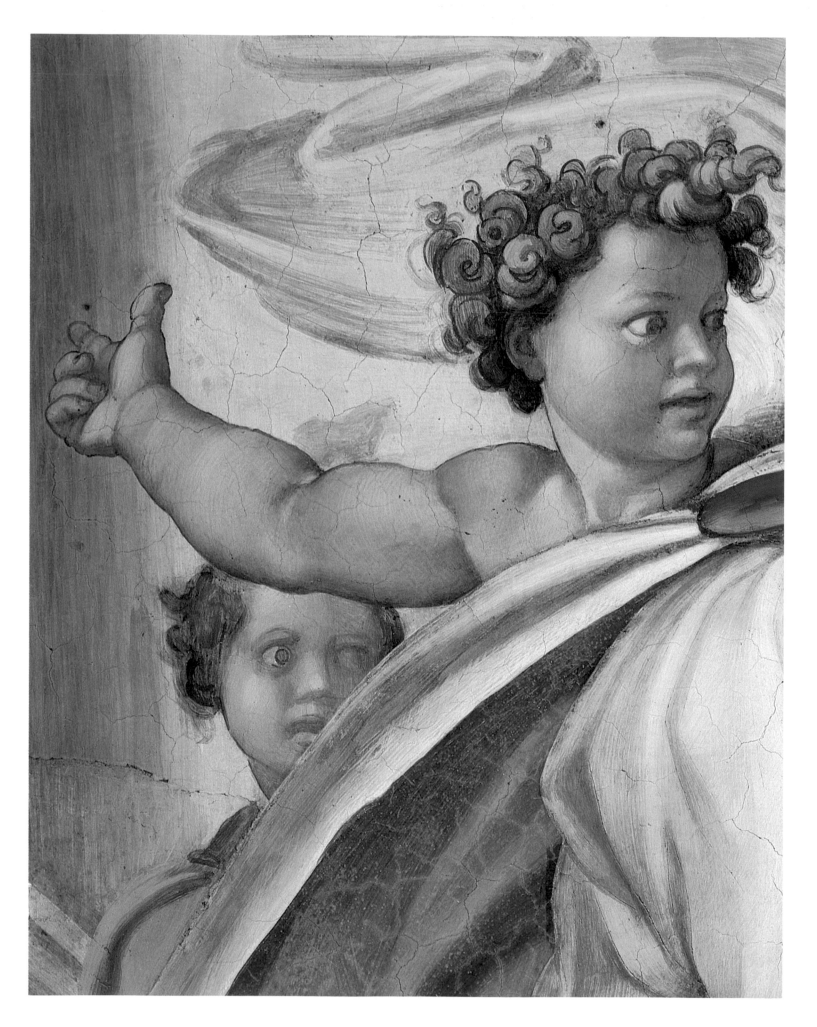

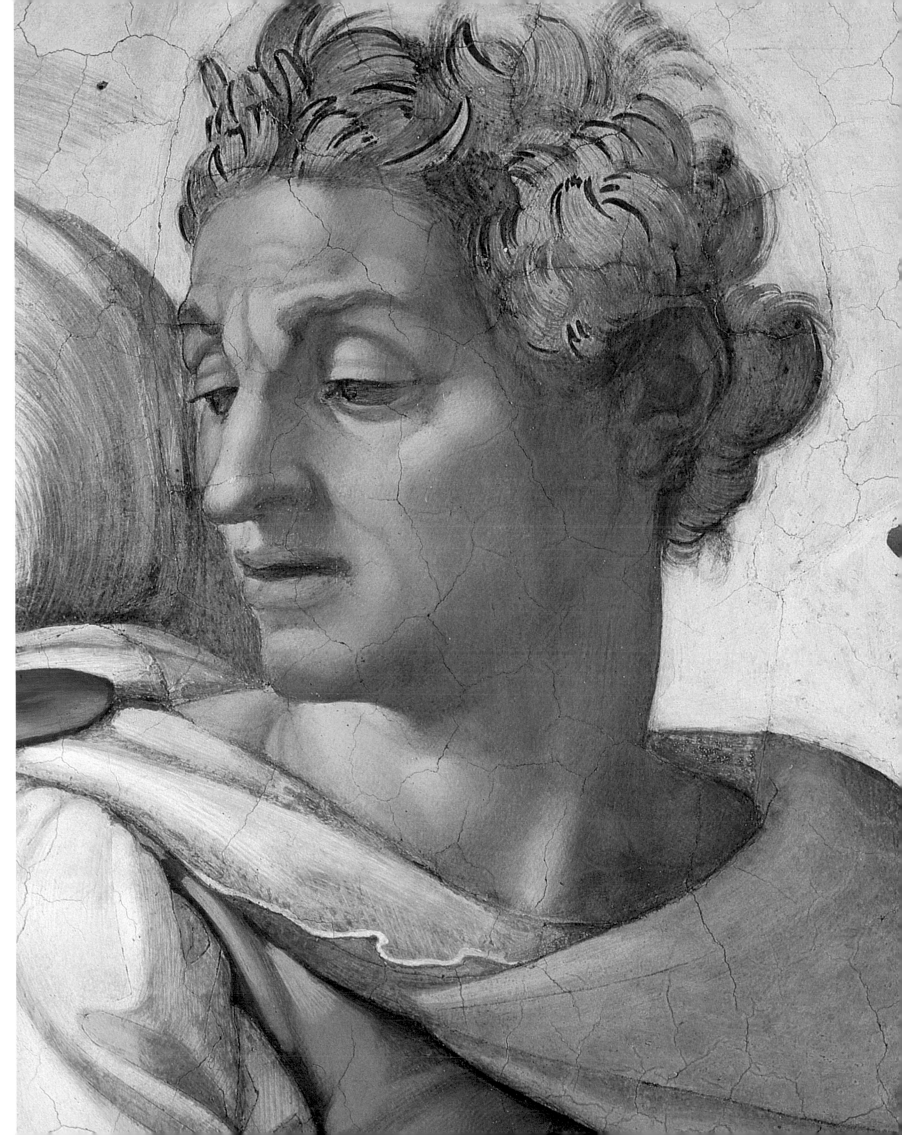

This pair flank the Creation of Eve. The choices are the most lucidly relevant to one another in the series because they both refer to the Church. Cumae was the Sibyl most closely associated with the Catholic Church and its mission. Virgil associated her in his Fourth Eclogue with the golden race that would rule the world. "Now is come the last age of the song of Cumae; the great line of the centuries begins anew. Now the Virgin returns, the reign of Saturn returns; now a new generation descends from heaven on high. Only do thou, pure Lucina, smile on the birth of the child, under whom the iron brood shall first cease, and a golden race spring up throughout the world." Cumae is depicted as an ancient crone in keeping with the story that she was beloved by Apollo, who granted her as many years of life as she had grains of sand in her hand, but he did not grant her eternal youth to go along with it. Her huge arms, shoulders, and breasts are still muscular and not withered like her face, but her eyes are as old as her visage, for she holds her book at a distance and strains to see the text. The patiently attentive genii stand by and observe, ready to offer another tome, for no revelation is imminent. Ezechiel, opposite her, is on the brink of ecstasy. His scarf is swept over his shoulder as he turns abruptly aside in response to what he has just read in the scroll that he has dropped from his open hand. He seems about to rise to his feet, and the genius behind him points up, signifying that divine inspiration is at hand. He, too, is appropriately placed beside Eve, who signifies the Church, for his prophecy concerned the purified temple, filled with the glory of God. The exact midpoint of the chapel, and the point at which the chancel screen originally divided the chapel, is marked by a triple reference to the Church. All the sources converge in announcing the inauguration of the era of the Church to guide the world toward the final glory.

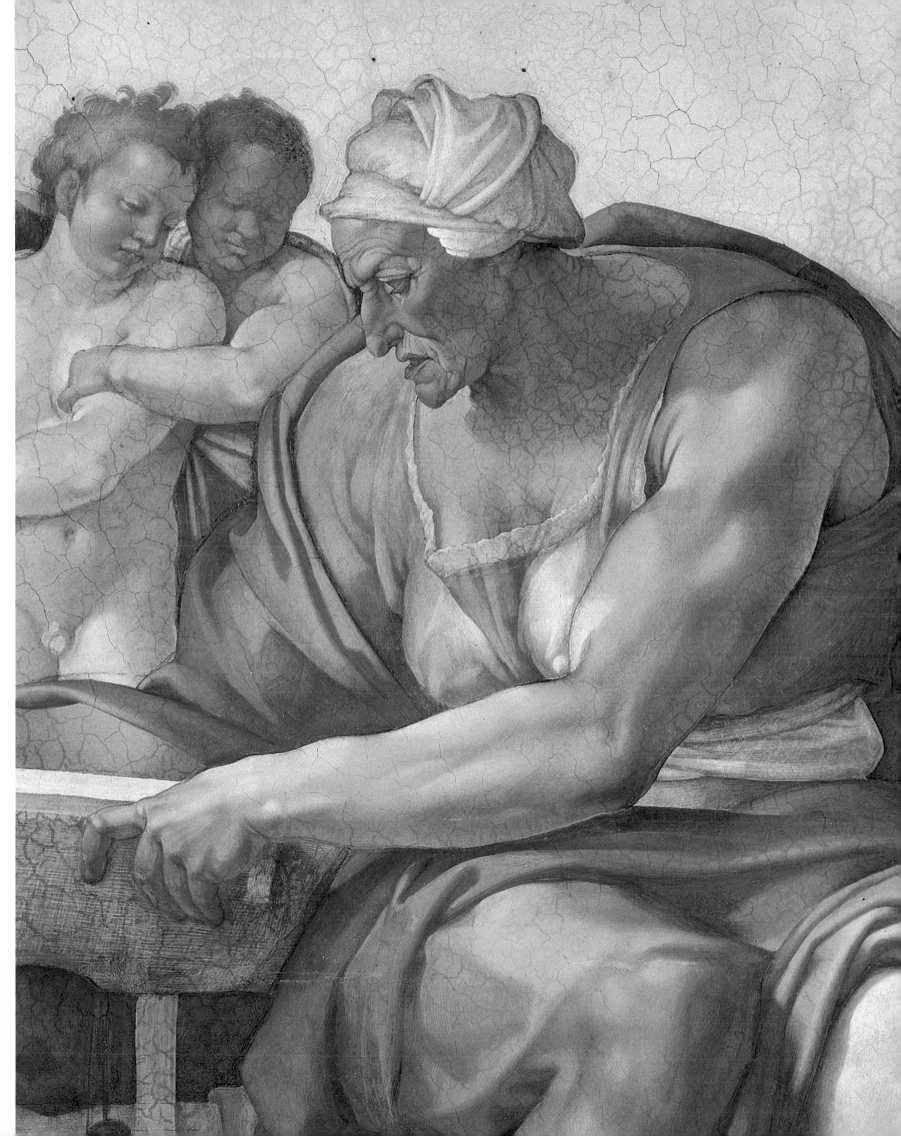

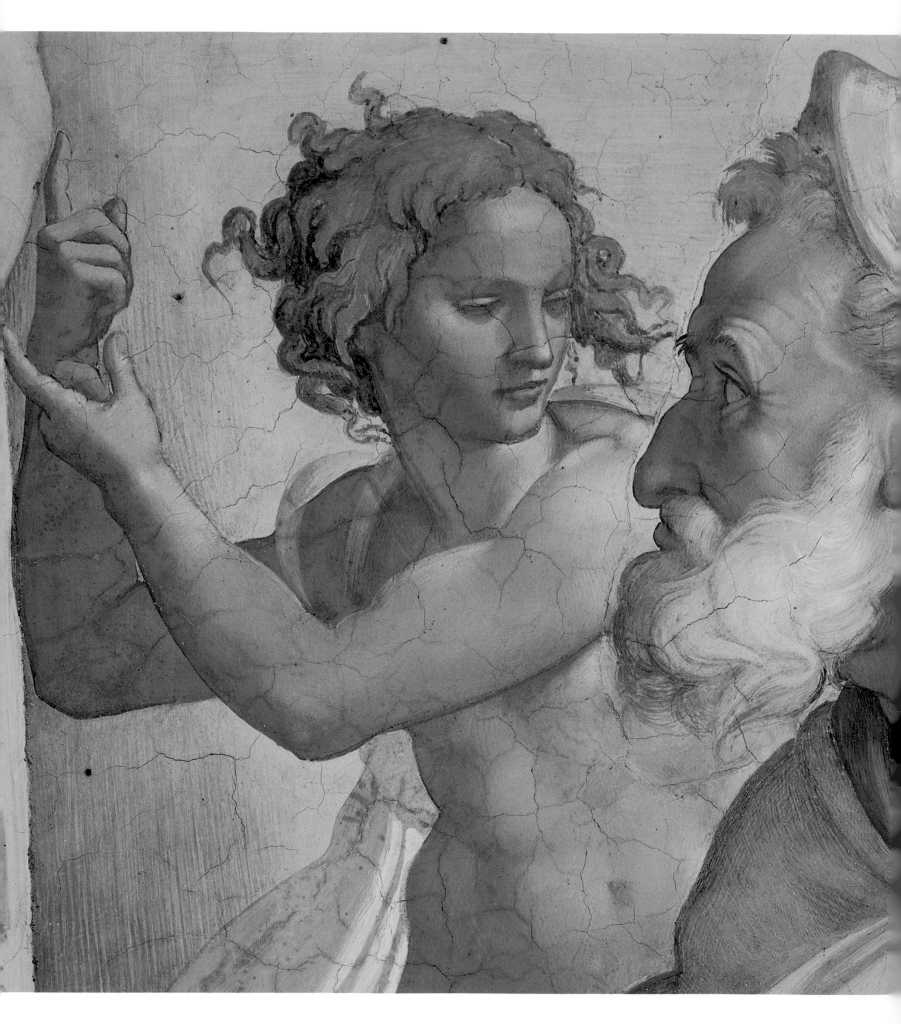

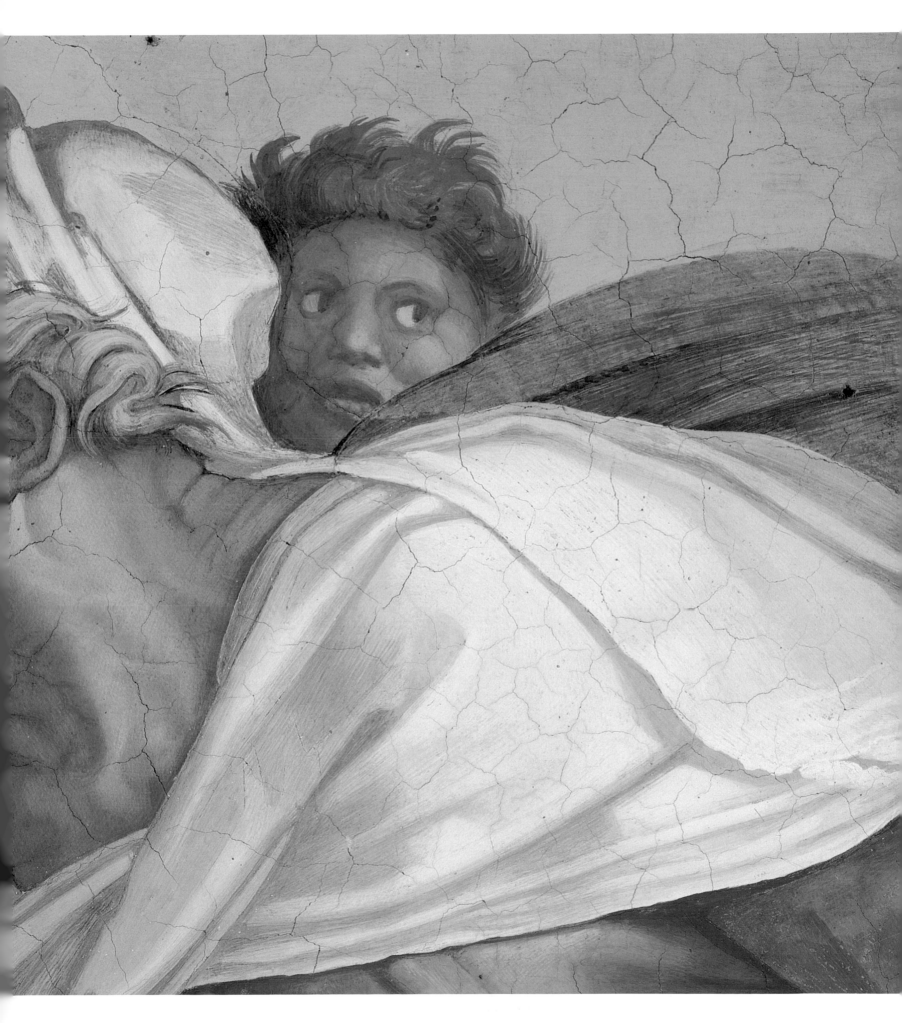

These Seers flank God separating the Earth from the Waters. Their prophecies concerned the Second Coming of Christ at the time of the Last Judgment. The Persian Sibyl prophesied a beast like that of the scriptural Apocalypse. Michelangelo imagined her as a wizened hunchback who has become myopic with age. She pores over her little book, holding it up to her nose. She turns away from the light, and her face is shaded. Her genii are likewise quiescent and waiting.

Daniel was renowned as the prophet of the Son of Man appearing in glory: "I saw a vision of the night, and behold, there was one coming with the clouds of heaven like a son of man; and he came to the ancient of days and was brought forward in his presence. And to him was given sovereignty, honor, and kingship; and all peoples, tribes and languages will serve him. His power is an eternal power that will not pass away and his kingdom will not be destroyed." (Dan 7:13–14).

In Michelangelo's conception Daniel is titanic. He is shown in the act of writing, with a book held open on his lap, supported from below by his genius. His face is full of concentration, his energy suggested by the active pose in which one foot is drawn sharply forward; his shoulder has dropped to allow him to reach toward his desk. This impression of energy is enhanced by the torsion in his pose and the strong cangiante from green to yellow in the drapery on his knee.

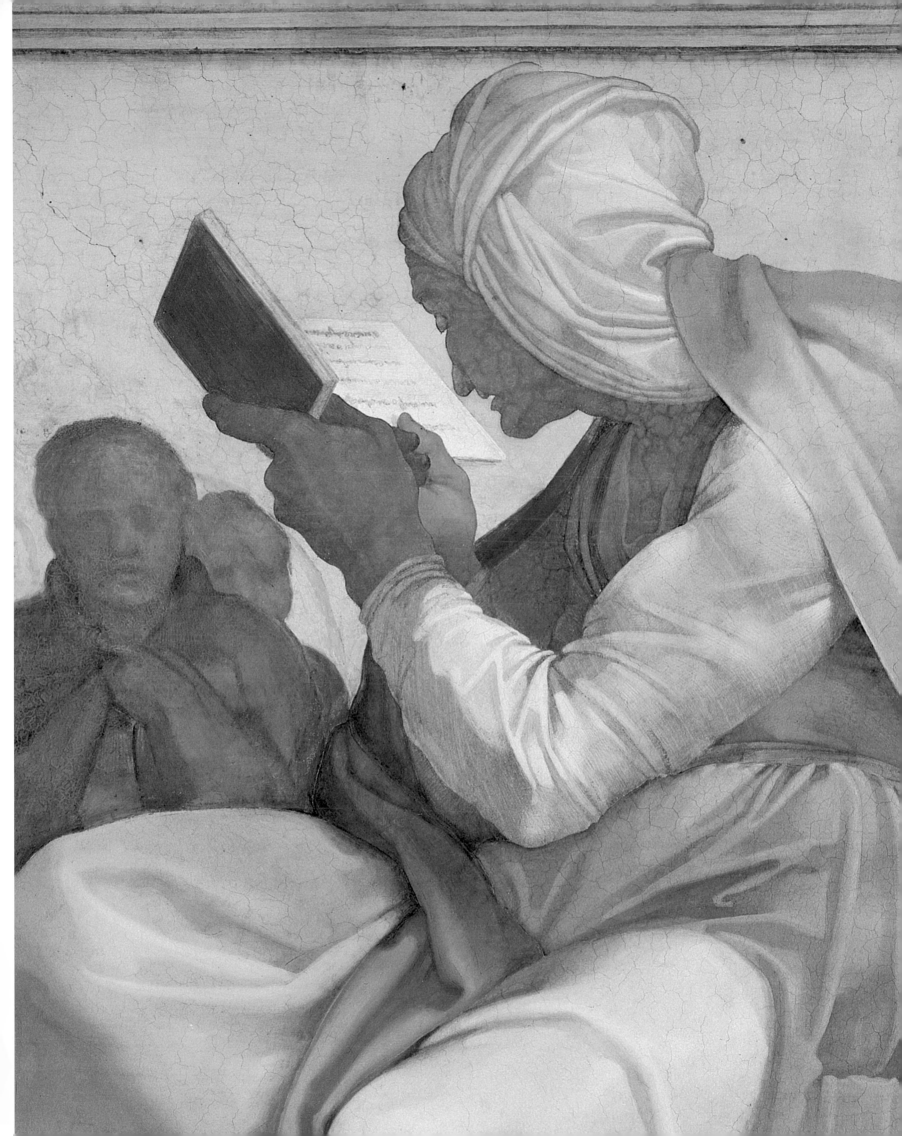

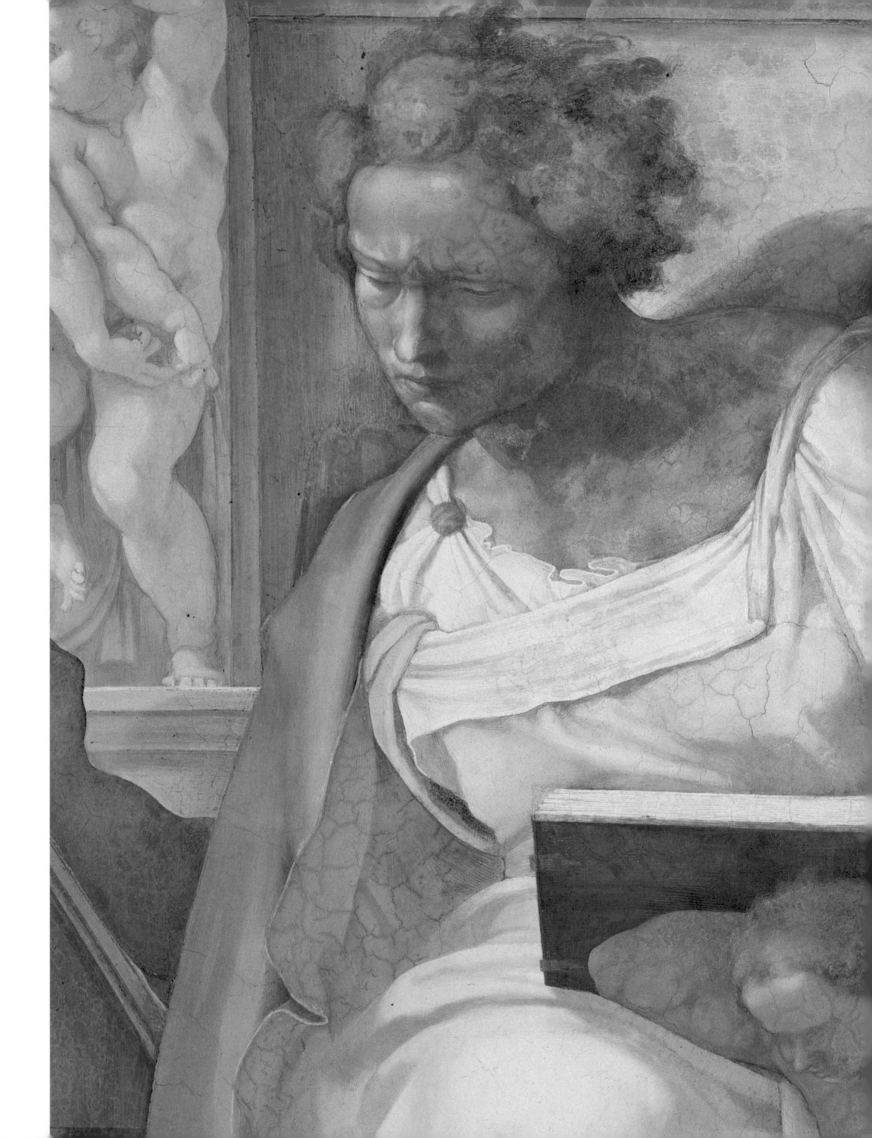

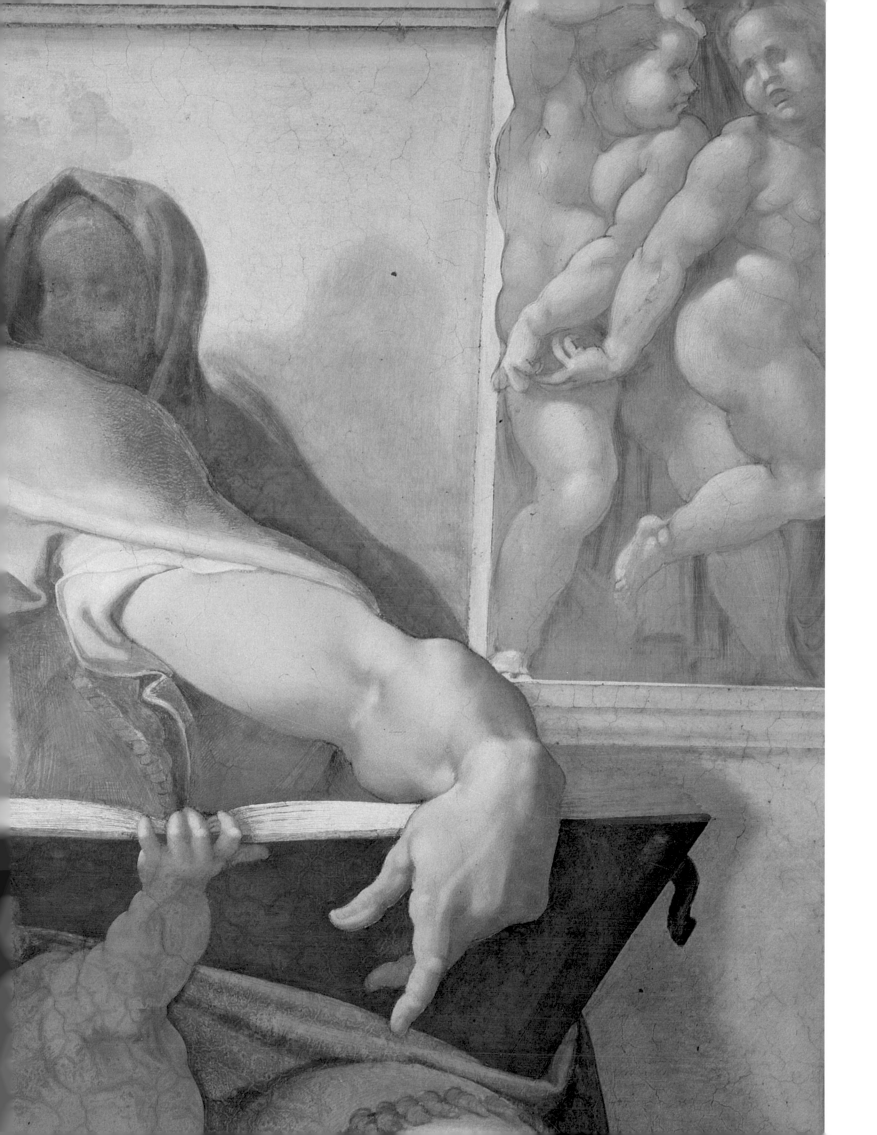

## THE LIBYAN SIBYL AND JEREMIAH

The final pair of Seers is placed alongside the first scene of Creation. Their prophecies, like those of Daniel and Persica—and of Jonah on the altar wall—have to do with the end of time. They are paired, in fact, in the most important Renaissance text, Filippo Barbieri's *Discordantiae Sanctorum Doctorum Hieronymi et Augustini*, which was certainly one of the principal sources used in shaping the Sistine program. Libica's oracle applied to the Final Day: "Behold the day shall come, and the Lord shall lighten the thick darkness [as the Creator is doing in the adjacent panel], and the bonds of the synagogue shall part, and the lips of men shall be silent; and they shall see the king of the living."

If the Last Judgment was planned for the altar wall at the time of Julius, then indeed "the king of the living" would have been at hand in the figure of Christ, as he is today in Michelangelo's *Last Judgment*. The Libica twists behind herself to lower her heavy book onto the shelf. She seems lost in thought, contemplating what she has just read. Her splendid pose is as ornamental as the *cangianti* colors that adorn her drapery. Jeremiah, opposite, is also lost in thought, but his gesture of head resting in his hand suggests the melancholy that is associated with the prophet, who was then believed to have authored the Book of Lamentations. His resignation, so atypical of the other Seers, is conveyed throughout his pose, with hand falling idle in his huge lap and feet crossed. This is one of the few areas of the vault where water damage caused a significant loss. The back of the prophet's head, where the color darkens, was replaced in the 1560s, when the painter matched the color to the darkened tone that he found.

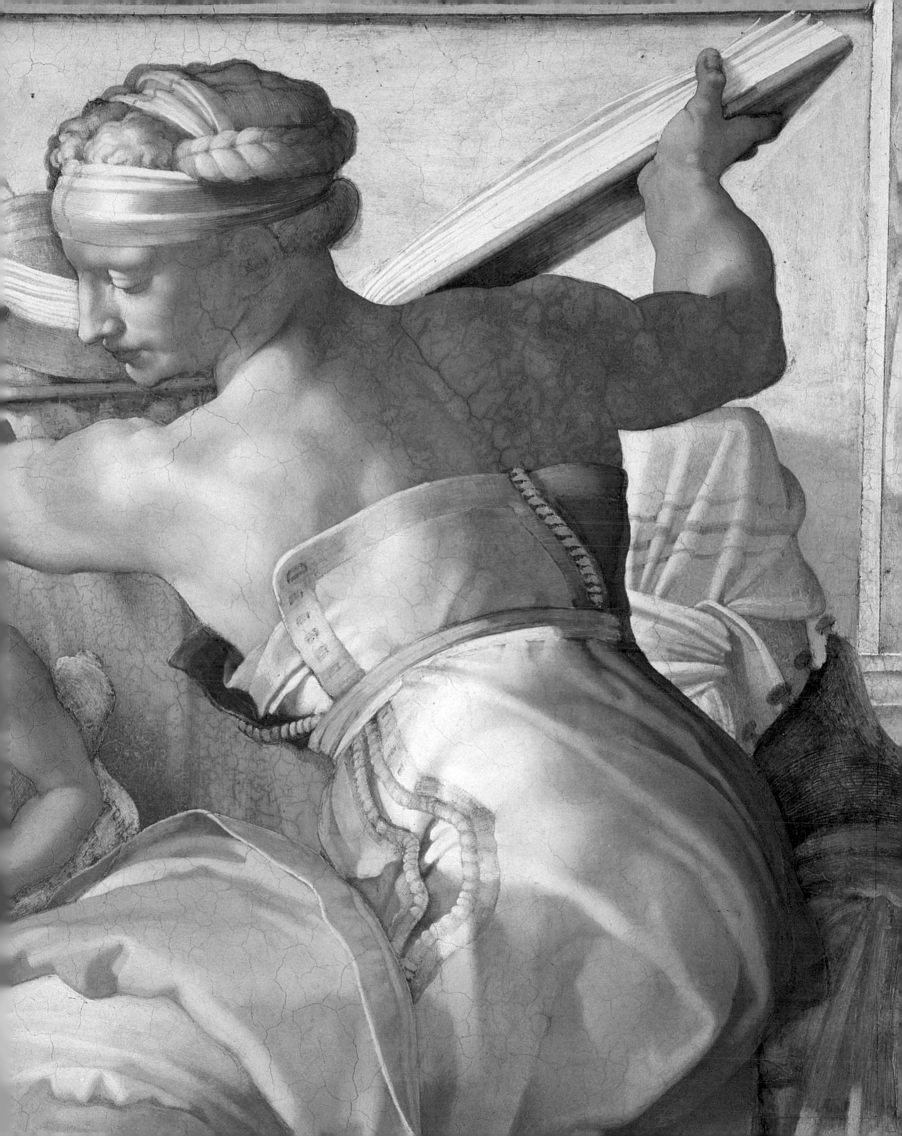

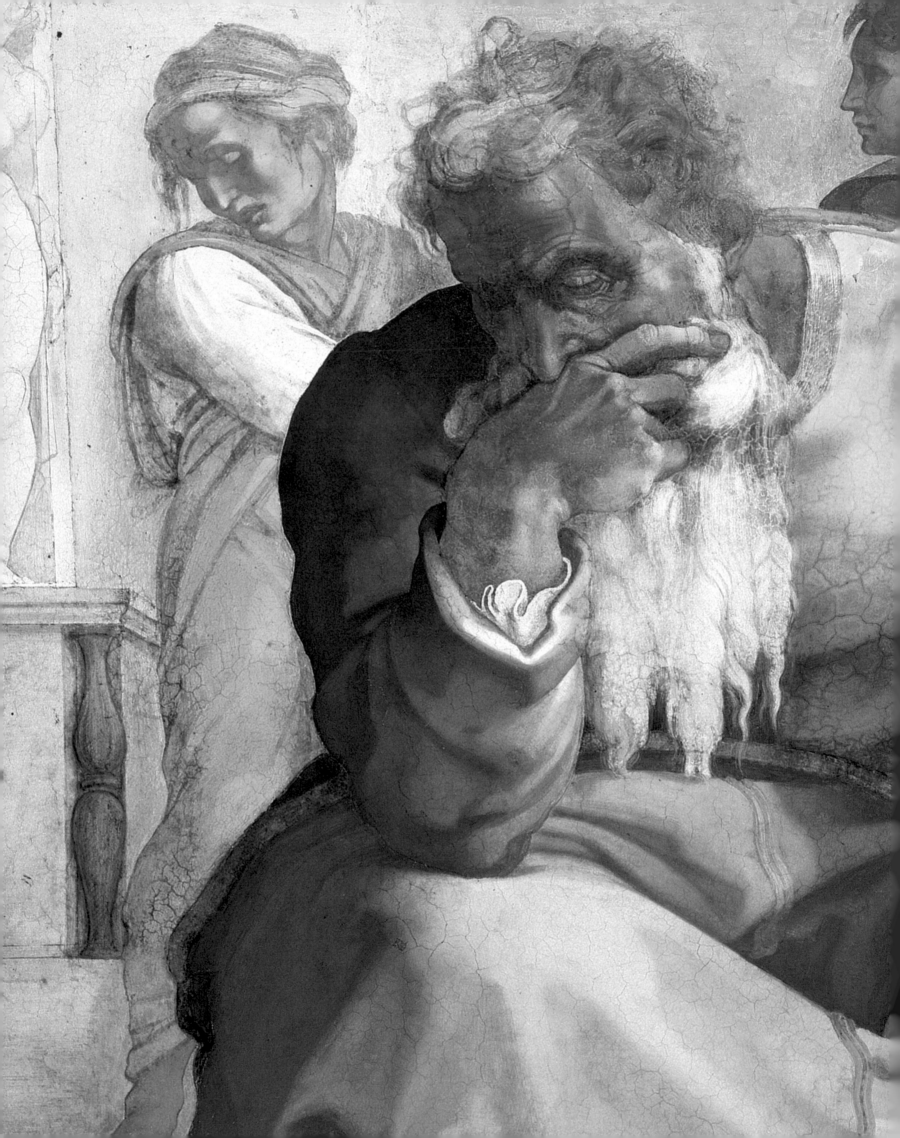

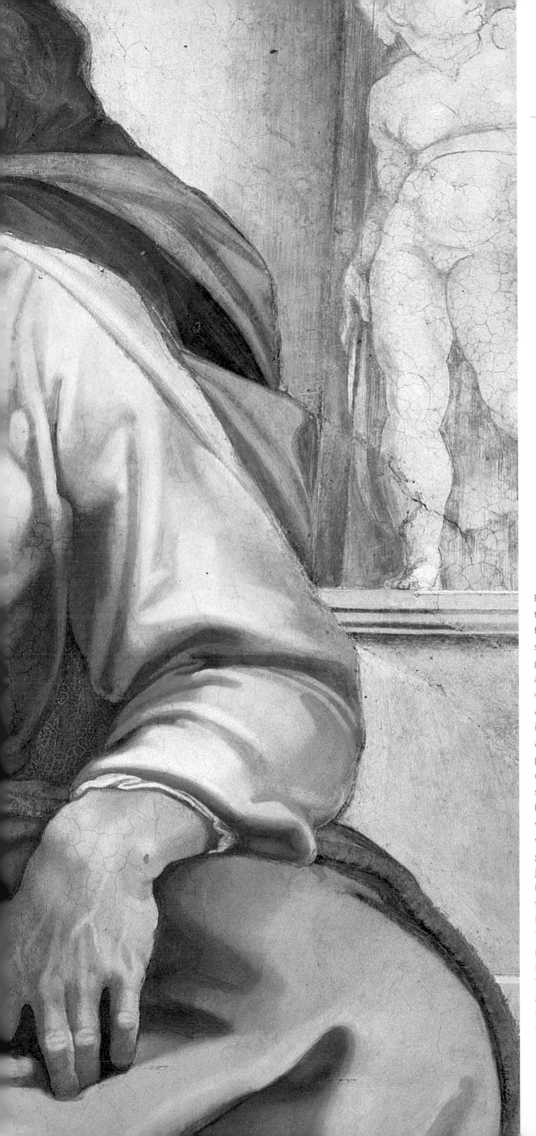

Placed over the altar, Jonah is the first figure the viewer sees from the entrance. Huge in scale and wildly abandoned in gesture, he has commanded awe since the chapel was first visited. His placement above the altar seems preordained, for he is the prophet most closely associated with Christ. The presence of his whale reminds us that he spent three days swallowed by that beast before being regurgitated. Thus, Jonah was seen as a type of Christ, who spent three days in the grave before his resurrection. Jonah throws his upper body backward and turns his head up to look at God separating the Dark and the Light above him. The swift vehemence of his posture suggests that he is seen in a moment of rapture.

The Cinquecento writers were awed by the technical tour de force of this figure. The sharply foreshortened body moves back on an oblique line where the vault itself curves forward. As if to show off the pose in miniature, the painter has arranged Jonah's hands steeply foreshortened. In color, too, Jonah is an appropriate climax to the vault with his bold *cangiante* contrast of green and the same reddish purple that had been used for the Creator's robe. In any number of the details the vault decorations seem to anticipate the placement of the *Last Judgment* on the altar wall. According to Vasari, Julius's plan had been to have Michelangelo paint it there, and to complement it with the *Fall of the Rebel Angels* on the entrance wall. Jonah, with his connection to resurrection, is the ideal choice to sit above the Final Resurrection just as the Brazen Serpent in the spandrel to the right anticipates the *Last Judgment* in its division of the saved from the damned.

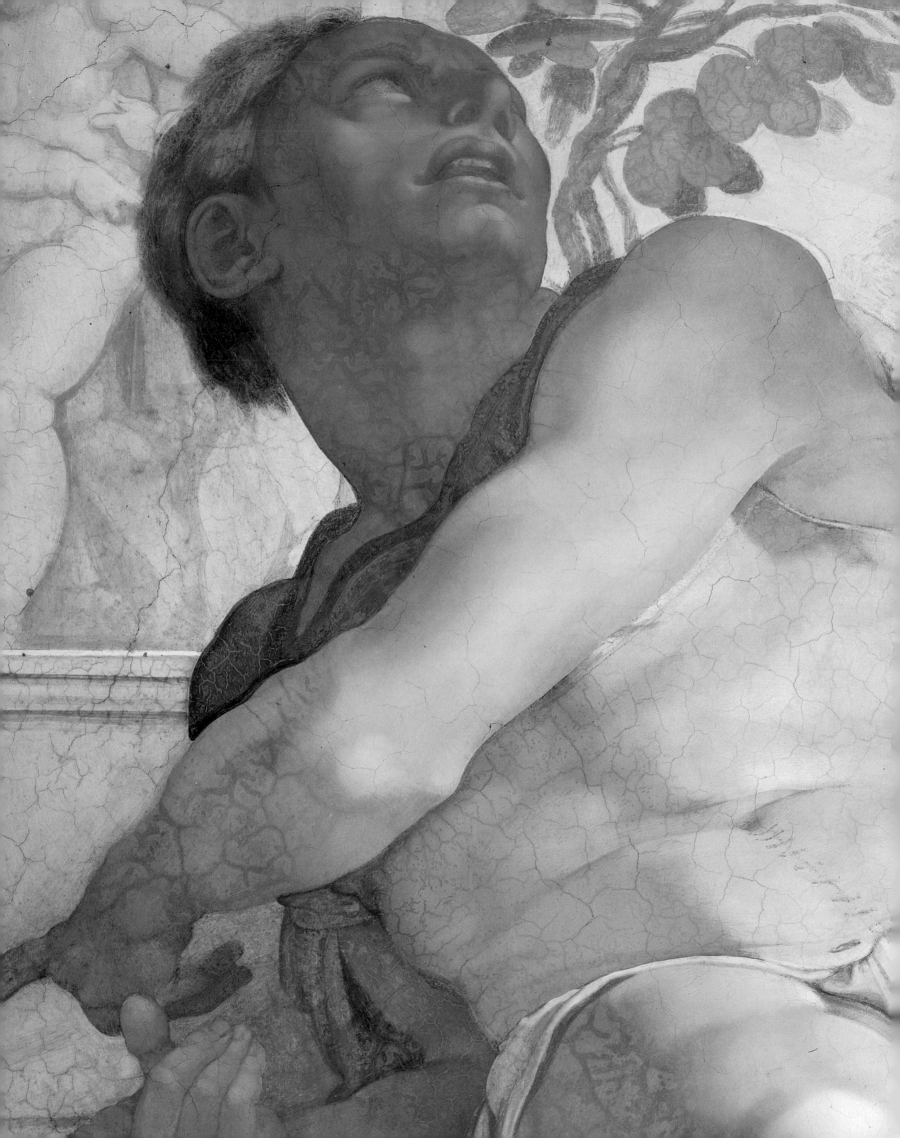

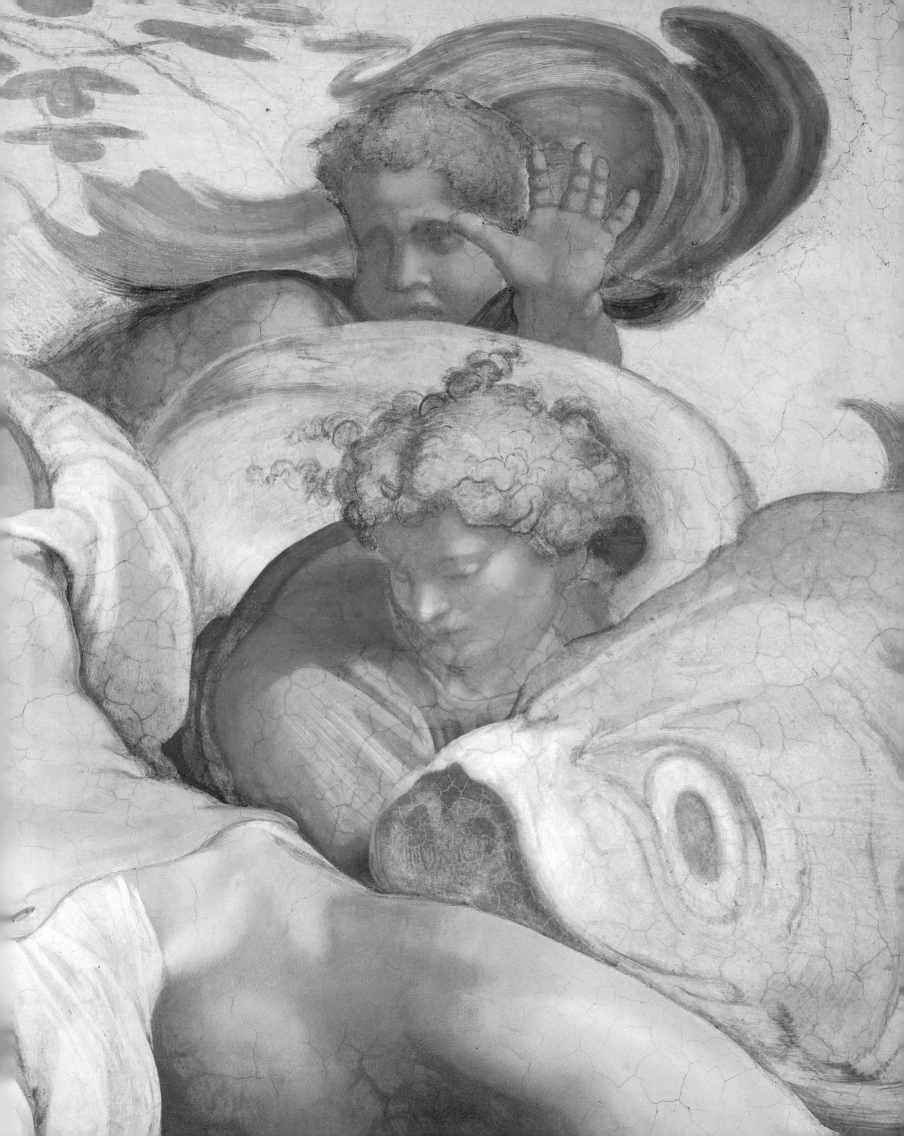

# THE LUNETTES

# THE ANCESTORS OF CHRIST

T he lunettes on the sidewalls above the windows, and the severies above them, are filled with the Ancestors of Christ, named in the first chapter of Matthew. Thus these figures link the Old Testament and the New, Abraham and Jesus Christ. They are identified by the names on the plaques at the center of each lunette.

The sequence began originally on the altar wall, but when it was rebuilt to receive the *Last Judgment*, Michelangelo had to oversee the destruction of two of his Ancestor lunettes. The series alternates from side to side, proceeding to the entrance wall. It concludes with the generation of Jacob, who "was the father of Joseph the husband of Mary, of whom Jesus was born, who is called Christ" (Mt 1:16).

The Ancestors had never been represented in such a manner before. In the Arena Chapel Giotto had shown their heads in roundels on the vault as a prelude to the life of Mary and life of Christ on the walls. But no one had ever undertaken to characterize them, giving them full figures, grouping them in families, and giving them poses, expressions, activities. It was a difficult task because most of the Ancestors are no more than names on Matthew's genealogy. The painter has emphasized their role in reproduction, carrying on the lineage. Mothers are prominent. One woman is pregnant and points to her womb. One holds a garment in her lap and is cutting a vagina-like slit in it. All have children, except those in the last two lunettes.

Michelangelo's decision to use the lunettes and severies for the Ancestors was an ingenious solution both from the point of view of the total program and that of filling the spaces. Referring as they do to the whole of the Old Testament from Abraham on, they fill the gaps between prophets and link up the vault to the walls below where the story of Christ and the history of the papacy had been represented. As Condivi claimed, Michelangelo painted almost the whole of the Old Testament.

Interpretations of the Ancestors differ. There is agreement that they are somber and that they appear to be idle or passing the time. The program of the cycle would suggest that they are waiting for the Messiah.

Esther Gordon Dotson draws a distinction between the Ancestors in the triangular severies and those in the lunettes. She sees them as citizens of the opposed Cities of God and Man. Those in the severies are united in tight, harmonious family groups, whereas those in the lunettes are hostile, absorbed in their own activities and in themselves. Men and women on opposite sides of the lunettes turn away from one another. Not one pair faces each other. They express suspicion or fear, lassitude, or even despair. Dotson interprets the families in the severies as pilgrims on the journey to the City of God. They are unencumbered with household furniture; they

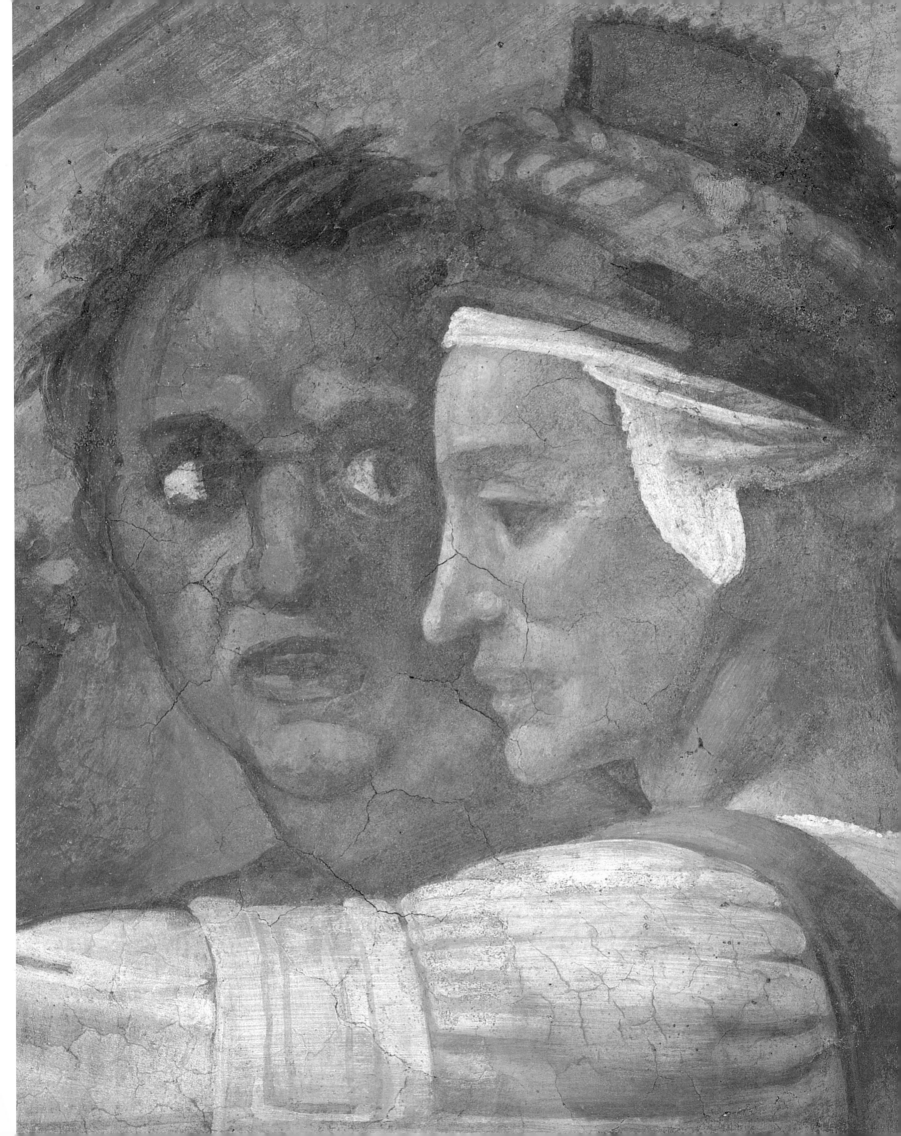

sit on the ground and carry their meager possessions in bundles. They look beyond the pleasures of this world to those of the Heavenly City. Those in the lunettes are domiciled. They have bits of furniture; they sit on stone seats or lean on walls. Many are taken up with domestic activities: cooking, minding the children, combing their hair, looking in a mirror, and perhaps keeping the books. They are preoccupied with concerns of this world, the city of man. We should not expect that the people of the City of God will appear more happy or joyous than the others. Augustine points out that citizens of the City of God experience the same feelings as those in the unholy city: fear, sadness, despair. The difference is in their focus on God, rather than on things of this world.

The lunettes were shapes that could not easily be adapted to narratives; they were surpassed in awkwardness only by the severies above them. Michelangelo adapted his family groups to the spaces. In the compact triangles the figures sit on the ground, stretching out across the broad base, their heads framed by the sloping sides. In the lunettes they are positioned on either side of the intruding window, all but one seated on stone steps. The curved sides crowd them, forcing some to crouch, others to huddle, giving to all a feeling of compression. Painted rapidly and without cartoons, the lunettes show Michelangelo at his most self-assured. Scholars have sometimes complained that the figures lack energy and that they must therefore reflect the painter's weariness at the end of the second campaign. In fact, it should be argued that they are brilliantly conceived to convey their status as unenlightened vessels bearing the seed of the house of Jesse. It is in their coloring that Michelangelo displayed his genius.

The lunettes had become the dirtiest part of the cycle, probably because candles were placed on the entablature directly below them. The scenes had been so obscured that they received little attention from scholars. The brilliant colors that emerged with the cleaning were unanticipated because the array of *cangianti* contrasts is unprecedented in earlier painting. These figures are in other ways quite ordinary, lacking the grace and beauty of the Seers and the actors in the Genesis scenes, or the energy and freedom of the Ignudi. But in the brilliant color of their raiment they equal and usually surpass those higher on the vault. There are practical reasons for this. The viewer, blinded by the light coming in through the window below, would not be able to discern subtle nuance, but the colors also lend interest to figures that in their features, poses, and activities do little to command it. The colors may symbolize the peculiar role of the Ancestors. They take no pride in their finery; indeed they seem unaware of it, just as they are unaware that they are vessels, links in the procreative chain leading to the Messiah. Traditionally, *cangianti* had been used to distinguish a supernatural being, such as an angel. In every other respect the Ancestors are shown trudging through their lives, indistinguishable from those around them, their special chosen fate known only to the Creator. Only in their colors are they extraordinary.

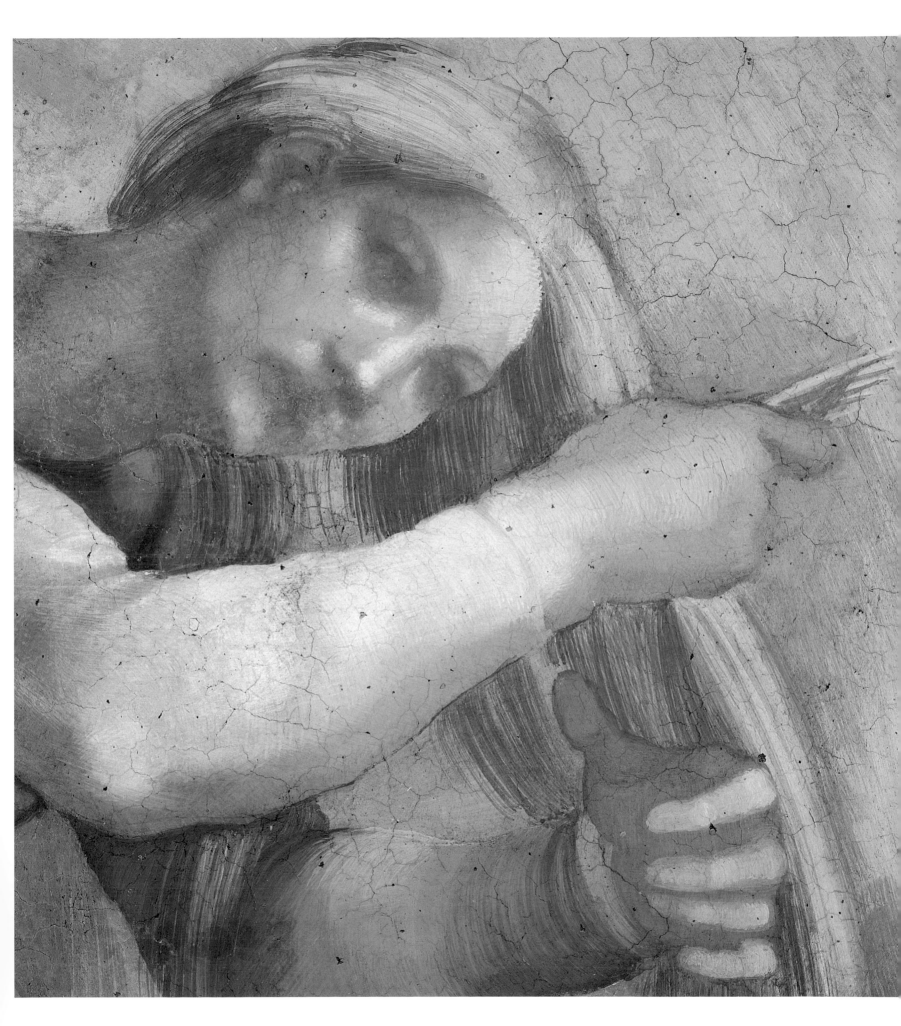

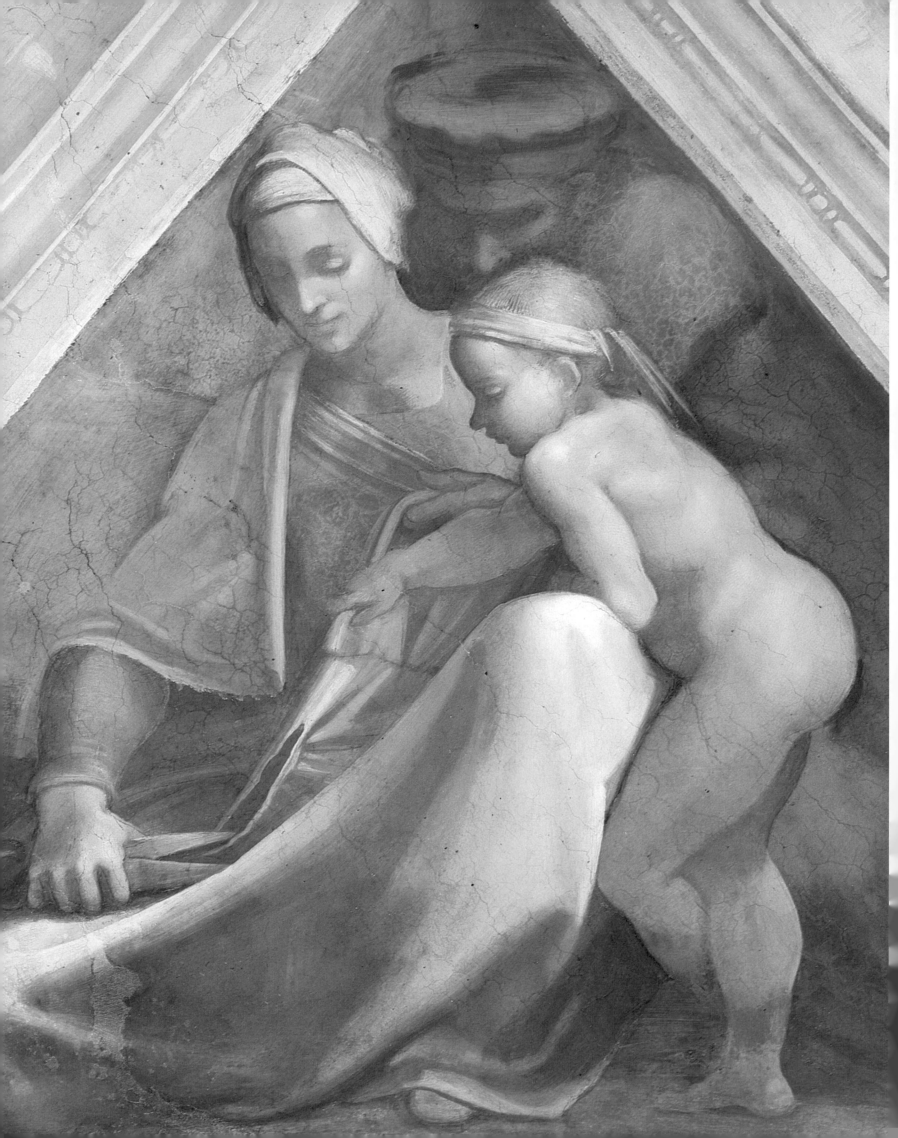

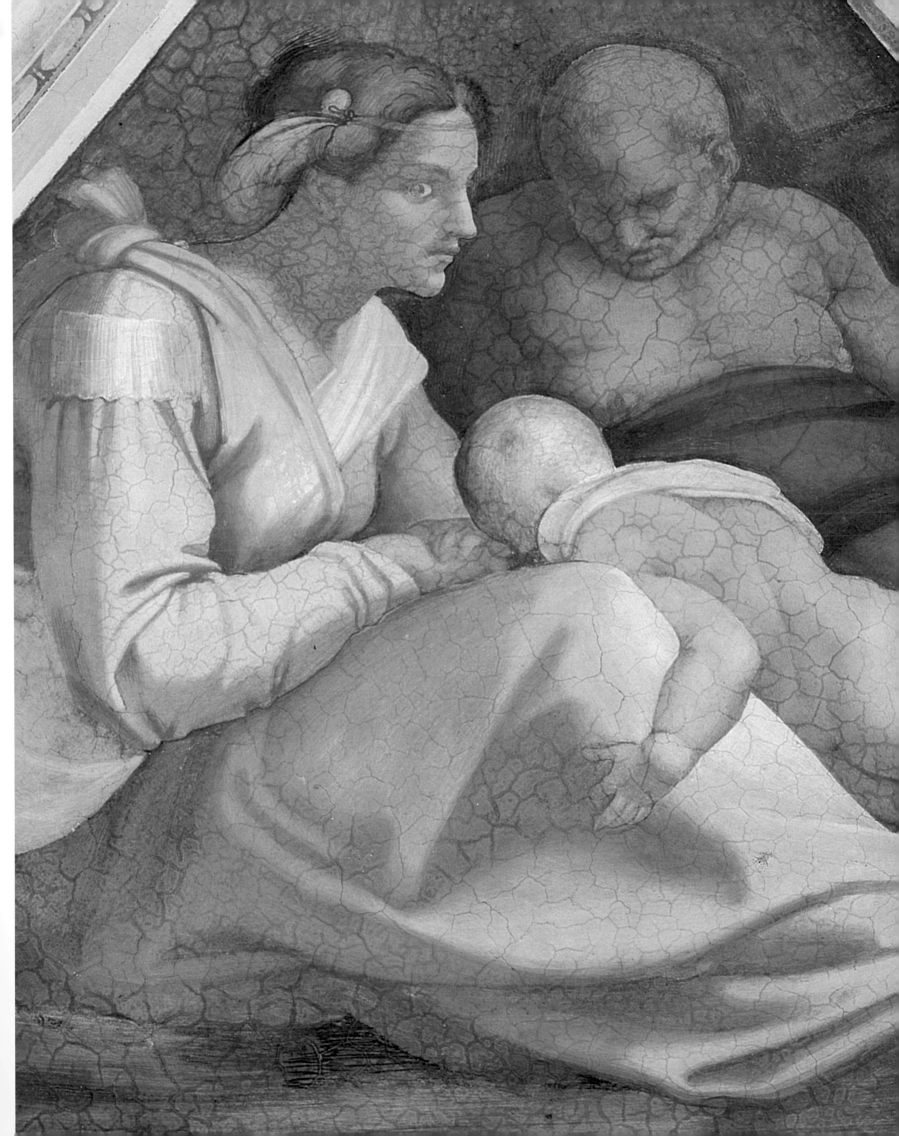

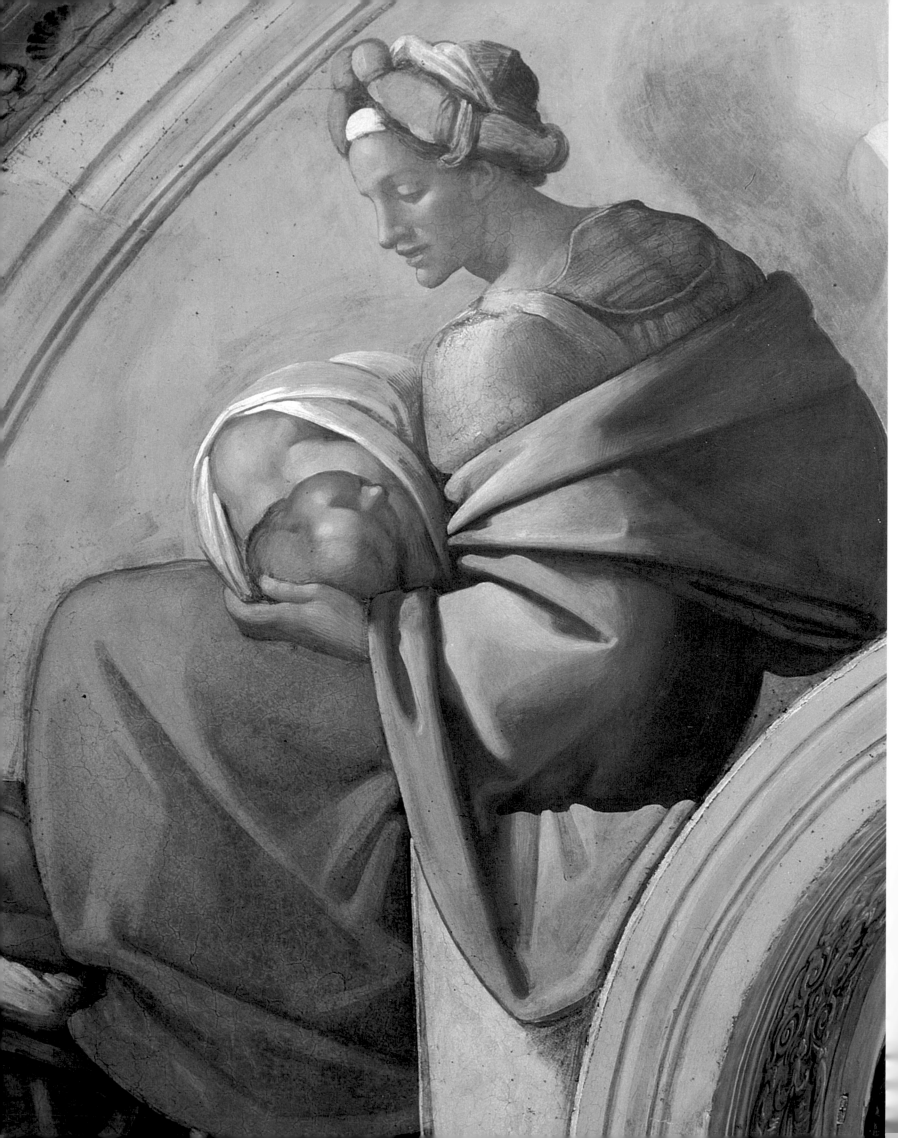

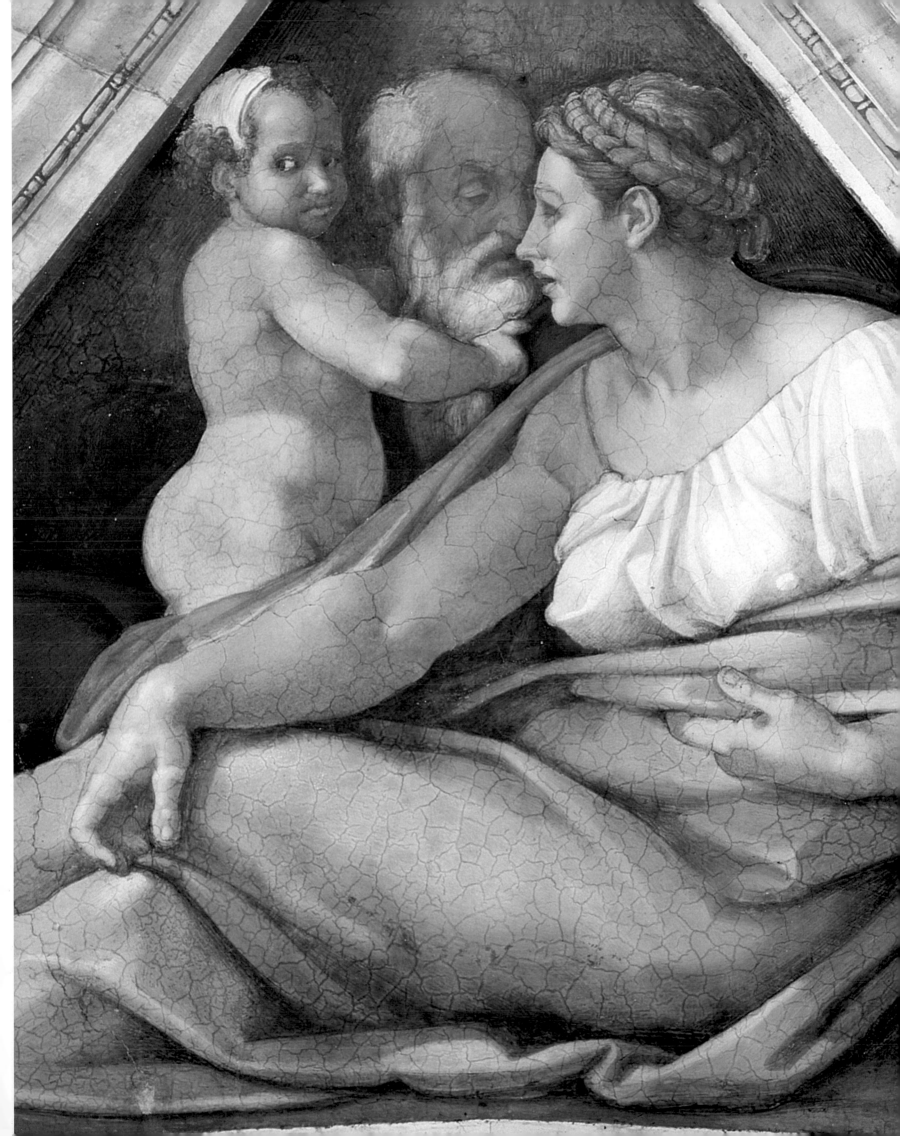

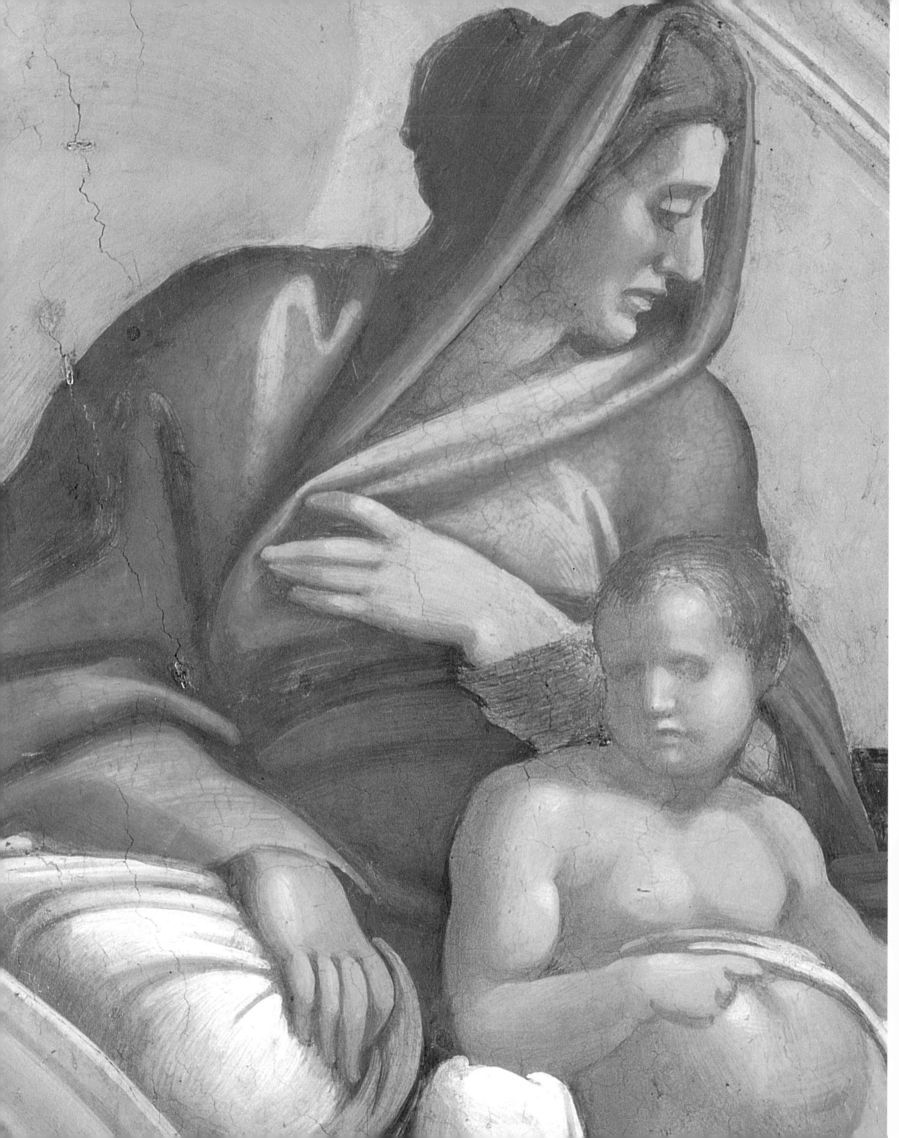

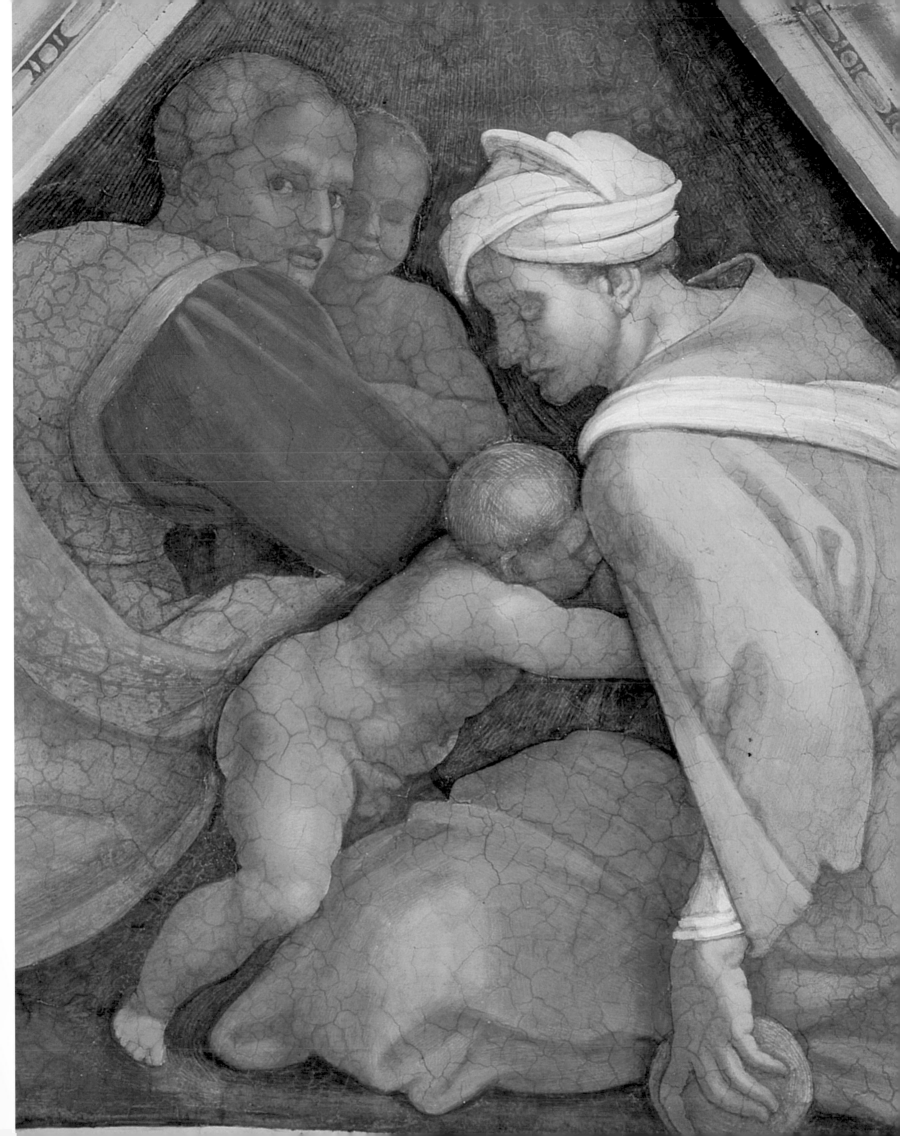

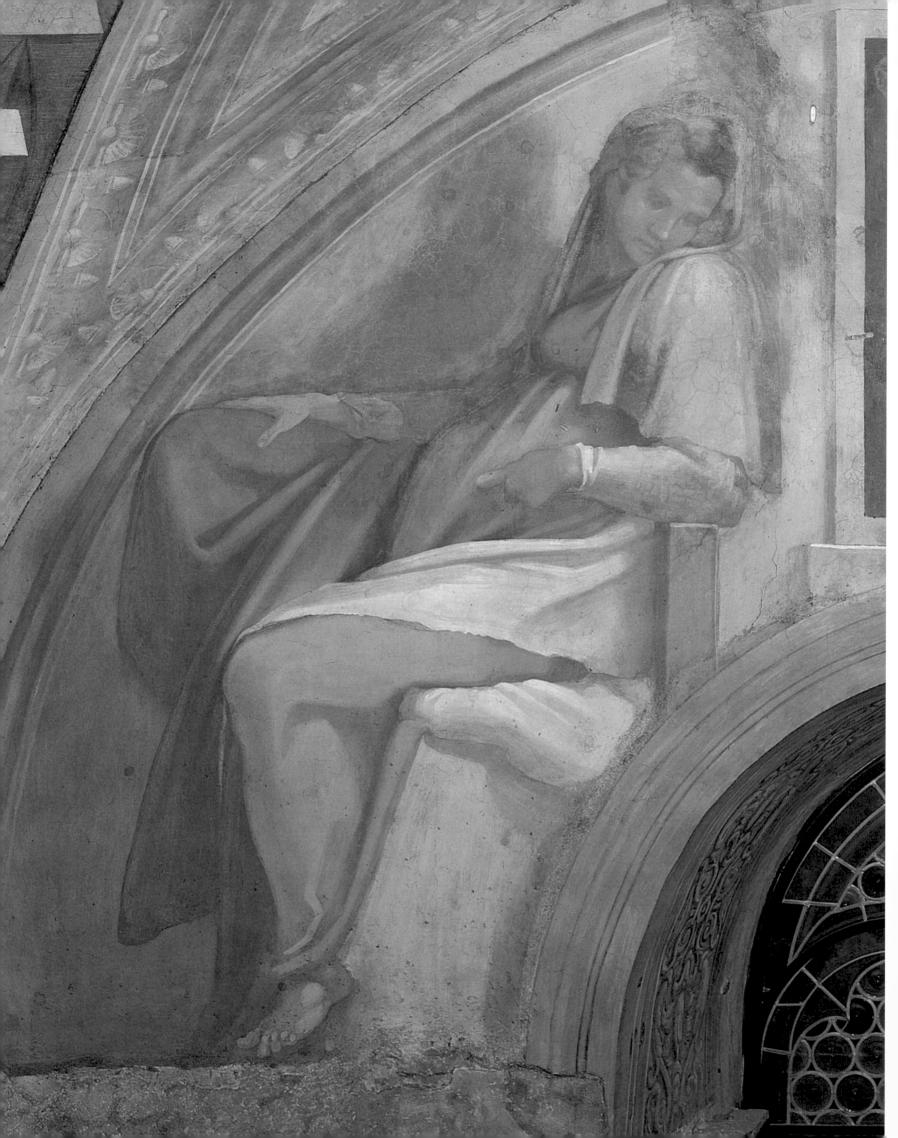

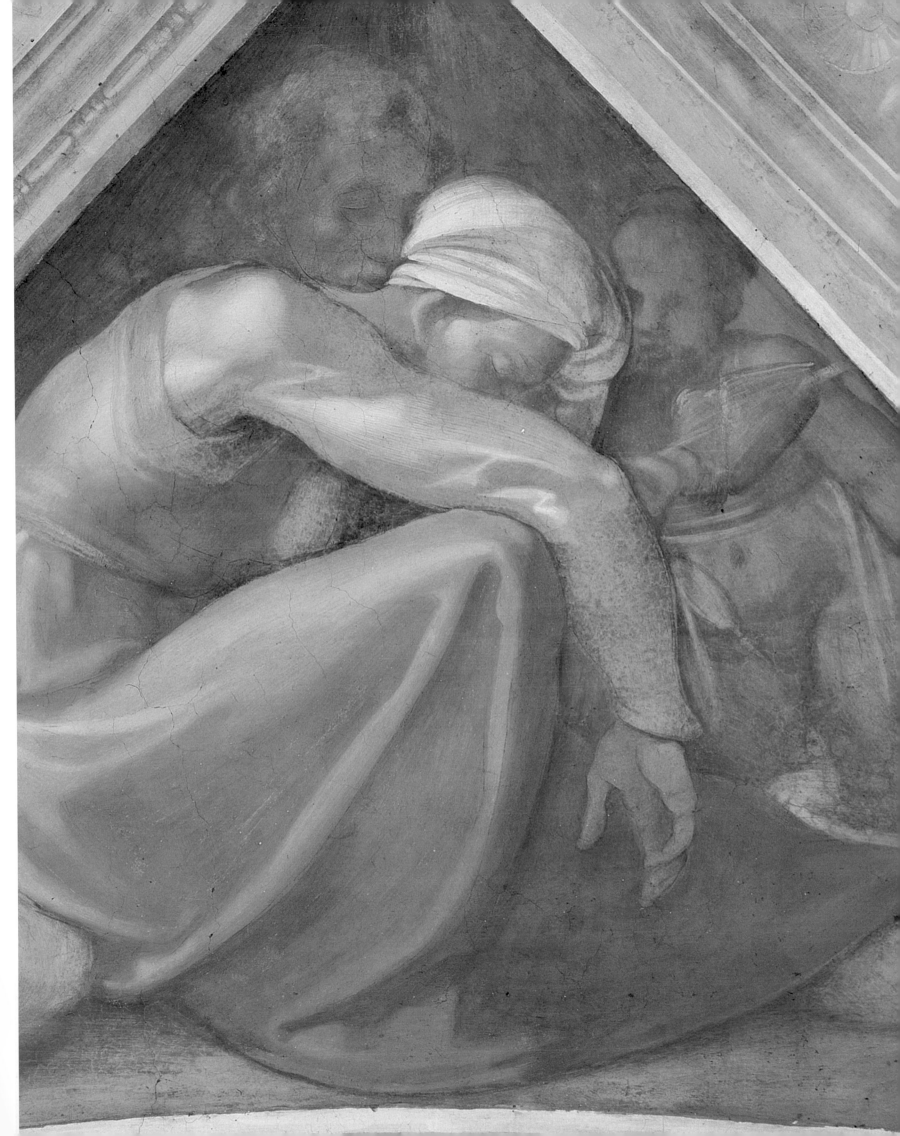

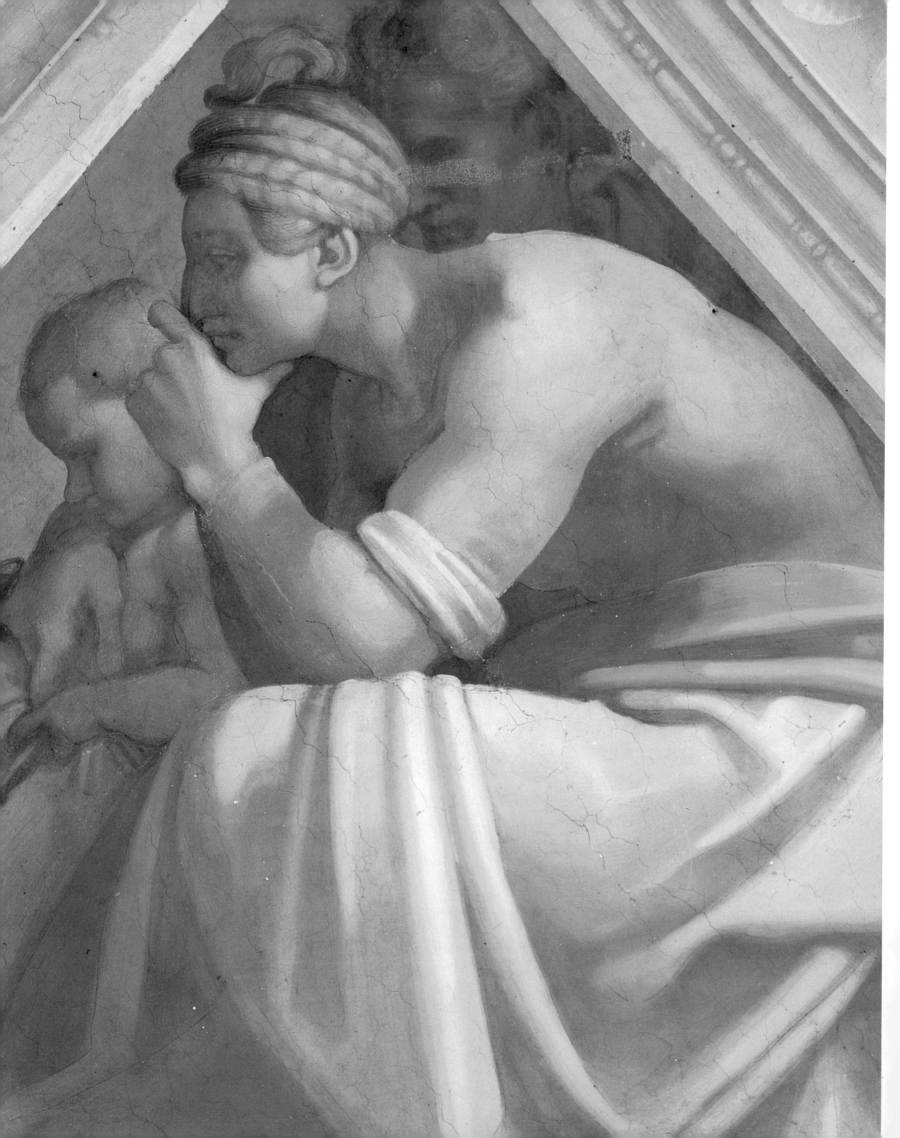

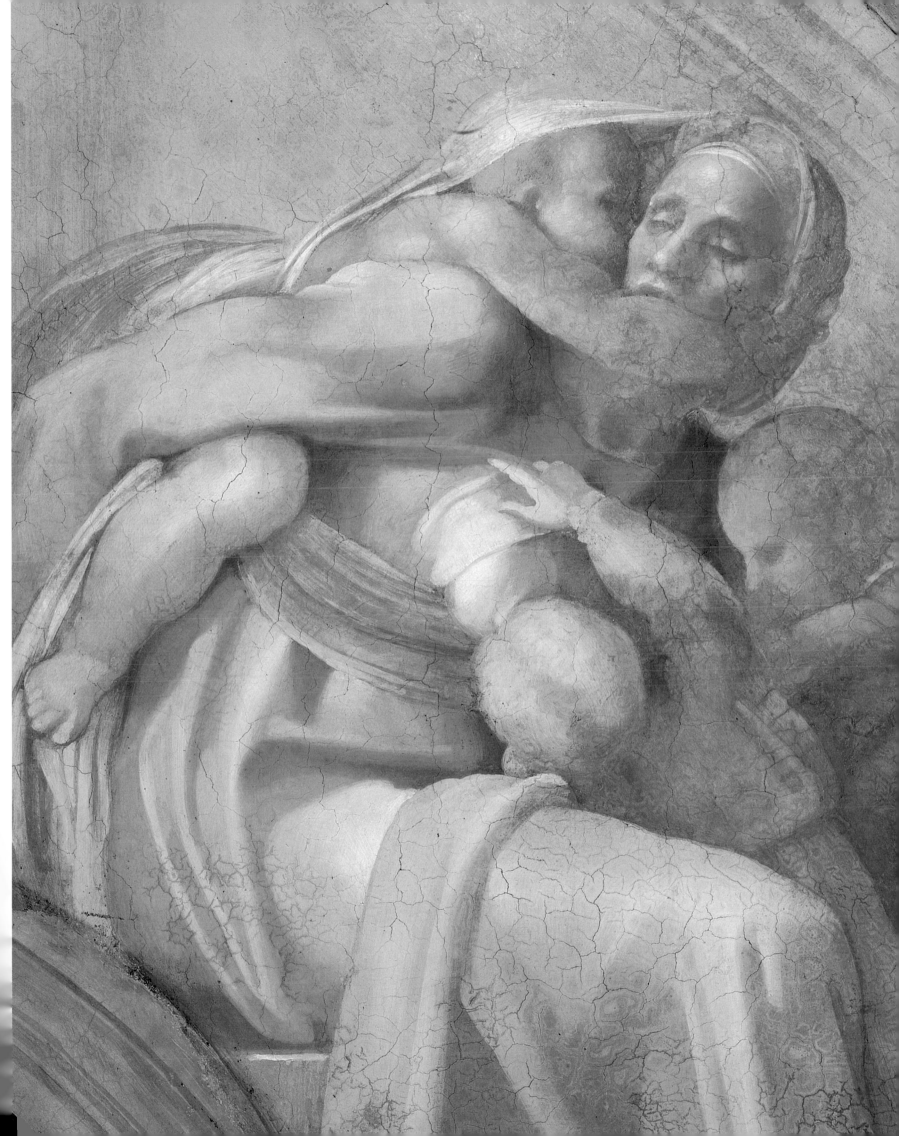

# THE MEDALLIONS

On either side of each of the five small Genesis scenes, two Ignudi support bronze roundels on silk ribbons. On the bronzes, which resemble medals cast to commemorate a hero but more on the scale of a shield, are scenes from Old Testament books of history, principally Kings and Maccabees.

The scenes are depicted in monochrome gold, further contributing to the impression of decorated metal.

The scenes have been convincingly identified by Edgar Wind as related to the Ten Commandments in the Bible: their observance, violation, or punishment for violation. Charles Hope has suggested alternative readings for the texts in some cases. The objection has been raised to this interpretation that the Commandments are not presented in the order that is familiar to us today, but the commandments did not have a canonical order in the Renaissance. Their placement here seems to have been determined by links to the subjects of the Genesis scenes, but those links have been lost in many cases. The identification of some of these very uncommon scenes depends upon woodcut illustrations in a vernacular Renaissance Bible, the Malermi Bible, dated 1493. It would be natural that Michelangelo would consult a Bible in Italian rather than Latin.

Comparison with the woodcuts in the Malermi Bible shows us that Michelangelo carefully adapted his style to the requirements of these fictive bronze medals. Whereas the woodcuts show at least rudimentary space organized by the principles of perspective, Michelangelo uses a pseudo-antique, relief-like style, He fills the space of each medal with the figures and tends to flatten them against the plane. He appears, however, to have left the execution of the medallions to his assistants.

Flanking the *Drunkenness of Noah* and above Joel, Joram is shown thrown from his chariot onto Naboth's vineyard to requite Ahab's murder of Naboth, whose vineyard he coveted (2 Kings 9:25–26). The vineyard connects to the vineyard Noah is depicted planting. Hope's alternative identification of this scene is that it represents Antiochus Epiphanes falling from his chariot (2 Macc 9). The reference is to Exodus 20:17, "Thou shalt not covet." Opposite and above the Delphic Sibyl, Abner is murdered by Joab under the gate (2 Sam 3:26ff.). The scene refers to Exodus 20:13, "Thou shalt not kill."

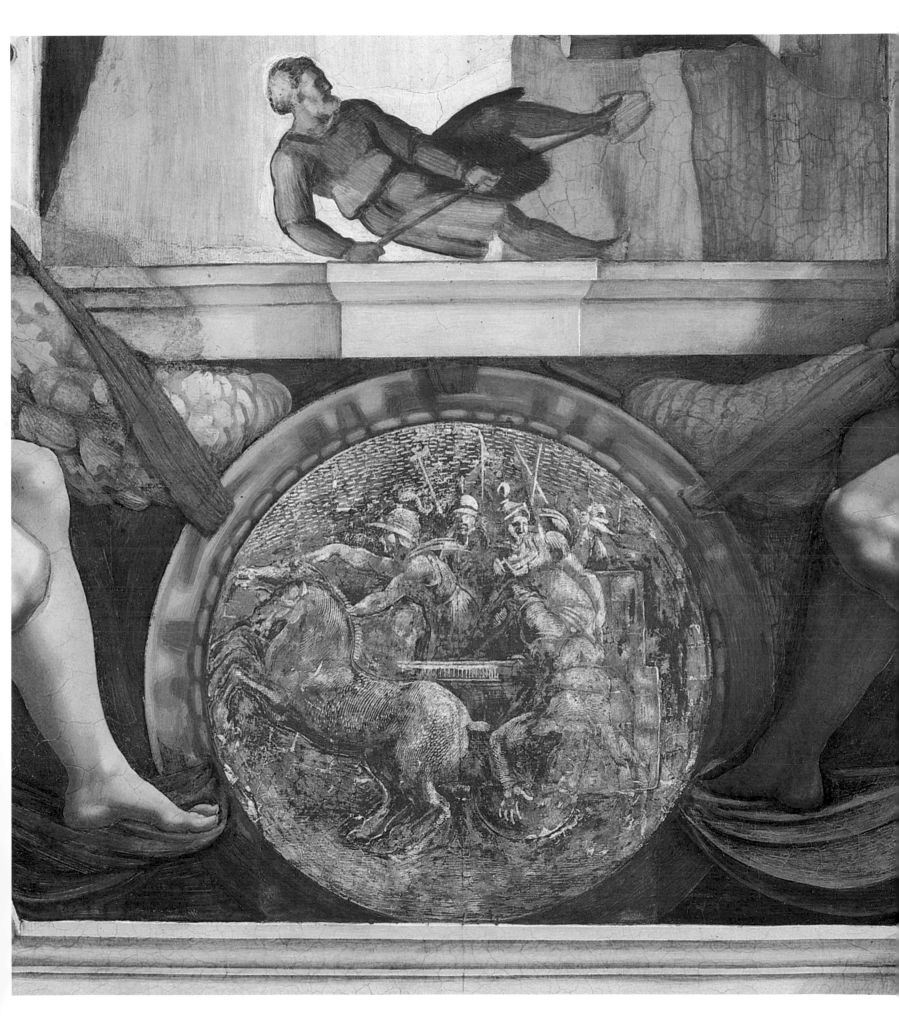

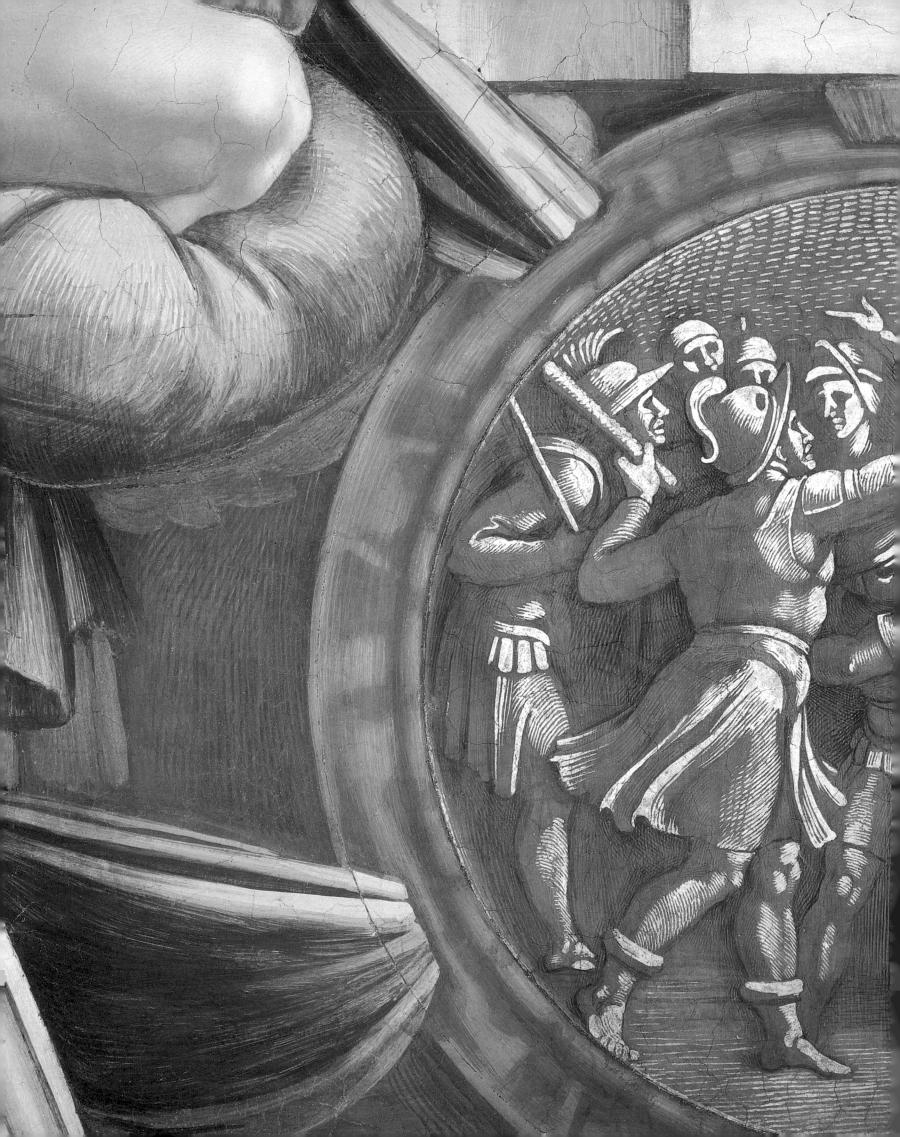

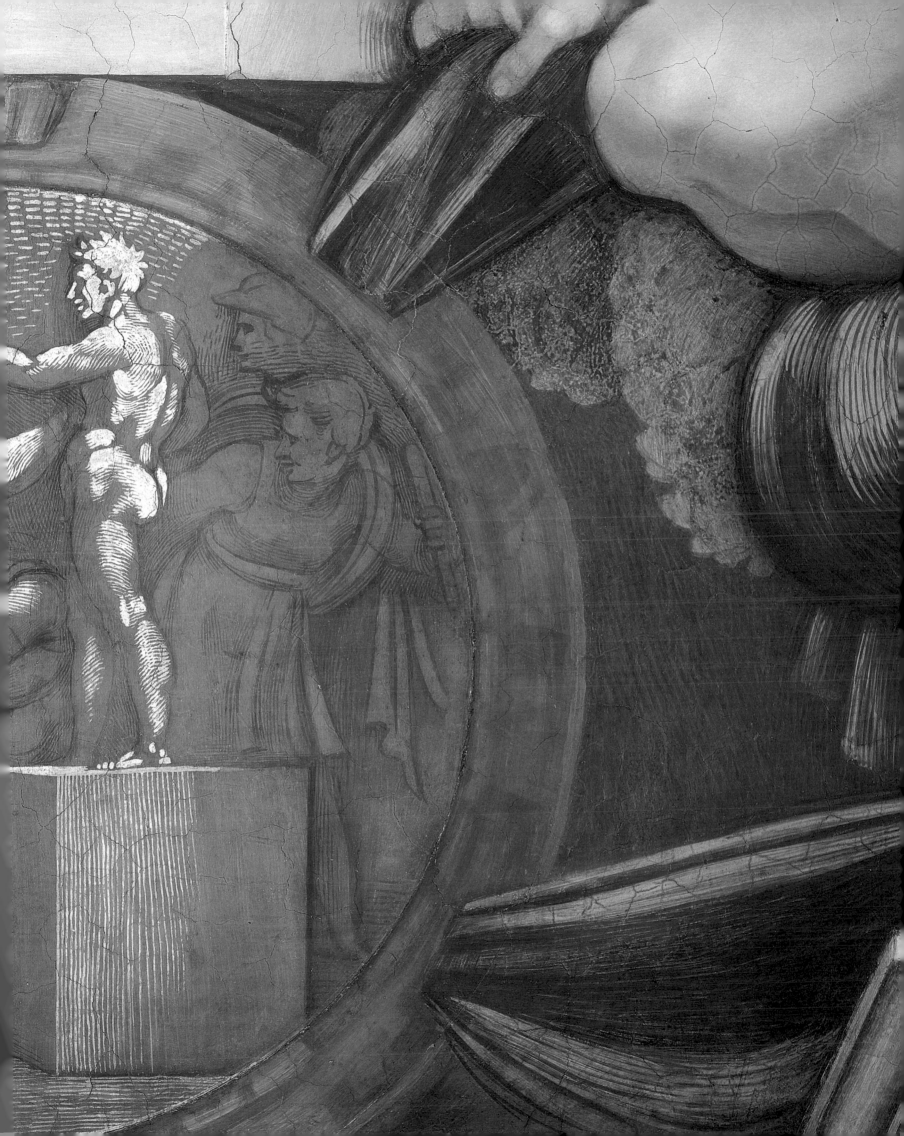

*previous page*

Flanking the *Sacrifice of Noah* and above the Erythraean Sibyl in the medallion is depicted Jehu destroying the image of Baal (2 Kings 10:27).

Hope identified this scene as Mattathias pulling down the altar in Modin (1 Macc 2). The reference is to Exodus 20:4-5: "Thou shalt not make to thyself a graven image nor the likeness of any thing . . . Thou shalt not adore them."

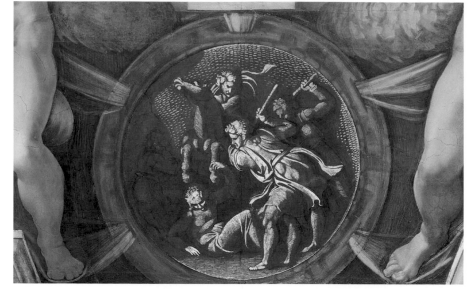

*top*

The scene in the medallion opposite and above Isaiah makes reference to Exodus 20:15, "Thou shalt not steal." The scene depicts Heliodorus attempting to steal the treasure of the temple, the same scene as that depicted by Raphael in the Stanza d'Eliodoro (2 Macc 3:23ff.).

*centre*

The medallion flanking the *Creation of Eve* and above Ezechiel evokes Exodus 20:8, "Remember that thou keep holy the Sabbath." The illustration is of Nicanor defeated and killed when he attacked Jerusalem on the Sabbath (2 Macc 15:1ff; also 1 Macc 7:43).

*bottom*

The scene depicted on the medallion on the opposite side above the Cumaean Sibyl, can be connected to Exodus 20:7, "Thou shalt not take the name of the Lord in vain." It is illustrated by Alexander the Great adoring the name of God written on the vestments of the High Priest of Jerusalem. This is the only story drawn from a non-biblical text, Petrus Comestor's *Historia Scholastica* (Pat. Lat. 198:1496–97) and it depends upon the Malermi Bible. There are obvious links to the allegorical meaning of the *Creation of Eve* as the founding of the Church. In both medallion scenes the sacred institution is revered and protected. The submission of the secular power (Alexander) to the ecclesiastical power is a frequent theme in papal iconography.

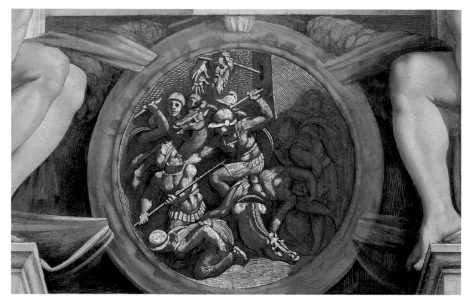

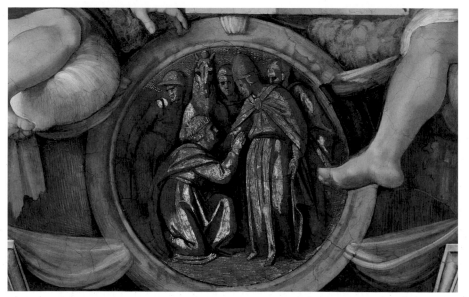

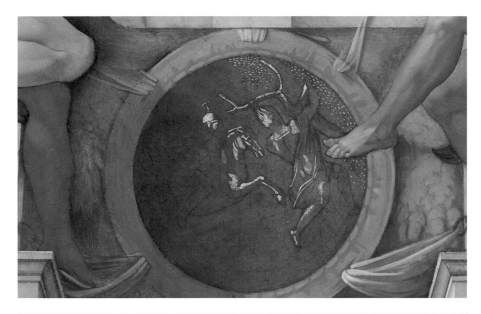

The scene on the medallion flanking *God Separating the Earth from the Waters* and above the Persian Sibyl has disappeared, apparently obliterated. A sixteenth-century engraving showed a naked couple making love, and might have referred to Exodus 20:14, "Thou shalt not commit adultery." It could have been effaced as obscene in the intervening centuries after its reason for inclusion had been forgotten. Hope related this scene to the Malermi woodcut of the Elisha healing Naaman (2 Kings 5).

*top*
On the opposite side above Daniel is illustrated the death of Absalom during the revolt he raised against his father, King David (2 Sam 18). The reference is to Exodus 20:12, "Honor thy father and thy mother." There is a "moral logic" to the pairing of these commandments, for they refer to a complementary pair of vices: Lust the most indulgent, Pride the most overbearing.

*center*
Flanking the *Separation of Light from Darkness* and above Jeremiah Elijah is shown caught up and carried to heaven in a chariot of fire to return and bear witness against the Antichrist (2 Kings 2:11). The scene might refer to Exodus 20:16, "Thou shalt not bear false witness."

*bottom*
On the medallion on the opposite side above the Libyan Sibyl is depicted the Sacrifice of Abraham in obedience (Gen 22:9ff.), a reference to Exodus 20:3, "Thou shalt have no other gods before me."

# THE IGNUDI

The male nudes placed at each corner of the small Genesis scenes are clearer in function than in meaning. They hold up the bronze medallions on silken ribbons or they support garlands of oak leaves laden with acorns—clear references to the emblem of the della Rovere family.

In formal terms they play a crucial role in animating the design and encouraging the viewer's progress from bay to bay.

Take the Ignudi away and the design becomes static, defined by the architectural compartments that frame each part. If the Ignudi have a representational or symbolic meaning, it has eluded commentators, hence their generic name, "nudes." It has been suggested that they represent wingless angels, and to be sure, the angels, Michelangelo would paint in the *Last Judgment* resemble these figures in both their athleticism and their winglessness. But the identification does not resonate: their tasks seem unworthy of angels and the presence of angels is not particularly called for. It is most satisfactory to regard them as the painter's invention to solve a formal problem, and to appreciate them on purely aesthetic grounds.

Here we can see Michelangelo celebrating the beauty of the body and delighting in his freedom to create youthful figures in energetic poses. In the other populations whose function is formal, the painter did not lavish comparable attention on individualizing each figure. For the bronze nudes that fill the awkward spaces above the severies, Michelangelo simply reversed his cartoon, making figures that are perfectly symmetrical.

Similarly, the caryatid putti adorning the uprights of the thrones are symmetrical copies of one another or nearly so.

The inspiration of antique statues is apparent in these figures. We know that Michelangelo greatly admired the Apollo Belvedere. Given its lack of head or limbs we might ask what he saw in it, until we note the strong twist in the muscular torso. Looking back to the fifteenth century, we find that the concept of contrapposto was two-dimensional; it did not include the kind of torsion we begin to see in the Ignudi, where the figure rotates out of the plane, like the Apollo Belvedere. The fifteenth-century theorist Alberti was in fact explicit in condemning this kind of contrapposto, but the *figura serpentinata* would become a hallmark of Michelangelo's style. The idea is developed in the Ignudi and the Seers. We do not see it in the earliest of these figures, which are still held parallel to the wall plane. As they progress, however, they move into three dimensions, culminating in the splendid rotation of the Libica, who seems to twist on the point of her extended foot.

Here more than anywhere else on the vault we can trace an evolution in Michelangelo's personal style over the course of

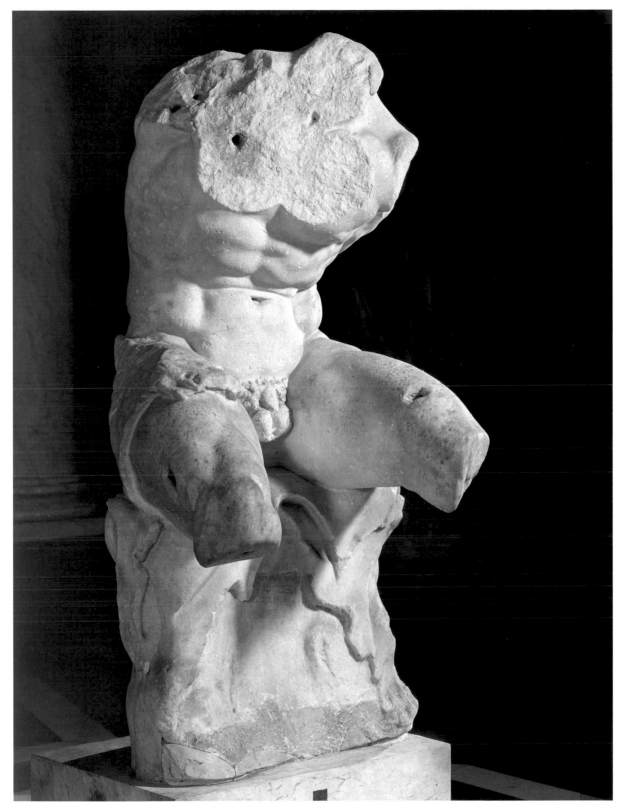

the four years he spent painting it. The Ignudi develop from restraint to assertiveness as we move toward the altar. Michelangelo designed the Ignudi as complementary pairs of figures. In the early pairs, like those above Joel (*following pages*), their poses are strictly construed in terms of symmetry. These two are restrained in their attitudes and held in the plane, parallel to the wall. But there are differences between them—the lean of the torso, position of an arm, hairstyle—and they are lit from opposite sides, like each pair. The pair opposite, above Delphica, cannot be studied in detail because of the damage.

137

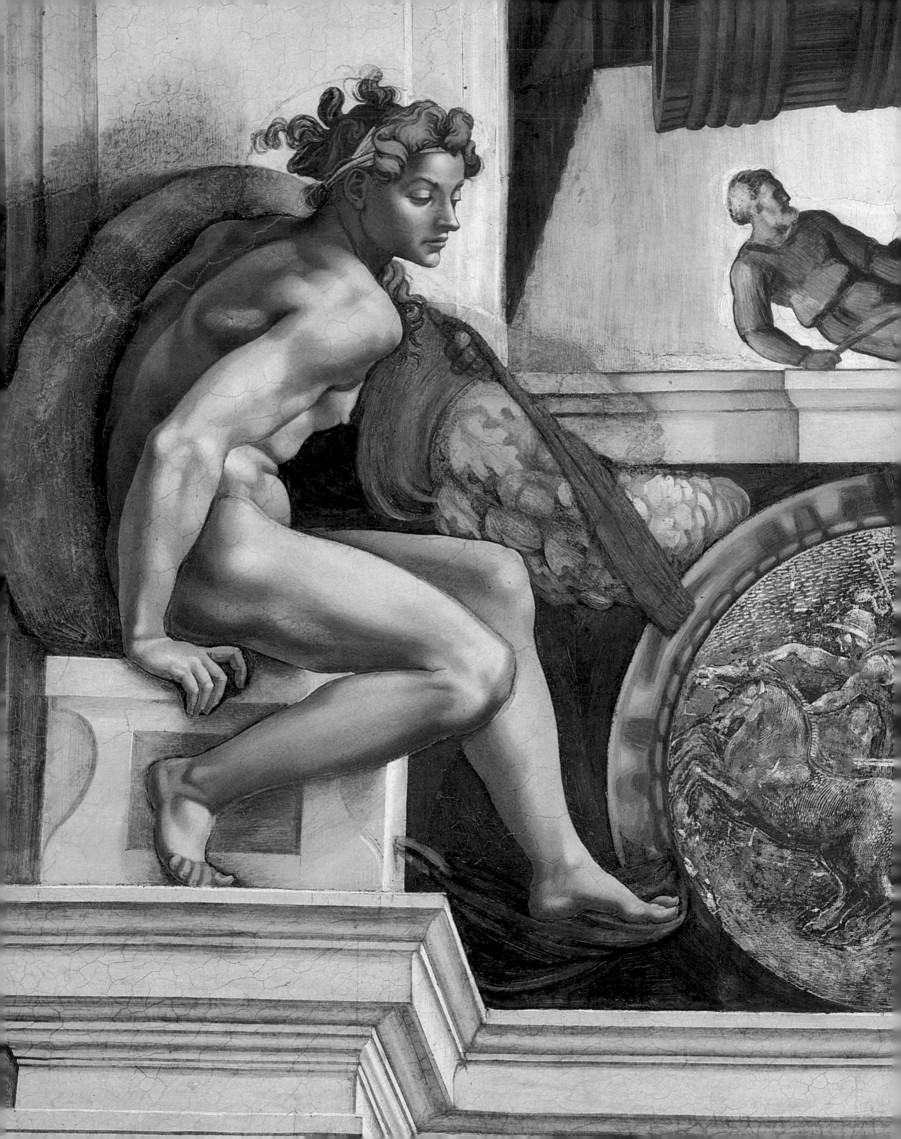

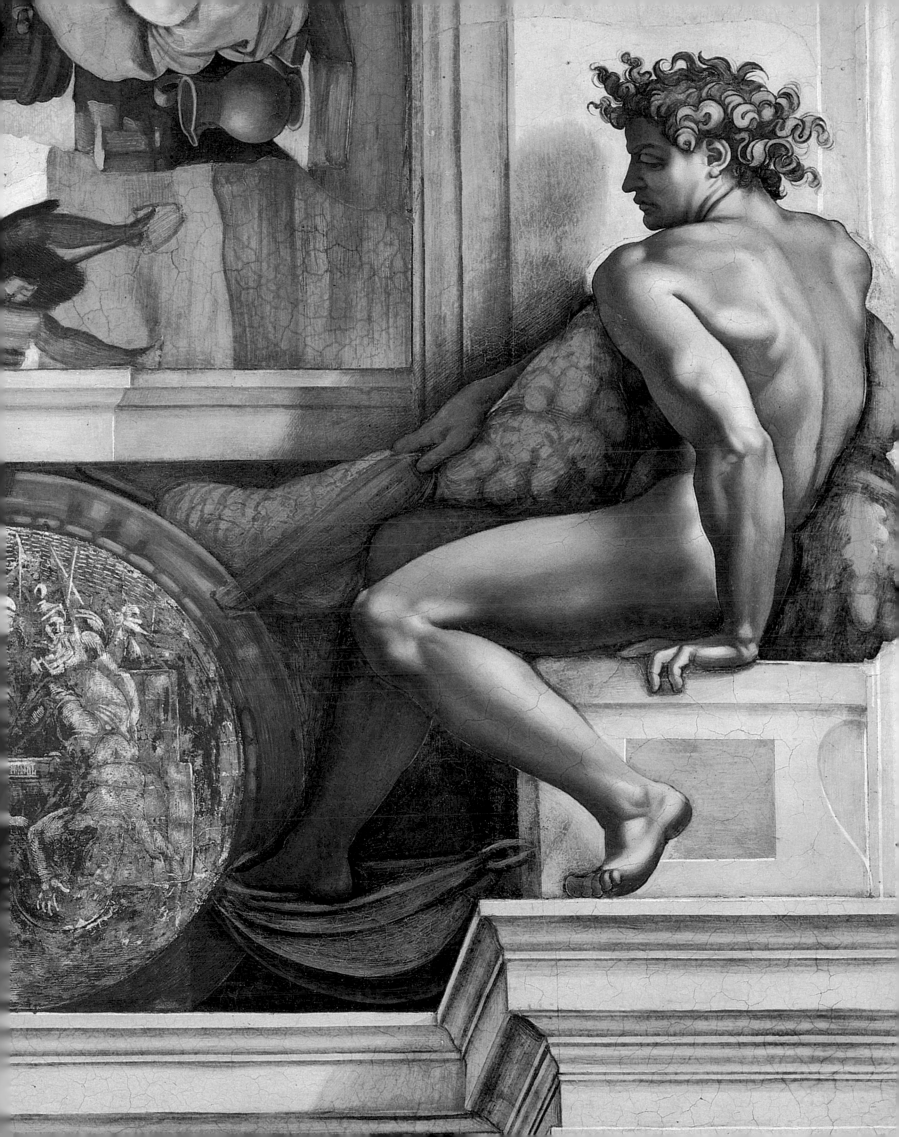

The pair of nudes above the Erythraean Sibyl are again quite similar in pose, but they appear less so because Michelangelo has given the one on the left a highly expressive face.

*following pages*
The pair opposite, above Isaiah, have similarly animated faces, and their torsos and arms are more divergent in pose from one another. They move more freely in space, projecting forward with bold foreshortenings.
On the left the figure actually overlaps the frame, intruding upon the lower right corner of the *Sacrifice of Noah*.

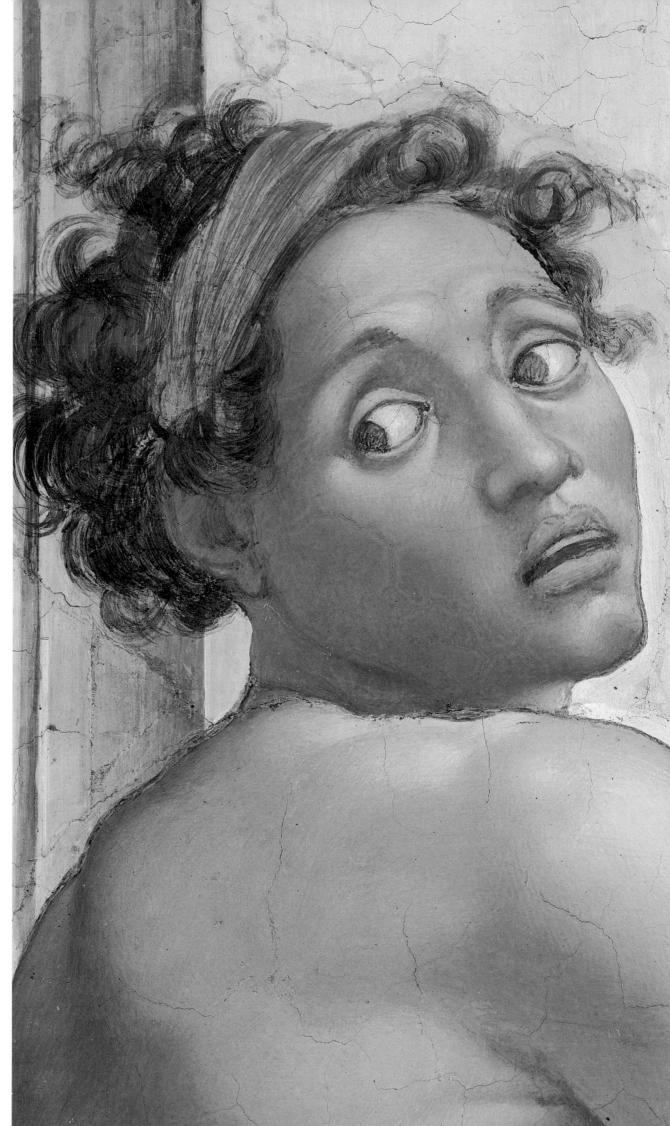

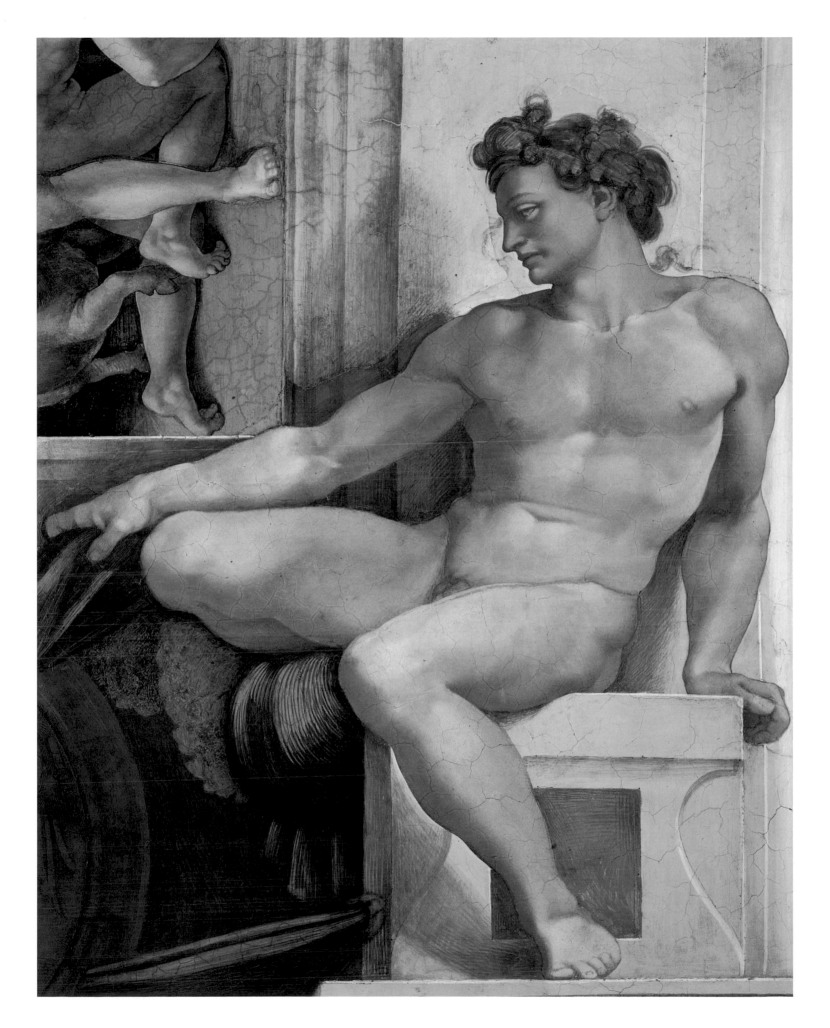

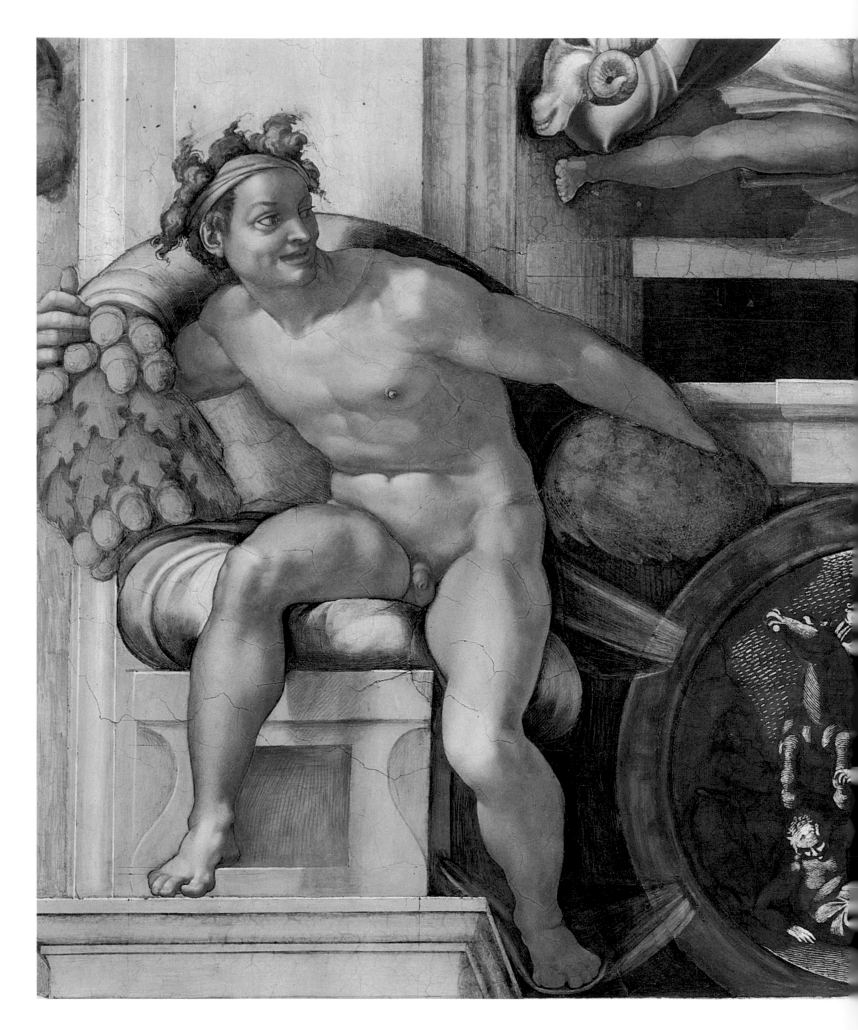

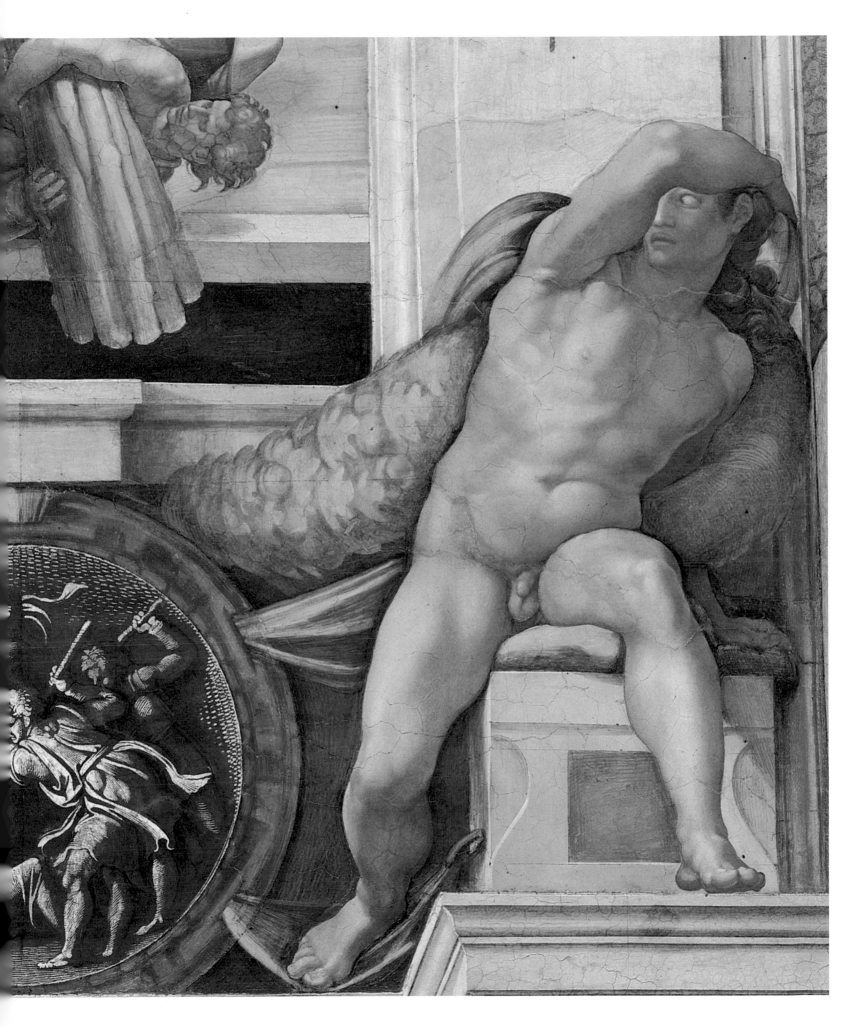

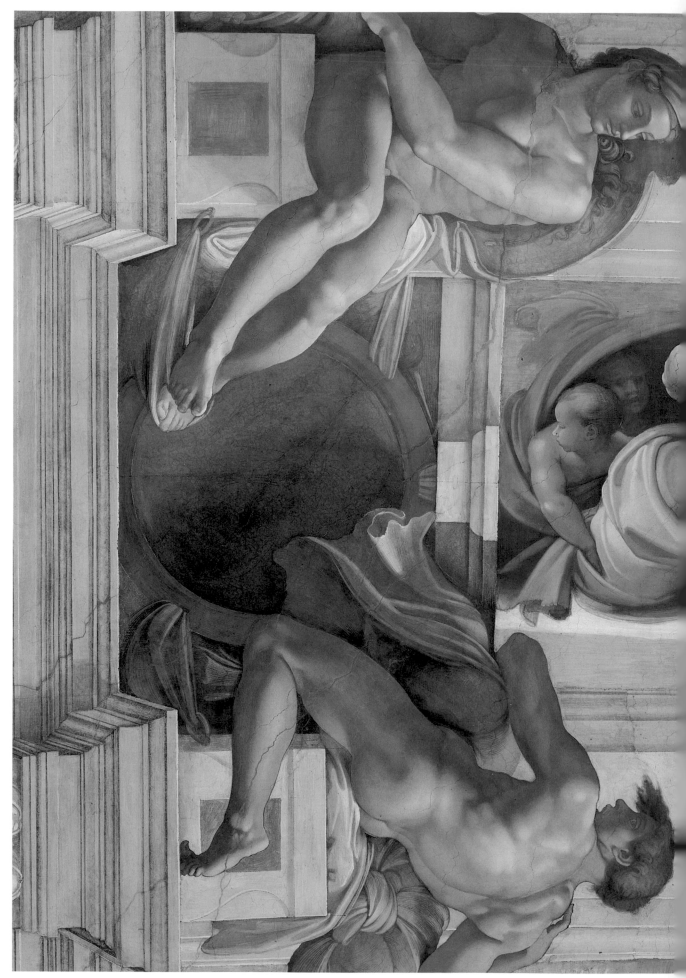

From this point on, the Ignudi will be less and less contained, less symmetrical, more excitable. They are no longer the calm spectators of the first bay. Bravura foreshortenings add to the sense of their energy. Three of the four overlap the frame of the *Creation of Eve*. As the Genesis scenes become simpler in composition, focusing on the solitary Creator, the Ignudi compensate by becoming more animated.

Above Persica the figure on the left balances on his hip, both feet off the ground. His counterpart seems to rise off his seat, one foot hidden from view, the other pulled back and supported on the toes. Windblown drapery adds to the movement. Again, three of the four overlap the scene of *God Separating the Earth from the Waters*, this time quite aggressively.

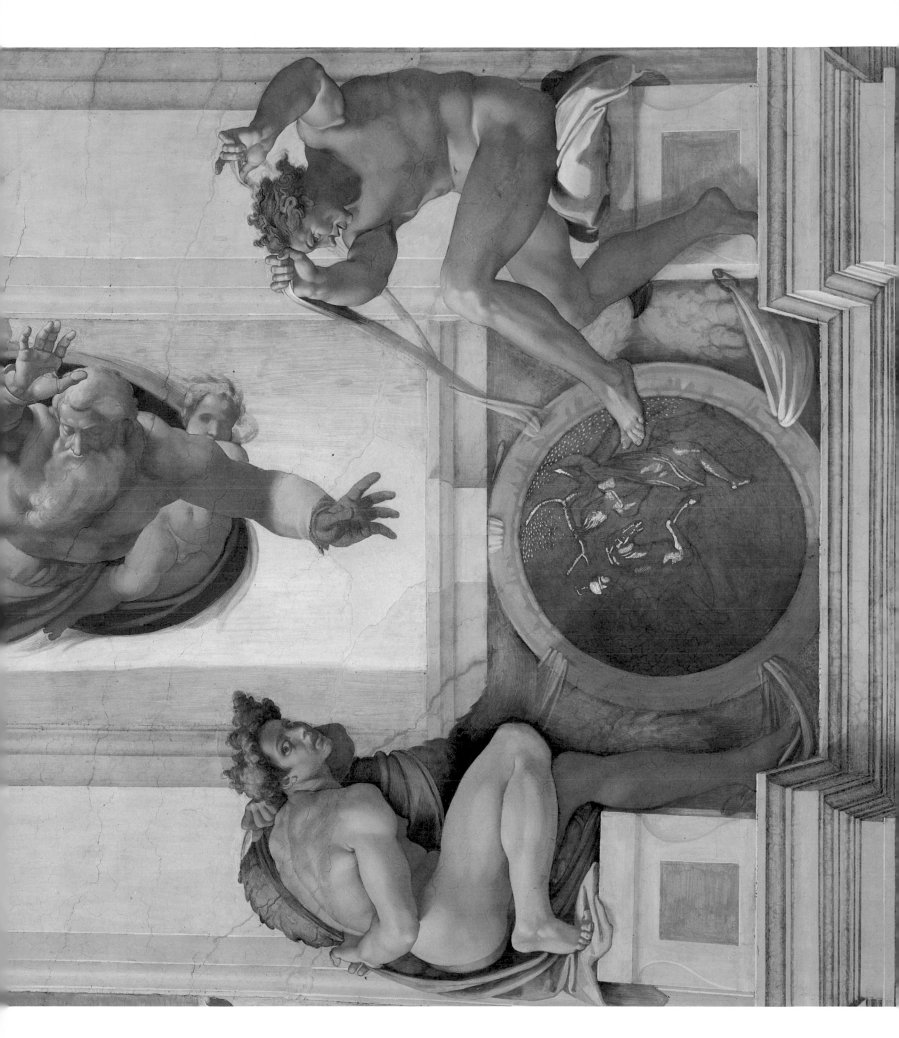

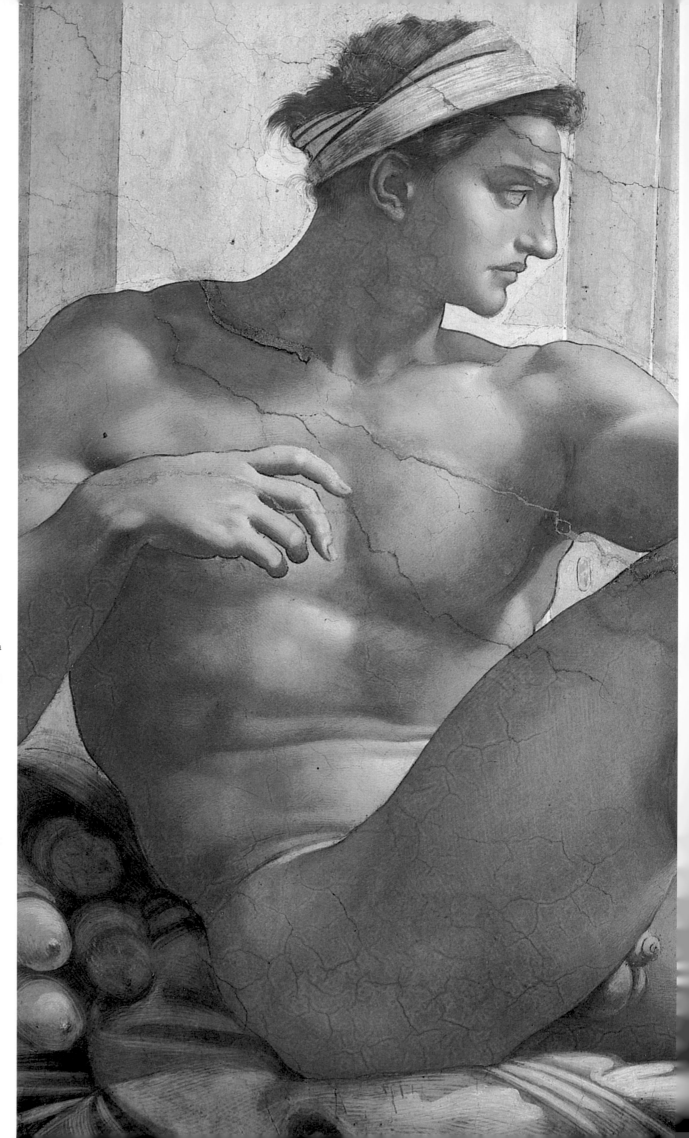

In the final bay above Jeremiah a restrained figure on the left contrasts with a titan of physical splendor at the right. Rather than leaning or facing in, his torso and head project sharply forward, occluding the light and creating strong shadows. He is in the act of rising, his foot floating above the ledge. He is likely intended to lead our attention to the right, to bridge the gap of blue sky and connect with Jonah on the end wall. His counterpart opposite, above Libica (*overleaf*), although less vehement in movement, leads us with his glance and leg in the same direction. We can trace in the Seers, as well, such a crescendo of scale, of vigor, of energy, from the start of the ceiling to the end, in terms of the chronology of Michelangelo's painting of it.

146

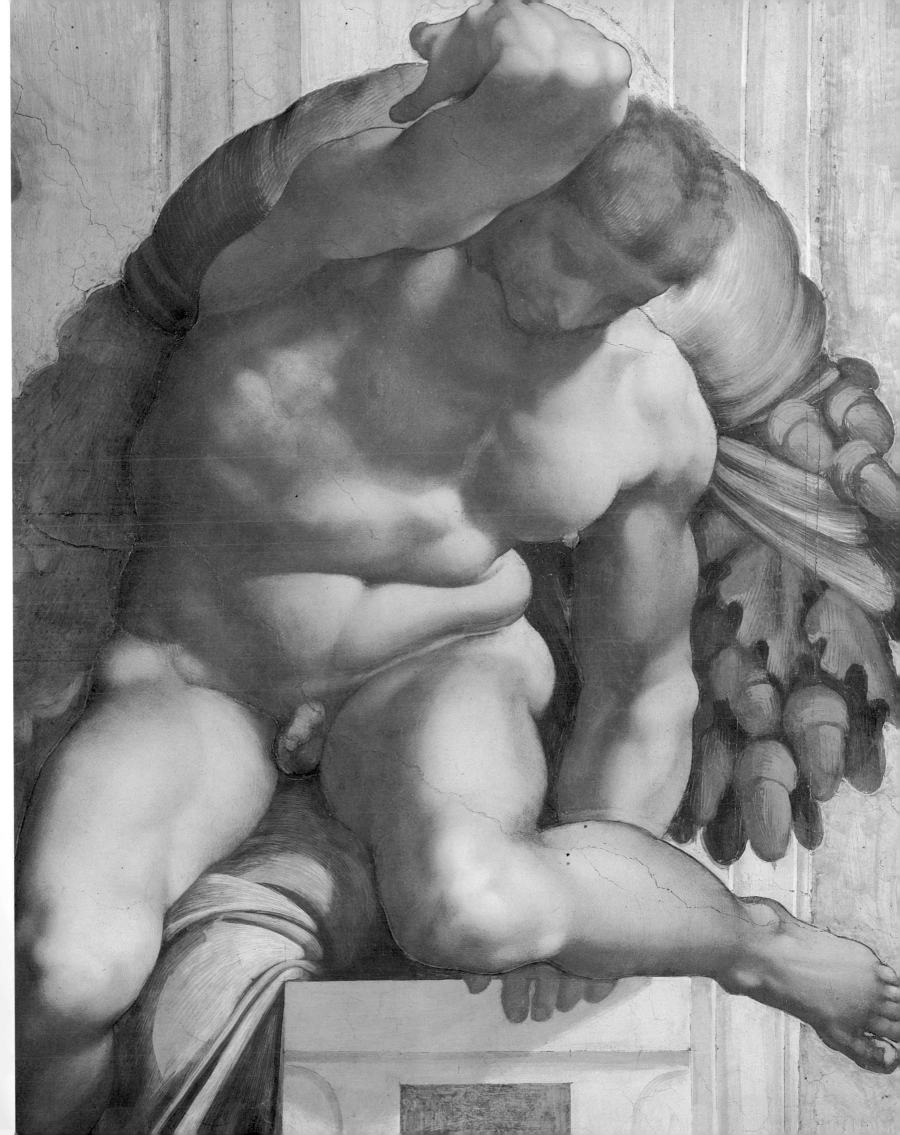

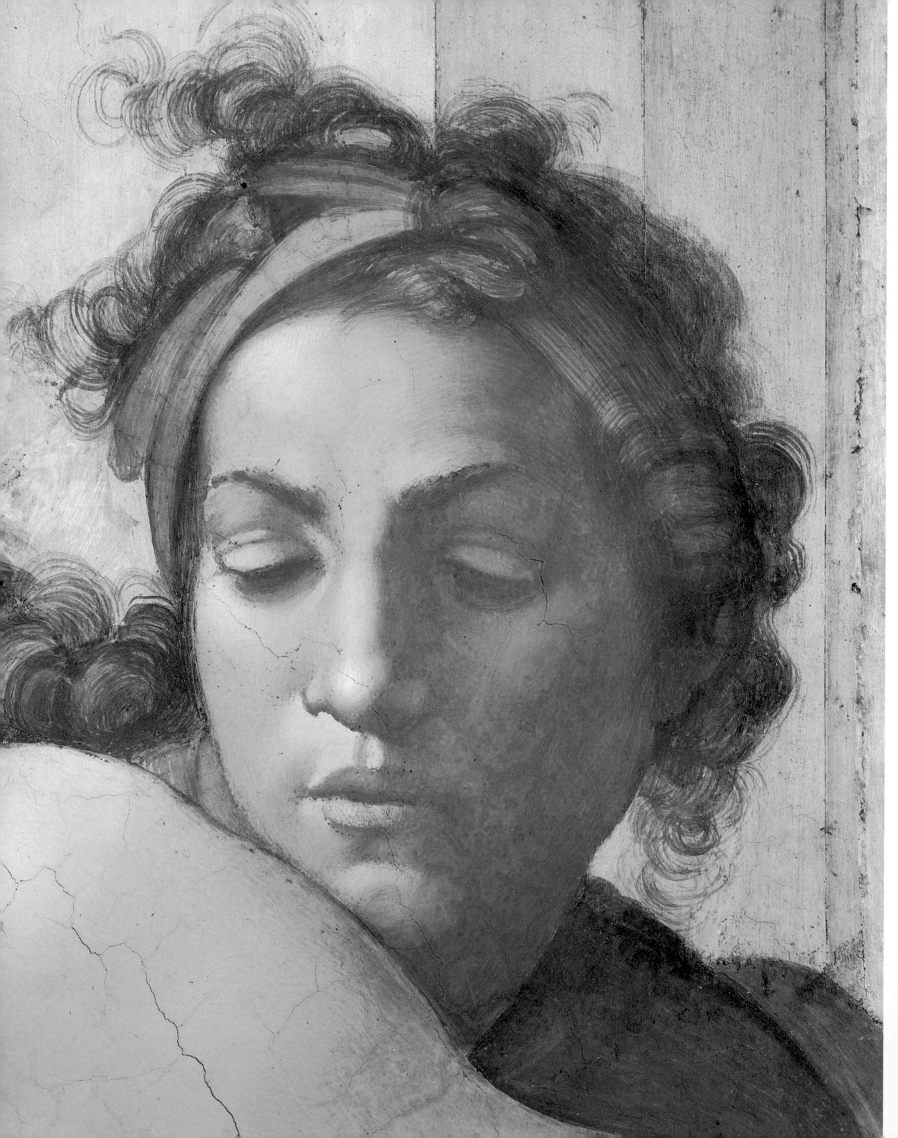

With Michelangelo's ceiling the chapel decoration was considered complete.
Twenty-one years would pass before another pope
would open discussion with the artist about repainting the altar wall.

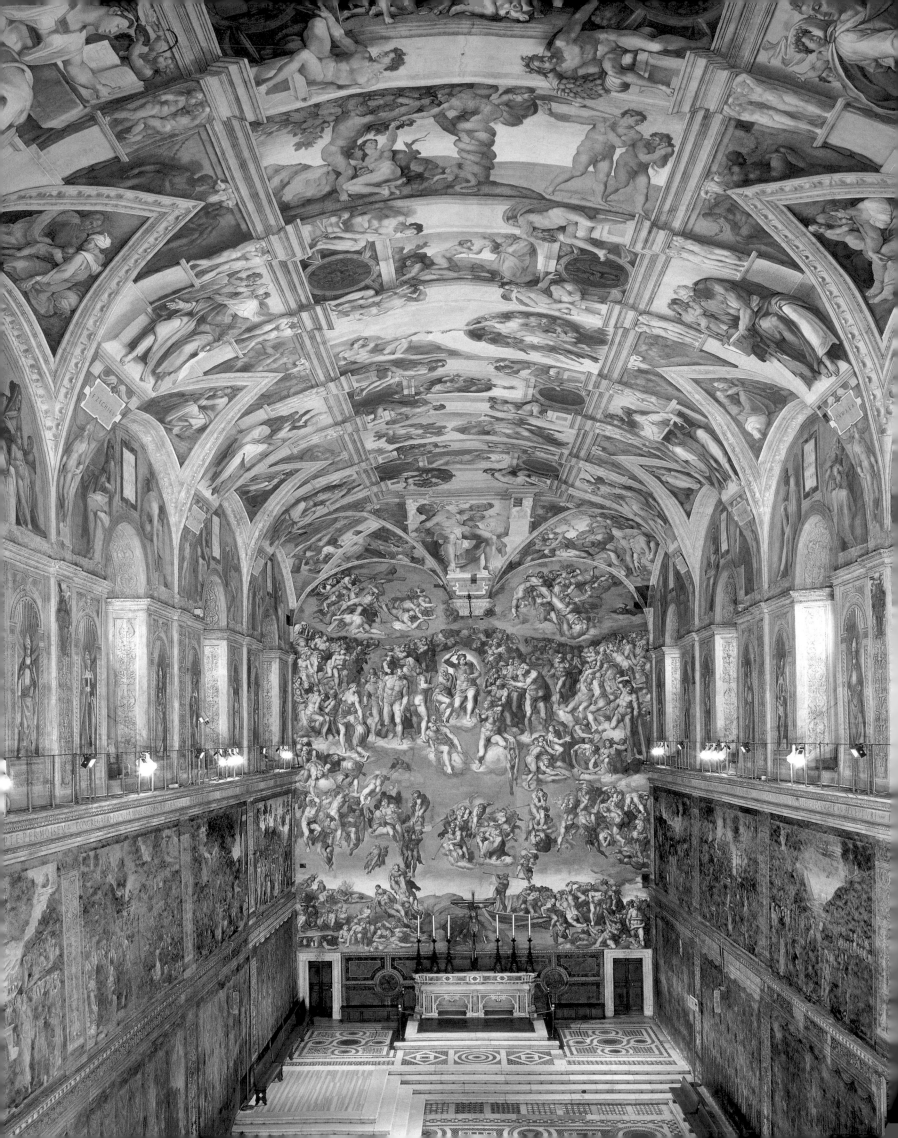

# THE LAST JUDGMENT

## THE HISTORY OF THE COMMISSION

The Medici pope, Clement VII (1523–34), conferred with Michelangelo in the fall of 1533 about commissioning him to paint the altar wall of the Sistine Chapel. The artist had been residing in his native Florence since Pope Leo X (1513–21) had dispatched him there to work on Medici family commissions in 1516.

Florence chafed under papal rule, so in 1527, when imperial troops sacked Rome and forced Pope Clement to take refuge in the fortified Castel Sant'Angelo and become a virtual prisoner there, Florence seized the opportunity to reestablish its republic. Michelangelo, always a convinced republican, abandoned the Medici Chapel in San Lorenzo and transferred his energies to designing fortifications for Florence. When the ensuing war ended with the defeat of the fledgling republic and the reimposition of Medici rule in 1530, Michelangelo found himself in a difficult position: alienated from the papal patron he had deserted and residing in a city ruled by the young Duke Alessandro de'Medici, whom he feared and hated. Furthermore, his obligation to finish the tomb for Pope Julius II, dead since 1513, for which he had signed contracts and received some payment, weighed heavily upon him. As had happened in the past, the ruling pope's demands interfered with the artist's attempt to complete the tomb for Pope Julius. Such was Clement's desire to have Michelangelo serve

him that he pardoned him and directed him to continue work at San Lorenzo. In 1532 the artist and the heirs of Julius II reached a compromise and negotiated a new contract, reducing the scale of the tomb and dividing Michelangelo's time between Medici commissions in Florence and the Julius tomb in Rome. Hardly had this new agreement been settled, however, when Clement placed the commission for the *Last Judgment* before the artist. If Michelangelo was reluctant, as seems to be the case, it must have been due to his unwillingness to take on another enormous task with both the tomb and the projects at San Lorenzo still unfinished.

Michelangelo transferred his residence to Rome in September 1534. When, only a few days later, Pope Clement died, Michelangelo thought that he would be relieved of the Sistine fresco and free at last to complete the Julius tomb. But this was not to be. Clement's successor, Pope Paul III (1534–49), already an old man, greeted Michelangelo's excuses with the exclamation (according to Michelangelo's biographer

We do not know what motivated Pope Clement's decision in 1533 to repaint the altar wall. Perhaps he was simply reviving the abandoned project of Pope Julius. The project necessitated bricking up the two clerestory windows and destroying the Quattrocento decorations, Pietro Perugino's frescoes of *Pharaoh's Daughter finding Moses* and the *Adoration of the Shepherds*, and the portraits of the popes, all of which had encircled the chapel and continued across this wall. It was also necessary to destroy Perugino's altarpiece and its frame and Michelangelo's own *Ancestors of Christ* in the two lunettes. The final solution reached by the painter to utilize the entire wall, without even a frame, radically changed the appearance of the chapel, overriding the horizontal accent, which the continuous bands of windows and frescoes across this wall and circling the chapel gave it, and introducing a strong vertical element. With the *Last Judgment* in place, the chapel now has a focus toward which the space seems to process, just as the papal entourage would proceed from the entrance opposite to the altar.

Michelangelo overhauled the
traditional Last Judgment,
which was rigidly organized to
convey God's central place in
the ordered cosmos and his
control of man's final destiny.
The composition was divided
into two tiers. In the celestial
zone, Christ the Judge was
flanked by the choirs of
Apostles, angels, saints, martyrs,
and Patriarchs. In the terrestrial
zone below, corresponding to
the Resurrection of the Dead
on the left were the Damned
in Hell on the right. Each
obedient population, assembled
in its designated place,
performed its role with
predictable emotion: the Elect
joyful, the Damned in torment.
The ranks were fixed and
closed. The composition

attained its order from the
ordering of the static units.
Michelangelo conceived his
*Judgment* as a swirl of bodies
around the dynamic center of
Christ, with every figure either
in motion or tense with
emotion. The predictability has
been swept away, replaced by
anxious uncertainty. Whereas
the traditional iconography was
static and hierarchical,
Michelangelo's vision is of a
dynamic, explosive event.
Flowing robes have been put
aside, for in Michelangelo's
view we will all meet the Lord
stripped of rank and emblems
of our earthly status.
Although Michelangelo avoided
the sharply divided bands of
earlier artists' versions, he subtly
introduced zones that

correspond to the divisions of
the side-wall frescoes. The area
of the lunettes at the top is
filled with the angels and the
implements of the Passion.
There is a break below, a bit of
sky, and then the densely
massed figures of the Elect
begin. Farther down, the
entablature at the bottom of
the window zone marks the
transition between those who
are already among the Elect
surrounding Christ and those
who are rising or descending.
The line continues across the
fresco, where there is suddenly
an unimpeded glimpse of blue
sky. At the extreme right of this
zone, Simon of Cyrene (or
Dismas) appears to place his
cross on the ledge of the
entablature. The Resurrection of

the Body and Hell correspond
to the lowest zone of the side
walls where the upper portion
of the fictive tapestries was
painted.
Some earlier painters, such as
Giotto, achieved the
appearance of a fictive depth
by rendering the choirs of
similarly posed figures receding
in perspective. Depriving
himself of this device,
Michelangelo resorted to
overlapping his figures in
densely packed groups,
forming chains to carry the
current of movement. As
figures move back in space,
they lose acuity, sometimes
painted very thinly and
seemingly without cartoon.
One of Michelangelo's most
remarkable innovations is his

elimination of a frame. Figures
are cut off at the edges, as if to
imply that we are seeing only a
portion, and the scene
continues in all directions,
laterally and below as well.
Instead of giving a sense that all
have their places here and
know what they are,
Michelangelo shows the
uncertainty of men and women
being moved by a force outside
themselves to a fate still
unknown to them. When they
discover their destinations, he
shows their explosions of
surprise, joy, or horror. There is
an ineluctable rotation rising
from the lower left, circling
around Christ, and descending
on the right, not perceivable to
those being moved by it, but
visible to the viewer.

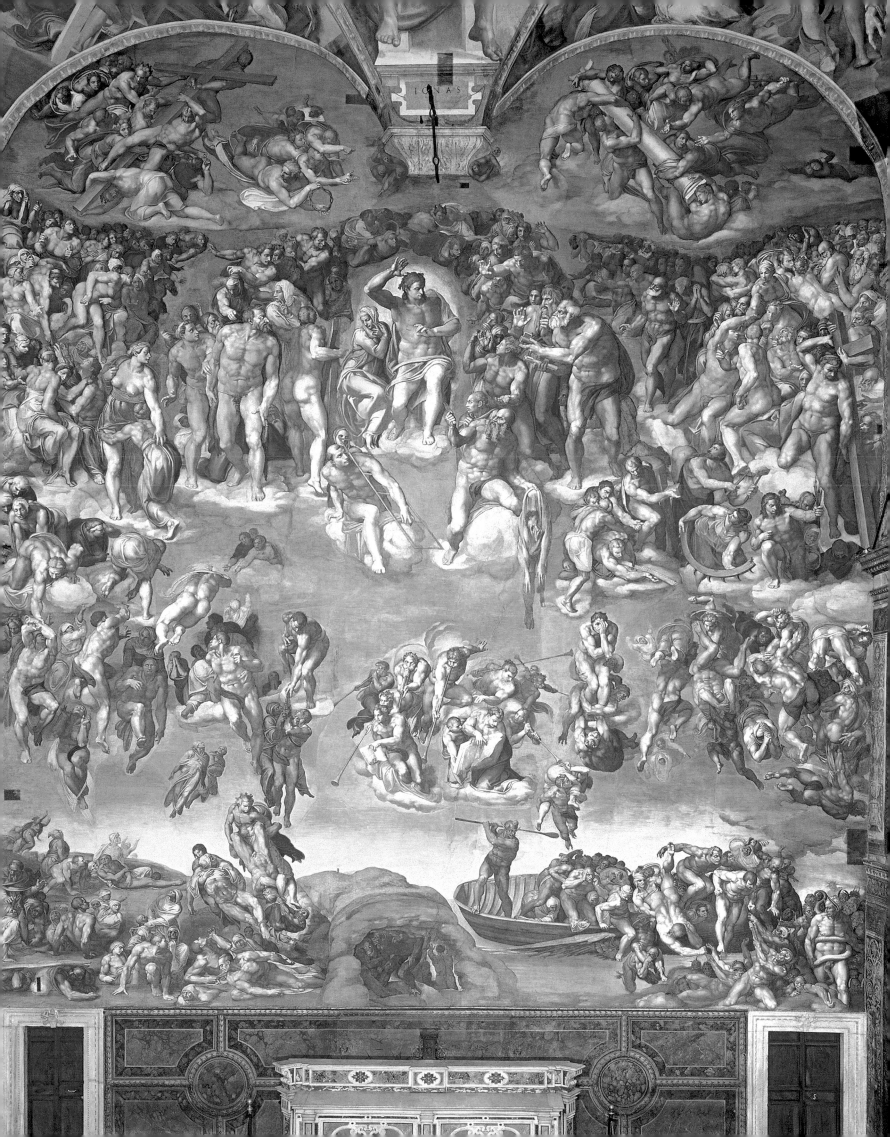

Condivi): "For thirty years I have had the wish that Michelangelo serve me. Now that I am Pope, can I not gratify it? Where is this contract? I want to tear it up." Again the tomb was discussed and Michelangelo's obligation reduced still further.

The preparation of the wall in the Sistine Chapel was protracted over the period of a year, beginning in April 1535. Michelangelo's friend, the painter Sebastiano del Piombo, had the wall prepared for an oil mural, a technique that Sebastiano himself had developed and practiced with success. Michelangelo allowed the work to proceed for almost nine months, during which he was working on his cartoon, before declaring the surface unsuitable and requiring that it be remade (January 25, 1536). No explanation for this curious behavior is offered by the documents or the contemporary sources; it may have been that he was stalling to gain precious time to complete statues for the Julius tomb, for the contract he had signed in 1532 had expired in 1535. Condivi tells of other ruses the artist devised to keep the pope at bay and says that "he procrastinated and, while pretending to be at work, as he partly was, on the cartoon, he worked in secret on the statues that were to go on the tomb."

The wall was at last ready in April 1536 and Michelangelo set to work painting before May 18, when the first of many payments for pigments was made.

## TRADITIONAL INTERPRETATIONS

In some past scholarship, Michelangelo's *Last Judgment* was regarded as an atonement, created in the wake of the Sack of Rome in 1527 by the troops of Emperor Charles V, who pillaged the city and compelled the pope to abandon his court at the Vatican and flee to Orvieto. These events were seen as an indication of divine wrath.

According to this view, Rome had been destroyed, like Sodom and Gomorra, because it had become a place of decadence and sin, and the *Last Judgment* reflected the mood of penitence that followed these traumatic events. Pope Clement's commission to Michelangelo has been described as an "illustration of the catastrophe of his reign."

This may, indeed, have been the view of the Sack held by the Protestants, who saw Rome as a new Babylon and the pope and his court corrupted by luxury. Nor is it to be doubted that this was the initial response of some Romans immediately following the event. Increasingly in recent years, however, we have come to recognize that the Catholic Church recovered its self-esteem rather quickly. Pope Clement signed a peace treaty with the emperor and carried on. Our understanding of the artistic environment of Rome in the 1530s has also been revised. It went about its recovery, experiencing at least an Indian summer, if not a whole new era, of High Renaissance visions of a Golden Age. We need to remember that, although it was Clement who originally commissioned the *Last Judgment*, it was the Farnese pope, Paul III, who continued it, and there is no evidence of despondency or overweening penitence in his personality. There are frequent references to the Golden Age of Farnese rule he was initiating in the many commissions of him and his family.

W e can deduce from preliminary drawings that at first Michelangelo intended to preserve Perugino's altarpiece and his own lunettes. On the sheet in the Casa Buonarroti, Florence, the top of the existing altarpiece has been drawn in and space left for it. The area of the lunettes is not included in the field.

We can see that from the start Michelangelo envisioned breaking down the rigid compartmentalization and arrangement in tiers of the traditional composition. The Elect flanking Christ are already conceived more in terms of an animated chain of intertwining figures than as the conventional row of dignitaries seated on clouds. In fact, in what is presumably an even earlier study (Musée Bonnat, Bayonne), we already see a figure who turns to look down at those ascending, an idea elaborated in the Casa Buonarroti drawing and used to great effect in the fresco. Between these two studies the figure of Christ has evolved away from the seated judge to a standing, even striding, one whose arrival sets the whole event in motion. To be sure, even Michelangelo's seated Christ twists in a dynamic contrapposto, banishing the traditional static icon of the Judge in his mandorla.

The designing of the fresco appears to have taken place in two phases. We know that Michelangelo presented Pope Clement with a *modello*, that is, a large finished drawing of the composition, presumably in the summer of 1534. Although this *modello* is lost, two copies survive. One in the Metropolitan Museum in New York shows the upper portion only, but a second copy in the Courtauld Institute in London, though reworked, shows the whole composition. An especially important change made by the copyist is to the pose of Christ,

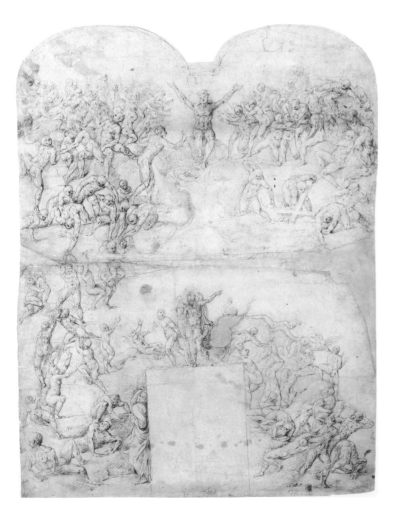

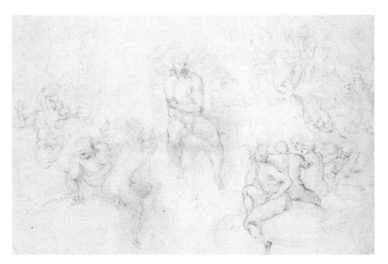

*left*
The copy in the Courtauld Institute in London, though reworked, shows the whole composition.

*above*
In what is presumably an even earlier study (Musée Bonnat, Bayonne), we already see a figure who turns to look down at those ascending.

On the sheet in the Casa Buonarroti, Florence, the top of the existing altarpiece has been drawn in, and space left for it. The area of the lunettes is not included in the field.

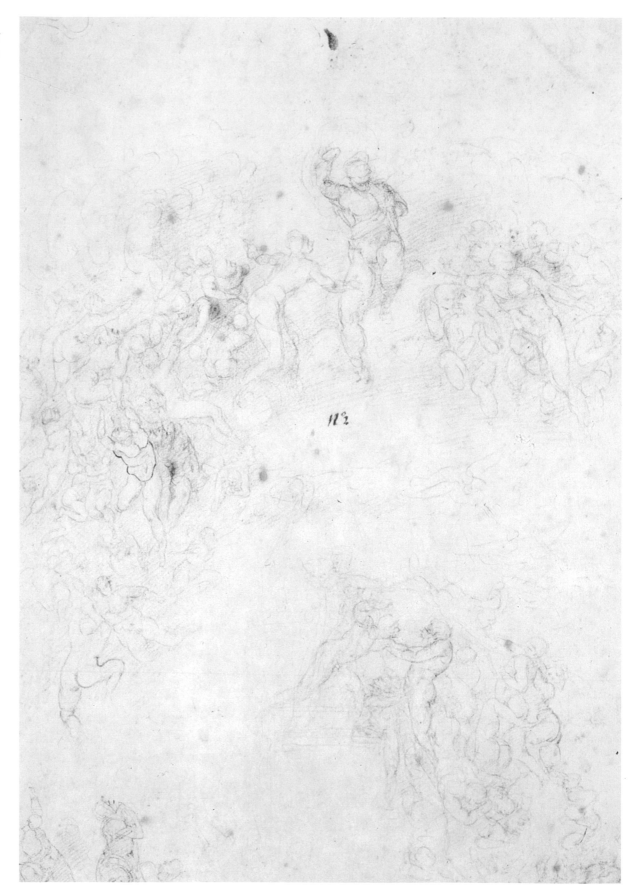

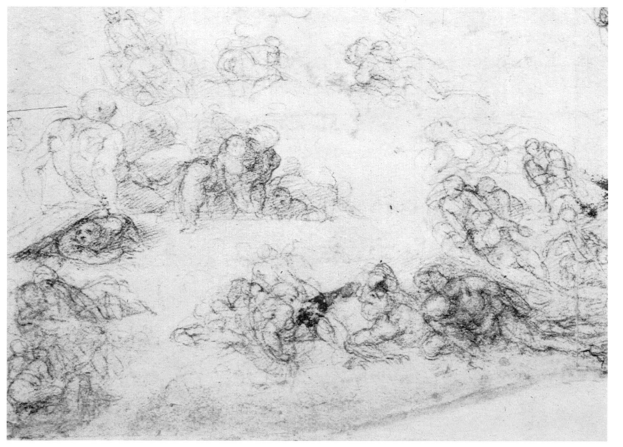

whom he shows with arms outstretched. There is no evidence that the artist ever considered such a pose. The rectangle for Perugino's altarpiece is reserved at the bottom center. Many of the figures of the fresco already appear, but their groupings will undergo significant development. They are sparsely spread about the sheet, not yet conceived in terms of the dense packing and overlapping that gives the final version the depth otherwise lacking because the painter has eschewed perspective renderings of choirs of similar figures. Only a few of the saints and martyrs have been designed at this point. In the upper right a figure leans forward and lifts a cross. His pose is close to that finally assigned to Saint Catherine lifting her wheel. Important for our purpose is the absence of Lawrence and Batholomew at this stage, who will appear at Christ's feet.

The drawings in Bayonne and Casa Buonarroti must have been preparatory to the *modello*. The second stage of design would have occupied the artist as he prepared the actual cartoons during the prolonged preparation of the wall in the fall of 1535 and early 1536.

The large sheet now at Windsor of the *Resurrection of the Dead*, shows many of the principal figures already invented, but their placement has not yet been determined. The sheet is a series of individual figure studies rather than a compositional sketch, but Michelangelo is also interested here in establishing the currents of motion: the pull to the right, where the cave will be, is clearly announced, and the upward movement as well. Details such as the skeletons and shrouds do not yet appear, and the figures will be rearranged.

## THE FINAL RESURRECTION

The subject of the Last Judgment had not been favored in the Renaissance, compared to the Middle Ages, when it frequently adorned the portals of churches or covered the inside of the entrance wall, so that this was what worshipers would see as they left the church and reentered the world.

The apocalypticism accompanying the turn of the half millennium in 1500 had perhaps been responsible for the major example to be commissioned in these years, Luca Signorelli's frescoes around the walls of a chapel in the Orvieto Cathedral. He divided up the traditional sections, so that the Blessed, the Damned, and the Resurrection of the Body were each assigned to a separate field, and Christ and the angels with trumpets appear above the Blessed in paradise. According to Vasari, writing soon after Michelangelo's fresco was unveiled in 1541, Signorelli's work had been much admired and studied by Michelangelo. Although scholars have generally failed to recognize it and have interpreted the fresco in terms of other

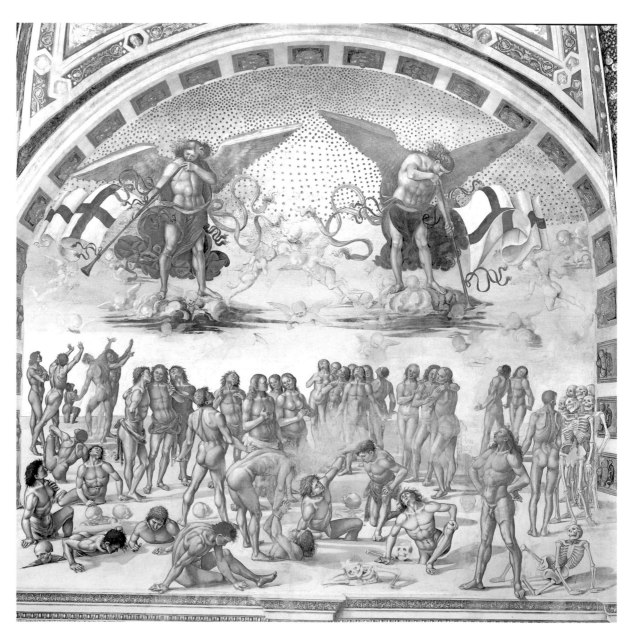

The apocalypticism accompanying the turn of the half millennium in 1500 had perhaps been responsible for the major example to be commissioned in these years, Luca Signorelli's frescoes around the walls of a chapel in the Orvieto Cathedral.

158

texts, the conceit of Signorelli's and other Renaissance Last Judgments is the same as of Michelangelo's. The text is from Paul's First Letter to the Corinthians and what is depicted is the Final Resurrection. At the Second Coming of Christ, as described by Saint Paul, everyone who has ever lived will be issued a new spiritual body to replace their physical bodies, worn out by earthly life.

The earliest reference to Michelangelo's commission is a letter of March 2, 1534, which described it as a "Resurretione." This has been misinterpreted as proof that there was a change of subject: Michelangelo was originally commissioned to paint a Resurrection of Christ, which was then enlarged to the *Last Judgment*. In fact the reference should be understood as shorthand for the Final Resurrection, or the Universal Resurrection, or the Resurrection of the Body.

If the papal commission was for a Final Resurrection based on Paul's Letter to the Corinthians, we can more easily understand the insistent corporeality of Michelangelo's fig-ures. This explains the necessity for nudity, because only nude figures could convey that these are not disembodied souls, but the spiritual bodies of the Pauline text. In this context we may find it easier to understand why Pope Paul would not have anticipated the storm of protest that arose over the nudity in the fresco. From his point of view, like that of the painter, it was indispensable to the illustration of the theological doctrine.

Michelangelo was uniquely suited to paint this theme, as Pope Clement certainly recognized. His love affair with the human body made him the painter who could discover the visual means to represent the mass of humankind assembled on the Final Day, each in idealized form, and imbue every one with individuality. The spirit of the piece, then, is anything but penitential; on the contrary, it is intended as a celebration of the humanist view of humankind: we are God's special creatures, reflecting the *imago dei*, and we have been promised a personal resurrection on the model of Christ's resurrection.

## THE THEOLOGICAL DEBATE

The question of whether there was such a thing as a personal life after death had been moot until shortly before Michelangelo's commission. The two Medici popes, Leo and Clement, had put their effort and their authority behind the endorsement made by the Fifth Lateran Council in 1513 of the doctrine of personal immortality.

The controversy surrounding this question had come to a head in the late fifteenth century. In the twelfth century the philosopher Averroes had proclaimed, on the authority of Aristotle, the mortality of individual souls. That is to say, there is no individual or corporeal life after death. Averroes posited instead a kind of collective immortality, persons being immortal insofar as they participate in the transcendental intellect, an entity that is spiritual and immaterial, as well as immortal. It was from Florentine humanism that the refuter of Averroes arose, in the person of Marsilio Ficino. His book, published in Florence in 1482, grounded personal immortality in the humanist tenets of the dignity of humankind, our central position in the cosmos, and our desire to be like God.

The leading theologian to address this issue in the Cinquecento who would play a major role in this controversy for the next thirty years, was Tommaso de Vio, known as Cajetan, from Gaeta, where he was born in 1469. He presented to Pope Julius II in 1503 a disputation on the subject. The Lateran Council a decade later produced a decree proclaiming again the Church's support of the doctrine of individual life after death. Nevertheless, controversy continued to rage, and treatise after treatise was produced, either in support of Aristotle or opposing him. Cajetan entered the battle again and pronounced that, while the doctrine could not be proven by reason, it must be accepted as an article of faith based on scripture.

This may have taken care of the issue raised by Averroes of collective versus personal immortality, at least as far as some were concerned, but there remained the question of *how* the resurrection would take place and *what* would be resurrected. These are the questions put by Saint Paul in his First Letter to the Corinthians. Paul recognized that the first-century

citizens of Corinth preferred their Greek conception of the immortal soul to the untidy Christian concept of bodily resurrection. As Paul said: "But some one will ask: 'How are the dead raised? With what kind of body do they come?'" (1 Cor 15:35). He therefore undertook to explain how it would be possible for the dead to be raised at the time of the Last Judgment. The essence of Paul's message lies in his distinction between the physical body, which must die, and the new spiritual body, which will be issued each of us when the trumpets sound. "Now if Christ is preached as raised from the dead, how can some of you say that there is no resurrection of the dead? But if there is no resurrection of the dead then Christ has not been raised . . . and your faith is in vain" (1 Cor 15:12–14).

Cajetan was a major theologian of his day. A Dominican, he devoted years to his commentary on the writings of the great Dominican father, Saint Thomas Aquinas. He was made cardinal in 1517 by Pope Leo X. He died in the same year as Pope Clement, in 1534. Many of his contemporaries, it is said, believed that if he had lived, he would have succeeded Clement as the next pope. Among Cajetan's last writings are his commentaries on the Epistles of Paul, published in Venice in 1531 with a dedication to Pope Clement. There is thus no doubt whatever that Cardinal Cajetan's writings were known and read in the papal inner circle. Within a couple of years of this publication, Clement would open discussion with Michelangelo on the subject of the *Last Judgment* commission. In his commentary upon Paul's Letters to the Corinthians,

Cajetan lays particular stress upon the spiritual body. Commenting upon the passage where Paul says, "What is sown is perishable, what is raised is imperishable. It is sown in dishonor, it is raised in glory . . . It is sown a physical body, it is raised a spiritual body" (1 Cor 15:42–44). Cajetan wrote: "He [Paul] did not say it will be raised spiritual, but it will be raised a spiritual body (NON DICIT RESURGIT SPIRITUALI SED RESURGIT CORPUS SPIRITUALIS.)."

Simultaneous with commissioning the *Last Judgment*, Pope Clement turned his attention to his tomb. Although it was finally executed after his death on a different design, Clement had Baccio Bandinelli make a design, of which a drawing survives. Bandinelli's sculpted wall tomb shows Clement stretched on his bier at the bottom. The focus, however, is not placed here but on the middle zone, where, ascending from the dead, Clement is shown as a splendid naked youth who, according to one scholar, resembles Michelangelo's *David*. But this is so because both Michelangelo's statue and Bandinelli's nude embody the Renaissance ideal of the male figure. What Bandinelli has represented is Pope Clement's spiritual body being raised to the company of Christ, the Virgin, and the Apostles in the lunette at the top. How better might the celestial body be represented than as an idealized youthful nude? Paul in his letter said: "Just as we have borne the image of the man of dust [i.e., Adam] we shall also bear the image of the man of heaven" (1 Cor 15:49). Cajetan comments: "Our body in the resurrection is compared without hyperbole to a celestial body."

## DEPICTING THE DAMNED

Although Saint Paul did not address himself to the question of how the Damned would be different from the Elect, Cajetan did. In an aside to his commentary on 1 Cor 50–52 which should have been of great help to Michelangelo—he remarked: "The bodies of the Damned will be imperishable with no use [need] of sex or food or body fluids, but they will not be glorified and insensitive to pain."

He goes on to say, commenting on verse 52, that the Reprobate will change from perishable to imperishable; the Elect however, will become not only imperishable, but also insensitive to pain, vigorous and glorified—whereas the

Damned will not. Michelangelo's decision was to show the Damned in as thoroughly corporeal a form as the Elect, but whereas the Elect are idealized, the Damned are ugly; whereas the Elect have recovered from all physical suffering

and have passed beyond it, the Damned are tormented and anguished. It might be remarked that there is nothing new here. The history of the representation of the Last Judgment has been to show the Damned suffering the tortures of Hell while the Elect enjoy a blissful life in heaven. While this is certainly true, what has changed in Michelangelo's rendition—and this is what outraged his sixteenth-century critics who failed to understand the context—was the insistence upon the naked body of everyone. These are bodies that are not concealed in draperies, bodies that are not desensualized. By stripping away clothing, Michelangelo is not only proclaiming universal equality on the Final Day but also rendering the corporeality of the resurrected body.

Later in the century, in 1564, Giovanni Gilio published his treatise *The Errors and Abuses of the Painters,* in which he centered his criticisms of painting on Michelangelo and his *Last Judgment.* He found it necessary first to explain the theology of the subject and what a representation of the Last Judgment should contain.

When one of the interlocutors remarks that he has heard theologians say that souls do not occupy space, another, who is the theologian in the dialogue, replies: "But we are not talking just about souls but about souls and bodies, and although the bodies will be glorified, they will nonetheless certainly occupy space." The text Gilio's spokesman depends on here, as he makes clear, is of course Paul's First Letter to the Corinthians. It could be deduced that the Cinquecento had settled on this as the indispensable description of the Final Day.

There is nothing in the fresco to contradict that the Pauline text was Michelangelo's principal source: The *Resurrection of the Dead* is prominent, represented in the lower left corner, as it had been prominent in Signorelli's frescoes at Orvieto where it merited an entire fresco to itself. There is no Saint Michael weighing the souls here, which often figured in earlier *Last Judgment*s.

Simultaneous with commissioning the *Last Judgment,* Pope Clement turned his attention to his tomb. Although it was finally executed after his death on a different design, Clement had Baccio Bandinelli make a design, of which a drawing survives.

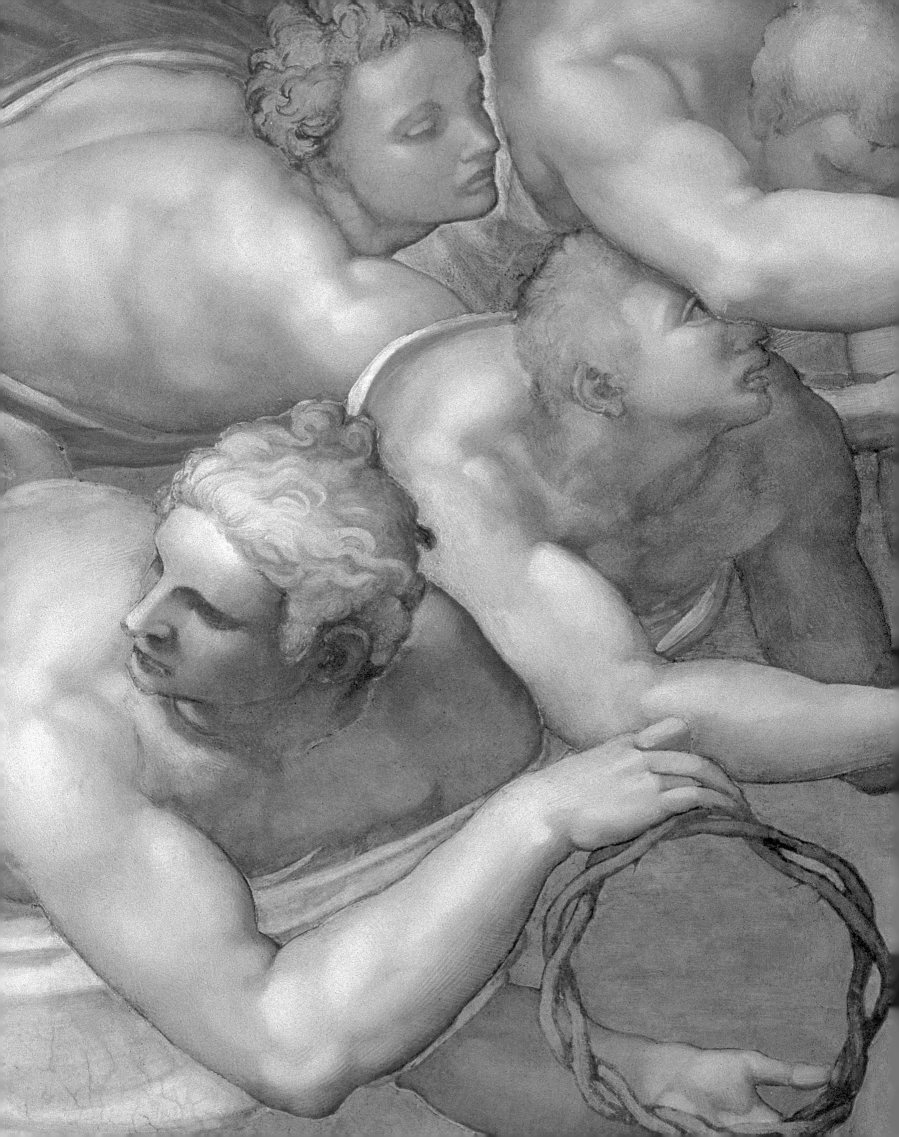

# THE LUNETTES

These are the areas that had contained the first of Michelangelo's Ancestors. To judge from his preliminary drawings for the *Last Judgment*, the painter initially intended to save his own work in these spaces, as well as Perugino's altarpiece, and only after working on the design did he decide that he must use the entire wall and therefore demolish them.

The symbols of Christ's Passion, the cross, the column against which he was scourged, the ladder, the sponge, the crown of thorns, are carried by wingless angels. They are given unaccustomed prominence because their inclusion makes it clear that the final resurrection depicted below was made possible by the sacrificial death of Christ and his resurrection.

The lunette at the left carries upward the movement of the ascending bodies with the oblique line of the cross, symbol of redemption, and the lunette on the right begins the downward movement of the Damned with the corresponding line of the column, emblem of the cruelty of humankind. The angels cling to each, lifting or lowering, in a maelstrom of energy.

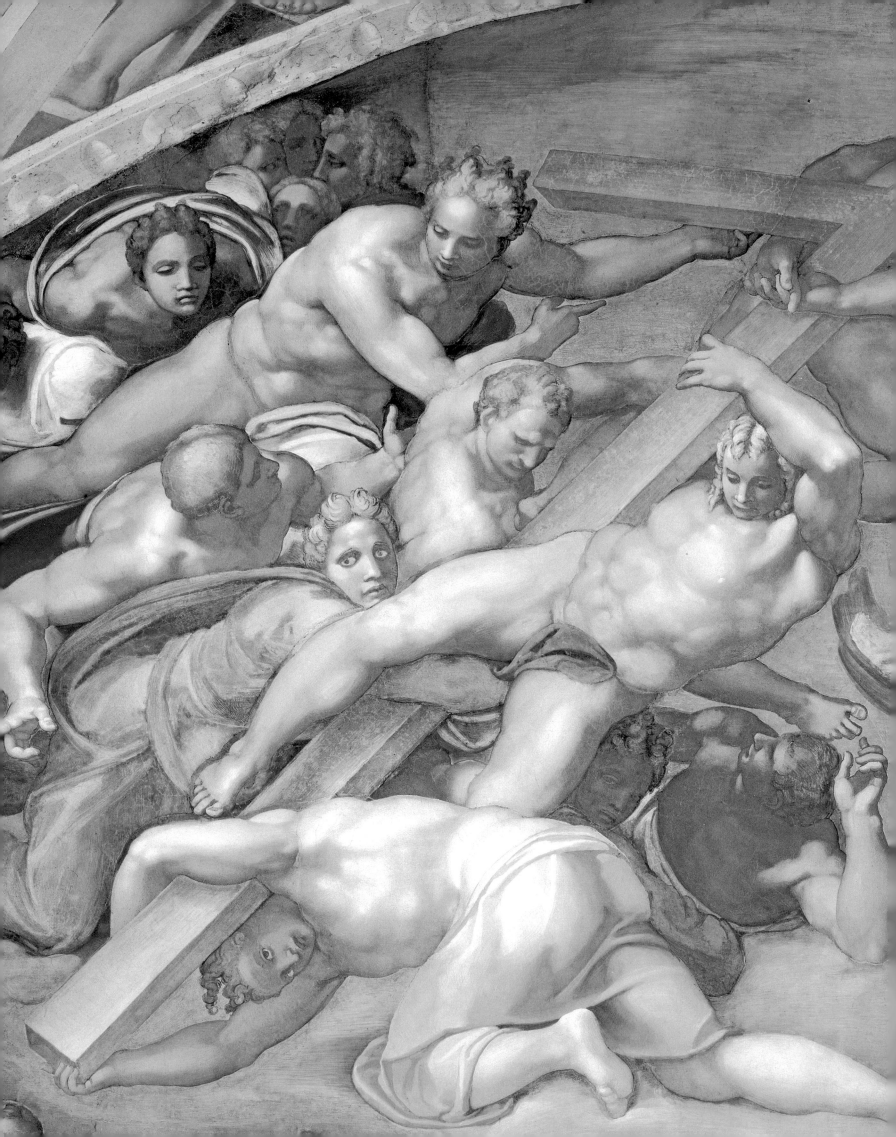

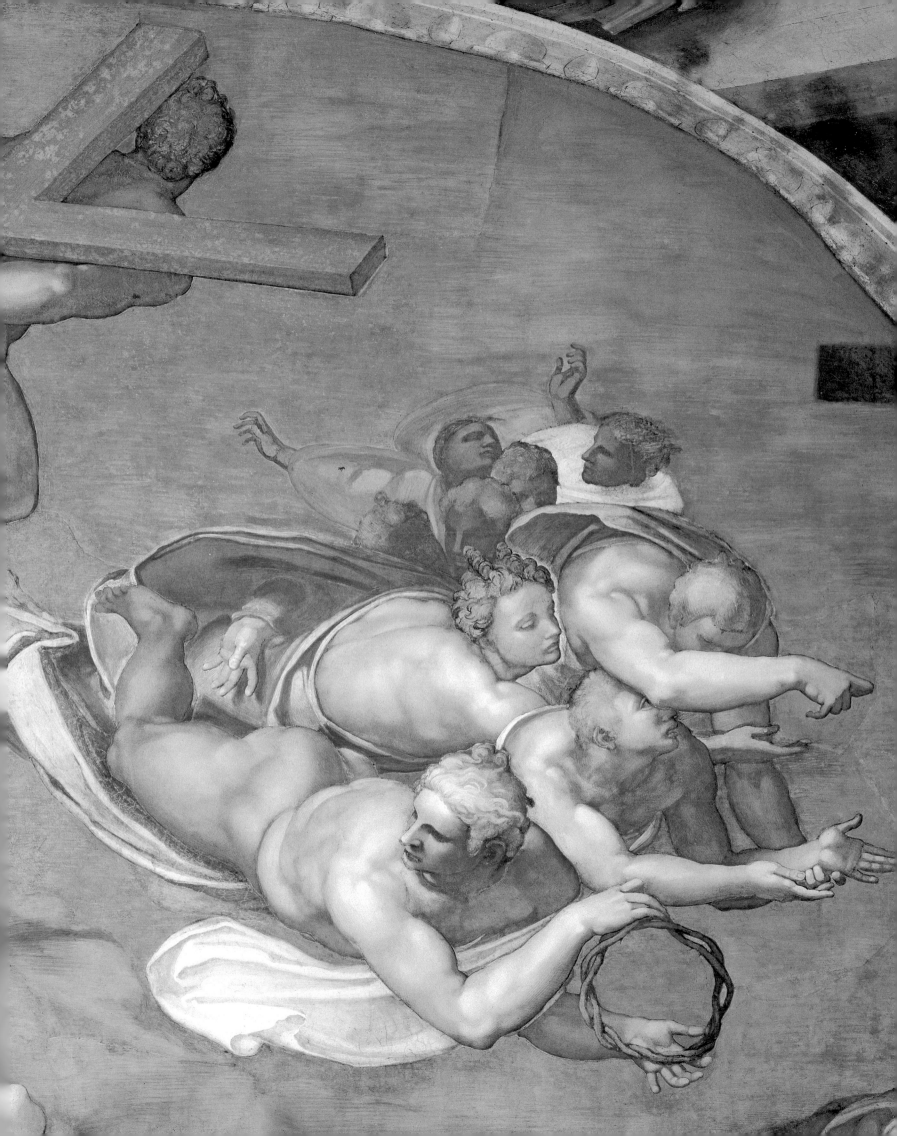

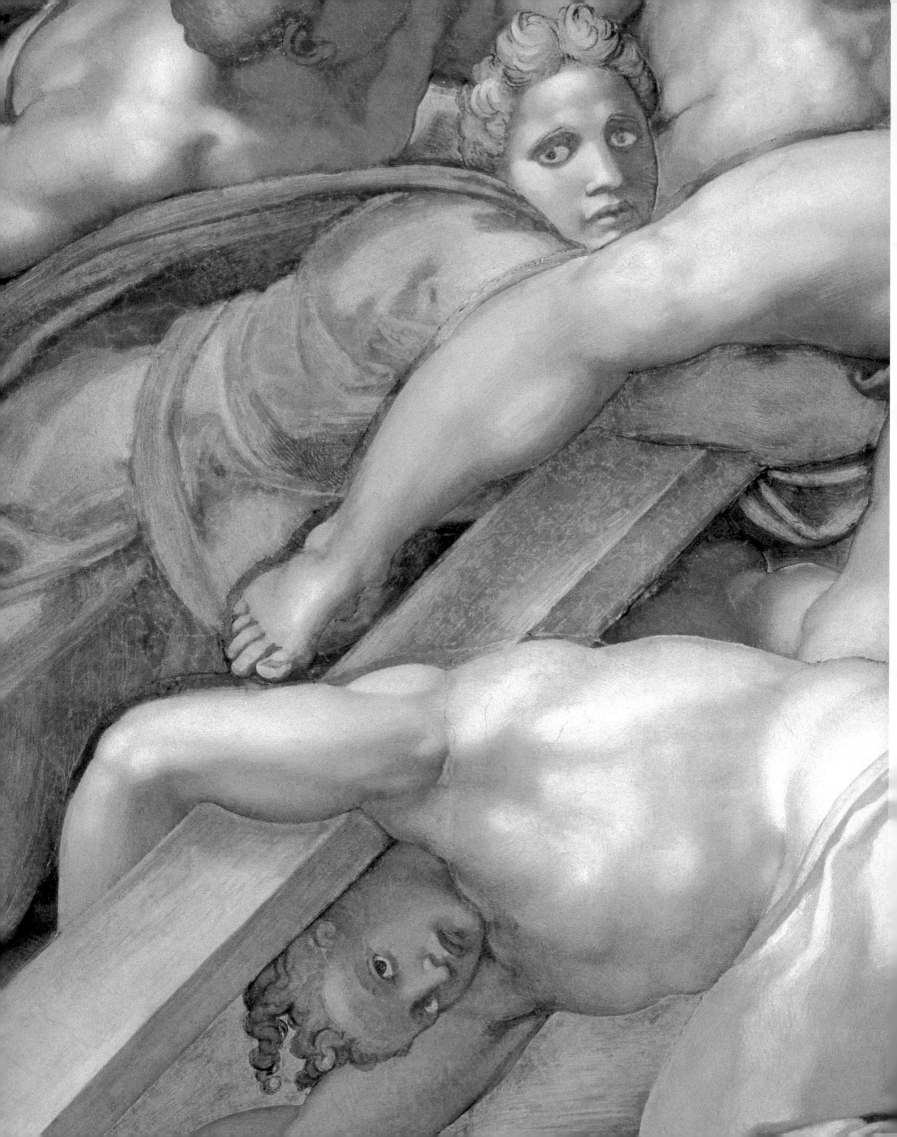

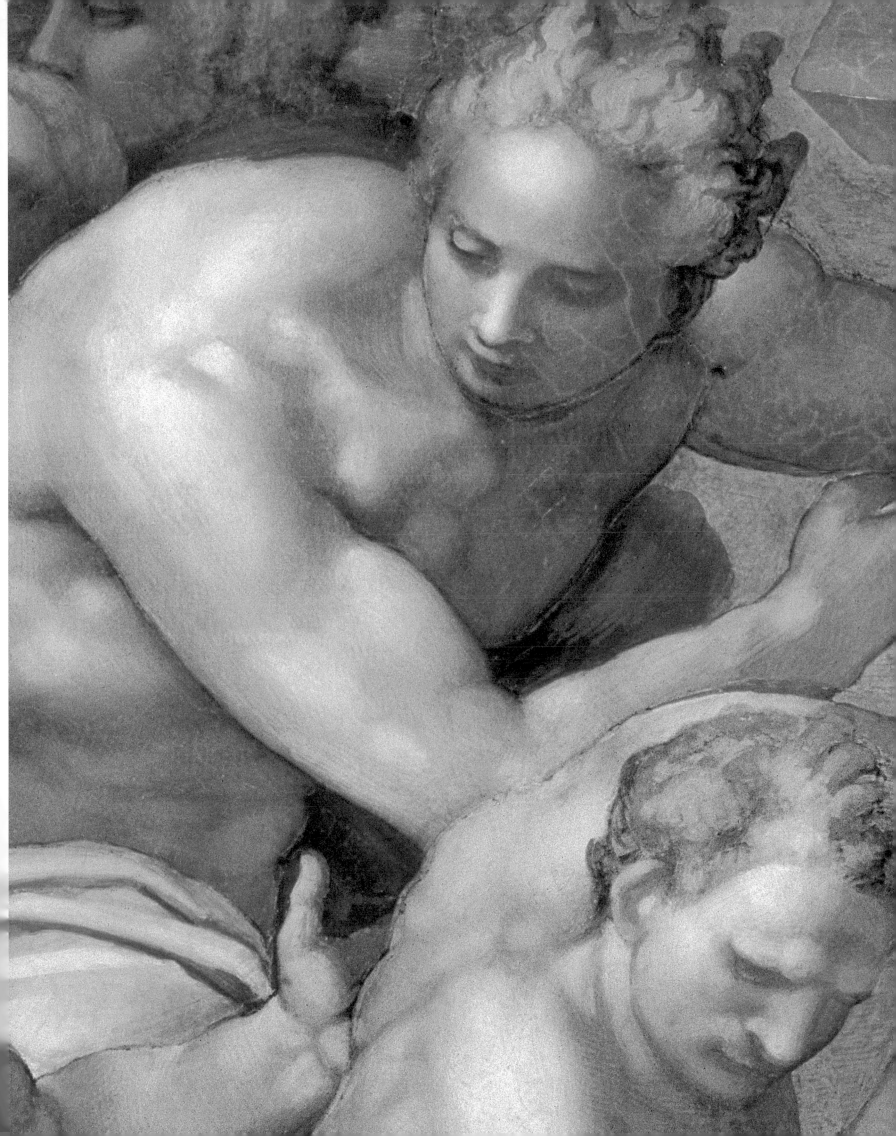

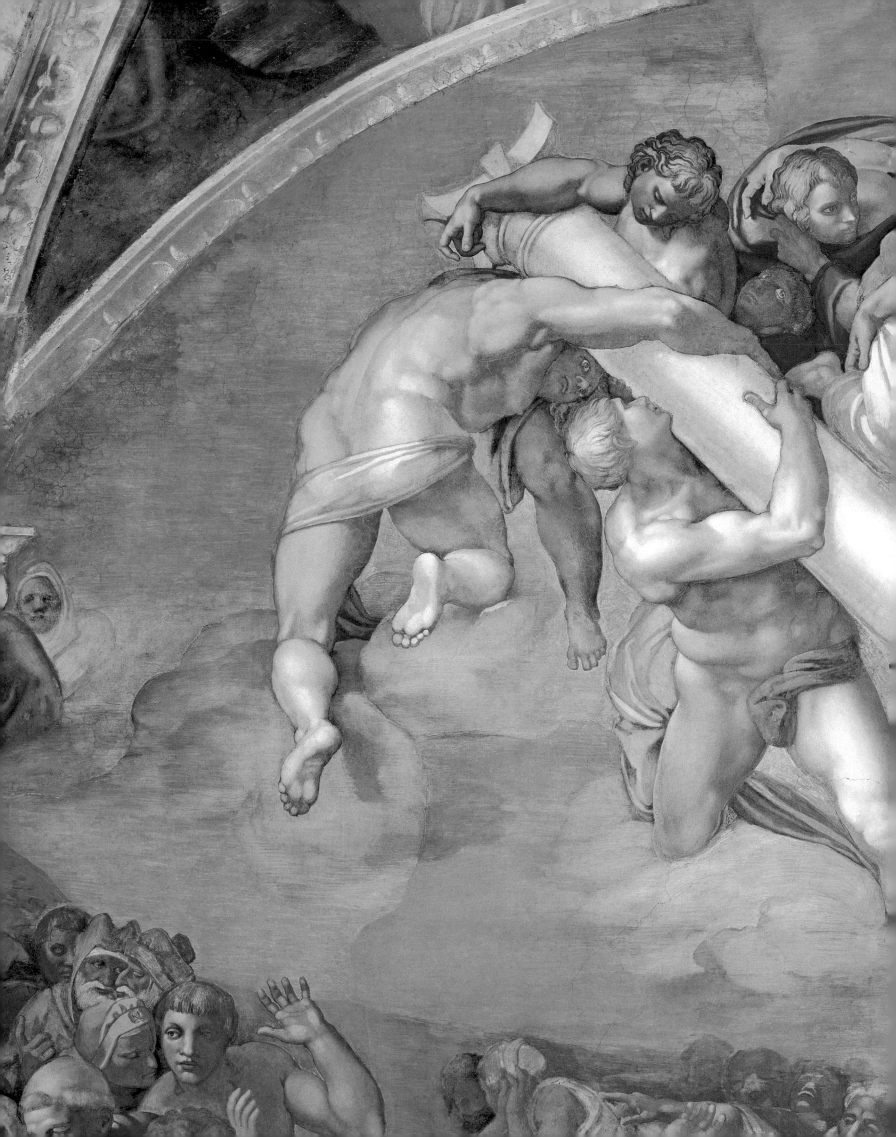

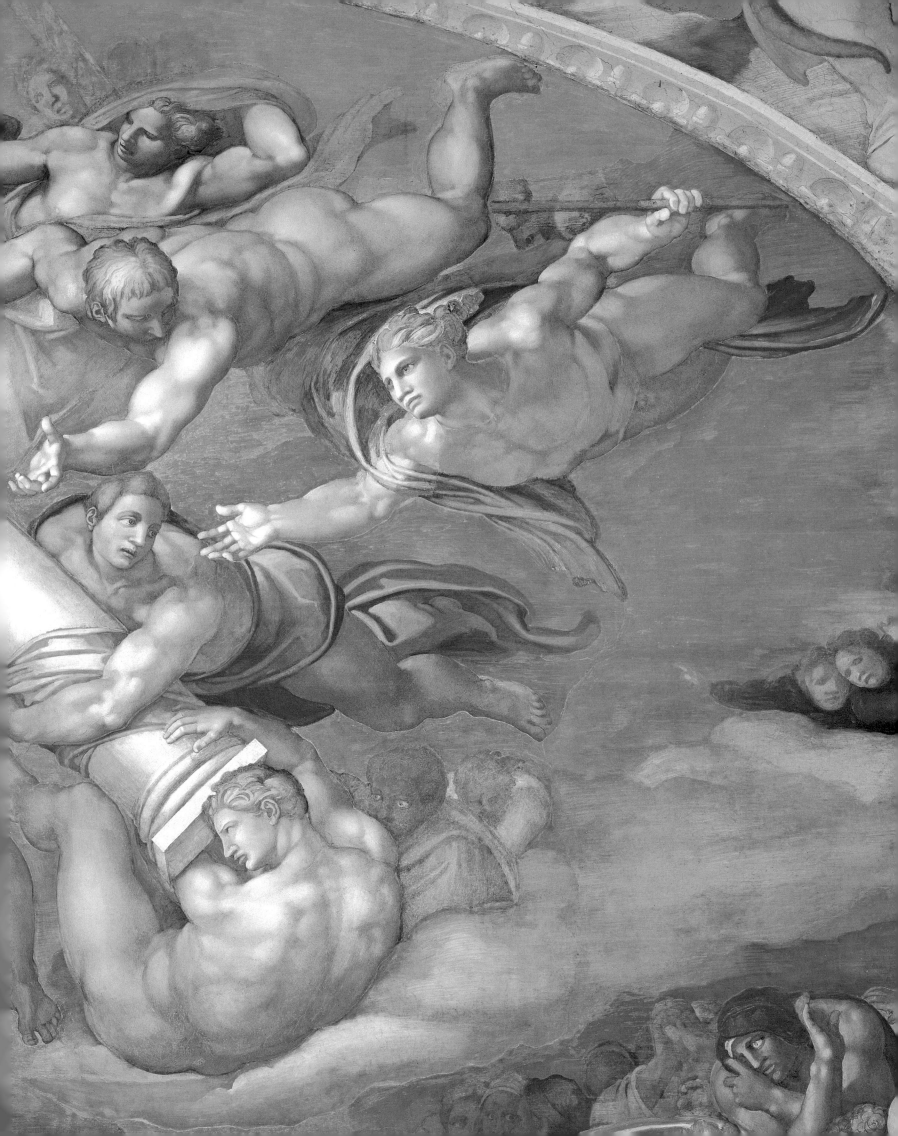

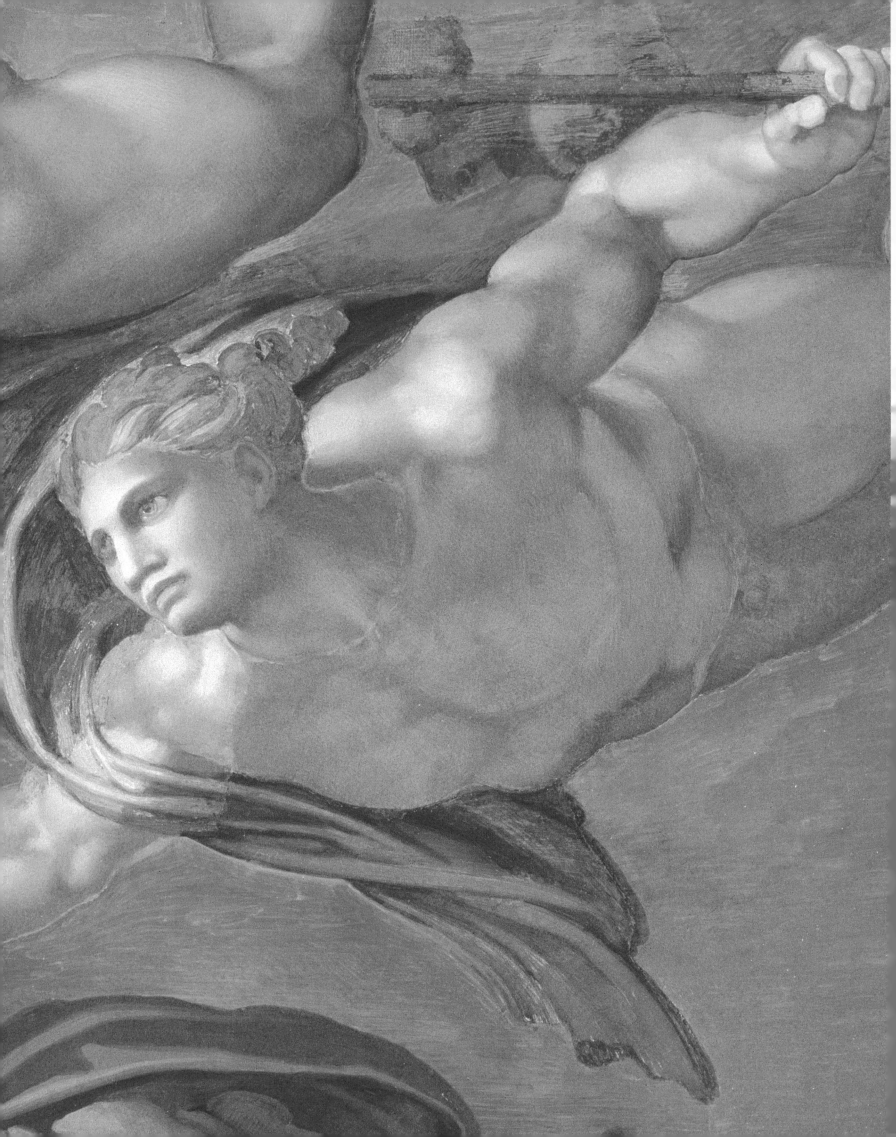

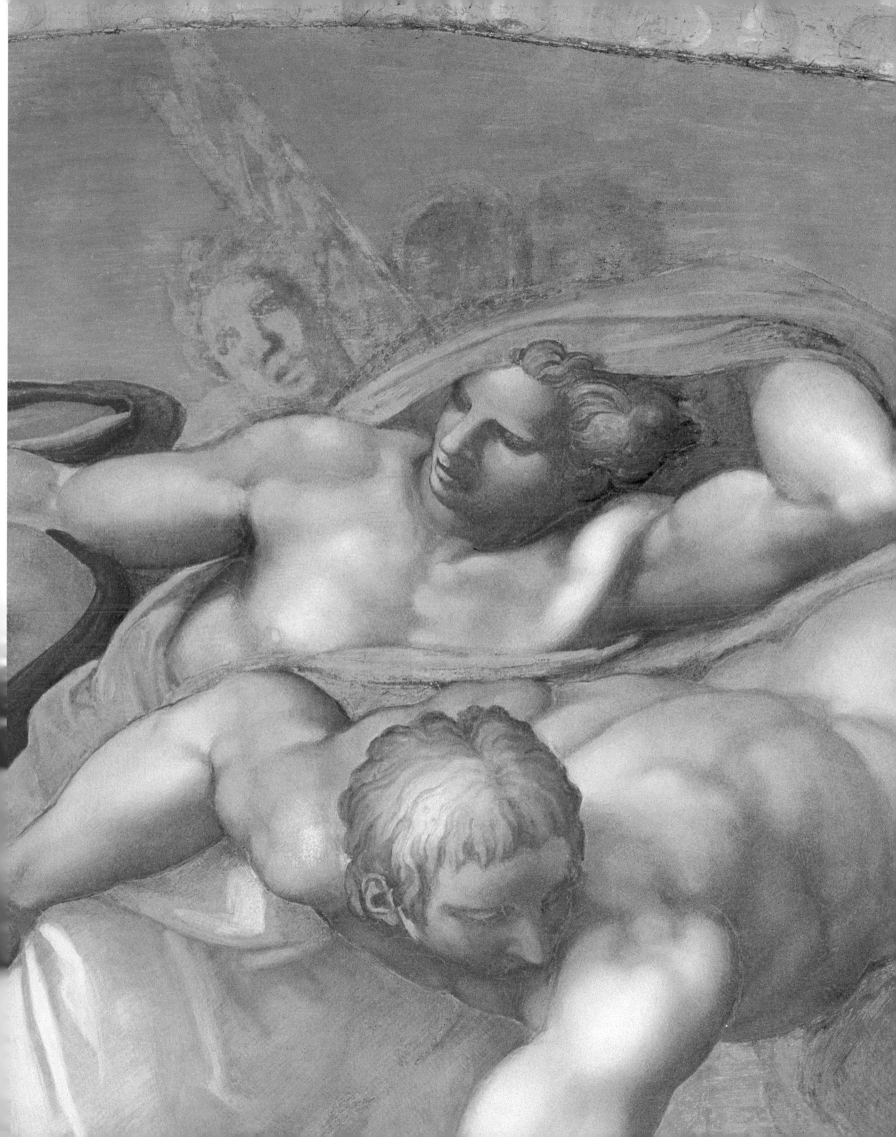

# THE TRUMPETING ANGELS

A nother group of angels at the center respond to Christ's coming and his command: "They will see the Son of man coming on the clouds of heaven with power and great glory; and he will send out his angels with a loud trumpet call, and they will gather his elect from the four winds" (Mt 24:30–31).

The four angels on the left have their cheeks puffed out in the manner of the ancient wind gods. Two of the angels hold up books that they consult. These are books in which the judgment concerning each life has been written at the time of death. These judgments, long since recorded, determine whether one will rise to heaven or descend to Hell. The book on the side of the Damned is bigger and thicker than the slim volume on the side of those ascending, which has been taken to imply that "many are called but few are chosen." This contradicts the demographics of Michelangelo's population, where many more Elect are shown than Damned.

This part of the fresco was damaged because the *baldacchino*, or canopy, installed (until the middle of the twentieth century) for solemn occasions, was hung from the two hooks still in place on either side. Thus the angels disappeared from view, together with the cave below it, whenever the *baldacchino* was used.

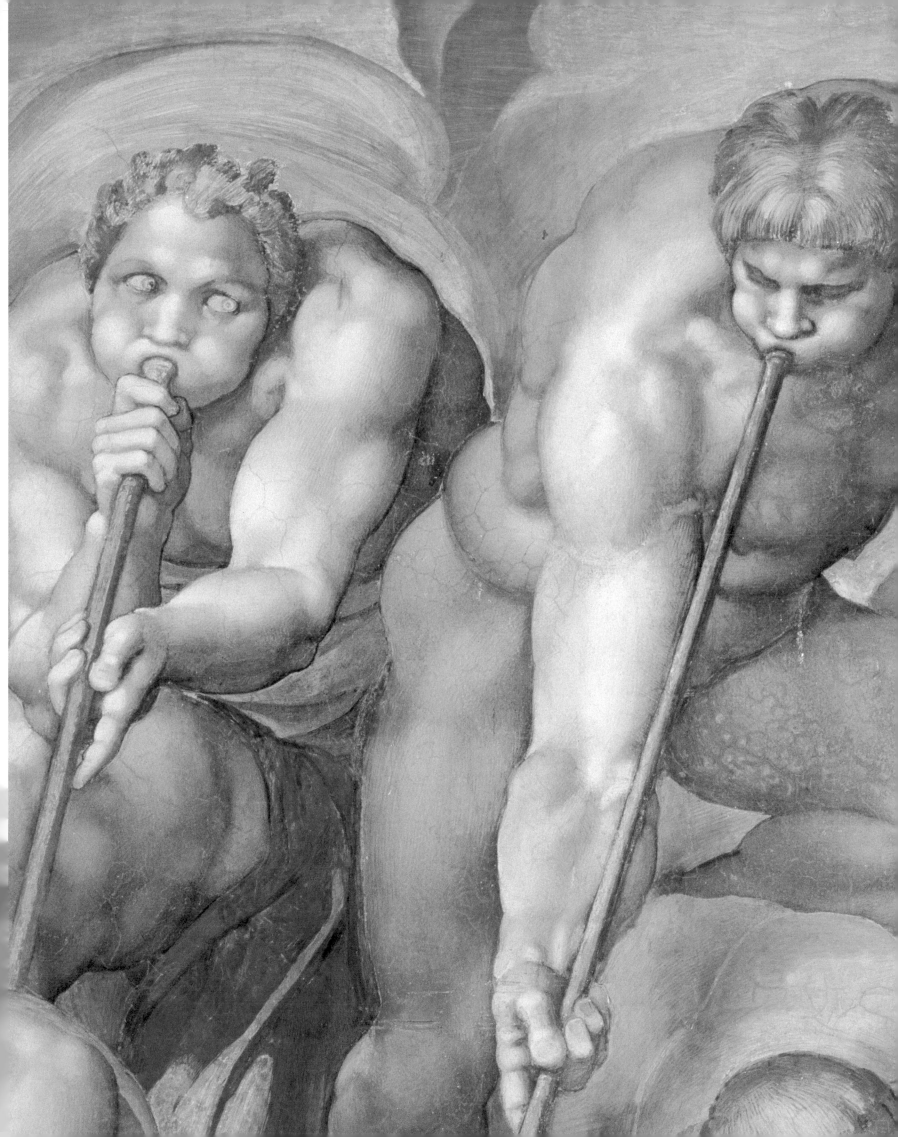

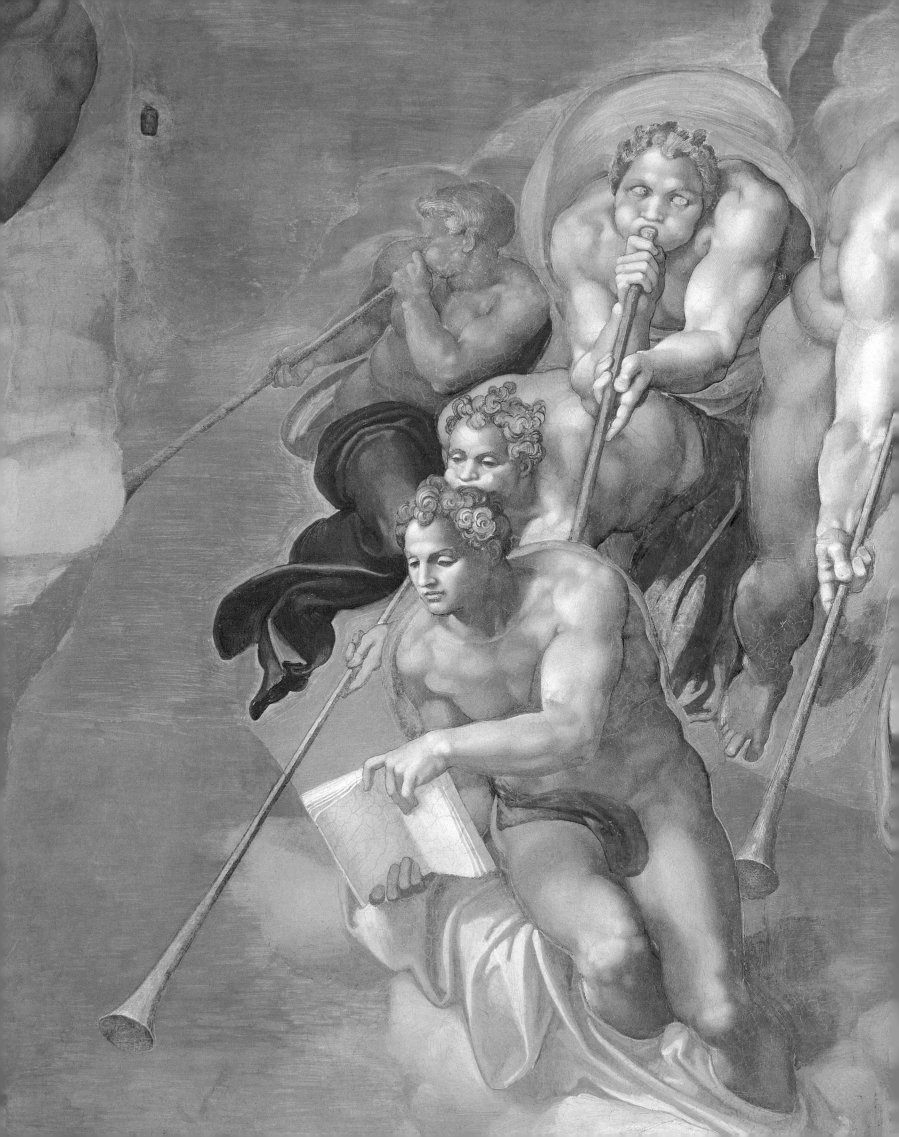

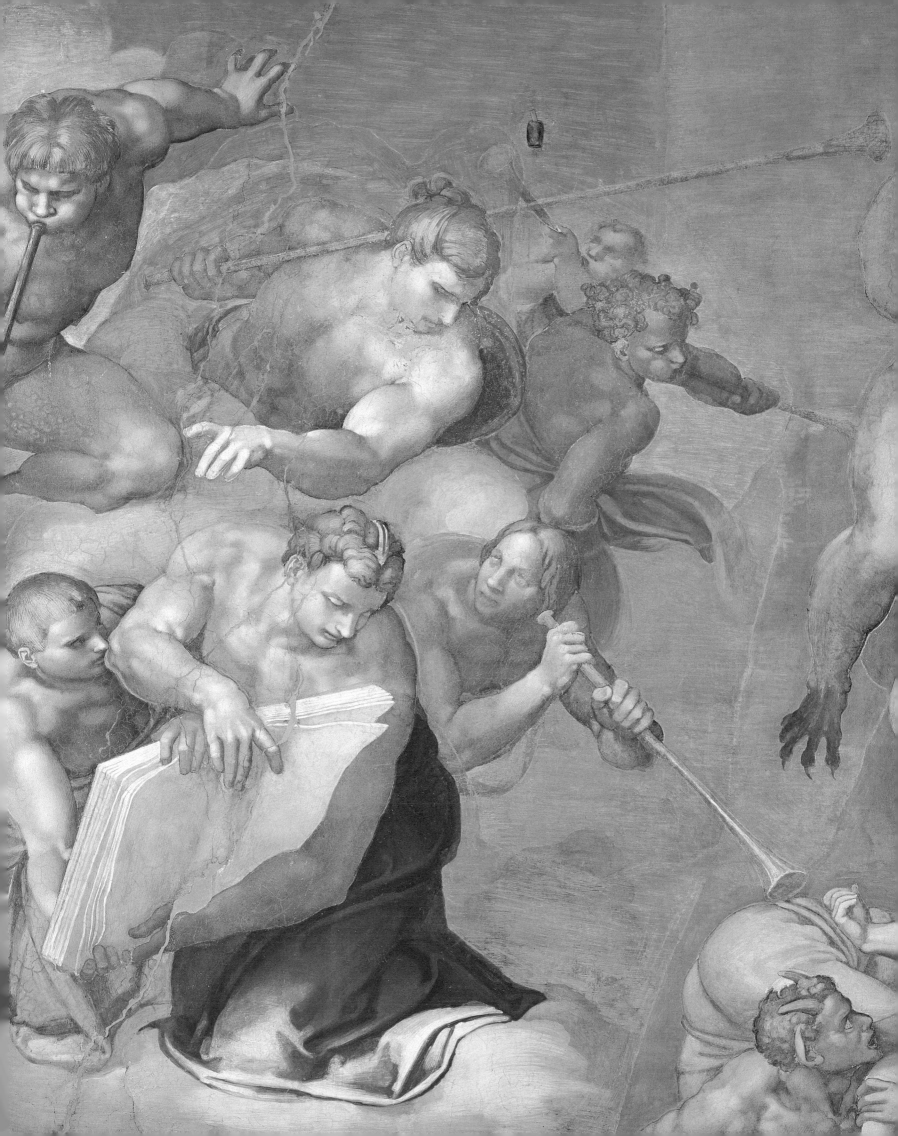

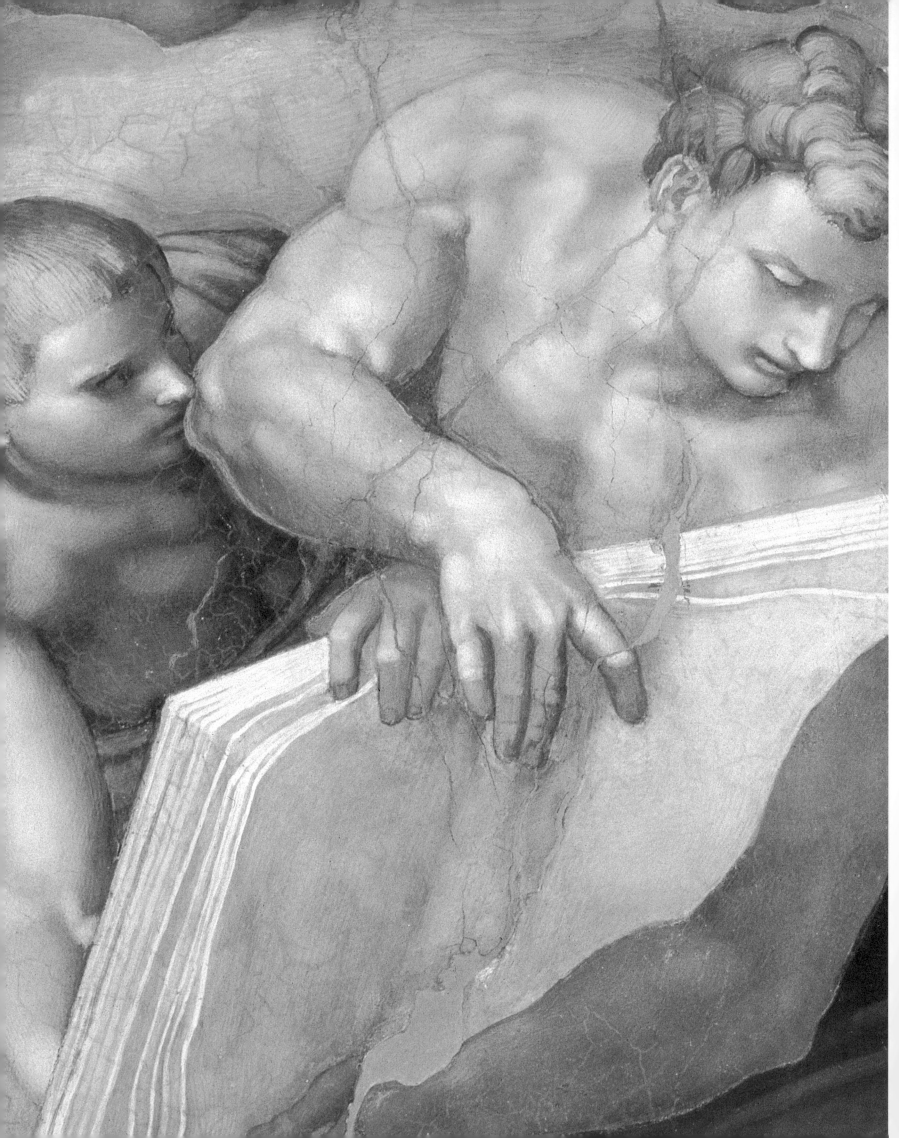

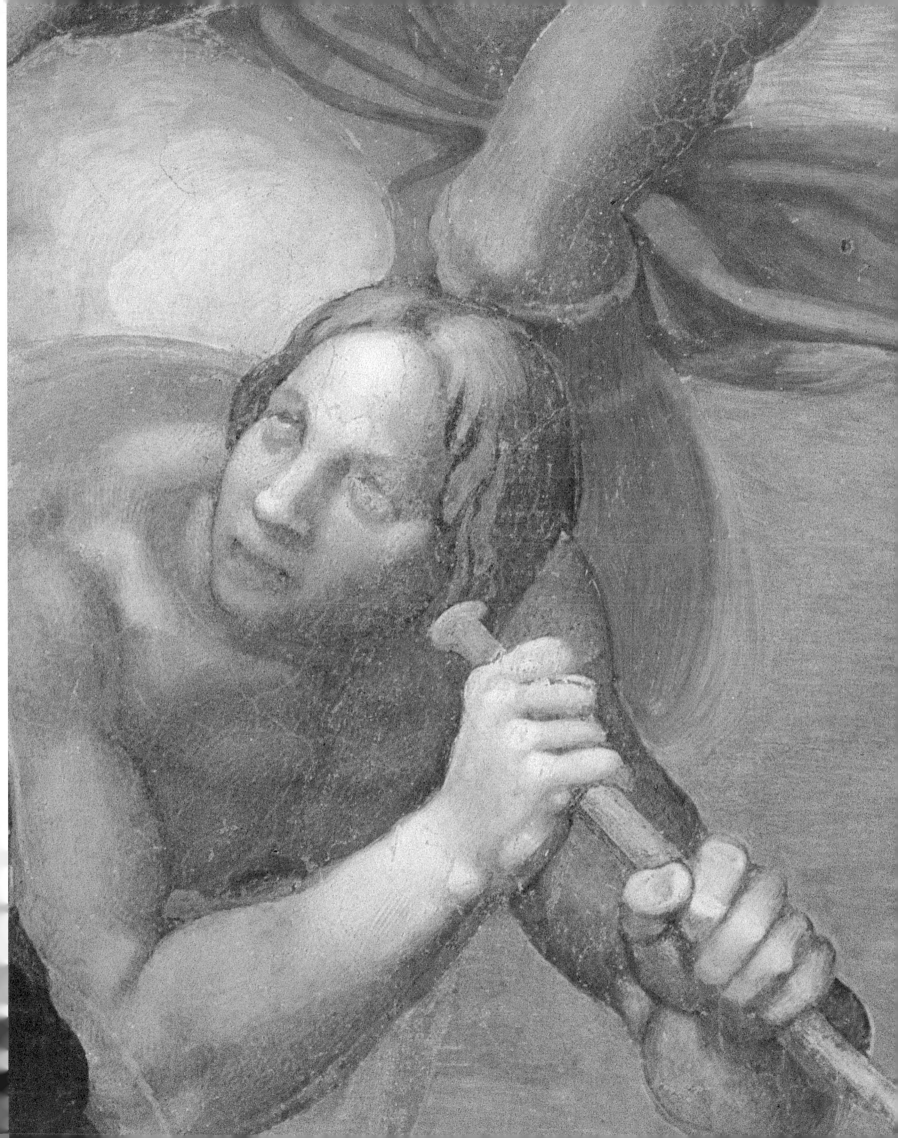

# CHRIST AND THE VIRGIN

The commanding figure of Christ dominates the fresco. He is set off against a golden aureole, which includes his mother, who cleaves to his side. In early sketches Michelangelo had drawn Christ seated in the traditional manner, but in the painting he seems rather to be striding forward, perhaps rising to his feet.

His stance reminds us of images of Christ at his resurrection, bursting from the tomb, even specifically of Michelangelo's drawings for such a figure. This is indeed the risen Christ, for it was his resurrection that makes possible the resurrection of the dead on the Final Day. As St. Paul stated it: "For as in Adam all die, so also in Christ shall all be made alive." (1 Cor 15:22)

Vasari and Condivi described Christ's gesture as angry, but his impassive face contradicts this interpretation. His raised arm should be understood rather as one of command, setting into action the events we see unfolding before us: The angels sound the trumpets, the dead are raised and proceed to their appointed places, either rising to be with Christ in heaven, or falling into the abyss of Hell. He displays the wounds on his hands and feet and side, reminding us that this is the resurrected Christ and also of his suffering and at what cost this eternal life was won for us.

The Virgin turns her head aside and folds her arms, as if to say that the time for her merciful intercession is past. An attractive interpretation sees the closeness of these two figures as indicating that Justice has already been tempered with Mercy, so the two have become one.

Michelangelo's unconventional beardless Christ was criticized by some of his contemporaries. His resemblance to Apollo, the god of the sun in classical myth, has recently been linked to the revolutionary Copernican discovery that the planets revolved around the sun, and not vice versa. Although Copernicus's book was not published until 1540, when the fresco was almost finished, Clement VII was briefed on the Copernican discovery at the Vatican in 1533, just around the time the pope first discussed the commission with the artist. The golden light behind Christ/Apollo, which Michelangelo went to the trouble of painting *a secco* in brilliant yellow pigments that he used nowhere else in the fresco, becomes the sun around which the whole event moves in an inevitable and unperceived rotation. Quite the opposite of the condemnation the Church would later impose on Copernicus' theory, Clement and Michelangelo appear to have embraced it, finding no conflict with Church doctrine.

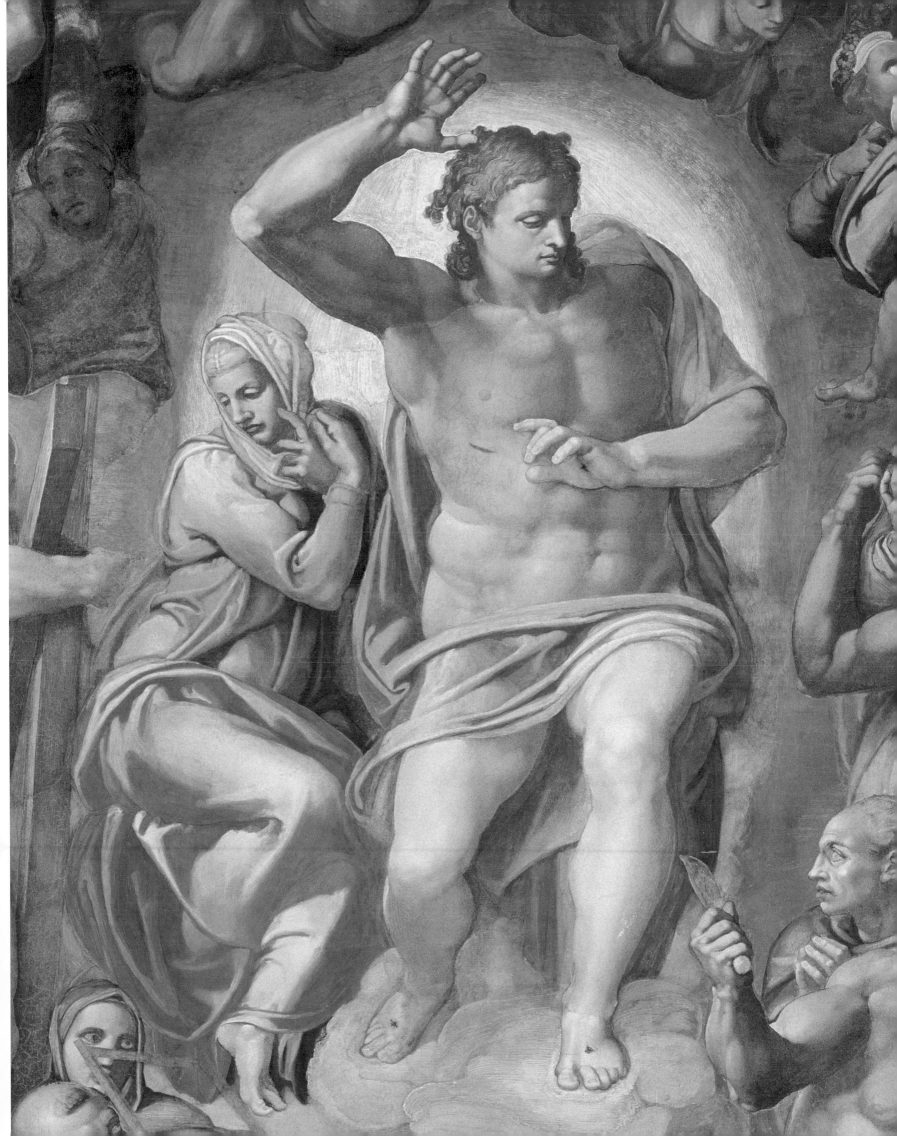

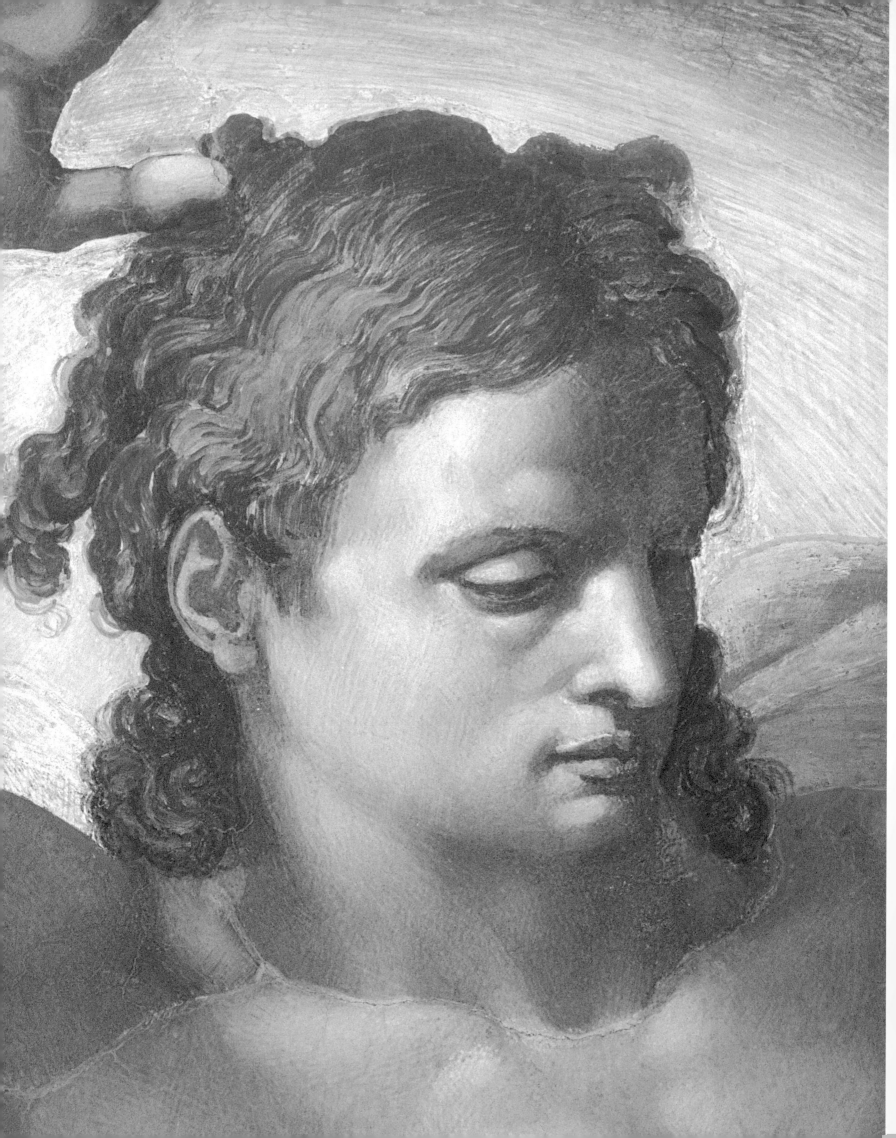

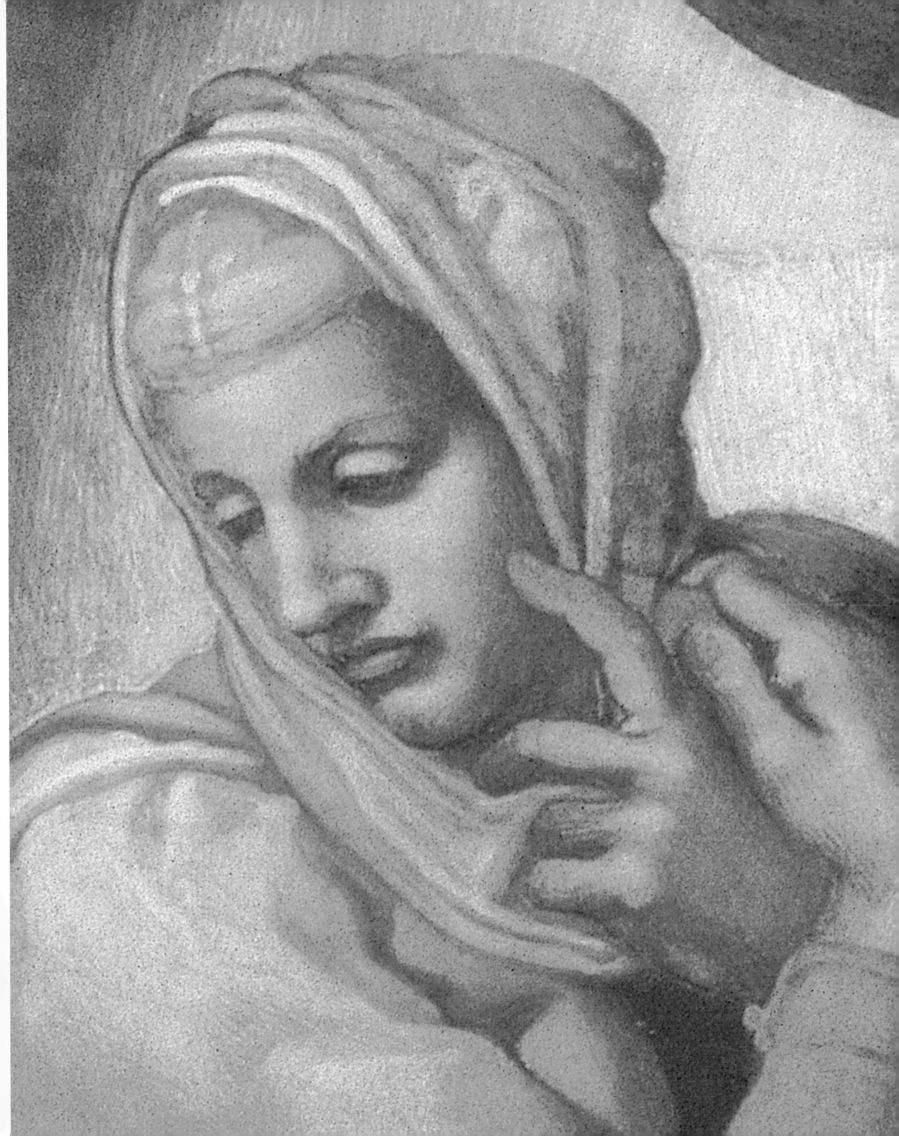

# THE RESURRECTION OF THE DEAD

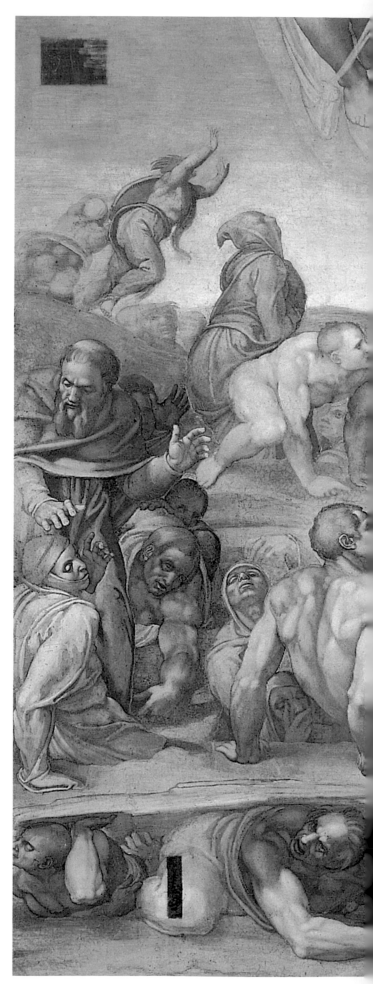

In response to the call of the trumpet, the graves are opened and the dead are reclothed in flesh. This scene was a standard part of Last Judgment iconography, for which the text was Ezek 37:1–11, the valley of the dry bones.

Luca Signorelli's fresco is similar. There, as here, bodies break through the ground. They are in all stages of recomposition: some are skeletons, some are fully awake. Michelangelo intensified the drama by multiplying the activities: he shows bodies unwinding their shrouds, and others, being lifted by angels, are grasped by greedy demons who try to pull them into the cave. The bodies of all those who are fully awake are robust and muscular because they have been issued new spiritual bodies. Just as the seed that is sown in the earth when it sprouts no longer resembles the seed, so, according to Saint Paul, "it is with the resurrection of the dead. What is sown is perishable, what is raised is imperishable. . . . It is sown a physical body, it is raised a spiritual body" (1 Cor 15:42, 44).

In the corner stands a man whose tonsured head marks him as a priest. He must represent the role of the Church in assisting Christians to a good death and final resurrection, for with one hand he blesses and with the other he gestures upward toward Christ and the company of the saints.

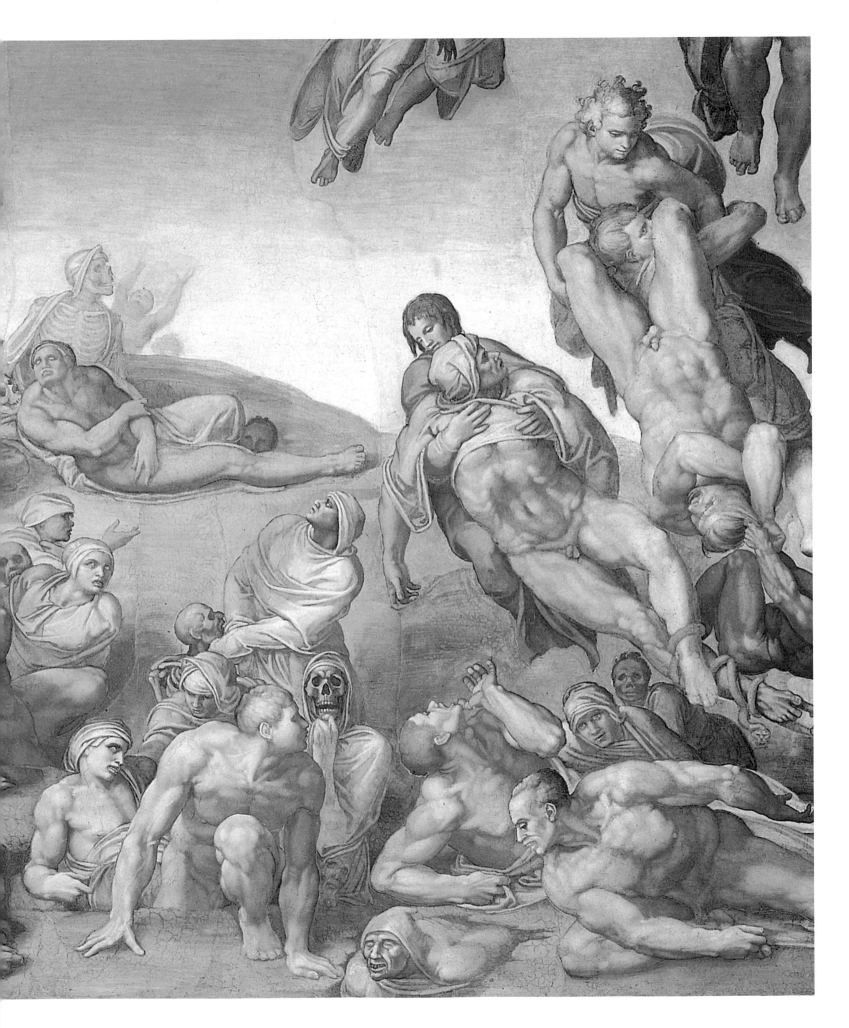

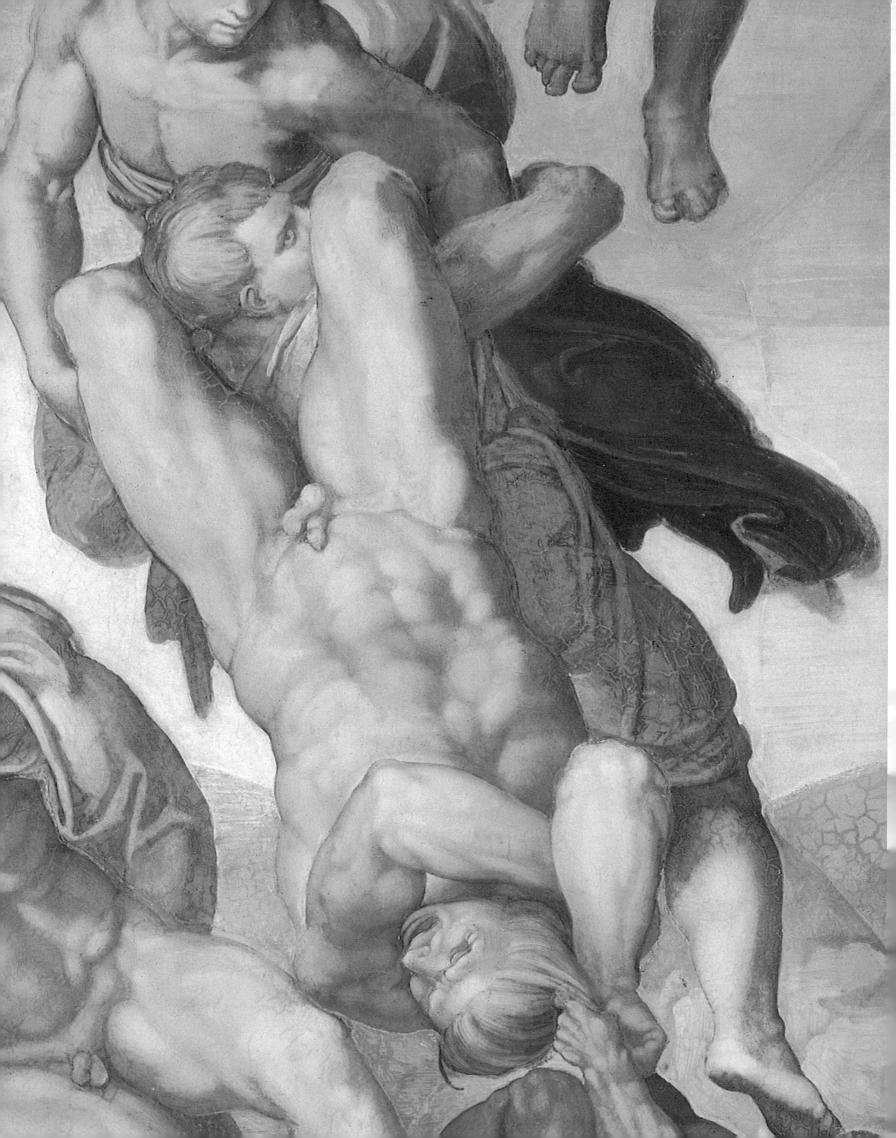

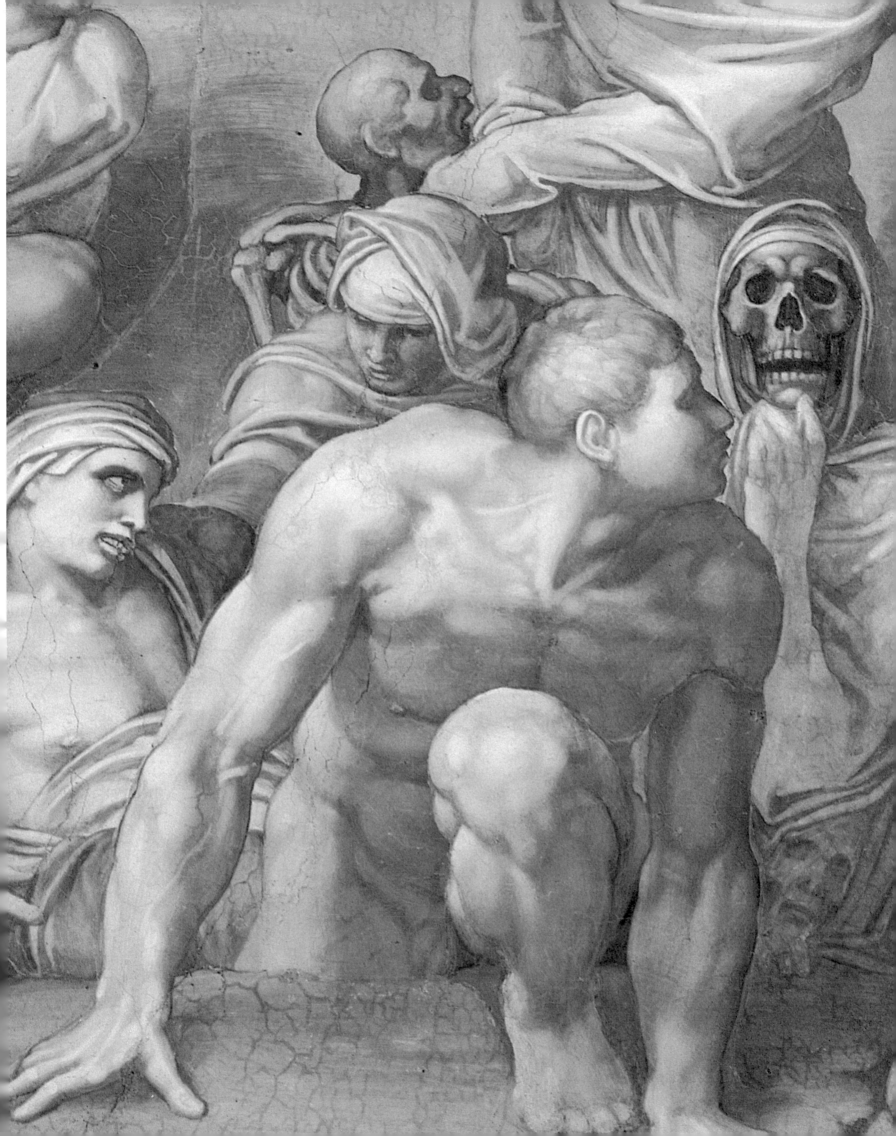

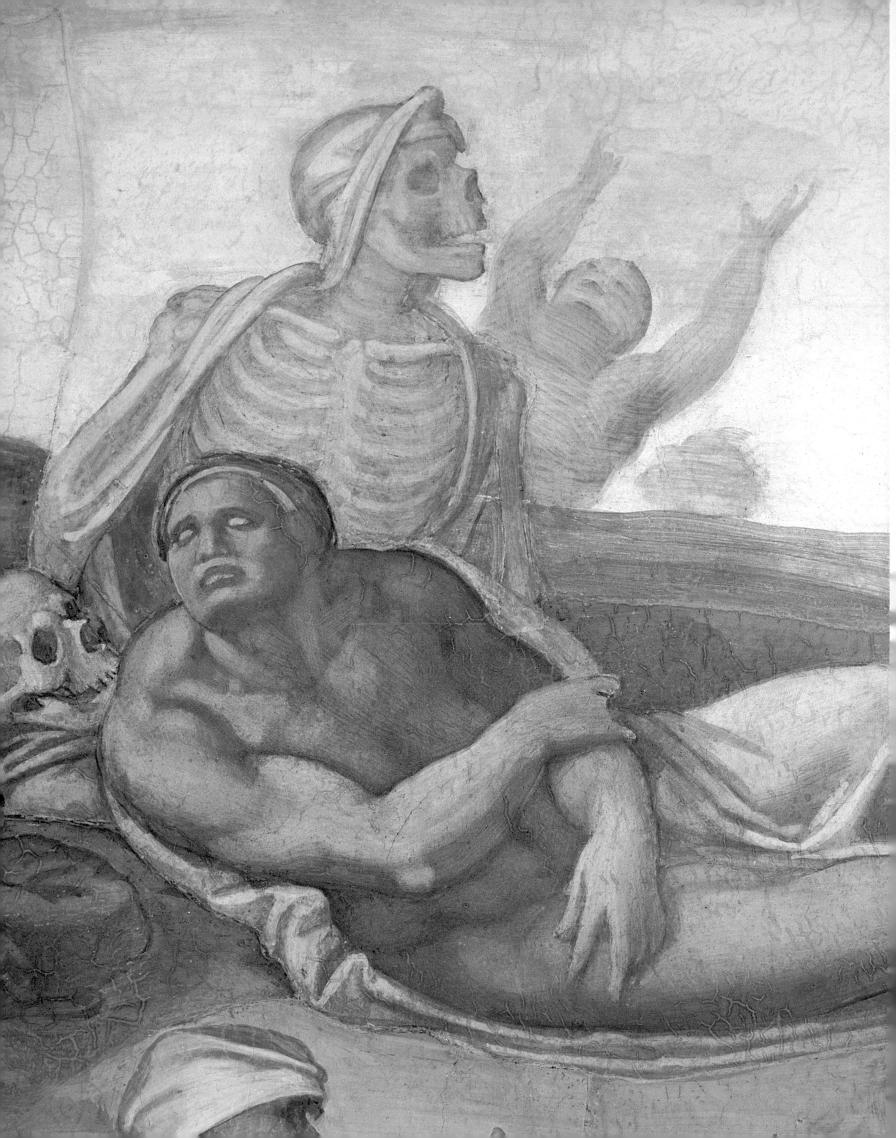

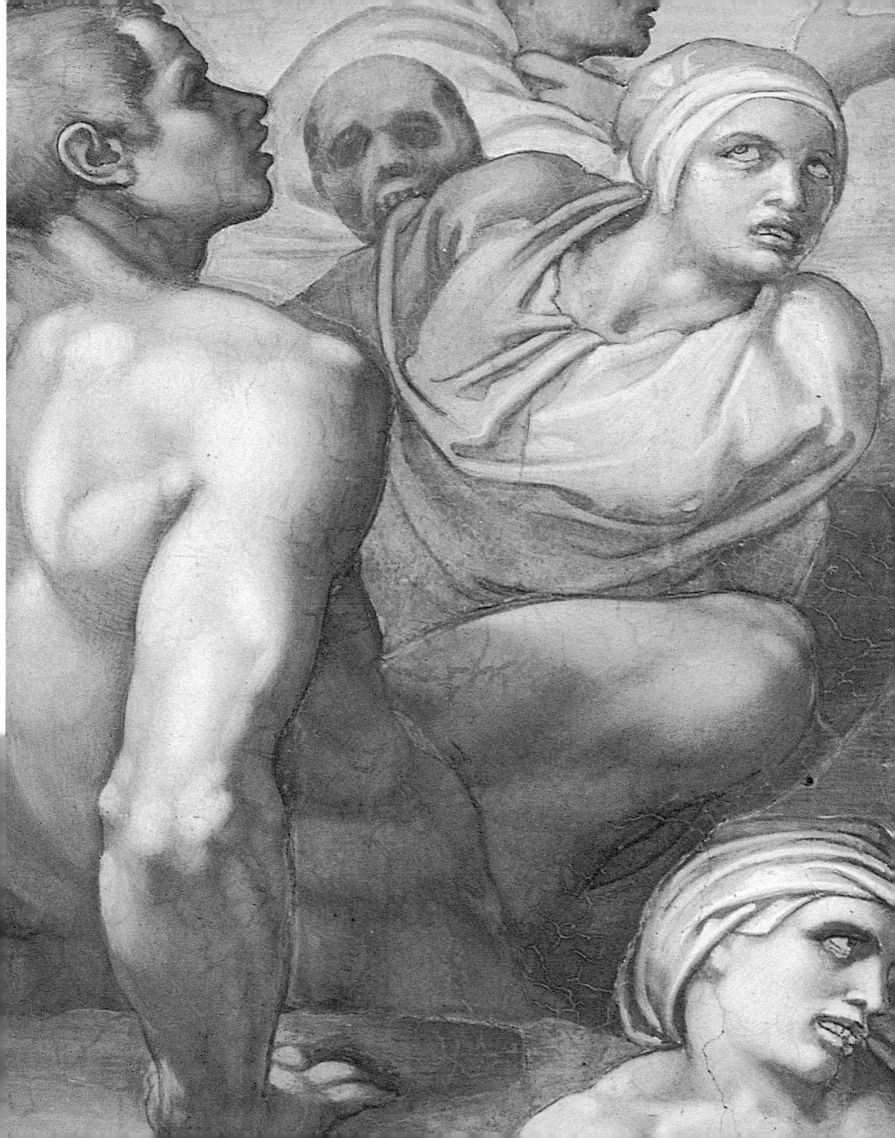

# THE ELECT

Surrounding Christ and the Virgin, in the zone corresponding to the windows, are crowds of the saints, martyrs, and others who have risen to Paradise. Some few have attributes and can be identified, but most cannot.

We recognize Saint Lawrence with his grate and Saint Bartholomew with his knife and flayed skin, Saint Peter holding the keys, Saint Andrew with his cross, Saint Sebastian holding up the arrows with which he was shot, Saint Blaise with his wool combs and Saint Catherine with her wheel. Two from the Crucifixion—the Good Thief, Dismas, and Simon of Cyrene, who carried Christ's cross for him—remind us again of the importance of Christ's sacrificial death and resurrection as the necessary precursor to the event represented. Some figures we can only guess at, and there was not even unanimity among Michelangelo's friends and contemporaries. The painter gave us only enough specifics to whet the appetite and stimulate the imagination. In the last century there were attempts to find an order here: "Choirs" of Prophets, of Apostles, of Sibyls, of Confessors, of Patriarchs, of Martyrs, and so on were identified, but all such efforts fail under examination. One scholar gave a name to every one of the 391 figures, an extreme example of exercising the imagination. The closest we can come to such choirs is the grouping of women at the left, balanced by a group made up largely of men in the corresponding position opposite. Because in traditional Last Judgments women were rare, Michelangelo's creation of this group is an innovation of considerable interest.

The Elect respond with a whole range of emotions. Some embrace loved ones from whom they have been long separated. Many look toward Christ with intense scrutiny; some raise their hands as if to ward off what they are expecting. Many look anxious, some even terrified. They are quite unlike the traditional Blessed, who were seated securely in the clouds in their appointed places. Michelangelo's Elect are not assured, and there is no complacency here. Are they awed by the splendor of the Risen Christ, or is the painter saying there is no such thing as certainty of election? To judge from Michelangelo's letters and poetry, he was much troubled by the realization that no one is worthy and that we can only be saved by God's grace and mercy.

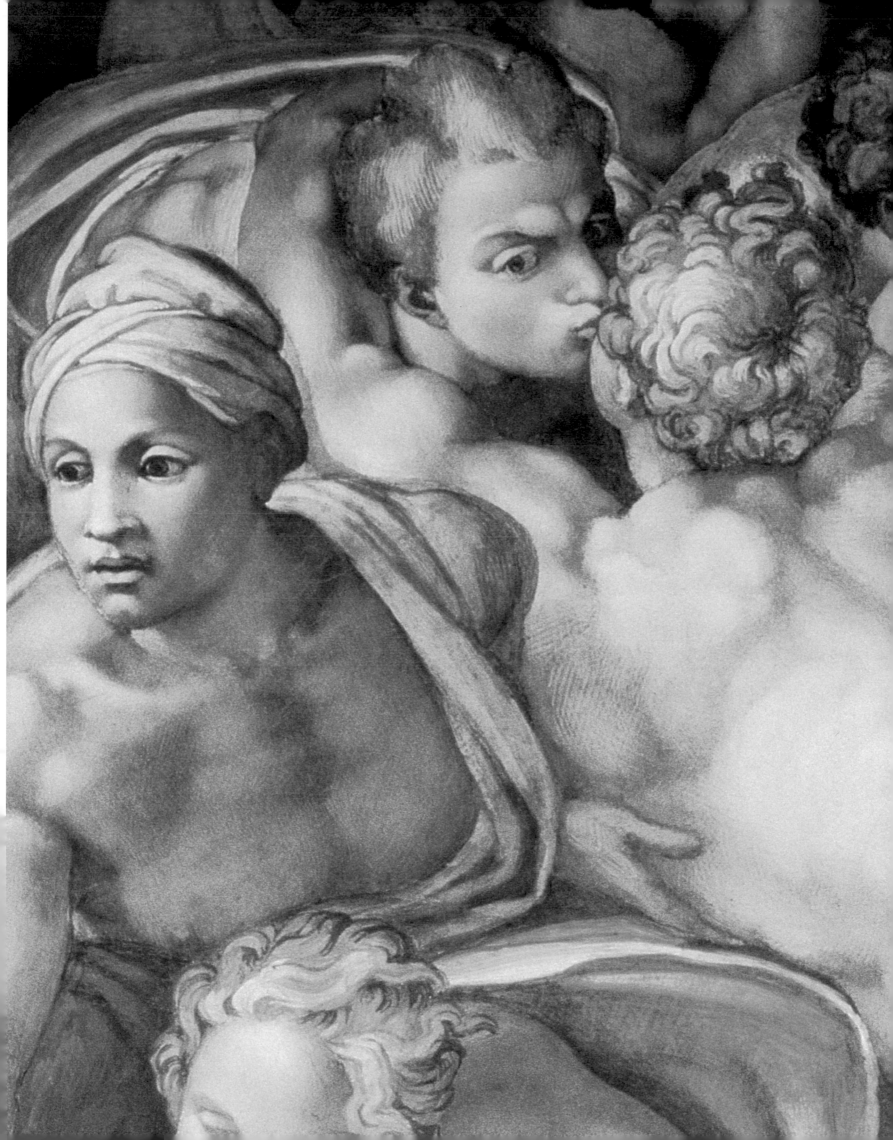

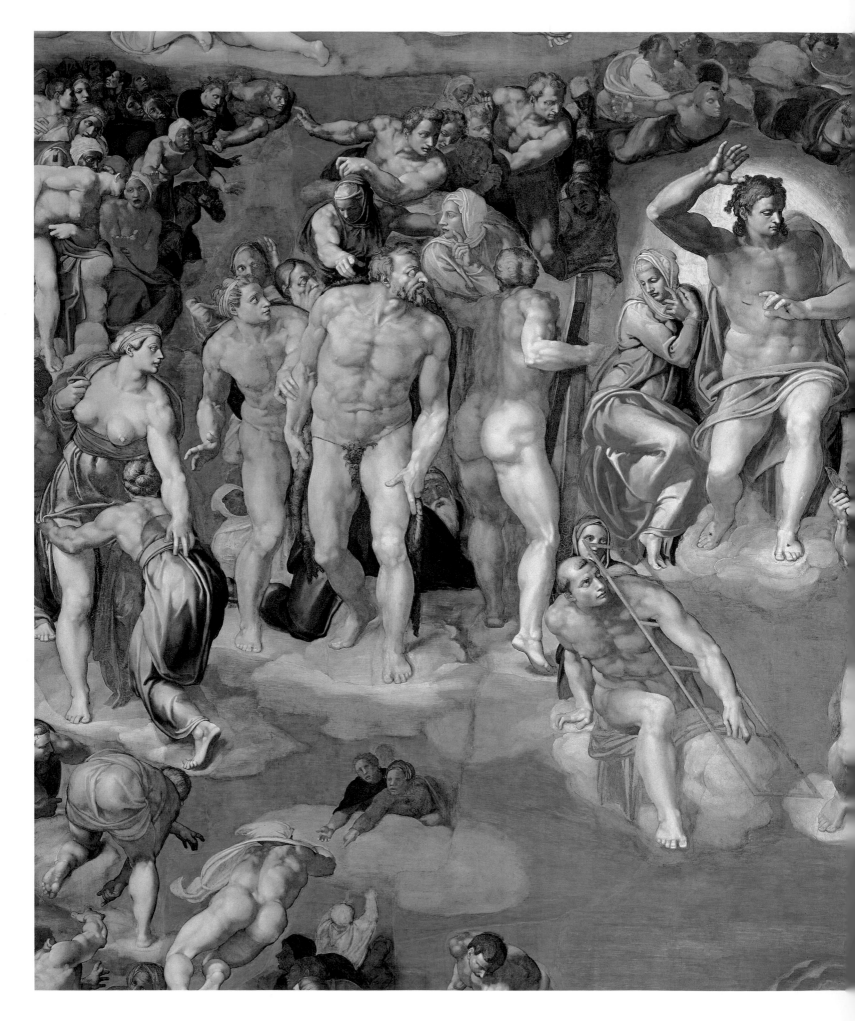

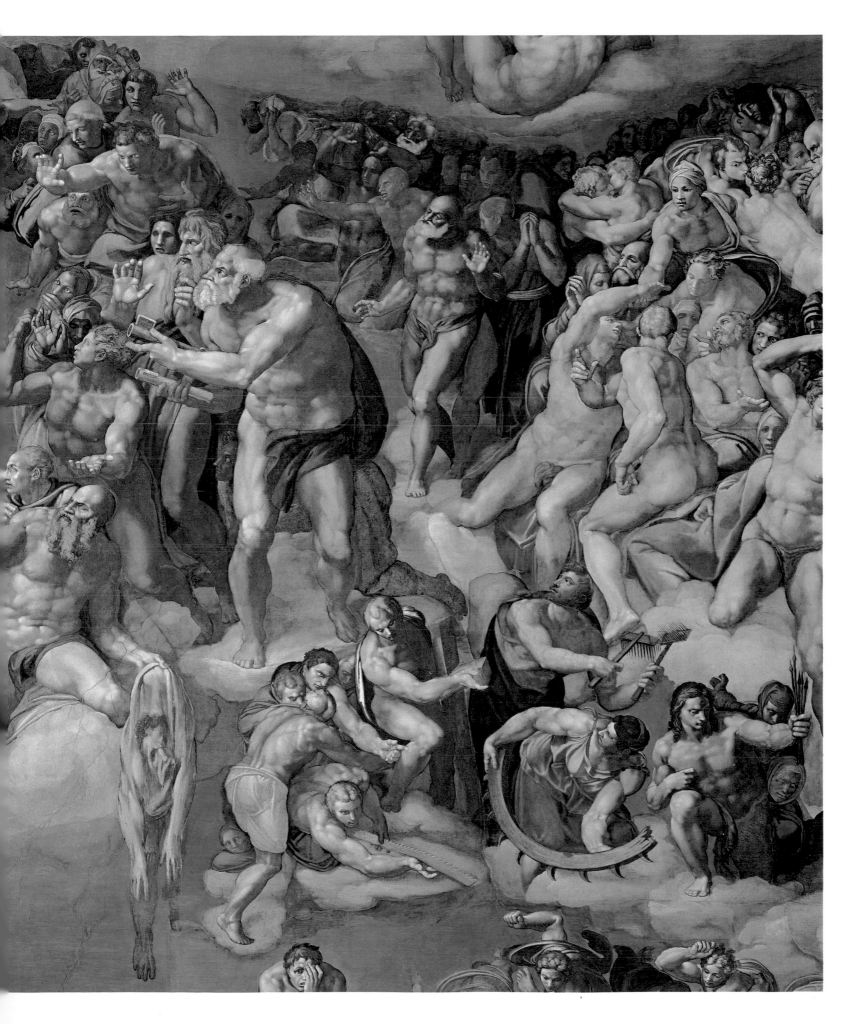

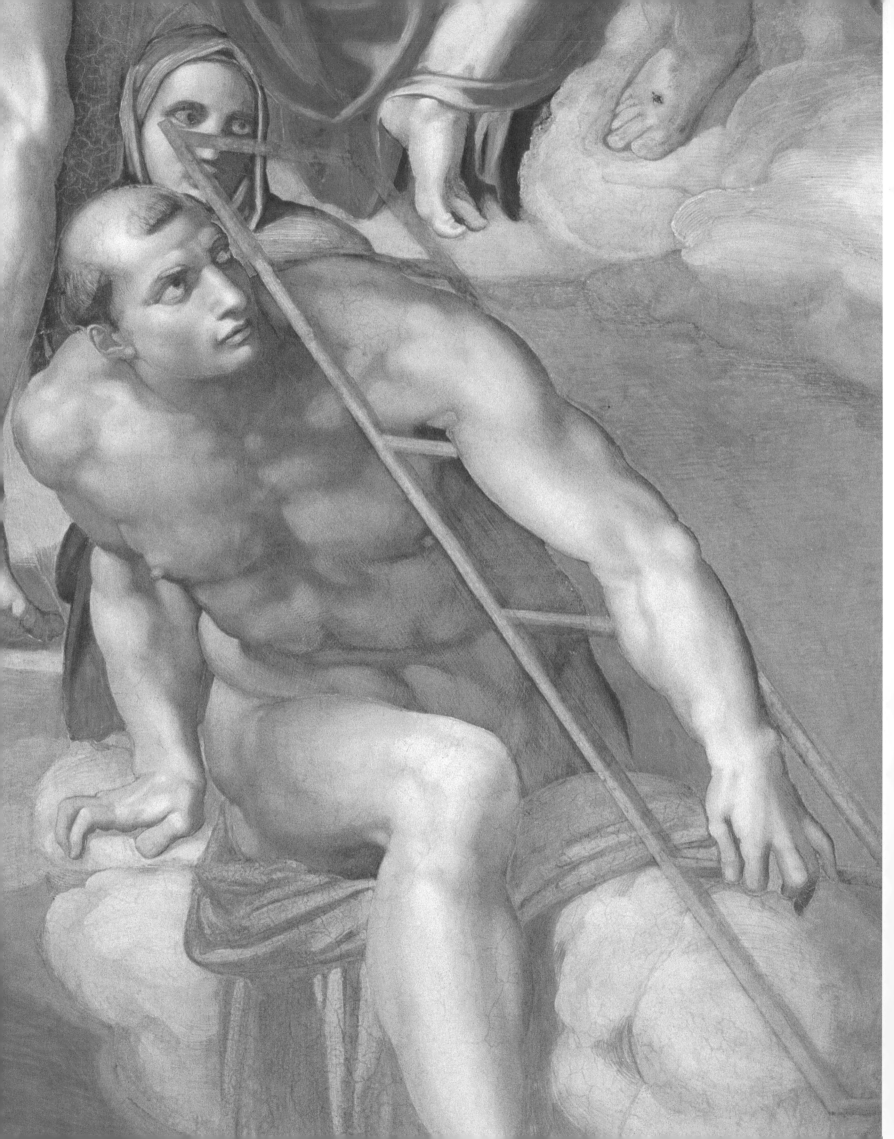

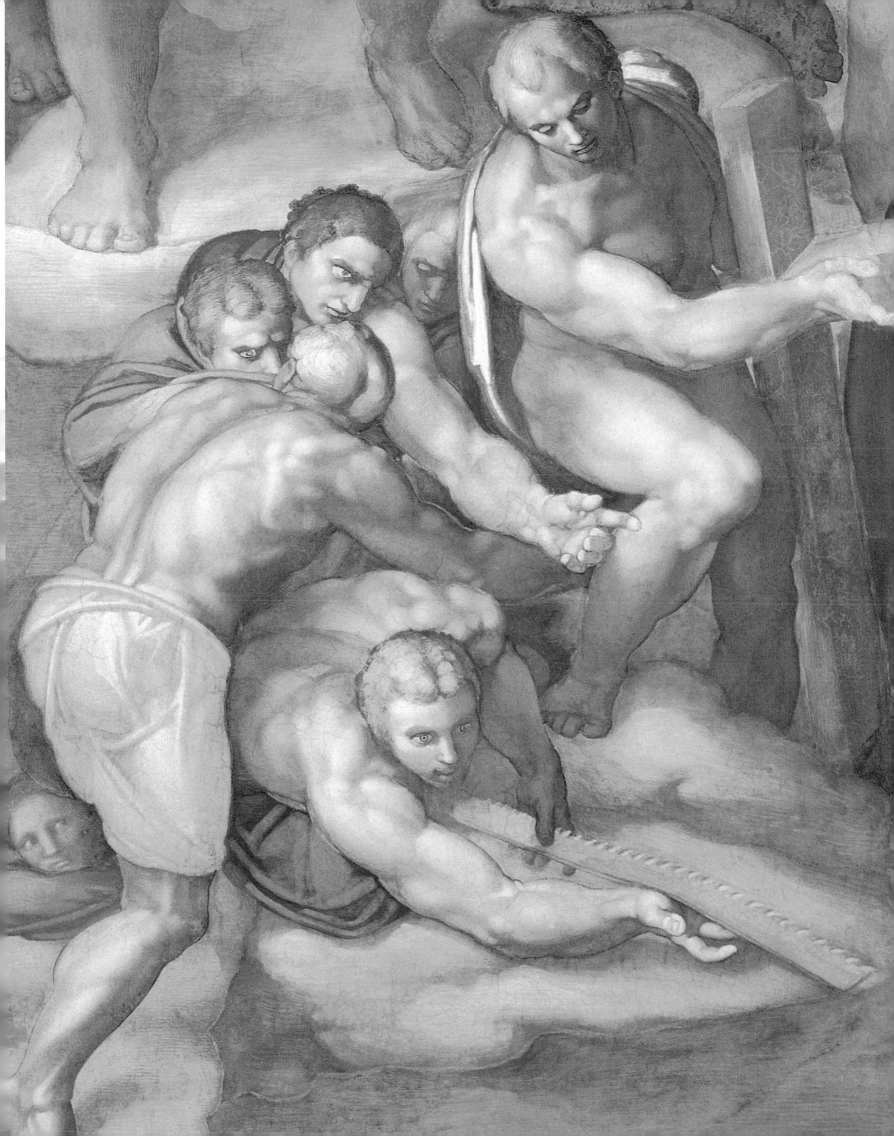

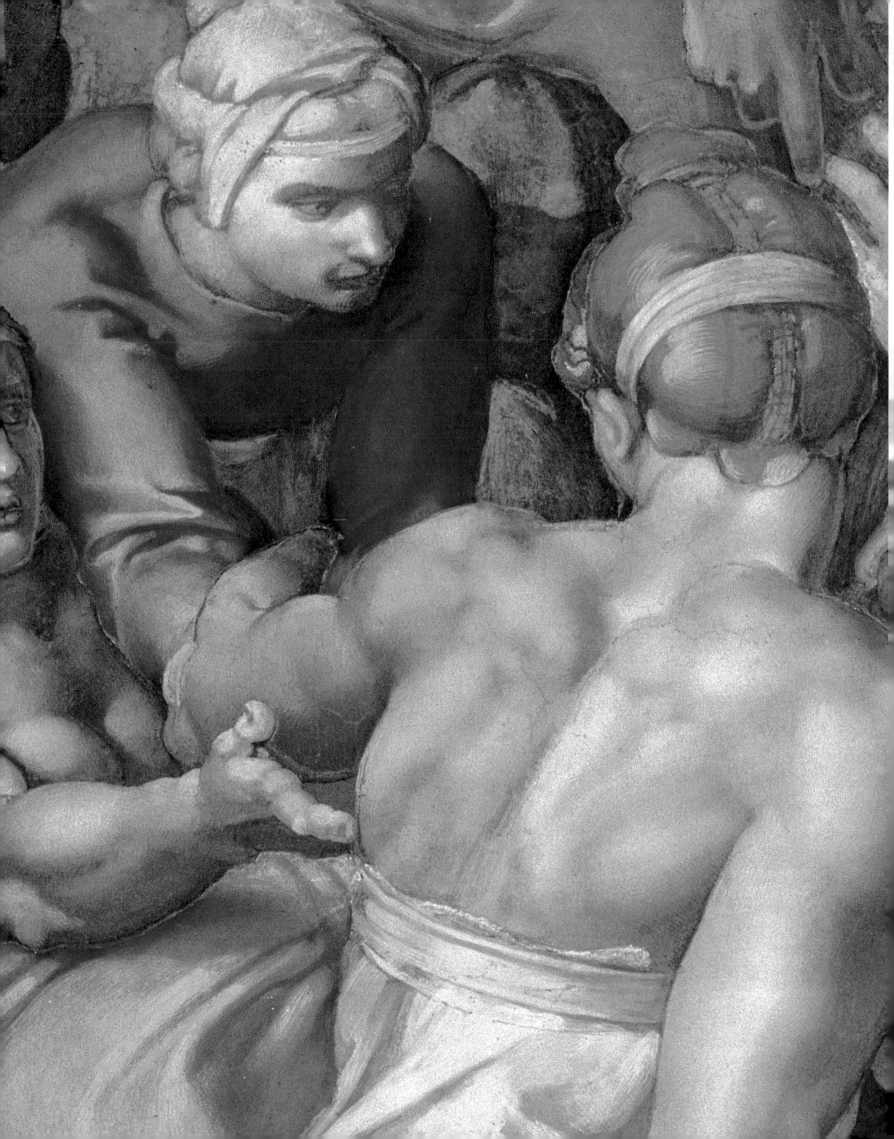

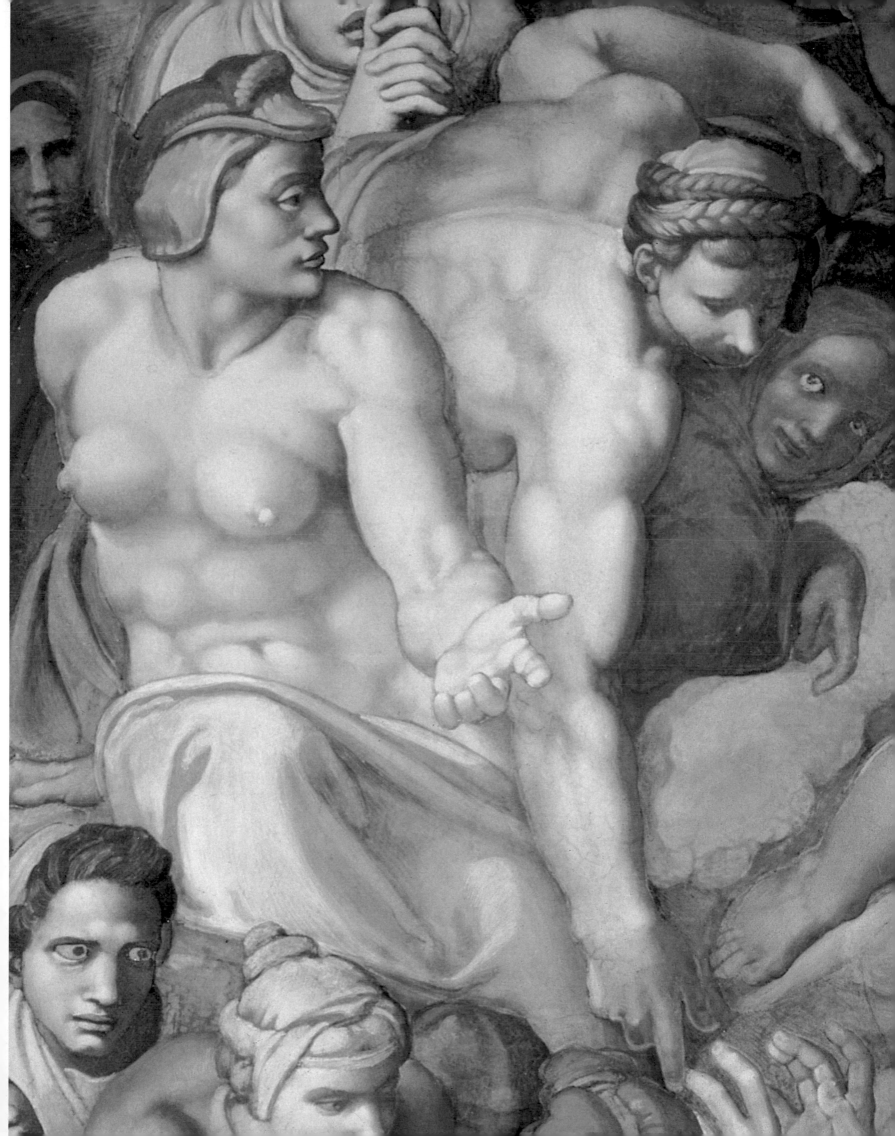

## SAINT CATHERINE AND SAINT BLAISE

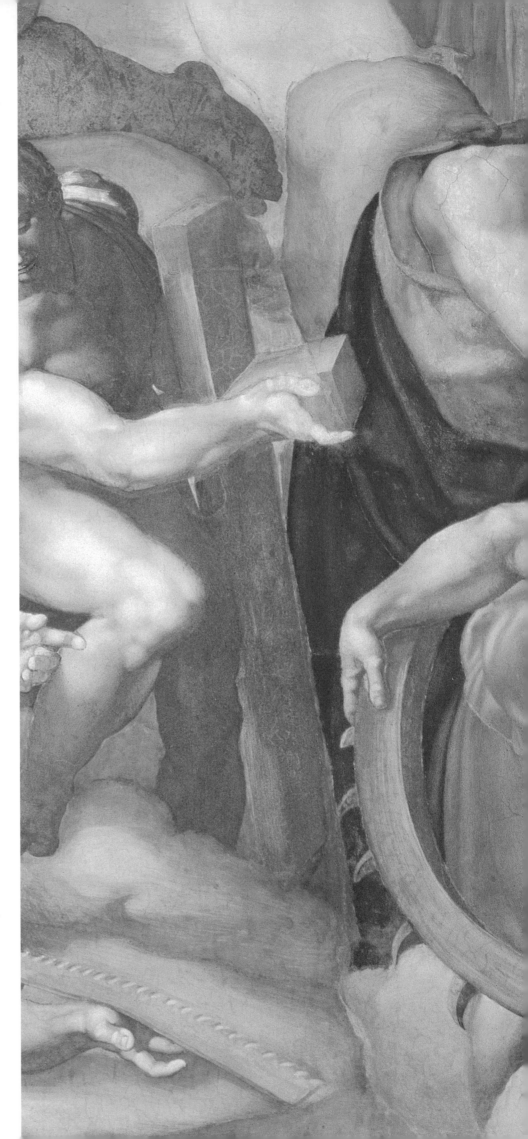

This section of Michelangelo's original fresco attracted more criticism than any other because the juxtaposition of the two figures invited bawdy jokes. Saint Blaise stood behind Saint Catherine and looked down at her as she leaned over to lift the broken wheel, symbol of her martyrdom, and turned her head back to look toward Blaise. As the speaker in Gilio's dialogue remarked, it looks as if she is saying to him, "What are you doing [back there]?" Michelangelo's closest follower, Daniele da Volterra, was called in to fix it in 1565, soon after the master's death in 1564. He made his repairs in true fresco, adding drapery to the upper body of Catherine and turning Blaise's head away so that he now looks at Christ and ignores Catherine. Now that the fresco has been cleaned, Catherine's drapery, executed in a bold *cangiantismo* in which the green shifts in the lights to yellow, stands out. Daniele chose the green pigment malachite, which Michelangelo had not used, possibly because he could not match the earth green used in

Catherine's skirt.

Daniele died the following year, but he began the process of adding loincloths to cover the genitals, for which he was nicknamed *il braghettone*, "the britches-maker." This was a process that continued in the seventeenth and eighteenth centuries, and, astonishingly, was considered even in recent times. A scholar reported that in 1936 rumors were current that Pius XI intended to continue the work of adding breeches. It was decided in the recent restoration not to remove most of them on the grounds that they can be taken off at any time in the future because all the changes, except these of Daniele, were made in *secco* on top of Michelangelo's original paint, and further, that those additions have become part of the history of the piece. Objections have been voiced on aesthetic grounds. Because the fresco had darkened and the additions were matched to the dirty surface, their dark, muddy tones now stand out against the pure colors of the cleaned fresco.

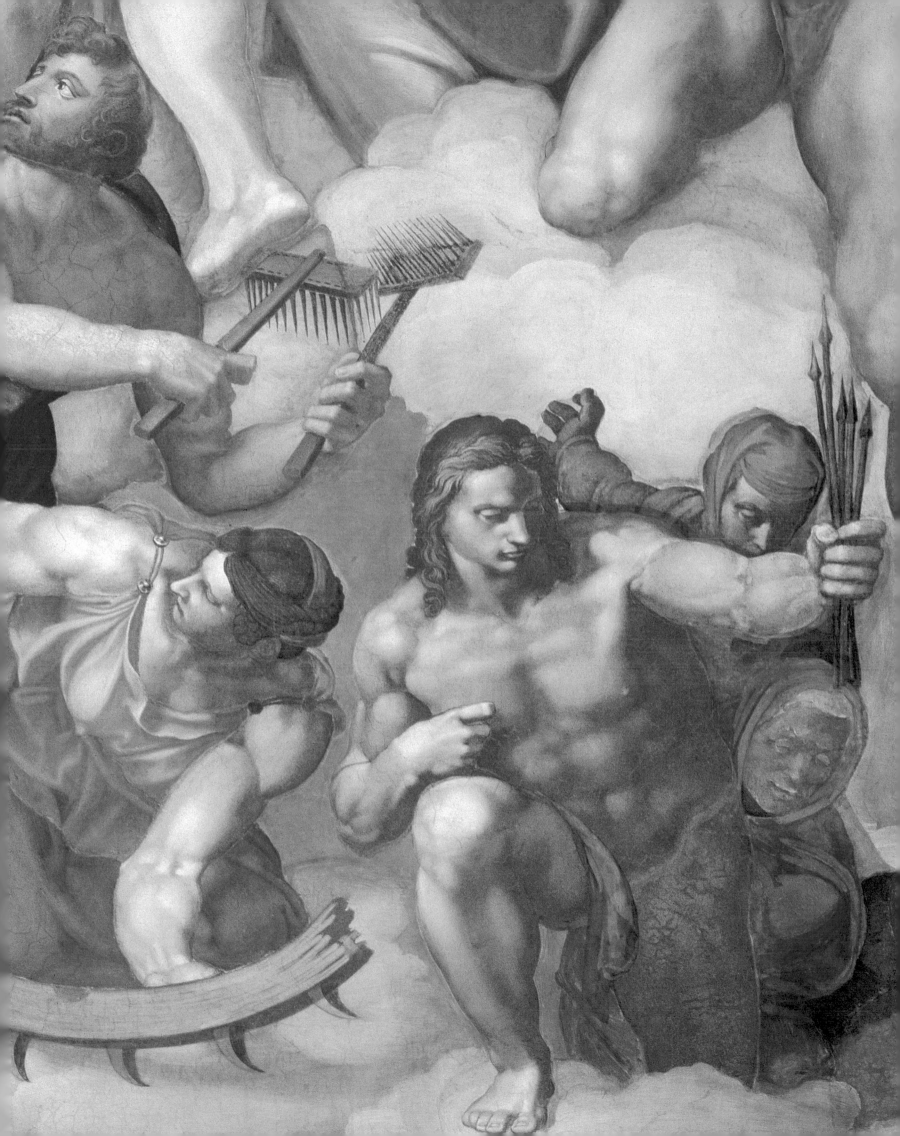

Saint Paul said (1 Cor 15:49): "Just as we have borne the likeness of the earthly man, so shall we bear the likeness of the man from heaven," that is, the resurrected Christ. Michelangelo needed a way to signal that the theme of his fresco was the resurrection of the body and that the text was Paul's Letter to the Corinthians. By placing in prominent positions just at Christ's feet two saints who had lost their flesh in their martyrdoms and representing them in their glorious new bodies he supplied the necessary clue. If the worshiper should miss the significance of this, surely he would note the anomaly in Bartholomew and his skin.

The figure of Saint Bartholomew is placed conspicuously at the center of the fresco just below Christ and opposite Saint Lawrence. Like Lawrence who holds the grate on which he was burned, Bartholomew holds the tokens of his martyrdom, in one hand the knife with which he was flayed and in the other, his skin. It has been noted ever since the fresco was unveiled in 1541 that the head on the skin does not match the head of the apostle. It was proposed in 1925 that the distorted face on the skin was a portrait of the artist, and this has come to be widely accepted, but this

identification has diverted our attention from the more important fact that the head and the skin do not match up. The face on the skin is worn and pained, whereas that of Bartholomew is handsome and robust. According to Gilio's

spokesman, the Blessed will retain only the parts that make the body beautiful and fit for glory. The martyrs will have all their wounds healed. Whether or not this is Michelangelo's face, was this not the perfect way to signal that what we are

shown are the new spiritual bodies that everyone will receive at the resurrection? If the head *is* a portrait of the artist, then it is offered as a supplication from one whose mortal body gave him much pain. Ever since he had spent

the better part of four years standing on the scaffolding and reaching over his head to paint the Sistine vault, Michelangelo claimed to have endured physical suffering. That sufferer, now in his sixties, expresses in the figure of Bartholomew his hope that he will be issued a glorified body for the resurrection and that he will be permitted to discard the one he now has. But—and this is important—the self-portrait does not need to be recognized for the image to work as a clue to the interpretation of the fresco. The viewer needs only to perceive the disparity between the appearance of the risen saint and that of his terrestrial skin. Whether or not it is Michelangelo's face is immaterial to anyone but the artist himself, for whom it would have served as a petition, a prayer.

It has been noticed that the skin was painted without cartoon, and we saw that Bartholomew did not appear in the early compositional sketches, which suggests that Michelangelo added him late. We do not know whether he was given a list of saints to include, as Fra Bartolomeo was for his *Last Judgment* in Santa Maria Nuova in 1498, but it appears that Michelangelo was not prevented from making his own additions.

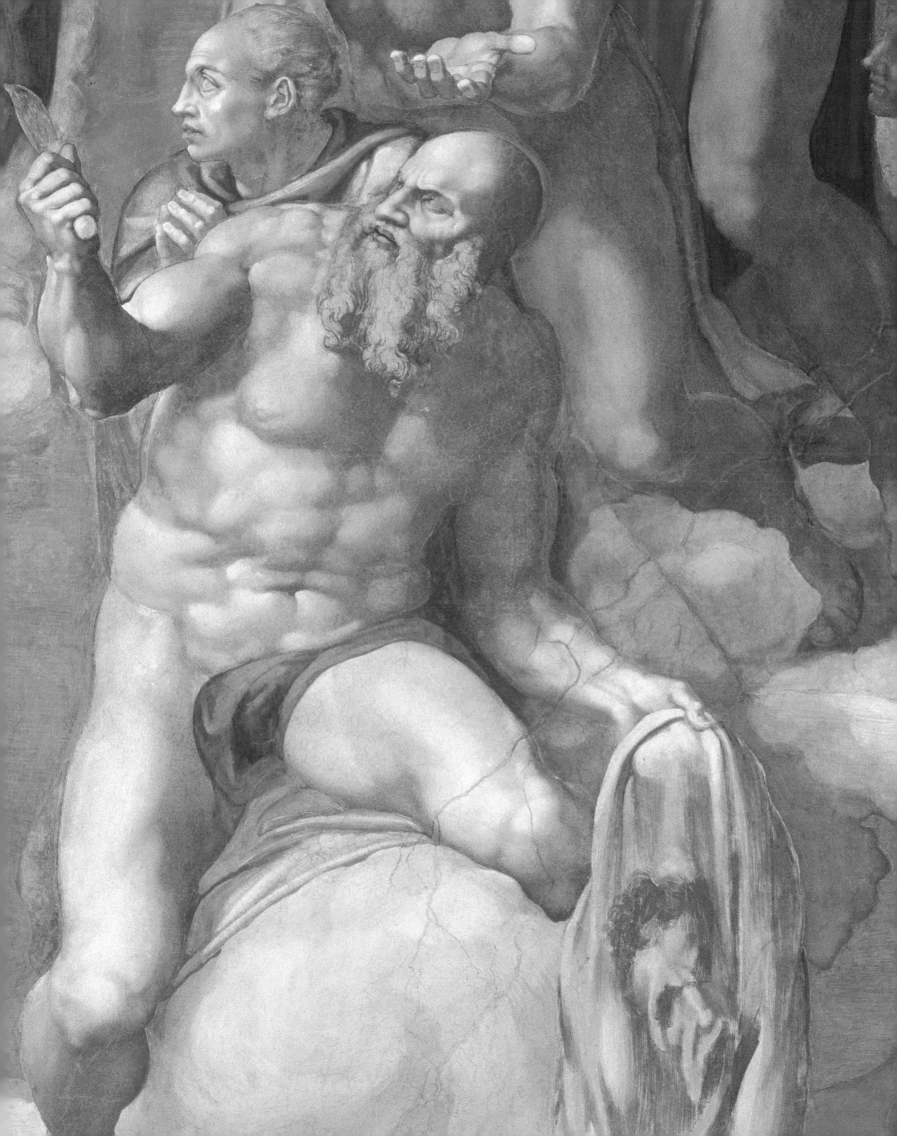

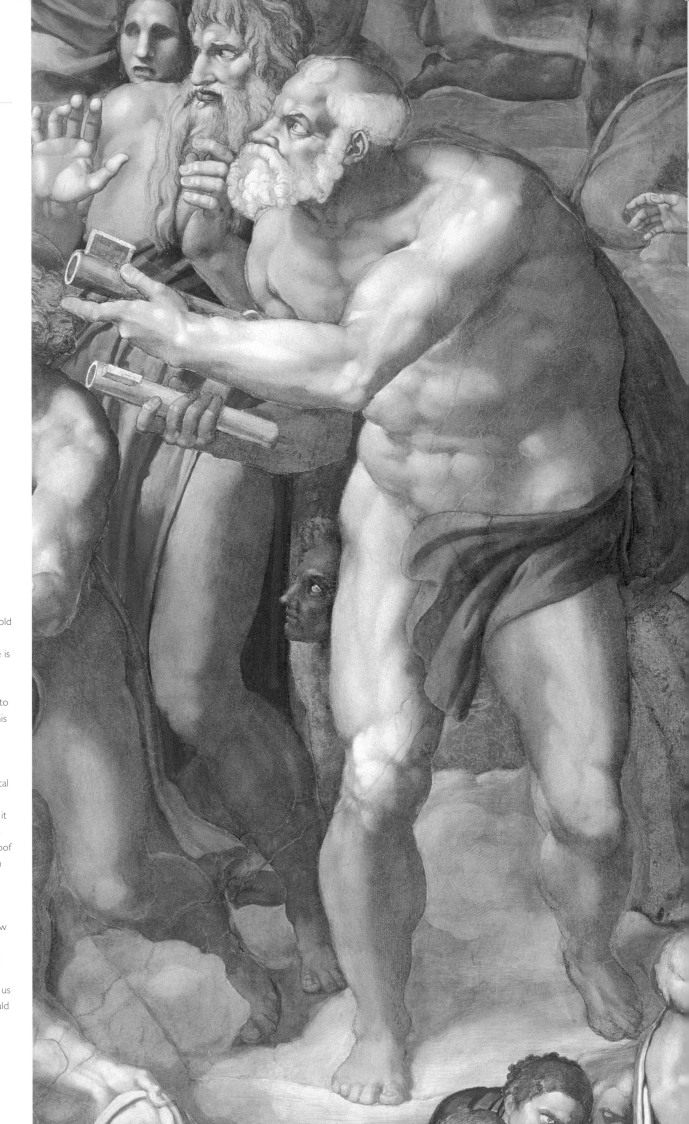

## PETER

The Prince of Apostles
brandishes his attribute, the gold
and silver keys, but they are
more than an attribute, for he is
returning the Keys of the
Kingdom to Christ, who had
entrusted them to Peter and to
his successors, the popes, as his
Vicar on earth. Some critics
have seen in this head the
features of Paul III, the
incumbent pope, not an illogical
identification. But what is the
meaning of Peter's gesture? Is it
a demand for justice, or is it a
timorous proffering of the proof
of his stewardship, tinged with
doubt that he has adequately
fulfilled his charge? Heinrich
Wölfflin, recognizing the
insistence of their gestures, saw
these martyrs as seeking
vengeance on those who had
caused their suffering, an
interpretation that may strike us
as strangely off the mark. Could
it be that not even Peter is
assured of his reception?

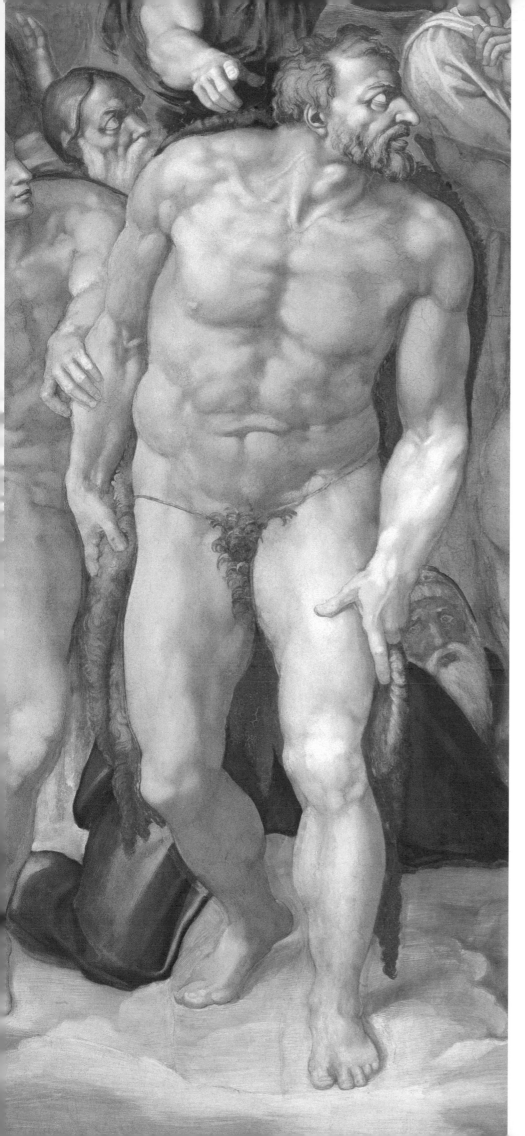

## SAINT JOHN THE BAPTIST

Vasari identified this figure as Adam, but Condivi, who was writing a few years after Vasari's first edition and, under Michelangelo's guidance, correcting it, identified him as John the Baptist. This would make sense, for he is pendant to Saint Peter opposite, who also looks inward to Christ: John represents the end of the tradition of Old Testament prophets and Peter the beginning of the era of Christianity, headed by the popes. There may be another level of allegory intended, for Christ not only reminds us of his Resurrection, but of his Transfiguration, in which he appeared to three of his Apostles in a blaze of light, flanked by the Old Testament figures of Elijah and Moses. According to the Gospels, Christ himself identified John the Baptist as a second Elijah to these Apostles in the context of the Transfiguration they had just witnessed (Mt 17:9–13). Whereas Elijah was traditionally represented on the left, Moses was placed on the right, where here we see Peter. The frescoes of the Sistine Chapel were among many instances in which Moses was shown as an archetype of Peter. In the Quattrocento frescoes on the side walls, for example, Botticelli's fresco of the Punishment of Corah, showing the passing of priestly powers from Moses to Aaron, was paired with Perugino's scene on the wall opposite depicting Christ Bestowing the Keys on Peter, the event understood as the institution of the papacy. The Transfiguration was itself a prefiguration of the Resurrection and was interpreted as an anticipation of the Final Resurrection in the theological literature. Thus all three events are linked by the imagery: Christ's Transfiguration, his Resurrection, and the Final Resurrection. The symmetry of John the Baptist and Peter would appear to have been carefully calculated to give added theological depth. The layman-painter could not be expected to have invented such a conceit as this. It is the kind of refinement the theological adviser would have suggested or required.

# THE ASCENDING

F rom the lower left where the graves are giving up the dead, bodies are rising toward the Elect. Some are taking flight, some are carried by angels. One pair grasping hold of a rosary is being hoisted by a muscular angel, apparently a demonstration of the power of Faith. The other cardinal Virtues may be recognized in other figures:

The woman with eyes still closed, her shroud falling away, her hands raised, could be the embodiment of Hope, and those Blessed who lean over the clouds to offer a helping hand, Charity. Some may be those who are still alive at the Second Coming of Christ, for Saint Paul assured that "The Lord himself will descend from heaven with a cry of command, with the archangel's call, and with the sound of the trumpet of God. And the dead in Christ will rise first; then we who are alive, who are left, shall be caught up together with them in the clouds to meet the Lord in the air" (1 Thess 4:16–17). Michelangelo must have been sorely taxed to find enough varied poses for so many figures. That, in fact, was one of the things that most impressed his contemporaries. Very few drawings of individual figures have survived. We are told by Armenini, whose how-to book of advice to artists was published in 1586, that Michelangelo had used a different, and more efficient, method. He made some wax figurines, which he would immerse in hot water, and then twist the limbs of the soft wax to find the pose he wanted. In this way he could bypass the time-consuming procedure of drawing from a live model in the studio. His profound knowledge of human anatomy permitted him to paint the musculature without recourse to a model.

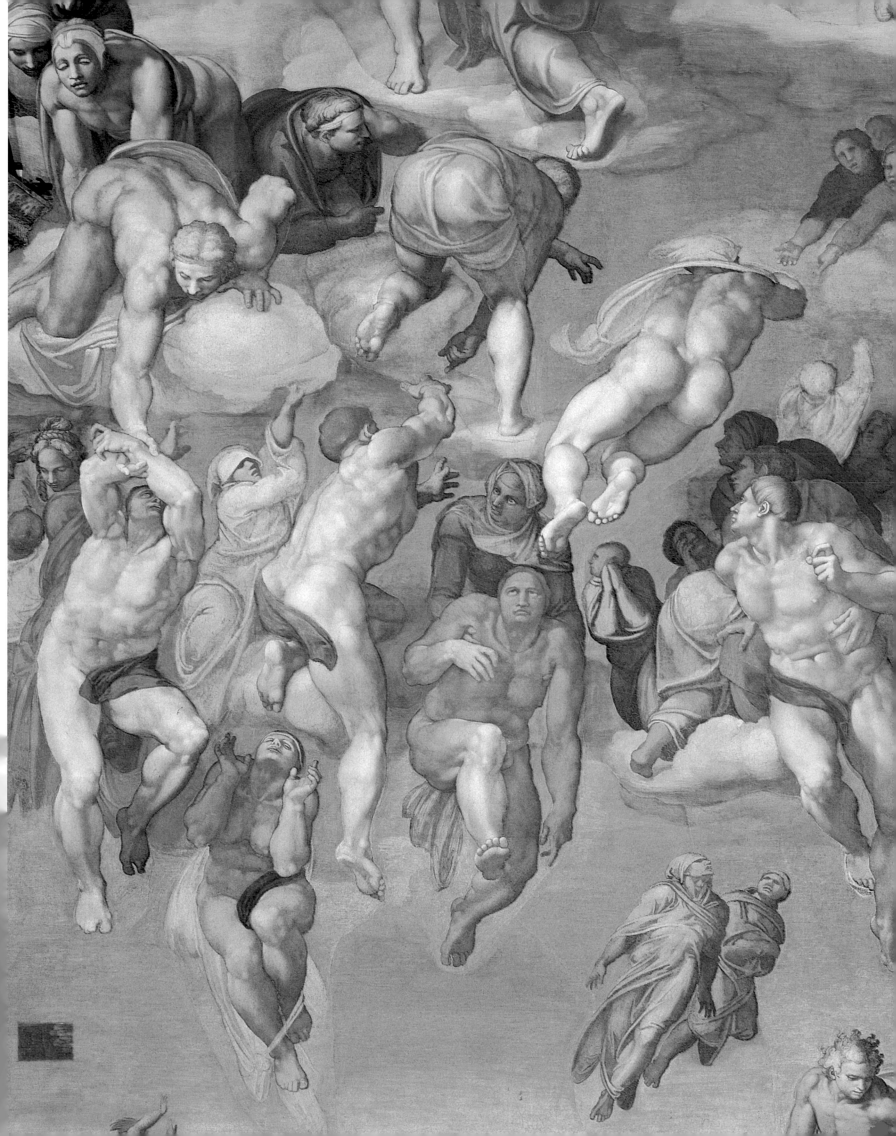

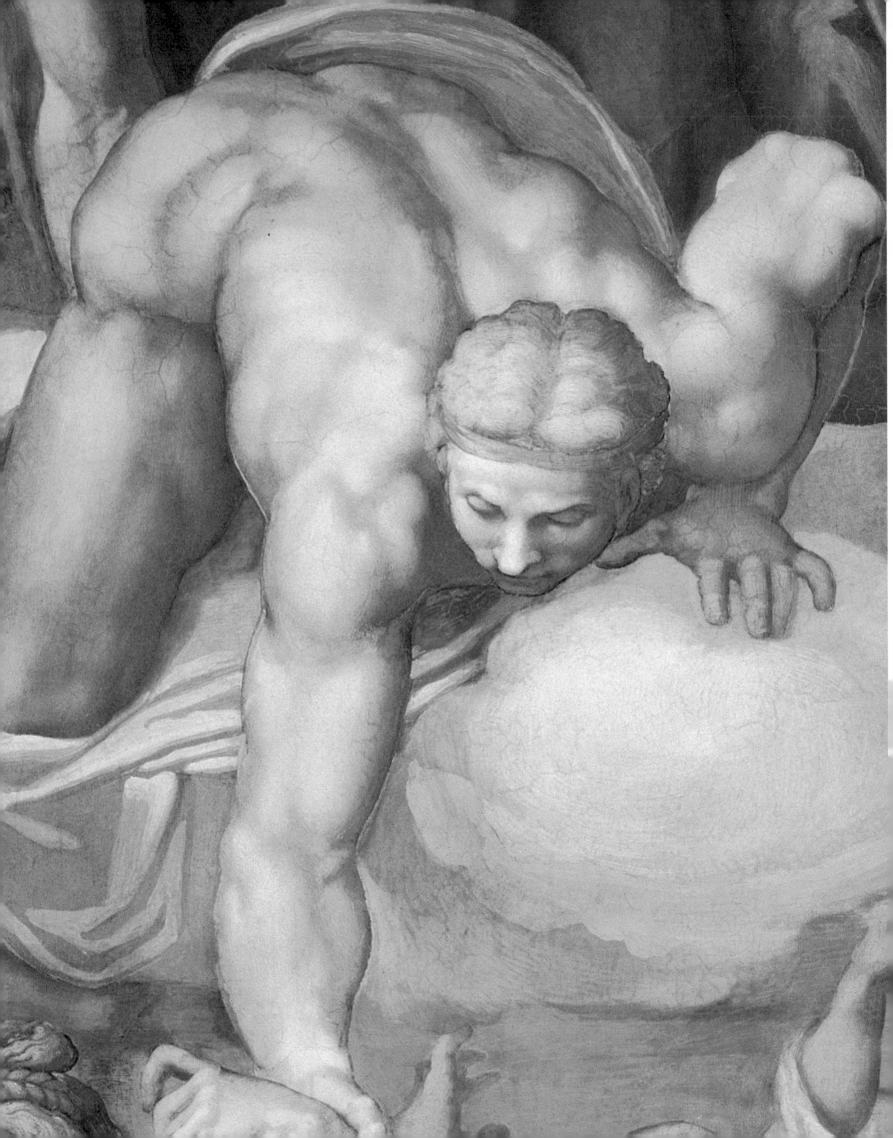

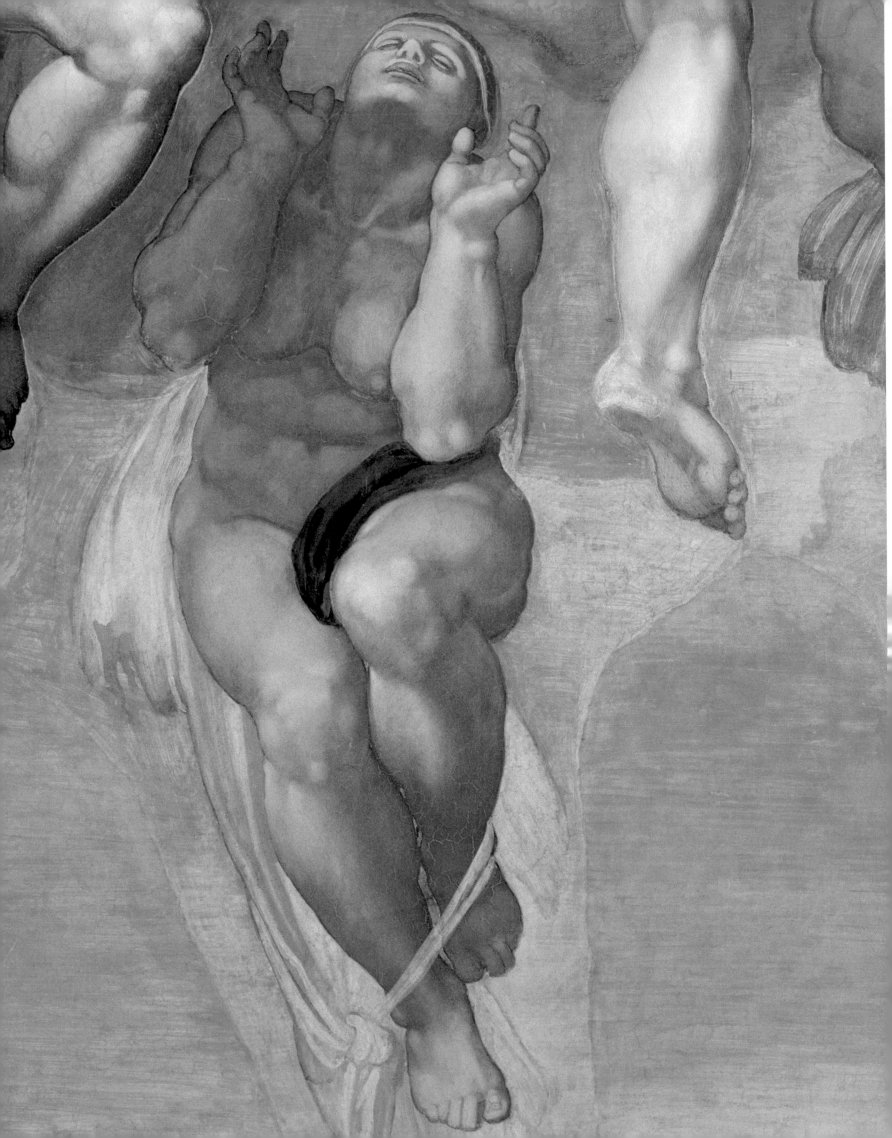

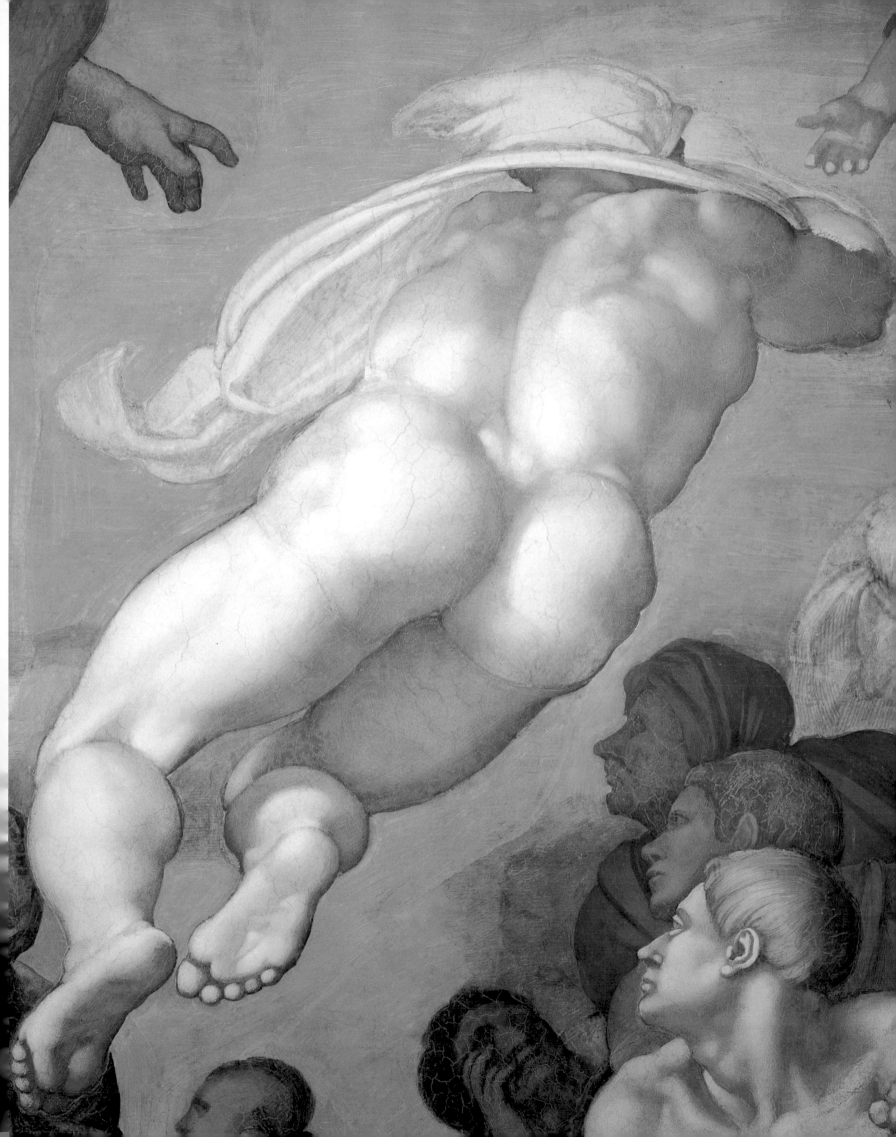

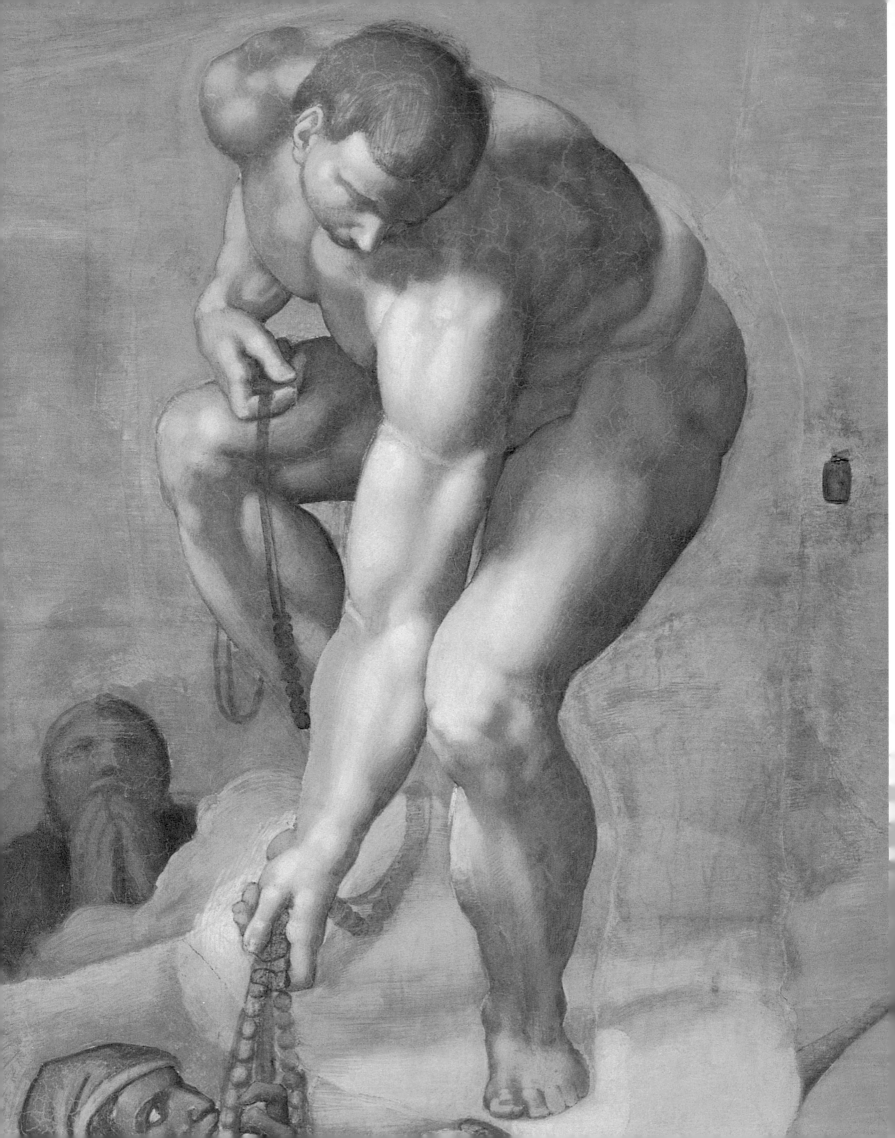

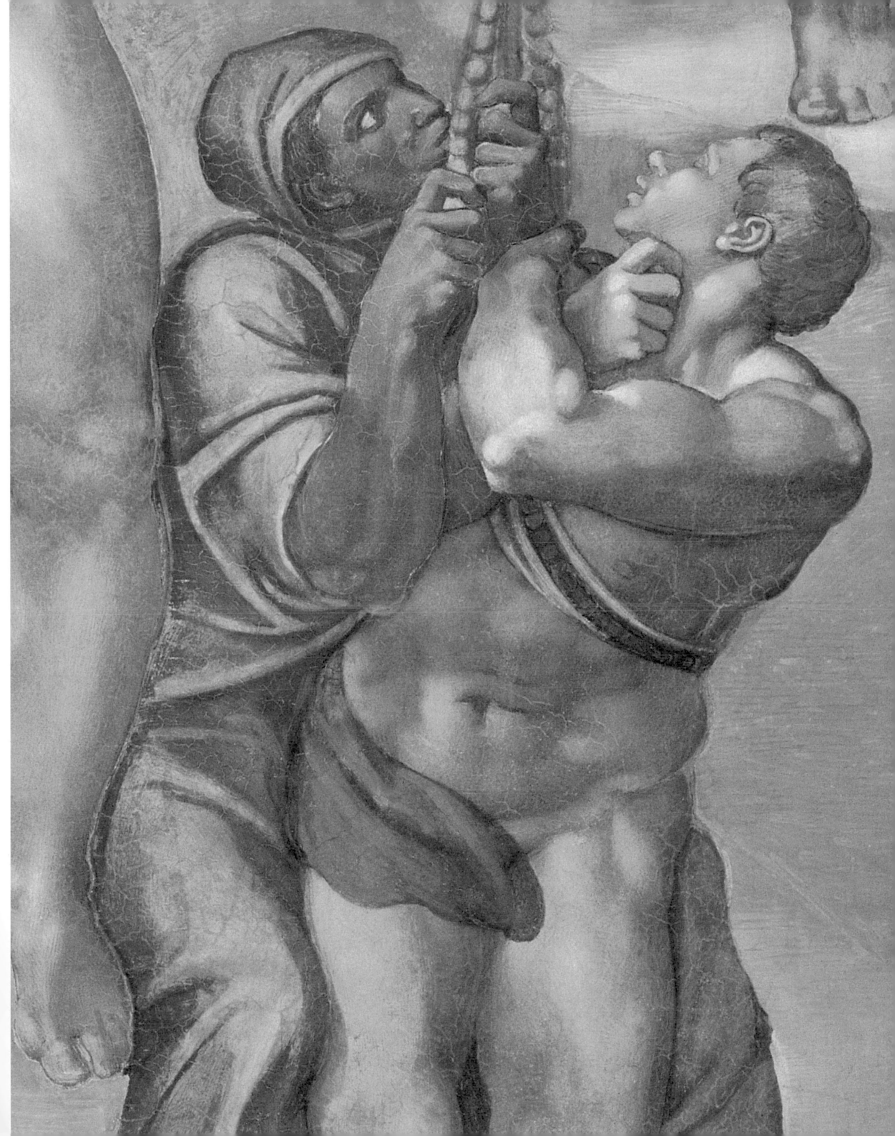

# THE DAMNED

O pposite those who are rising on the left toward the Elect are those who are descending into Hell on the right (Christ's left). Battered down by angels, who thwart their frantic attempts to ascend, some are cast down headlong while others are dragged by demons.

According to Condivi, sinners are hauled down by the part of the body with which they sinned, the proud by their hair, the lascivious by their pudenda. In fact, these figures seem to be allegories of the Vices, some even with attributes, like the money purse that identifies Avarice. The spiritual bodies of the sinners are no less powerful or beautiful than those of the Elect, but the suffering and torment to which they are susceptible distorts their faces and contorts their bodies. They are still vigor- ous, in contrast to the Damned as depicted by many of Michelangelo's predecessors in their Last Judgments, where they are reduced to wasted cadaverous creatures, as if malnutrition were the price of sin to be paid in the afterlife. Often the Damned and their sufferings are on the threshold of the comical, reduced to implausible caricature. Before Michelangelo, only Signorelli had shown the reprobates as still robust, preserving thereby their ability truly to inspire horror.

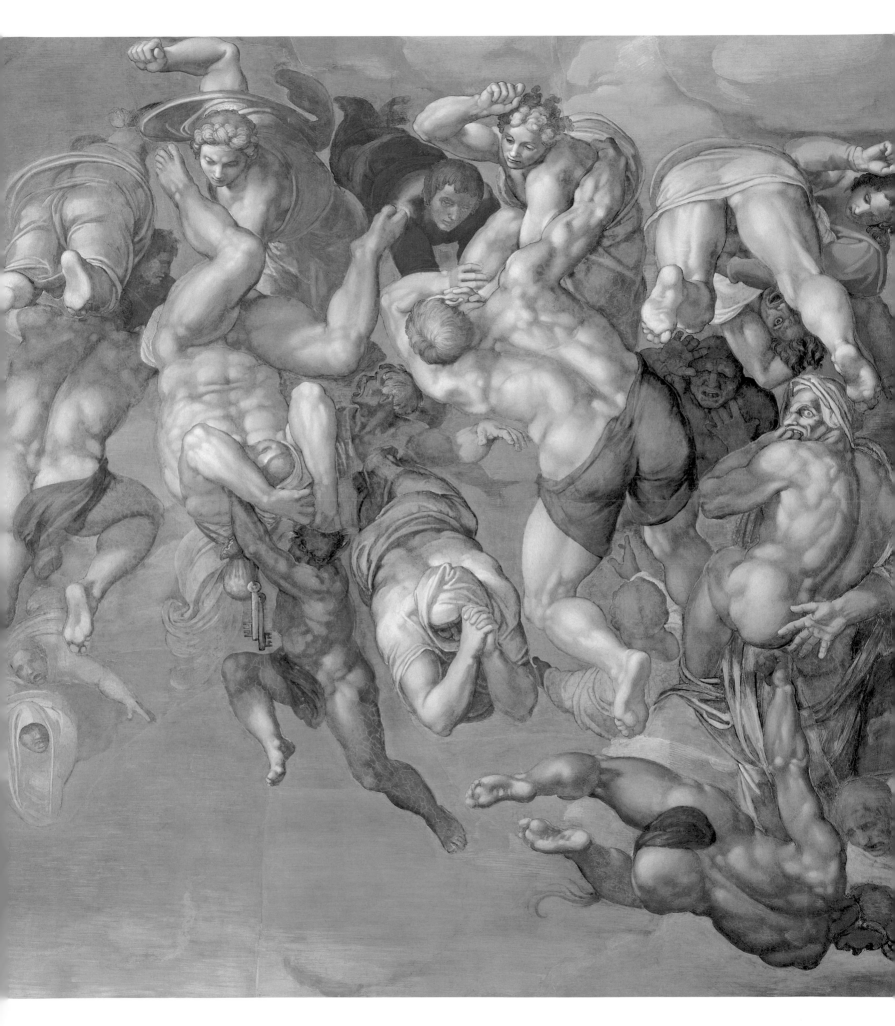

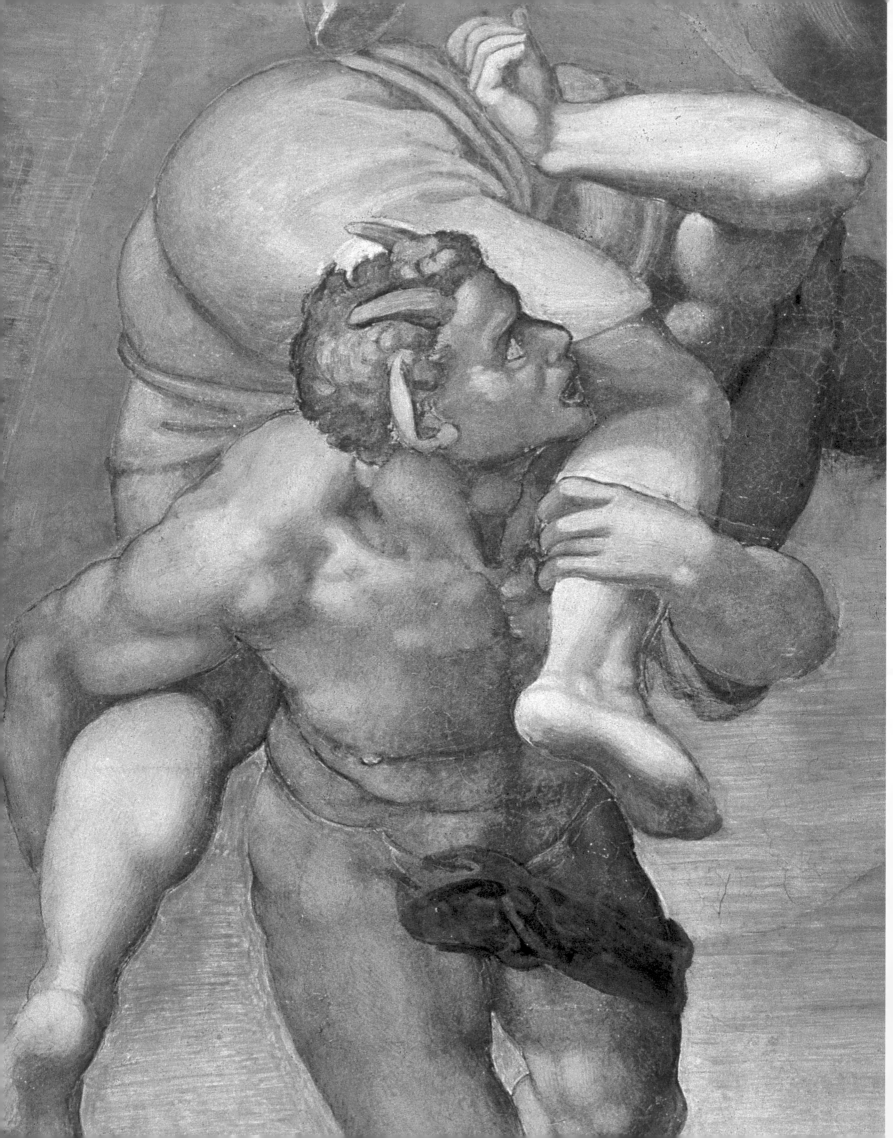

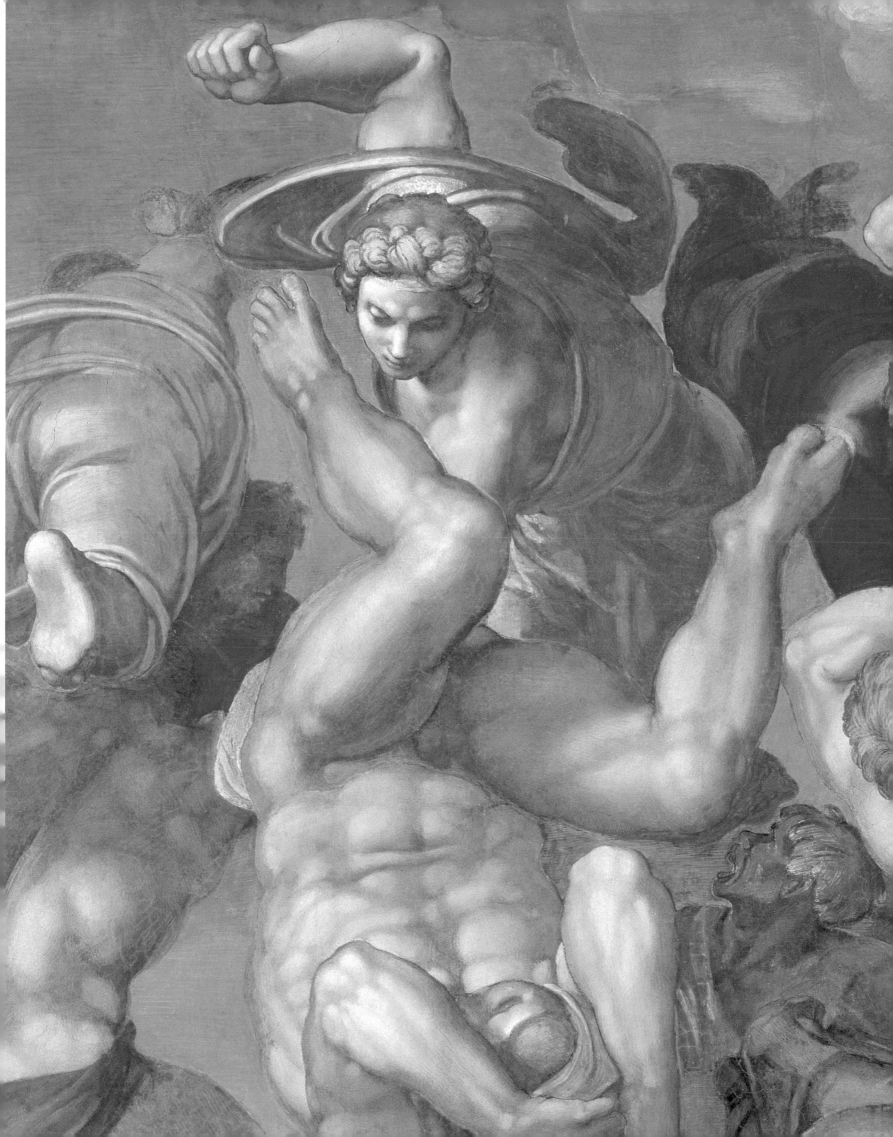

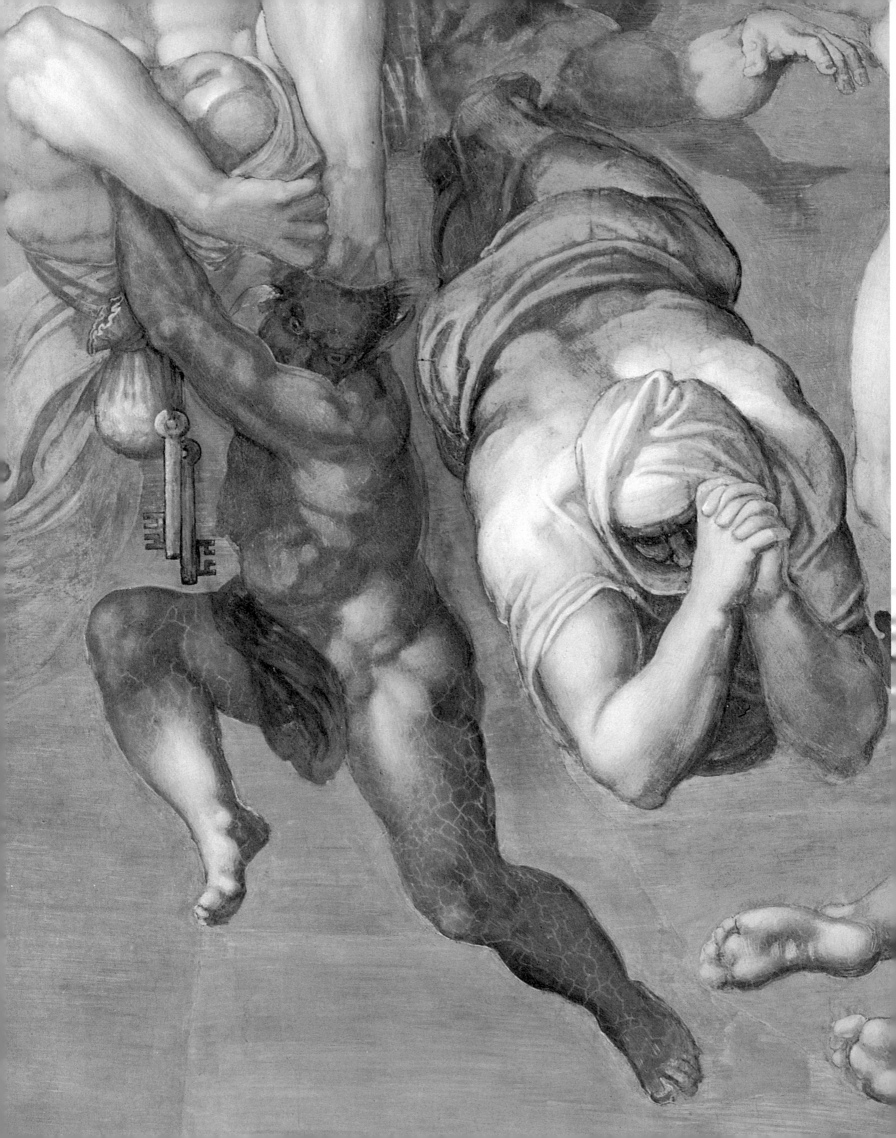

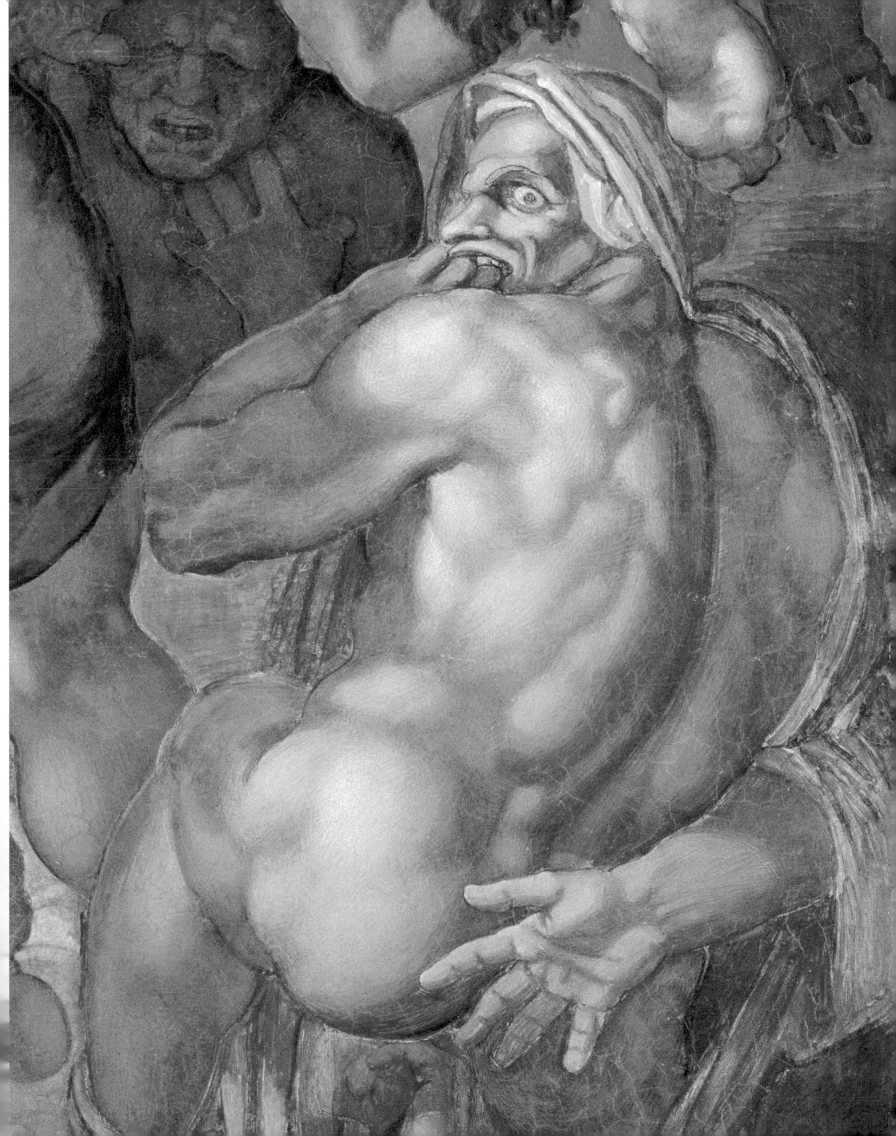

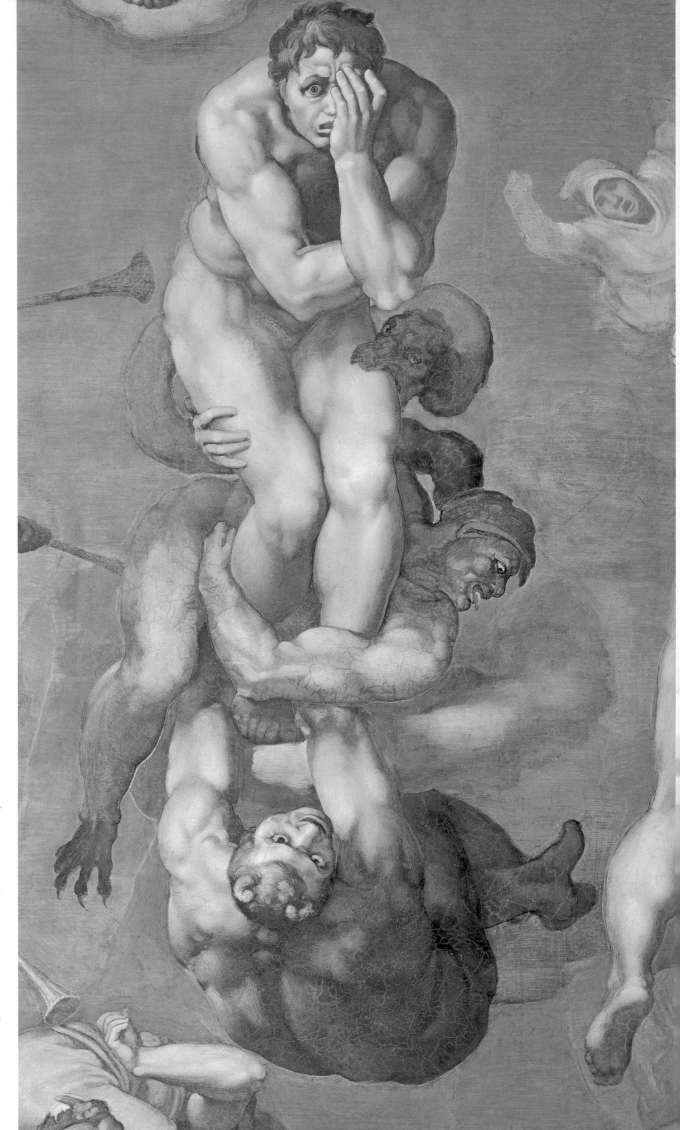

## THE ANGUISHED
## REPROBATE

The despair of the Damned is embodied in this single titanic man, whose isolation enhances the horror. His legs wrapped by a demon, another pulling on his feet, he plummets toward the abyss of Hell below. His face half covered with his hand, his shoulders humped, with his one staring eye he conveys vividly the dawning realization of his fate. Michelangelo wisely distilled into a single portrait of psychic despair the wages of an unredeemed life. His lonely figure anticipating eternal damnation is a far more effective admonition than the graphic images of physical torture that mark the depictions of Hell in earlier *Last Judgments*.

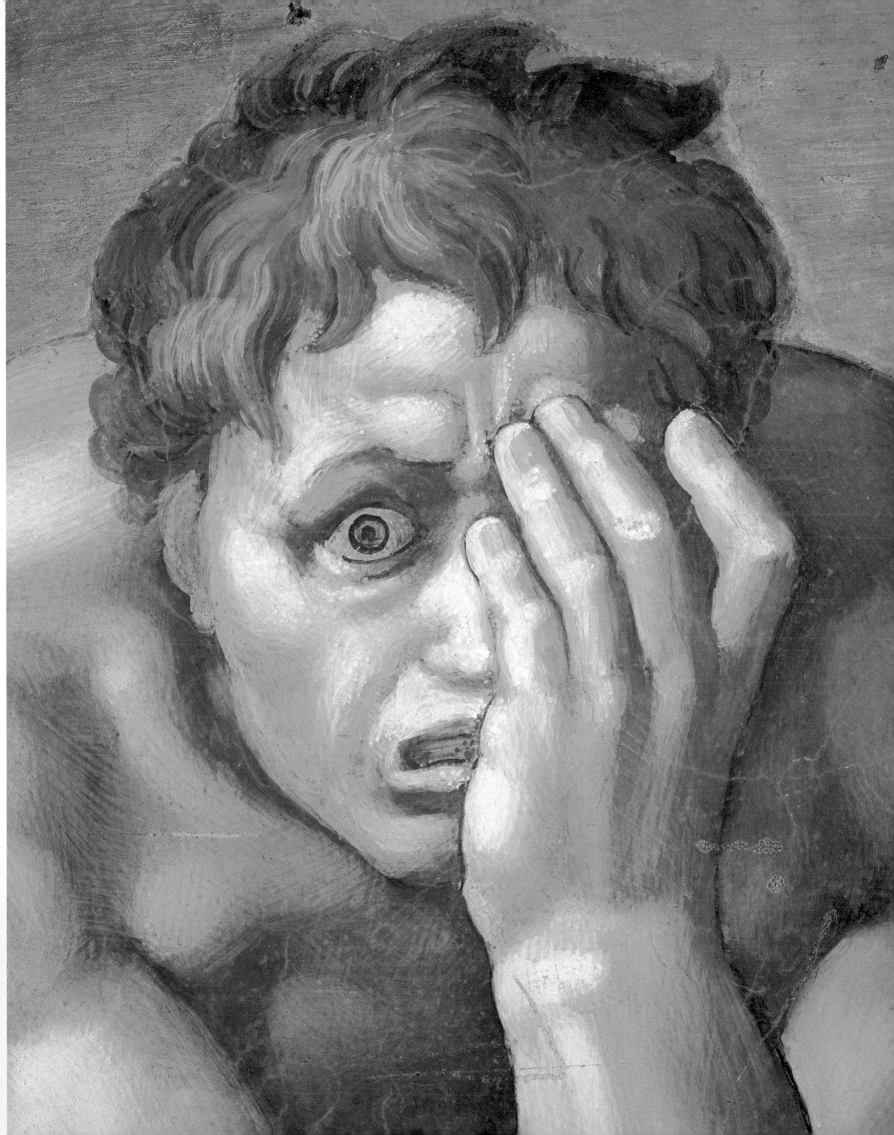

# CHARON

In classical myth Charon is the boatman who ferries the Damned across the river Styx (or Acheron) to the underworld. Like Minos, he figured in Dante's *Divine Comedy*, where he is described as a demon who torments the Damned with their hopeless plight and urges along the reluctant with blows from his oar. There is very little in the scripture describing the afterlife, so Dante's vivid imagery filled the gap for Michelangelo, who knew his Dante so well, we are told by his contemporaries, that he could recite much of it from memory.

But the artist is older and wiser than when he was commissioned to paint the Sistine vault, and so also is the culture of Rome. The optimism of the High Renaissance humanists has been tempered by events such as the Sack of Rome and the success of Martin Luther's revolt. We find now a strengthened acknowledgment of human depravity and dependence upon divine grace. Michelangelo's Adam at his creation represented the attainable perfection of the creature God made in his own image. The *Last Judgment* required the artist to confront the consequences of the Fall and the wages of sin. Although it was not a major theme in the vault, in the *Flood* and the *Expulsion from the Garden*, the loss of Adam's innocent perfection was depicted. In the *Brazen Serpent*, as well, he depicted the

condemned in a composition, we noted, that was very like that of a Last Judgment. In each of these Michelangelo had had to confront the question of how to represent the sinner. These are the figures in his repertory that are deprived of the idealized beauty, energy, and, above all, grace of his other creations. Contrasting the sensuous Eve of the *Temptation* with the Eve of the *Expulsion*, we see a woman who has become gawky, lumpish, and clumsy, without the lovely contrapposto and serpentine poses with which the painter imbued those who have received God's grace. They anticipate the Damned he would depict in the Hell of his *Last Judgment*, but his thinking has become more refined, perhaps with the help of Cajetan. Like those who are fleeing the Deluge, the Damned move with an urgency that precludes grace. In the case of the Damned, however, they are not self-motivated but are spurred by demons or by Charon's oar, so they have even less dignity than those hoping to escape the rising waters. Like Adam and Eve, the Damned are driven by agents of justice to the place appointed for them. Their strapping bodies, ironically powerless, become a weighty encumbrance to their reluctant obedience. Eve's unloveliness is unmatched in the Damned because Michelangelo was bound to the rendering of the spiritual body, which can only register the effects of pain, but cannot be deformed.

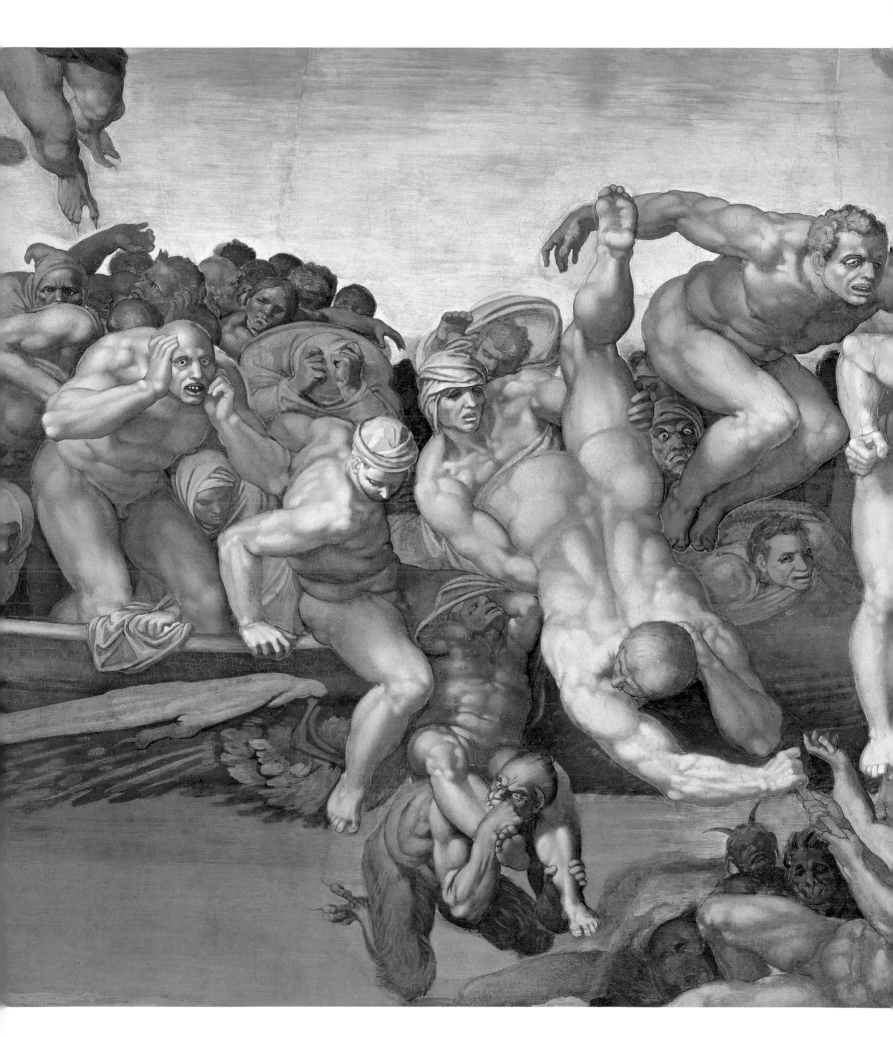

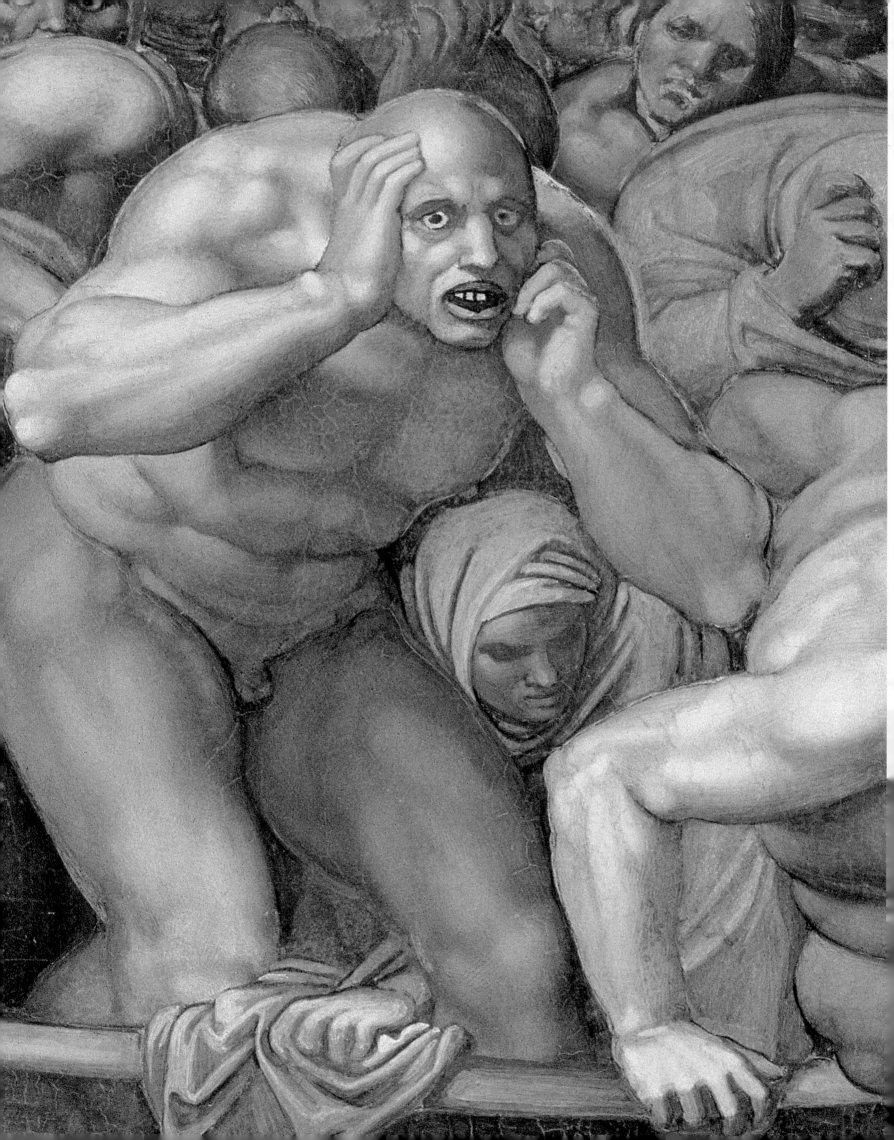

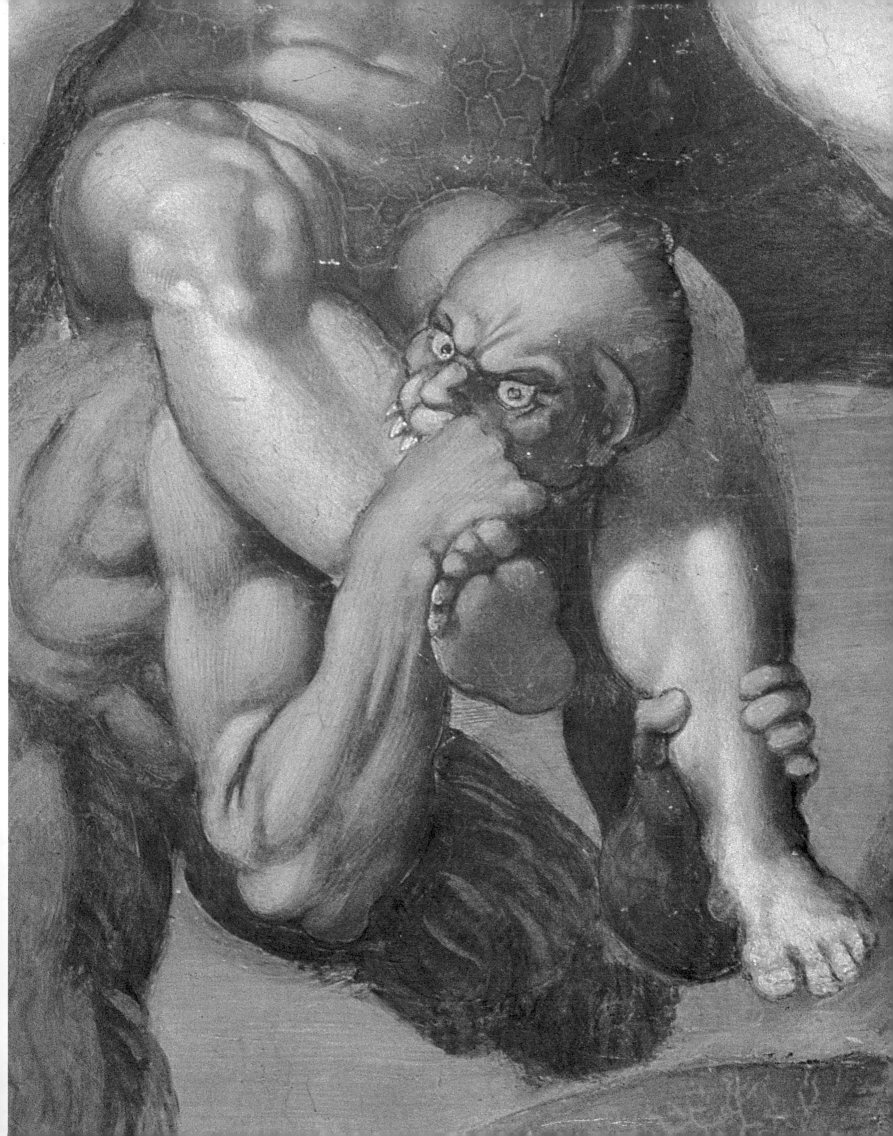

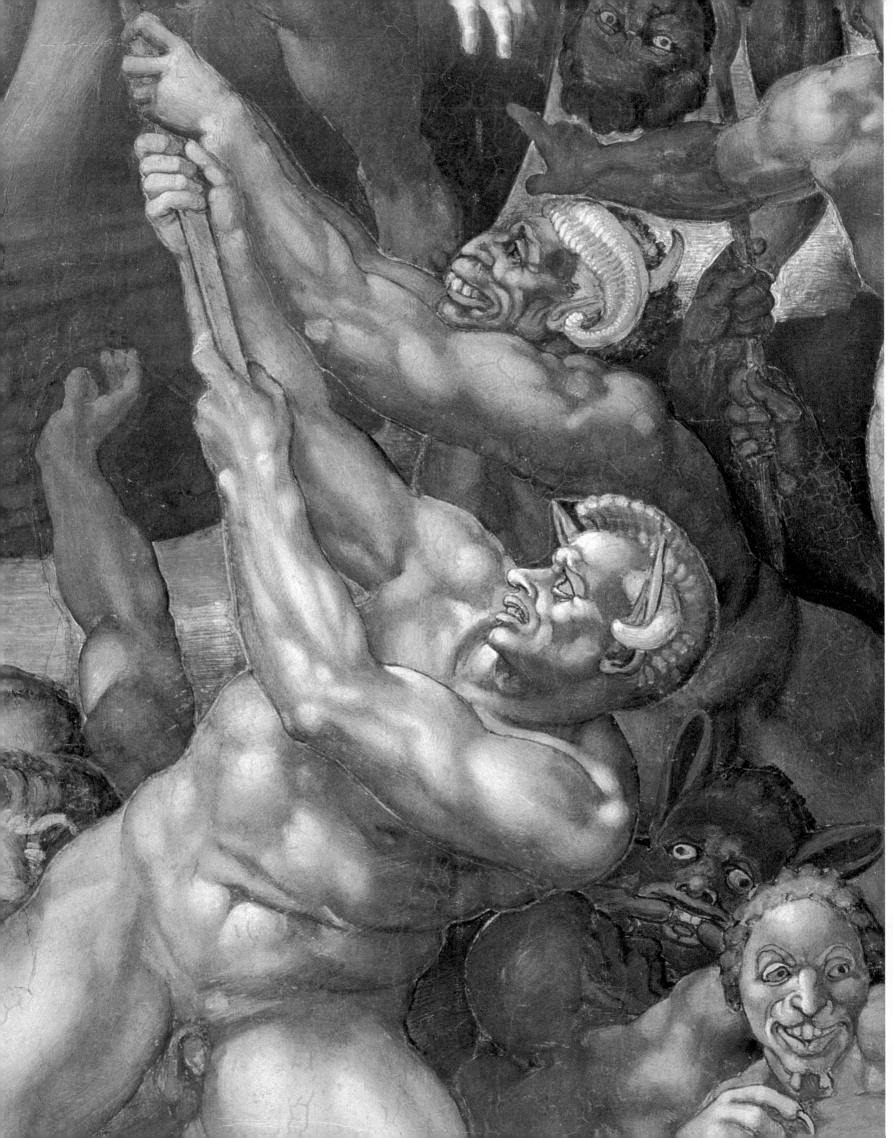

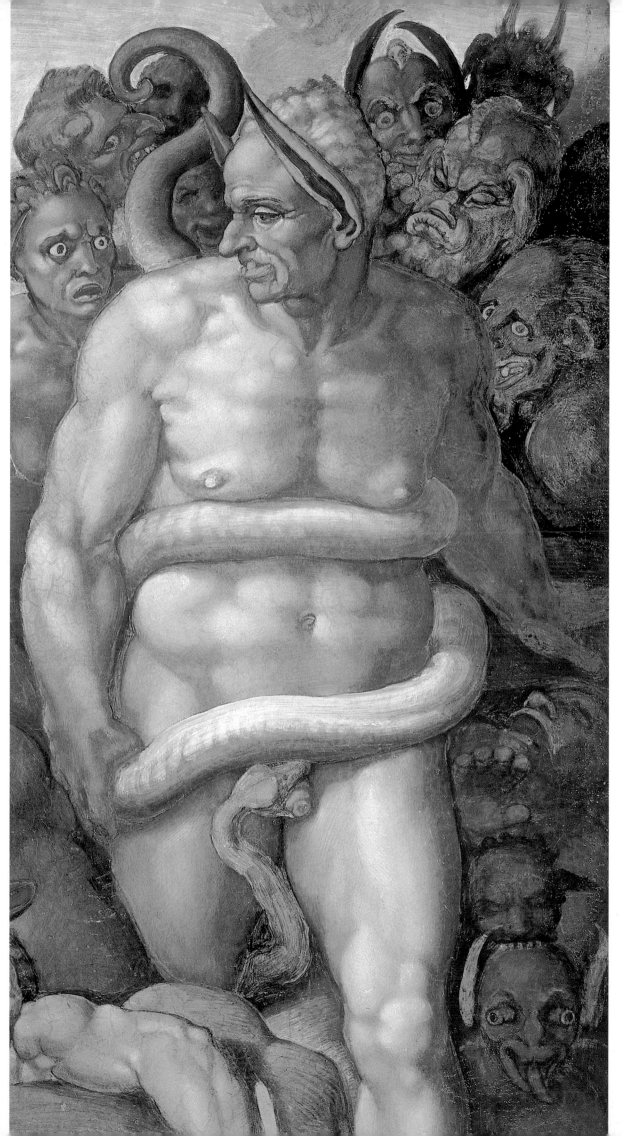

## MINOS

In the lowermost corner is Minos, the judge of the Underworld in Greek mythology, who appeared to Dante at the entrance to the second circle of Hell in his *Inferno*. Vasari relates how Pope Paul brought his master of ceremonies, Biagio da Cesena, with him when he inspected Michelangelo's still unfinished fresco. Asked his opinion, Biagio replied that it was disgraceful to represent so many nudes in such a place and that the work was better suited to a public bath than to a chapel. No sooner had they left than Michelangelo took his revenge by giving to Minos the features of the master of ceremonies and wrapping an enormous serpent around his torso with its head on his genitals. Another figure has been more convincingly identified as the portrait of Biagio, but Minos is the consummate emblem of evil and of abuse of the body, for his right hand gently supports the friendly serpent in her fellation of him.

223

Directly behind the altar, placed so that the celebrating pope or priest would look directly into it, is this black cavern filled with demons and a single figure, seen from the back, silhouetted by a fiery glow. The left wall of the cave has been breached where we see angels and demons battling over bodies. Scholars have differed over whether these are escaping or being nabbed by malignant demons as they awaken from the dead. There is even less certainty over what this cavern represents, but the arguments in favor of Purgatory are the most convincing. It is only from Purgatory that one can escape, and in fact the priest at the altar would have in mind that his celebration of the Mass helped the souls suffering in Purgatory. The Council of Trent was quick to confirm the existence of Purgatory in the face of the Protestant claim that it was a fraud that benefited the Church through the sale of indulgences. The anecdote concerning Biagio, the Master of Ceremonies, appears to confirm that Purgatory was included in the fresco. When Biagio complained to Pope Paul of Michelangelo's portrayal of him,

the pope is alleged to have responded that if Michelangelo had consigned him to Purgatory he could have helped, but over Hell he had no power.

There was even a serious threat to destroy the fresco during the papacy of the fanatical Paul IV Carafa (1555–59). This zealous reformer had been the first general of the Inquisition when it was established in Rome in 1542. When more space was needed in the chancel area of the Sistine Chapel to accommodate the enlarged College of Cardinals, he proposed tearing down the altar wall and moving it back, thereby incidentally demolishing the *Last Judgment*. In the event, the space was provided by moving the chancel screen forward to its present location, but the threat to the fresco had been real and it is an index of the intensity of the animosity it aroused in some, and the seriousness of the demands for reform of sacred art. Protestant attacks upon the Church for idolatry and abuse of images goaded the ecclesiastical hierarchy to redefine the position of the Church on the proper use of images and to take a fresh look at religious art.

In the lower right corner the tonality shifts abruptly. In Dante's *Inferno*, the light is so dim it is hard to make out the forms. Thus the painter, following Dante, when he came to grapple with the demons and Damned at the entrance to Hell, needed a deeper palette than fresco can provide, with its technique of applying semi-transparent tones over a white ground. The ultramarine sky does not penetrate here; instead we see the murky waters of the river Styx, and dingy figures barely distinguishable in the forbidding gloom. To obtain the doleful effect he sought, Michelangelo covered the white *intonaco* with a reddish-brown umber, then painted the mid-tones and lights on top. In a few passages in this zone where he wanted to use certain green and blue metallic pigments that are not compatible with fresco, he used oil as his medium, as Sebastiano del Piombo had proven could be done successfully in his murals in the chapel in San Pietro in Montorio.

# THE CRITICAL RECEPTION, THEN AND NOW

As soon as the fresco was unveiled in 1541 it became a new model for artists. The painter and writer Armenini (1586) recollected how, as a young man, when he was in the chapel drawing, he would be among many others, and he would overhear discussions and disputes about minute details of the work.

It became a kind of school of anatomy, the best place in Rome—or anywhere—to study the nude figure. This created its own set of problems, as Armenini also noted. The obsessive and slavish imitation practiced by some artists led to their loss of good judgment, so that they would fail to integrate the imitated parts into the whole: "Some painters are so blind they place in their works some ridiculous nudes made with graceful heads and soft arms, but with muscular body and loins, while the rest of the work is in soft contours and light shadows." Michelangelo himself was aware of the danger offered to young artists of this wholesale imitation if they did not take into account the context and subject of his fresco. Armenini tells of Michelangelo visiting the chapel on some sort of business in the company of a bishop and, seeing the copyists, remarking, "Oh, how many men this work of mine wishes to destroy." But many experienced artists and some brilliant ones learned from the *Last Judgment*, assimilating what they learned and making it part of their own styles: for example, Agnolo Bronzino, the principal painter in Florence at midcentury, and Francesco Salviati, who deserted the model of Raphael after the *Last Judgment* and took up a Michelangelesque sculptural style in his painting.

Among the chorus of praise reporting on the fresco when it was first viewed, we hear a disturbing undercurrent criticizing the nudity. Even in 1541 there were already those who felt that such a display was indecorous on the altar of the Papal Chapel, echoing Biagio da Cesena's remarks of a few years earlier. This became part of a reaction that was building within the Church against the prevailing artistic style, regarding it as inappropriate for sacred images. The fashion for contorted nudes imitated from Michelangelo's fresco exacerbated the situation and added fuel to the critics' fire.

Complaints against the artists – not just Michelangelo but also his contemporaries –proliferated after the first meetings of the Council of Trent in 1546. A Sienese Dominican, Ambrogio Catarino (1552), noted that painters did not imitate nature; he had seen "some images so extravagant that you can hardly recognize the human figure in them . . . And elsewhere you see compositions made with so much artifice that at times among so many improper gestures they ignore the decorum of the figures, and do not have any dignity and do not excite any devotion at all." This was the crux of the issue: that the virtuoso display of artistry led the worshiper away from devotion to contemplating the art, rather than the sacred subject. But Catarino was writing for ecclesiastical circles—his text was in Latin—and it would be another decade and more until Gilio's *Dialogue* in the vernacular would aim such denunciations directly at the painters and their patrons.

Gilio published his treatise attacking Michelangelo's *Last Judgment* in 1564, the same year that the Decrees of the Council of Trent were published and Michelangelo died. Apparently out of respect for the venerable old man, Gilio waited until his death, for he says that the treatise had been completed in 1562. The full title indicates its thrust: *Dialogue on the Errors and Abuses of the Painters . . . with many notations on the* Last Judgment *of Michelangelo . . . with clarification of how they should paint sacred images*. He criticized the fresco for many small departures from scripture and for the excessive nudity, although he acknowledged that when the final trumpet sounds we will certainly be raised naked. In demanding clarity, purity, and piety in sacred images, Gilio was restating what by then were widely held views that were codified in the Tridentine Decrees. Gilio's real concern was that the virtuoso display of the "excellence of art" distracted from the religious content and was therefore inappropriate in sacred images. He makes Michelangelo's *Last Judgment* the scapegoat because it had engendered so many of the abuses he wished to bring to an end, abuses that Armenini also would criticize another quarter-century later. Armenini's book is proof that Gilio's point was successfully made, and the artistic establishment became persuaded that a new kind of sacred image was required because, unlike Gilio's book which is dedicated to the leading patron of the day in Rome (Cardinal

Alessandro Farnese), Armenini's is addressed to the artists. In discussing altarpieces Armenini gives these instructions: "When paintings are in a sacred place, they must be such that they draw men's thoughts as much as possible toward purity and honesty. Certainly, it is very unsuitable to see in holy places paintings of such a nature that they turn the minds of men away from religious thought and toward the pleasures and delights of the senses."

We are given a hint in another contemporary source of how Michelangelo would have responded. Francisco de Hollanda quoted Michelangelo as saying that to render the image of our Lord, the painter should be of blameless life, even if possible a saint, so that the Holy Spirit could inspire him. Interestingly, he insisted on the value of artistic quality, saying that a badly wrought image could distract the attention and prevent devotion, "while those that are divinely fashioned excite even those who have little devotion or sensibility to contemplation and tears and by their austere beauty inspire them with great reverence and fear."

Michelangelo would not have disagreed even with that most conservative Counter-Reformation critic, the bishop of Bologna, Gabriele Paleotti (1582), when he defined what he believed to be the task of the artist. As Paleotti conceived it, the artist's image was an instrument to unite man with God. He should "recall men from vice to the true cult of God" (Book 1, Chapter 19, 211) but his artistic excellence should always be in the service of his devotion. It was not enough to be a good artist and to show the excellence of art: The artist is a Christian and is therefore obliged to seek to show in his images a Christian soul (Book 1, Chapter 3, 136). It is ironic indeed that Michelangelo, who was probably the most devout artist of the Cinquecento, should have become the source of so much abuse on the part of his followers and the target of the Counter-Reformation campaign to reform religious imagery.

One of the criticisms of the *Last Judgment* was that it contained concealed meanings. At one point in his treatise, Gilio broaches a discussion of covert allegorical meanings that might be concealed from the understanding of the simple and the uninitiated. The Church had held that some truths are so precious they should be cloaked in mystery to guard their sanctity, but this position had been attacked by Protestants. Martin Luther had condemned the premise that the laity are not worthy of sharing in these mysteries and denounced, for example, the exclusiveness of such practices as the priest lowering his voice in the Mass so that the congregation should not hear the words of the consecration of the host. In its efforts to democratize itself, the Counter-Reformation Church was moving away from arcane and hidden meanings. Already in 1557 in his treatise, *Dialogo della Pittura intitolato L'Aretino*, Ludovico Dolce discussed the possibility that Michelangelo's fresco contained hidden allegories. Michelangelo's defender in the dialogue, Fabrini, tried to justify him by saying that the *Last Judgment* "embodies allegorical meanings of great profundity which few people arrive at understanding." With evident irony, Dolce puts into the mouth of his fictitious Pietro Aretino, one of the most learned men in Italy, the criticism of such practice. Aretino responds that if that is so, and Michelangelo did not want his inventions to be understood except by a few intellectuals, "then I, who am not one of the intellectual few in question, leave thinking about them to him." In other words, what is the use of allegory unless it can be generally perceived and understood?

One of Gilio's concerns was that ordinary people would not respond as they should to the image. More than once he remarked that the worshipers would be moved to laughter when they should be awed and devout. Michelangelo was a victim of technological change, which he could not have anticipated, that broadened the audience for his *Last Judgment* far beyond what he had in mind when he conceived the fresco in the mid 1530s. The congregation that would assemble in the Sistine Chapel was made up principally and regularly of the College of Cardinals and members of the papal court and household, most of whom would have been familiar with the theology surrounding the Final Resurrection. But it was in just these years that reproductive engraving first made cheap copies available to everyone. By the end of the century, at least seventeen different engravings of the *Last Judgment* were in circulation. This media revolution made small-scale reproductions of the fresco available to an audience who had no experience with Michelangelo's style, or with the conventions of Renaissance art, and no particular training in theology. No wonder Gilio worried.

It has often been commented that the modeling of Michelangelo's figures is exaggerated. Late in the sixteenth century Annibale Carracci characterized the nudes in the *Last Judgment* in contrast to the figures of the Sistine Ceiling as "too anatomical." Even the critic Raffaello Borghini, writing in Michelangelo's native town of Florence (1584), where Il Divino continued to be regarded as the greatest of the great, warned artists against the excesses that arose from copying

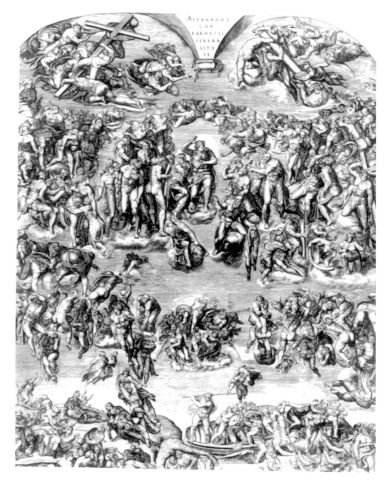

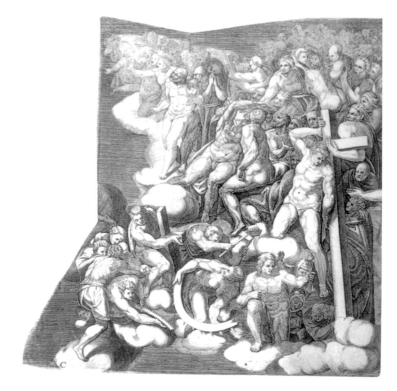

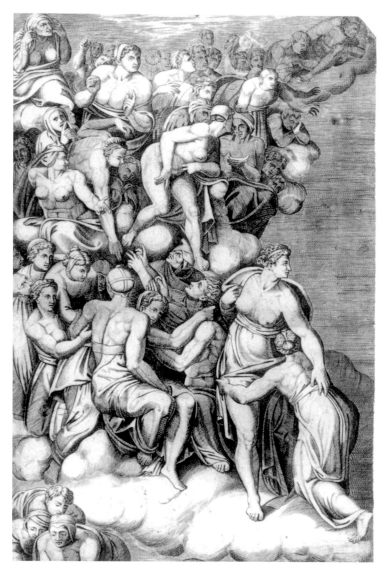

*top left:* Giorgio Ghisi, *The Elect*, detail, engraving

*top right:* Domenico del Barbiere (Domenico Fiorentino), *Angels carrying the Symbols of Christ's Passion*, detail, engraving

*bottom left:* Giulio Bonasone, *Last Judgment*, engraving

*bottom right:* Niccolò della Casa, *Last Judgment*, detail, engraving

Michelangelo's anatomy. Do not give a delicate woman the limbs and muscles of a ferocious man, the painter is told. The modeling of muscles should not be exaggerated. Although it is never stated, these faults resulted from uncritical imitation of Michelangelo.

The compromise to save the fresco from destruction was that some of the nudes would be covered with loincloths and the most troubling juxtaposition of Saints Catherine and Blaise would be adjusted. Out of respect for the master, Michelangelo's closest follower was assigned the task of making these changes.

## TECHNIQUE

In executing the vault, Michelangelo had used three methods of transferring his design onto the wall. In the lunettes of the Ancestors of Christ on the side walls no signs of either pouncing or incision were found. It appears that he enlarged his small sketches freehand and painted without other preparation.

On other sections, especially where the vault curved and foreshortenings were a problem, he used pouncing, the surest method of transfer and the most time consuming. The least tedious procedure was to trace the outlines of the cartoon with a blunt point, and the indentation would be recorded in the damp plaster of the *intonaco*. All three techniques were used in the *Last Judgment*. Michelangelo used pouncing at the top, then as he proceeded downward, incisions become more frequent. There were groups of figures painted without cartoon, in fact added afterward in *secco*, sometimes at a distance of several days. The crowds of indistinct heads among the Elect, appearing in the rearmost plane, are such later filler.

The artist was older now and more shrewd. He was less the perfectionist and more the pragmatist, less in love with effects that could never be seen from the floor, more aware of what was worth taking the time to render carefully, and what would be quixotic. There is more *secco* than in the vault, there are more corrections, and the preparation is more economical, the brushstrokes broad and rapid, the palette reduced and simplified. His choices were astute. In preparing the plaster to go under figures he took the trouble often to add marble dust, presumably to make the surface smoother and the base lighter in color. On the other hand, on occasion in the vault a figure had been elaborately prepared with different tones of *terra verde* (umber) and *verdaccio* (dirty green). Nothing of the sort appears in the *Judgment*. All the figures were prepared with a brown local color, usually umber, then the mid tones and lights were added on top. This was a quick and efficient method, making it possible to execute the vast number of figures that people the wall. He was now less cautious about using *secco* to make corrections, additions, and refinements. Whereas on the vault he had normally scraped away the *intonaco* in such cases, here he only scraped away the color.

Michelangelo was prohibited from following one of the fundamental rules of fresco painting. Because it is almost impossible to match a color from one *giornata* to another, the frescoist arranged to encompass all of a single field of color in a *giornata*. For this reason we normally see the seams of a day's work following the contours of a figure or a drapery. The blue of the sky here, however, had of necessity to be executed in many patches, with the result that there were seams running across *giornate* that the painter had to go back and conceal with *secco*. Over the centuries they became visible again, as the *secco* wore away. In old photographs they are very apparent but, happily, they were successfully concealed again in the recent restoration. The use of ultramarine for the sky and the preparation under it is another instance of Michelangelo's perspicacious use of time and resources. The pope was paying for the materials, so Michelangelo used precious ultramarine, replacing the much-cheaper smalt that had been used for the blues in the vault. To bring out its purplish tone he underpainted it with red ochre, giving it a rosy tonality. Never before had ultramarine, which is derived from the semiprecious stone lapis lazuli, been used on such a scale. Michelangelo recognized that no effort should be spared to enhance its richness and its brilliance.

In fact the color scheme hinges on the blue, which dominates and binds together the enormous painting. The other colors are scattered across the prominent nude flesh and are fewer in

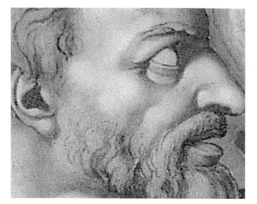

The Last Judgment, detail of Saint John the Baptist. Traces of *spolvero* are visible on hair and beard.

The Last Judgment, detail in raking light of one of the demons, showing traces of incision.

The Last Judgment, detail of a *secco* correction to the left foot of an angel in the right lunette (before restoration).

number than on the vault. The typical pigments of fresco prevail: yellow and red ochre, *terra verde* for green, lime white (*bianco di sangiovanni*), vine black (obtained by burning grapevines), and for browns, umber and burnt sienna. In *secco* passages, however, he used pigments that were almost never used in fresco: red lake, orpiment, and lead-tin yellow (*giallolino*). These last two were needed to give sufficient brilliance to the sunlike aureole behind Christ.

The problem of how to represent the celestial sphere must have occupied Michelangelo's mind. The traditional gold background of mosaic was normally replaced in frescoes from Giotto onward with blue. Giotto's background was done with azurite, applied *secco*; but as happens when the wall becomes wet, in places it has turned green. Signorelli used a very pale background, almost white. Michelangelo's solution in terms of the extravagance of ultramarine was a brilliant innovation. It carried some of the same connotations as gold, without appearing to be a throwback to an outmoded medievalism. No sixteenth-century viewer would have failed to recognize its preciousness and its novelty.

## RESTORATIONS

The recent restoration has brought back to life the image and the colors that had been masked by the accumulated grime and smoke and had been distorted by earlier attempts to refresh or restore. The restoration was the culmination of a fourteen-year campaign begun in 1980 with the Ancestors of Christ in the lunettes, unveiled to nearly universal acclaim in 1984.

The vault required six years. The *Last Judgment* was begun in early 1990 and presented to the public in March 1994. The entire restoration was funded by Nippon, the Japanese television company, which scrupulously recorded every stage on film. In exchange Nippon received exclusive rights to the photographs, which expired three years after each phase of the restoration was completed.

On the vault the principal task had been removal of the glue that restorers of the past had repeatedly applied to refresh the colors as they darkened with grime. The problem for the restorers presented by the *Last Judgment* was the unevenness of its discolorations (the condition of the vault had been more homogeneous). This was due only in part to Michelangelo's technique, and due more to the variety of different interventions in different parts that the fresco had undergone over the past centuries. Especially the lower zone, in the vicinity of the altar candles, had become so dark that it was almost illegible, while the lunettes high above were still light and readable. That lower zone, being easily accessible, was subjected to numerous restorations in the past. Beginning soon after Michelangelo completed it, and continuing even into the twentieth century, the fresco was regularly dusted, which damaged the fragile *secco* passages and abraded the surface. As in the vault, animal glue, to which was added a small amount

of vegetable oil, had been applied to the surface to refresh the colors, much as varnish was used on oil paintings. Not only did this coating darken, like varnish, but it encouraged the growth of fungus, producing a spotty appearance, particularly in the upper part of the fresco. In some places oil alone was used to resaturate the colors, and where the *intonaco* was porous it absorbed the oil, penetrating the cracks and creating irregular dark spots, some of which cannot be removed. Nevertheless, because there was no water damage, there were fewer layers of glue than had been found when the vault was cleaned. There were numerous retouchings, including reinforcement in the shadows to revive the modeling. Where the additions were heavy, the surface was dark and vitreous; where thin, it was lighter.

The strategy the restorers devised allowed them to move slowly and to compare a newly cleaned segment with what had already been completed to insure that the same level was achieved. The delicate sky required special treatment because it could not be rubbed even with a soft brush, and matching the color throughout was critical. The dirt had to be removed with a blotter, wet with a sponge, so that no friction was created. It was decided to entrust it to one restorer, the indomitable Gianluigi Colalucci, to insure a uniform level of cleaning. With its completion the chapel has attained a new coherence not seen for centuries. The brilliant ultramarine sky, though unique within the chapel, focuses the decorative scheme so that the altar wall becomes the dramatic climax.

## PERINO'S TAPESTRY DESIGN

Shortly after the fresco was completed, the pope commissioned Perino del Vaga to design a tapestry to hang below on the wall behind the altar. Perino was the pope's other favorite painter. He had recently executed a similar commission, the *basamento* in Raphael's Stanza della Segnatura, frescoed with caryatids and fictive bronzes containing narratives from antique mythology, and he was at work on the stuccoes in the Sala Regia.

Although the tapestry was never executed, Perino's cartoon has survived. To our eyes its exuberant ornament in the Maniera style contrasts strikingly, even shockingly, with Michelangelo's skeletal bodies rising from the grave and the Damned crossing the river Styx into the mouth of Hell, which would have been directly above it.

Here in a nutshell is to be seen the unresolved dichotomy of the age. In the cultivated circle of the Farnese pope there was no conflict between the two images. They simply could not see what is apparent to many modern observers: that Perino's splendid frame would trivialize Michelangelo's apocalyptic image.

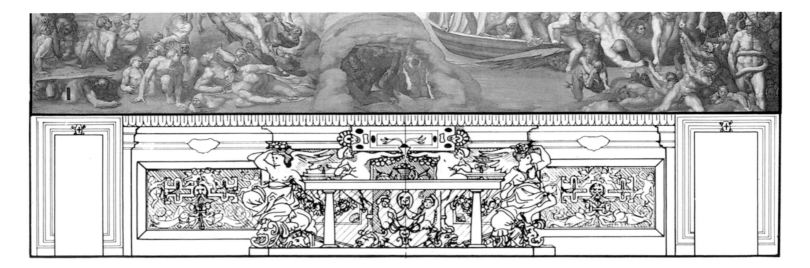

# CONCLUSION

Until this point in Michelangelo's career, the premise of High Renaissance humanist art had remained intact and operative: that the body conveys the dignity of human creation in the *imago dei*. To judge from the change in his style that took place following the *Last Judgment*, what Michelangelo discovered here was the limitation of the idealized figure as a visual metaphor, for he abandoned it after the *Last Judgment* and never used it again.

In his last paintings in the Pauline Chapel (Vatican), in his late drawings, sculptures, and even architecture, he turned to a late-medieval model—we are reminded of his own early drawings after Giotto—and invented what has been dubbed his "drab style." In place of his elegant and dynamic serpentine poses we find heavy, stolid, blocklike figures who move ponderously as if weighed down.

In his search to express the spiritual body in visual terms, Michelangelo had drawn upon his lifelong conception of the ideal body. Not only in the Sistine vault but generally in Michelangelo's artistic language, strength and energy had always been his means to express ideality. The *Moses* is an old man with flowing beard, but his bared arm and muscular build convey the power of his sanctity and his closeness to the Lord. Michelangelo's amazonian Virgin in the Doni *Holy Family* is a far cry from Leonardo's lovely evocations of feminine grace in his Virgins, but she is no less potent a metaphor for the terrestrial embodiment of the divine.

In the lowest zone of the *Judgment*, the final setting of the scaffolding, the idealized and perfected body was not suitable to represent those being reclothed in flesh at the left, the demons in the cave, and the Damned in Hell at the right. Nowhere here was the idealized and perfected body appropriate. Instead Michelangelo had to search beyond his accustomed repertory to present human forms that were not in the image of God, yet were still Saint Paul's "spiritual bodies." Did this trigger his rethinking that resulted in his forsaking Renaissance ideality and his conversion to the drab style? His personal spiritual odyssey in these years had brought him to the tormenting fear that he would not be among the Elect, and the recognition that most of humankind had not earned redemption.

The criticism has been made that the similarity in the way old and young, male and female, are treated in the *Last Judgment* results in a certain schematism. The sense of lifelikeness is compromised. Precisely that individuation that Michelangelo sought falters and is replaced by a not fully plausible artistic pattern. It may be the tragic irony of this work that it is impossible to do what Michelangelo set out to do: represent all of humankind, respecting each person's uniqueness, but conforming his or her form to an ideal, an ideal that includes physical maturity, consummate strength and energy. If everyone must have a perfected body, how is it possible to introduce sufficient variation to depict nearly four hundred figures? To compensate for the uniformity of his bodies, he had to rely on diversifying their poses in what, with so much repetition, came to appear contrived. The very diversity (*varietà*) was an artistic asset, however, in Michelangelo's century (unlike today), when virtuosity was expected of an artist and admired. This commission demanded a tremendous virtuosity; possibly no artist but Michelangelo commanded a repertory of anatomies equal to the task. But if what he undertook could not be achieved, what he did accomplish was nonetheless to balance in tension the terror and the joy of the Final Day, and to represent both God's initiative and man's responsibility as no artist before had done.

# A SELECTED BIBLIOGRAPHY

**VAULT**

On the general cultural climate of Julius's
Rome, see Rowland. On artistic
developments, see Hall (1999).
Vasari and Condivi give the earliest
descriptions of Michelangelo's decoration.
For the classic study of the chapel see
Steinmann. See also De Tolnay.
On the chapel before Michelangelo, see
Shearman; Ettlinger; Lewine.
New evidence for Sixtus's preservation of
the walls of the pre-existing chapel has been
provided by Pagliara.
On the problem of Michelangelo's assistants,
see Wallace (1987); Mancinelli, (1992b).
On Michelangelo's biography, see Vasari;
Condivi, De Tolnay, Hibbard. For the letter of
1523, see Ramsden.
For the Augustinian interpretation, see
Dotson.
For the interpretation of the Seers, see
O'Malley; Dotson.
On the decorative scheme, see Sandström;
Leach.
For the Renaissance humanists, in particular
the preachers in the papal chapel, see
O'Malley (1979).
On the medallions, Wind (1960) identified
the texts and interpreted the images;
corrected by Dotson. The alternative reading
to Wind's commandments has been offered
by Hope, in which the scenes are related to
the Moses and Christ frescoes on the walls
below and understood as exempla.
On the development within the vault from
start to finish, see Freedberg.
On the adaptation of Domus Aurea designs
in Renaissance decorations, see Sandström;
Hall (1999), and specifically by Michelangelo,
Hibbard.
Bober and Rubinstein connected the gesture
in the *Sacrifice of Noah* with the roman relief
(no. 116, Rome, Villa Albani).
On Michelangelo's contrapposto, see
Summers.

Armenini, Giovanni Battista. *De' veri precetti della pittura* (1586). English trans, and ed. by Edward J. Olszewski. *On the true precepts of the art of painting*. Renaissance Sources in Translation. New York: Burt Franklin & Co., 1977.

Barnes, Bernadine Ann. "A Lost *Modello* for Michelangelo's *Last Judgment*." *Master Drawings* 26 (1988): 239–48. Reprinted in Wallace, William E., ed. *Michelangelo: Selected Scholarship in English.* (5 vols.) Vol. 4: *Tomb of Julius II and Other Works in Rome.* New York: Garland, 1995, 55–64.

Barnes, Bernadine Ann. "Metaphorical Painting: Michelangelo, Dante, and the *Last Judgment*." *Art Bulletin* 77 (1995): 65–81.

Barnes, Bernadine Ann. "Aretino, the Public, and the Censorship of the *Last Judgment*." In *Suspended License: Censorship and the Visual Arts.* Ed. E. Childs, Seattle: University of Washington Press, 1997, 59–84.

Barnes, Bernadine Ann. *Michelangelo's Last Judgment: The Renaissance Response.* Berkeley: University of California Press, 1998.

Barolsky, Paul. "Metaphorical Meaning in the Sistine Ceiling." *Source* 9, no. 2 (1990): 19–22. Reprinted in Wallace, William E., ed. *Michelangelo: Selected Scholarship in English* (5 vols.). New York: Garland, 1995 vol. 2: 413–16.

Barolsky, Paul. "Looking Closely at Michelangelo's Seers." *Source* 16, no. 4 (1997): 31–34.

Barolsky, Paul. "What Is the Libyan Sibyl Doing?" *Source* 19 (1999): 9–12.

Barolsky, Paul. "The Imperfection of Michelangelo's Adam." *Source* 20 (2001), 6–8.

Barolsky, Paul. "Michelangelo's *Creation of Adam* and the Aesthetics of Theology." *Source* 20 (2001): 9–11.

Beck, James. "Cardinal Alidosi, Michelangelo, and the Sistine Ceiling." *Artibus et Historiae* 11, no. 22 (1990): 63–77. Reprinted in Wallace, William E., ed. *Michelangelo: Selected Scholarship in English* (5 vols.). New York: Garland, 1995 vol. 2: 417–31.

Beck, James. "Michelangelo's 'Sacrifice' on the Sistine Ceiling." In *Renaissance Society and Culture: Essays in Honor of Eugene Rice.* Ed. J. Monfasani and R. G. Musto. New York, 1991, 9–22. Reprinted in Wallace, William E., ed. *Michelangelo: Selected Scholarship in English* (5 vols.). New York: Garland, 1995 vol. 2: 433–46.

Blunt, Anthony. *Artistic Theory in Italy 1450–1660* (1940). Oxford: Oxford University Press, 1962.

Bober, Phyllis Pray, and Ruth Rubinstein. *Renaissance Artists and Antique Sculpture: A Handbook of Sources.* London: Harvey Miller, 1986.

Borghini, Raffaello. *Il Riposo.* Florence: 1584. Facsimile of 1584 ed., with bibliography and index, Mario Rosci, ed. 2 vols. *Gli storici della letteratura italiana*, no. 13. Milan: Edizioni Labor, 1967.

Brandt, Kathleen Weil-Garris. "Michelangelo's Early Projects for the Sistine Ceiling: Their Practical and Artistic Consequences." In Craig Hugh Smyth, ed., in collaboration with Ann Gilkerson, *Michelangelo's Drawings*, 57–88. *Studies in the History of Art*, no. 33. National Gallery of Art, Washington. Center for Advanced Study in the Visual Arts, Symposium Papers, XVII. Hanover, NH: University Press of New England, 1992. Reprinted in Wallace, William E., ed. *Michelangelo. Selected Scholarship in English* (5 vols.). Vol. 2: *The Sistine Chapel.* New York: Garland, 1995, 543–73.

Calì, Maria. *Da Michelangelo all'Escorial: Momenti del dibattito religioso nell'arte del Cinquecento.* Turin: Einaudi, 1980.

*Canons and Decrees of the Council of Trent.* Original text and trans. H. J. Schroeder. St. Louis: Herder, 1941.

Chastel, André. *The Sack of Rome, 1527.* Trans. Beth Archer. Princeton: Princeton University Press, 1983.

Condivi, Ascanio. *The Life of Michelangelo*. Trans. Alice Sedgwick Wohl; ed. Hellmut Wohl. Oxford: Phaidon, 1976.

De Hollanda, Francisco. *Four Dialogues on Painting* (1548). Trans. Aubrey F. G. Bell. Oxford: Oxford University Press, 1928.

De Maio, Romeo. *Michelangelo e la controriforma*. Bari: Laterza, 1978.

De Tolnay, Charles. *Michelangelo*. 5 vols. Princeton: Princeton University Press, 1943–60.

De Vecchi, Pierluigi. "Michelangelo's Last Judgement." In *The Sistine Chapel. The Art, the History, and the Restoration*, 176–207.

Dempsey, Charles. "Mythic Inventions in Counter-Reformation Painting." In P. A. Ramsey, ed., *Rome in the Renaissance: The City and the Myth*, 55–75. Papers of the Thirteenth Annual Conference of the Center for Medieval and Early Renaissance Studies. Medieval and Renaissance texts and studies, no. 18. Binghamton: Center for Medieval and Early Renaissance Studies, 1982.

Di Napoli, Giovanni. *L'immortalità dell'anima nel Rinascimento*. Turin: Società Editrice Internazionale, 1963.

Dotson, Esther Gordon. "An Augustinian Interpretation of Michelangelo's Sistine Ceiling." *Art Bulletin* 61 (1979): 223–56, 405–29. Reprinted in Wallace, William E., ed. *Michelangelo: Selected Scholarship in English* (5 vols.). Vol. 2: *The Sistine Chapel*. New York: Garland, 1995, 203–27.

Ettlinger, Leopold. D. *The Sistine Chapel before Michelangelo: Religious Imagery and Papal Primacy*. Oxford-Warburg Studies. Oxford: Clarendon Press, 1965.

Freedberg, S. J. *Painting in Italy 1500–1600* (1971). 3rd ed. New Haven: Yale University Press, 1993.

Friedlander, Walter. "The Anticlassical Style." In *Mannerism and Anti-Mannerism in Italian Painting*. New York: Columbia University Press, 1957. Trans. of "Die Entstehung des antiklassischen Stiles in der italienischen Malerei um 1520" (1925).

Gilbert, Creighton. *Michelangelo: On and Off the Sistine Ceiling*. New York: Braziller, 1994.

Gilio, Giovanni Andrea. *Dialogo nel quale si ragiona degli errori e degli abusi de' pittori circa l'istorie*. Camerino, 1564. In Paola Barocchi, ed. *Trattati d'arte del Cinquecento fra manierismo e controriforma*. Vol. 2, 3–115. Bari: Laterza, 1960-2.

Goldberg, Victoria L. "Leo X, Clement VII, and the Immortality of the Soul." *Simiolus* 8 (1975/1976): 16–25.

Greenstein, Jack M. "'How Glorious the Second Coming of Christ': Michelangelo's *Last Judgment* and the Transfiguration." *Artibus et Historiae* 10, no. 20 (1989): 33–57. Reprinted in Wallace, William E., ed. *Michelangelo. Selected Scholarship in English* (5 vols.). Vol. 4: *Tomb of Julius II and Other Works in Rome*. New York: Garland, 1995, 73–97.

Hall, Marcia B. "Michelangelo's *Last Judgment*: Resurrection of the Body and Predestination." *Art Bulletin* 58 (1976): 85–92. Reprinted in Wallace, William E., ed. *Michelangelo. Selected Scholarship in English* (5 vols.). Vol. 4: *Tomb of Julius II and Other Works in Rome*. New York: Garland, 1995, 65–72.

Hall, Marcia B. *Color and Meaning: Practice and Theory in Renaissance Painting*. New York: Cambridge University Press, 1992.

Hall, Marcia B. "Wisdom in God's Embrace: Michelangelo's *Creation of Adam*," letter to the editor, *Art Bulletin* 75 (1993): 340.

Hall, Marcia B. *After Raphael: Painting in Central Italy: 1520–1600*. New York: Cambridge University Press, 1999.

Hall, Marcia B. "Michelangelo's Hidden Clue." In *Michelangelo's Last Judgment*, ed. Marcia B. Hall. New York: Cambridge University Press (forthcoming).

Hibbard, Howard. *Michelangelo: Painter, Sculptor, Architect* (1975). London: Octopus, 1979.

LAST JUDGMENT

On the lost modello and preparatory drawings, see Barnes (1988).

For the Copernican interpretation, see Shrimplin (2000).

On the question of whether the subject was changed, see Hall (1976).

On the theological debate, see Di Napoli; Goldberg.

Tommaso de Vio's (Tommaso Caejtano) commentary on the Epistles of Saint Paul can be found in the Vatican Library (BAV R.I.II.712): *Epistolae Pauli et aliorum apostolorum ad graecum veritatem castitatae...*, Venice 1531.

On the contribution of Cajetano, see Hall (forthcoming).

On Bandinelli's tomb design for Pope Clement, see Goldberg; Chastel.

On John the Baptist as part of a *Transfiguration*, see Greenstein.

De Tolnay identified the three cardinal virtues, seeing these figures as corresponding to the seven vices opposite, which had been pointed out by Vasari and Condivi.

La Cava identified the face on Bartolomew's skin as Michelangelo's.

See Steinberg (1980a) on Minos and the serpent.

On the critical reception of the fresco, see Scavizzi, Hall (1999), Blunt, Dempsey. Barnes (1998) has discussed the critical reception of the fresco most recently and most thoroughly. Scavizzi quoted Catarino ("Disputatio de culto et adoratione imginum," in *Enarrationes*, Rome, 1552).

For the drab style, see Joannides (1992).

On Perino del Vaga's cartoon, see Partridge (1997).

Blunt reported the rumor that Pius XI was considering adding more loincloths to the nudes.

On the restoration of the *Last Judgment*, see Mancinelli et al. (1992; 1994).

Walter Friedlander quoted Carracci's criticism of Michelangelo's modeling.

Hirst, Michael. *Michelangelo and His Drawings*. New Haven: Yale University Press, 1988.

Hope, Charles. "The Medallions on the Sistine Ceiling. In *Journal of the Warburg and Courtauld Institutes* 50 (1987): 200–04. Reprinted in Wallace, William E., ed. *Michelangelo: Selected Scholarship in English* (5 vols.). Vol. 2: *The Sistine Chapel*. New York: Garland, 1995, 286–90.

Joannides, Paul. "'Primitivism' in the Late Drawings of Michelangelo: The Master's Construction of an Old-Age Style," in ed., Craig Hugh Smyth in collaboration with Ann Gilkerson, *Michelangelo's Drawings*, 245–62. *Studies in the History of Art*, no. 33. National Gallery of Art, Washington. Center for Advanced Study in the Visual Arts, Symposium Papers, XVII. Hanover, NH: University Press of New England, 1992.

Joannides, Paul. *Michelangelo and His Influence: Drawings from Windsor Castle*. Exh. cat. Washington: National Gallery of Art, 1996.

Kuhn, Rudolf. *Michelangelo: Die sixtinische Decke. Beiträge über ihre Quellen und zu ihren Auslegung*. Berlin: de Gruyter, 1975.

La Cava, Francesco. *Il volto di Michelangelo scoperto nel Giudizio finale*. Bologna, 1925.

Leach, Edmund. "Michelangelo's Genesis: A structuralist interpretation of the central panels of the Sistine Chapel ceiling." In *Semiotica* 56. 1/2 (1985): 1–30. Reprinted in Wallace, William E., ed. *Michelangelo. Selected Scholarship in English* (5 vols.). Vol. 2: *The Sistine Chapel*. New York: Garland, 1995, 235–64.

Lee, Rensselaer W. "*Ut pictura poesis*: The Humanistic Theory of Painting." *Art Bulletin* 22 (1940): 197–269; reprinted New York: Norton, 1967.

Lewine, Carol F. *The Sistine Chapel Walls and the Roman Liturgy*. University Park: Pennsylvania State University Press, 1993.

Manca, Joseph. "Sin, Sadomasochism, and Salvation in Michelangelo's *Last Judgment*." *Source* 13, no. 3 (1994): 20–26.

Manca, Joseph. "Michelangelo as Painter. A Historiographic Perspective." *Artibus et Historiae* 16, no. 31 (1995): 111–23.

Mancinelli, Fabrizio, Gianluigi Colalucci, Nazzareno Gabrielli. "The *Last Judgment*: Notes on its Conservation History, Technique, and Restoration." In *The Sistine Chapel: A Glorious Restoration*. New York: Abrams, 1992 (1992a).

Mancinelli, Fabrizio. "The Problem of Michelangelo's Assistants." In *The Sistine Chapel: A Glorious Restoration*. New York: Abrams, 1992 (1992b).

Mancinelli, Fabrizio, Gianluigi Colalucci, Nazzareno Gabrielli. "Michelangelo: Il Giudizio universale. " In *Art Dossier* 88 (March 1994).

*Michelangelo e la Sistina: La tecnica, il restauro, il mito*. Exh. cat. Rome: Fratelli Palombi, 1990.

*Michelangelo: La Cappella Sistina. Documentazione e Interpretazioni*. 3 vols. Novara: Istituto Geografico de Agostini, 1994.

O'Malley, John W. *Praise and Blame in Renaissance Rome: Rhetoric, Doctrine, and Reform in the Sacred Orators of the Papal Chapel, c. 1450–1521*. Durham, NC: Duke University Press, 1979.

O'Malley, John W. "The Theology behind Michelangelo's Ceiling." In *The Sistine Chapel: The Art, the History, and the Restoration*, 92–148.

Pagliara, Piernicola. "New Documents on the Construction of the Sistine Chapel." In *The Sistine Chapel: A Glorious Restoration*, 256–65.

Paleotti, Gabriele. *Discorso intorno alle imagini sacre e profane*. Bologna, 1582. In Paola Barocchi, ed. *Trattati d'arte del Cinquecento fra manierismo e controriforma*. Vol. 2, pp. 117–503. Bari: Laterza, 1960-2.

Partridge, Loren W. *Michelangelo: The Sistine Chapel Ceiling, Rome*. The Great Fresco Cycles of the Renaissance. New York: George Braziller, 1996.

Partridge, Loren W. *Michelangelo: The Last Judgment: A Glorious Restoration*. With texts by Fabrizio Mancinelli and Gianluigi Colalucci. New York: Abrams, 1997.

Pon, Lisa. "A Note on the Ancestors of Christ in the Sistine Chapel." *Journal of the Warburg and Courtauld Institutes* 61 (1998): 254–58.

Posèq, Avigdor. "Michelangelo's Self-Portrait on the Flayed Skin of St. Bartholomew." *Gazette des Beaux-Arts* 124 (July–Aug 1994): 1–14.

Ramsden, E. H., ed. and trans. *Letters of Michelangelo*. 2 vols. Stanford: Stanford University Press, 1963.

Roskill, Mark W., ed. *Dolce's "Aretino" and Venetian Art Theory of the Cinquecento*. Monographs on Archaeology and the Fine Arts, no. 15. New York: College Art Association, 1968.

Rowland, Ingrid. *The Culture of the High Renaisssance: Ancients and Moderns in Sixteenth-Century Rome*. New York: Cambridge University Press, 1998.

Sandström, Sven. *Levels of Unreality: Studies in Structure and Construction in Italian Mural Painting during the Renaissance*. Uppsala: Almqvist and Wiksell, 1963. Reprinted in Wallace, William E., ed. *Michelangelo. Selected Scholarship in English* (5 vols.). Vol. 2: *The Sistine Chapel*. New York: Garland, 1995, 111–34.

Saslow, James M. *The Poetry of Michelangelo. An Annotated Translation*. New Haven: Yale University Press, 1991.

Scavizzi, Giuseppe. *The Controversy on Images from Calvin to Baronius*. Toronto Studies in Religion, no. 14. New York: Peter Lang, 1992.

Shearman, John. "The Chapel of Sixtus IV." In *The Sistine Chapel. The Art, the History, and the Restoration*, 22–91.

Shrimplin, Valerie. "Hell in Michelangelo's *Last Judgment*." Artibus et Historiae 15, no. 30 (1994): 83–107.

Shrimplin, Valerie. *Sun-Symbolism and Cosmology in Michelangelo's* Last Judgment. Sixteenth-Century Essays and Studies, 46. Kirksville: Truman State University Press, 2000.

*The Sistine Chapel: The Art, the History, and the Restoration*. New York: Harmony, 1986.

Steinberg, Leo. "Michelangelo's *Last Judgment* As Merciful Heresy." *Art in America*, November/December 1975, 49–63.

Steinberg, Leo. "A Corner of the *Last Judgment*." *Daedalus* (Spring, 1980a), 207–73.

Steinberg, Leo. "The Line of Fate in Michelangelo's Painting." *Critical Inquiry* 6 (Spring, 1980b), 411–54.

Steinberg, Leo. "Who's Who in Michelangelo's *Creation of Adam*: A Chronology of the Picture's Reluctant Self-Revelation." *Art Bulletin* 74 (1992), 552–566.

Steinberg, Leo. "All about Eve." *Art Bulletin* 75 (1993): 340–44.

Steinmann, Ernst. *Die Sixtinische Kapelle*. 2 vols. Munich: Bruckmann, 1901–05.

Summers, David. "Contrapposto: Style and Meaning in Renaissance Art." *Art Bulletin* 59 (1977). 336–61.

Vasari, Giorgio. *La Vita di Michelangelo nelle redazioni del 1550 e del 1568*. Ed. Paola Barocchi. 5 vols. Milan: Riccardo Riccardi, 1962.

Von Einem, Herbert. *Michelangelo*. Trans. Ronald Taylor. London: Methuen & Co., 1973.

Wallace, William E., "Michelangelo's Assistants in the Sistine Chapel." In *Gazette des Beaux-Arts* 110 (Dec. 1987): 203–16. Reprinted in Wallace, William E., ed. *Michelangelo. Selected Scholarship in English* (5 vols.). Vol. 2: *The Sistine Chapel*. New York: Garland, 1995, 327–40.

Wallace, William E., ed. *Michelangelo. Selected Scholarship in English* (5 vols.). Vol. 2: *The Sistine Chapel*; Vol. 4: *Tomb of Julius II and Other Works in Rome*. New York: Garland, 1995.

Wallace, William E. *Michelangelo: The Complete Sculpture, Painting, and Architecture*. New York: Hugh Lauter Levin Associates, 1998.

Wilde, Johannes. *Michelangelo: Six Lectures*. Eds. John Shearman and Michael Hirst. Oxford Studies in the History of Art and Architecture. Oxford: Oxford University Press, 1978.

Wind, Edgar. "Maccabean Histories in the Sistine Ceiling." In Ernest F. Jacob, ed. *Italian Renaissance Studies: A Tribute to the Late Cecilia M. Ady*, London: Faber and Faber, 1960, 312–27. Reprinted in Wind, Edgar. *The Religious Symbolism of Michelangelo: The Sistine Chapel*. Ed. Elizabeth Sears. Oxford: Oxford University Press, 2000.

Wölfflin, Heinrich. *Classic Art: An Introduction to the Italian Renaissance*. Trans. Peter and Linda Murray. London: Phaidon Press, 1961.